The Creativity Complex

The Creativity Complex

Art, Tech, and the Seduction of an Idea

Shannon Steen

University of Michigan Press
Ann Arbor

Copyright © 2023 by Shannon Steen

For questions or permissions, please contact um.press.perms@umich.edu

Published in the United States of America by the
University of Michigan Press
Manufactured in the United States of America
Printed on acid-free paper
First published July 2023

A CIP catalog record for this book is available from the British Library.

Library of Congress Cataloging-in-Publication data has been applied for.

ISBN 978-0-472-07627-7 (hardcover : alk. paper)
ISBN 978-0-472-05627-9 (paper : alk. paper)
ISBN 978-0-472-22123-3 (e-book)

for Aaron, Auden, Ethan, and Samantha

Contents

Digital materials related to this title can be found on the Fulcrum platform via the following citable URL: https://doi.org/10.3998/mpub.12083938

Acknowledgments

I wish there was a way to thank properly the numerous people in my life who have helped bring this book into being, but it is nearly impossible to meaningfully repay people who have inspired, supported, cared for, teased, exasperated, and pushed you in your writing process. I will simply say that this book would not exist without the people listed here.

Margaret Werry, Julia Fawcett, Nick Ridout, SanSan Kwan, Paul Rae, Diana Looser, Rustom Bharucha, Suk-Young Kim, and Charlotte McIvor all heard or read drafts of earlier versions of the material here and supplied invaluable insights and responses. My faculty colleagues at UC Berkeley in the Department of Theater, Dance, and Performance Studies and in the Program in American Studies likewise imparted generous insights and enormous enthusiasm and encouragement at our annual research gatherings. Renee Fox at UC Santa Cruz did me the huge favor of pointing me toward Jeanette Winterson's *Frankissstein*, for which I am enormously grateful. The audiences and working group members at Performance Studies International and the American Society for Theater Research also offered timely and important feedback, as did listeners at Duke University and the National University of Ireland at Galway. I am especially indebted to the numerous graduate students in the PhD in Performance Studies program at Berkeley, who have shaped my thinking at least as much as I have shaped theirs. Shane Boyle, Charlotte McIvor, Emine Fisek, Michelle Baron, Khai Nguyen, Bradley Rogers, Kathleen Polling, Joy Palacios, Marc Boucai, Caitlin Marshall, Takeo Rivera, Martha Herrera-Lasso Gonzales, Kimberly Richards, Sarah Whitt, Aparna Nambiar, Rebecca Struch, Jaclyn Zhou, and Crystal Song have left their imprint on this project in countless ways.

Numerous individuals provided research aid at key moments. I am especially grateful to the librarians of a number of institutions who kept researchers like me going even in the depths of the pandemic, when many archives and libraries were closed. Special thanks at UC Berkeley goes to Susan McElrath of the Bancroft Library, Corliss Lee of the Instruction Services Division, and Abby Scheel of Doe Library, all of whom helped me track down odd requests and special materials, and to the staff of the Pacific Film Archive, who unearthed Pat Brown's gubernatorial campaign ads. Lewis Wynam of the Library of Congress and Jennifer Mandel of the Ronald Reagan Presidential Library were both instrumental in helping find materials on Reagan's gubernatorial campaign. I would also like to give an enormous thank-you to David Henry Hwang for sharing the unpublished manuscript of *Soft Power*.

My graduate student assistant Crystal Song put in an enormous amount of work on manuscript preparation, and I'm grateful for her patient and meticulous aid, as well as for her help in selecting cover art. I am indebted to LeAnn Fields for her expert shepherding of the project through the University of Michigan Press, including her finding two outstanding external readers who furnished very useful counsel on how sharpen the book. Thanks too to Flannery Wise at Michigan, who answered a hundred questions about process issues at the press, Marcia LaBrenz for overseeing the production process, and Daniel Otis, who provided meticulous copy editing. I would have been unable to research and complete the manuscript without a sabbatical through the Humanities Research Fellowship at UC Berkeley.

Many thanks to the organizations who gave permission to reproduce images in this book, especially to the following artists who shared their work: Tobias Klein, Eric Poulton, Duane Flatmo, Five Ton Crane, Obtainium Works, and Manual Cinema. For a few images in the book, we were unable to procure permissions—we made every attempt to contact these organizations to access licensing rights to reproduce these images, but our inquiries received no response. The material in chapter 6 from my article "Neoliberal Scandals" is reproduced by permission of Johns Hopkins University Press, and the material in chapter 2 from my article "Dogwhistle Performance: Concealing White Supremacy in Right-Wing Populism" is reproduced by permission of Taylor and Francis, a division of Informa PLC. This permission does not cover any third-party copyrighted work that may appear in the material requested.

Lara Reynolds deserves a special thanks for keeping my son going while schools were closed for the pandemic—her help meant that I didn't lose my final semester of research leave while tending to his care and education (when nearly every other parent I knew was extraordinarily burdened in this regard). More than almost anyone else on this page, Lara enabled the existence of this book.

And finally I must thank my family, who offered enormous love throughout my time on this project. My son Auden Berry is an unending source of joy and laughter, and continues to inspire me with his own creative path through the world. I am beyond grateful for how Samantha and Ethan Sheanin have expanded my life and the circle in which I find myself. And I cannot imagine a more loving and supportive partner than Aaron Sheanin, who is a model of humor and integrity and patience—the world is a better place because you are in it. You have all brought more love to my life than I knew was possible.

Introduction

The Creativity Complex

"Creativity" is a central keyword of our time. Within it, we have vested vital questions over the nature of self-fulfillment and a life well-lived, over how developed-world economies can survive the tidal changes of postindustrialism and globalization, over how and with what values we should raise, teach, and train the next generation. It houses and organizes some of our foremost cultural debates about education, economics, self-identity, happiness, and even citizenship. Consider just a few examples of the term's circulation from the past decade: at over seventy million views as of this writing, the most frequently viewed talk on TED.com is "How Schools Kill Creativity"; health and wellness blogs tout the mental and physical health benefits of creative activity; a 2010 survey of 1,500 CEOs found that corporate heads around the world see creativity as the key leadership competency of the twenty-first century, and business schools now rush to develop courses on it.[1] It is, in the words of 1960s research psychologist John Gardner, "a kind of wonder drug, powerful and presumably painless; and everybody wants a prescription."[2]

Concepts of creativity have held a special purchase on contemporary policy debates across an impressively wide institutional spectrum for the past twenty years. Since the publication of Richard Florida's *The Rise of the Creative Class* (2000) and John Howkins's *The Creative Economy* (2002), an avalanche of books, TED talks, podcasts, and white papers on creativity has been produced—largely with a view toward how creativity might best be developed in ourselves, our organizations, our localities, and our chil-

dren. Although it is both heralded as an inexhaustible economic resource capable of resolving the problems of postindustrialism and derided as a hollow slogan of entrepreneurialism, neither of these formulations truly captures the whole story of what creativity means and does for us and *to us* today.[3] What precisely do we mean by the term "creativity"? What is the relationship of the arts—once considered creativity's proper or even sole domain—to how we think about and act on this term now? What are the social implications of the concepts attached to this impressively mobile and capacious word?

As even a brief encounter with research on the term "creativity" will reveal, its tantalizingly slippery features make it nearly impossible to define it precisely. Over the course of its circulation in the English language, "creativity" has covered an impressively—even confusingly—broad semantic range. Within the English language, creativity has denoted both an exclusive exercise of divine power and a core mechanism of the individual, especially in relation to self-expression, self-fulfillment, and self-making more generally. In its definition as a special and elevated form of cognition, it is understood to enable new ways of perceiving, doing, and making, a capacity once construed as the transformative ability that differentiated art from artisanship and invention from craft, but it is now seen to connect these two forms of detailed, impassioned labor. In this latter sense, it has migrated from referring to the privileged arena of the artist to the bridge that links the arts to the sciences and to technological invention, especially in its capacity for problem-solving.

But creativity has also been used to chart a relationship between the individual and the larger social world. In its relationship to self-definition, it has been construed as a disposition that enables cognitive flexibility, agility, and personal agency, and in that form has been seen as a sign of intellectual strength and superiority. At the same time, it has been defined as a social good. In its social sense, creativity has been elaborated as an antidote to a variety of ills, from loneliness and postindustrial economic precarity to mental, personal, and professional stagnation. In its economic iteration, it has been posed as the foundation for a powerful, new economic system uniquely freed from the constraints of scarcity, one that serves as the basis for individual, regional, or national economic competitiveness. Underlying these connotations is the idea that creativity provides a shield against stultifying convention in a variety of social, artistic, cognitive, economic, and professional contexts. In this sense, it is seen as a defense against excessive state power and authoritarianism as well.

As this brief semantic sketch suggests, at least as interesting as the term's meandering connotative pathways are the ways these ideas have been used. The wide-ranging investments in creativity that we see at work today function as a "complex" in both the psychoanalytic and the state institutional senses of that term. Psychoanalytically, creativity circulates as a kind of Jungian complex, or "a knot of unconscious feelings and beliefs, detectable indirectly," and also, more loosely, as "'stuck-together' agglomerations of thoughts, feelings, [and] behavior patterns" that indicate a kind of collective anxiety and concern.[4] Increasingly, creativity also emerges as an institutional complex. In the contemporary world, it is a rhetorical device that enables an infrastructural network based on policy and monetary relationships between seemingly disparate institutional interests in education, real estate development, the military, electoral politics, the corporate world, and technology, often in ways that sideline or subordinate the domain of the arts even as they are symbolically embraced within these institutional webs. Where the notorious mid-twentieth-century military-industrial complex linked the defense industry, legislative bodies, and federal agencies via an "iron triangle" (in a set of policy-making dynamics determined by legislative committees, state bureaucracies, and private interest groups in the defense industry), the creativity complex has operated more like an "issue network," one of the "webs of influence" that "provoke and guide the exercise of power."[5] Highly diffused, issue networks offer a range of institutional settings—governmental and non-corporate and not-for-profit, grassroots and top-down—within which mass-scale social decision-making occurs.[6]

The creativity complex is especially diffused, because its "issue" is much less concrete or specific than those political scientists typically track (abortion, national defense, and so forth). Instead, the term is used to advance goals that vary considerably by institutional context, and tends to emerge as a proxy for qualities or objectives that are at once quite ineffable and amorphous and yet somehow are seen to hold the key to our individual and collective future happiness. The individual entities of the creativity complex sometimes coordinate projects or work together to advance its "cause," and sometimes they operate independently, but either way they employ a surprisingly common set of concepts around creativity, regardless of the sometimes contradictory senses in which it is used.

How did we get to this place? *The Creativity Complex* argues that our institutional and collective psychological investments in creativity function as one of neoliberalism's central mechanisms of seduction. Part cul-

tural history and part analysis of contemporary dynamics across a range of cultural venues, this book disentangles the ways in which the thinking about creativity within the United States is inspiring and necessary and useful from the ways it comports with—and even produces—neoliberal effects. Its various chapters illuminate how creativity discourses actively reshape our concepts of geopolitics, education, labor, aesthetics, ethics, and even the relationship between the supposedly antithetical domains of the arts and technology. Along the way, the book explores how creativity discourses and their various manifestations entice even those of us critical of neoliberalism into its operations. It makes the case for seeing the arts—once considered creativity's special domain—as central to understanding neoliberalism's operations, and asks not just whether the creativity complex has produced a set of economic effects that make the arts unsustainable, but whether the decline of the arts is a gauge for the ethical cost of creativity's hegemonic rise.

While researchers in neoliberalism have noted its identity as an ideology (and not as itself the economic effects with which it is most commonly associated—the outsourcing of labor to the developing world, the post–Bretton Woods realignment of international finance, the shifting of wealth from the public sector to the private), it is still somewhat puzzling as to why it has taken root so successfully. It's all too easy to see neoliberalism as installed through coercion, as though it turned out that Margaret Thatcher was right, and there wasn't an alternative to the structures imposed through the various global policies of the last half century. But as David Harvey notes, "For any way of thought to become dominant, a conceptual apparatus has to be advanced that appeals to our intuitions and instincts, to our values and our desires, as well as to the possibilities inherent in the social world we inhabit." This conceptual apparatus requires a series of "compelling and seductive ideals."[7] Harvey's claim here points to perhaps the most crucial facet of neoliberalism, namely its operation as a cultural formation, which anthropologists Catherine Kingfisher and Jeff Maskovsky identify as "a set of cultural meanings and practices related to the constitution of proper personhood, markets and the state that are emergent in a contested cultural field."[8] The biggest, most important shifts occasioned through neoliberalism are not those on the level of policy, but those of our collective and individual values, goals, and identities. While these elements purportedly exist in the realm of the personal, in practice they have occasioned major shifts in the realm of the public, of the mass

cultural world. As Wendy Brown puts it, neoliberalism "disseminates the model of the market to all domains and activities even where money is not at issue—and configures human beings exhaustively as market actors, always, only, and everywhere as *homo oeconomicus*."[9] She warns, however, that "if neoliberalism is conceived only as economic policy and effects . . . we cannot grasp the new formations of subjectivity and politics that are, in good part, neoliberal effects."[10] In this context, creativity discourses seem particularly important to watch—the transformation Brown describes is camouflaged by the seductions of the creative self. Rather than being told we're *Homo oeconomicus*—Brown's sobriquet for the idealized, economically rational social actor—we name ourselves *Homo creativus*.[11]

Within this framework, we might look at creativity as one of Foucault's "technologies of the self," as one of the disparate forms of "truth games . . . that human beings use to understand themselves," those that "permit individuals to effect . . . a number of operations on their own bodies and souls, thoughts, conduct, and ways of being, so as to transform themselves in order to attain a certain state of happiness, purity, wisdom, perfection, or immortality."[12] Seeing creativity as the way "an individual acts upon himself" might explain at least in part its status as a keyword in so many institutional domains. Given the way it appeals to our deepest sense of who we are in the world and how we conduct ourselves, it should not be a surprise that creativity has operated as one of the most important motivations by which we join ourselves—willingly—to neoliberal modes of being in the world. It now circulates as one of our core ideals, a quality to which everyone is meant to aspire, hence its power as a world- and personhood-shaping principle. And while on a casual level we generally think of creativity as the release of or even the antidote to discipline, in fact it might prove to be precisely the reverse. If twenty years ago white-collar workers and others were pressured to "perform or else!" (in Jon McKenzie's pithy phrase), they are now mandated to "create or else!"[13]

The dynamics this book attempts to trace and understand cannot be considered without noting how difficult it is for anyone in the arts to talk about creativity. As an arts researcher, it has been rather disquieting to watch creativity be taken up with enthusiasm by figures in such a wide range of institutional settings—especially as it has become a branding slogan for everything from educational think tanks to athletic clothing companies. For a significant period of its circulation, it has been so deeply synonymous with the domain of the arts as to comprise its essential condition,

with the unsurprising result that many figures in the arts and humanities exhibit a certain amount of territorial defensiveness around the term. This apprehensiveness was perhaps best articulated by Raymond Williams, who warned in his 1976 *Keywords* anthology that:

> The word puts a necessary stress on originality and innovation, and when we remember the history [as originally the sole provenance of the Divine] we can see that these are not trivial claims. . . . The difficulty arises when a word once intended, and often still intended, to embody a high and serious claim, becomes so conventional, as a description of certain general kinds of activity, that it is applied to practices for which, in the absence of the convention, nobody would think of making such claims. Thus any imitative or stereotyped literary work can be called, by convention, creative writing, and advertising copywriters officially describe themselves as creative.[14]

More recently, William Deresiewicz made a similar argument in his 2015 essay for *The Atlantic*, "The Death of the Artist and the Birth of the Creative Entrepreneur":

> When works of art become commodities and nothing else, when every endeavor becomes "creative" and everybody "a creative," then art sinks back to craft and artists back to artisans—a word that, in its adjectival form, at least, is newly popular again. Artisanal pickles, artisanal poems: what's the difference, after all?[15]

Deresiewicz's snarky slide from pickles to poems mirrors Williams's earlier disdain toward "culture industries" such as advertising. Aside from the difficulties of separating this scorn from a certain tight-lipped Puritanism, we should perhaps pause to ask what drives the felt need to identify and separate creativity from its market-driven analogues, especially given the various challenges mounted to those kinds of dichotomies within cultural studies.

Given the ways that creativity is now frequently understood as synonymous with innovation, it's no surprise that, as I've worked on this project, one of the questions I've been asked most frequently is at what point this became true. In some ways, the term "creativity" has carried connotations of innovation from its biblical roots, in the sense of being able to pro-

duce something that has never existed before. So perhaps a better question might be why we wish to distinguish creativity from innovation, or at least to ask what we mean by innovation that some parties may wish to see as distinct from creativity. I suspect that what my interlocutors intend, perhaps not quite consciously, is to distinguish the capacity for novelty from its more market-driven manifestations. Forms of financial innovation (the creation of new "instruments" that can be sold to customers or new ways of dodging regulatory restrictions) and consumer innovation (new soft drinks or new ways to market them) are both frequently described (as both Williams and Deresiewicz lament) as "creative" in some sense. But these distinctions are frequently bound up with questions of taste (high versus popular culture), of scale (domain-transforming activity versus more modest, quotidian advances), or of instrumentalization and end goals (innovation for its own sake versus for monetizable ends or for otherwise empirically measurable outcomes). Those who wish to distinguish creativity from innovation usually see it as the true and authentic occupant of the more valued term in these oppositions. In other words, our desire to separate creativity from innovation may not be merely linguistically difficult; it may reinforce a set of dichotomies that we may not actually wish to encourage, and that certainly have been problematized by scholars in the humanities for several decades now.

Even with these caveats in mind, we also cannot avoid the fact that creativity is now seen as an economic resource, a tendency that many readers of this work may fear will interpolate them into institutions they perceive as deadening and rapacious. For arts researchers and practitioners, the defensiveness Deresiewicz exemplifies may well be driven by the extent to which many of us see the very quality on which our self-identity hangs being appropriated by those we assume would undermine the elements of our work we hold most dear: inquiry, exploration, curiosity, complexity, even beauty. This anxiety surely isn't eased by the fact that many of us now feel compelled to justify our programs of study by pointing out that we inculcate the very quality apparently most in demand by employers (by which term we almost never mean arts organizations, which we seemingly assume do not actually employ anyone). We stress creativity as a key utility and primary benefit of our training, in part because we genuinely value it and believe that we cultivate it in unique ways, but also because we are very much aware of its desirability among employers who increasingly identify it as the "leadership competency" alluded to in the 2010 CEO survey.[16]

Alongside this kind of rationale, arts departments are increasingly put in the position of justifying their training as a species of business degree. In a blog post in this vein titled "3 Reasons a Theater Degree Is Important," Harvey Young notes that "the business of theater is good preparation for other careers,"[17] and goes on to argue that "although people may pretend that professional theater is a bunch of people putting on a play *just for fun*, the reality is that virtually every production is a meticulously planned and coordinated business activity."[18] Many of us in arts departments—myself very much included—have echoed variations of this argument with students, parents, donors, and university administrators (very often having honed it with our own family and friends before using it in professional contexts). Exacerbating these trends, creativity has increasingly come to be defined by those with little to no interest in the arts. It's notable that much of the data for Florida's *The Rise of the Creative Class* comes from interviews he conducted in the IT sector—virtually nowhere does he interview anyone in the fields we might have described thirty or forty years ago as "creative" in the sense to which Williams or Deresiewicz refer. In light of these developments, it is easy to see claims to creativity as straw-clutching by disciplines founded in the nineteenth or early twentieth centuries as part and parcel of (and not in opposition to) the industrial age, and that now seem destined to the same "disrupted" fate.[19]

That arts organizations in education and elsewhere are trying to, in the words of one colleague, "ride the creativity train," is the result of a genuine crisis they face in the collapse of institutional-scale funding. The managers and directors of these organizations turn to creativity discourses in hopes of attracting a demographic that hasn't been particularly prone to institutional support, but that self-identifies deeply with discovery, with invention, and with curiosity, sometimes even in their more whimsical manifestations. It may be that what figures like Deresiewicz (or even myself) long for is not some prelapsarian notion of creativity as free from commercial interests or even a primary association with the artist, but an infrastructural network that could actually support a lively, vigorous arts culture. In other words, the frustrated claim that creativity is simply empty sloganeering may actually be guilty of mistaking symptom for cause.

Having noted this, it would be useful, even important, to understand the historical basis and impact of creativity discourses, so that when we employ them we do so with full knowledge of the context into which we enter. The past century has witnessed a sea change in how we define cre-

ativity itself, particularly in its relationship to economics, a change most explicitly manifested in (though by no means limited to) creative economies theory.[20] If in the past creativity was understood as a mystical characteristic of the artist, it is now treated as a rationalizable, capturable "competency" that functions as the central driver of economic growth.[21] A term of fashion among policymakers across a surprisingly wide global range, "creative economies" now refer primarily to the wealth-generating capacity of those industries based in knowledge, ideas, and information. Among policy-makers, creativity is now cast as the primary economic force across the globe, producing the assumption that the greatest policy challenge of the twenty-first century is to figure out how to best harness and channel it to foster economic growth. This claim forms the bedrock of Florida's *The Rise of the Creative Class*, in which he argues that the massive changes in social norms and labor structures that animated the second half of the twentieth century were not due to economic shifts or social displacements, but to "the rise of human creativity as the key factor in our economy and society . . . for the first time, our economy is powered by creativity."[22] "The ability to create new forms," he posits, provides "the decisive source of competitive advantage . . . and has come to be the most highly prized commodity in our economy."[23] Similarly, John Howkins defines the creative economy as one that could transcend the limitations of traditional economics: "Economics generally deals with the problem of how individuals and societies satisfy their wants, which are infinite, with resources that are finite; it is thus primarily about the allocation of scarce resources . . . ideas are not limited in the same way as tangible goods, and the nature of their economy is different."[24]

Within creative economies logic, the arts—the activities we might traditionally refer to as "creative"—play varying roles in different geographic locales. In the EU, the arts are heralded as a model domain, valuable for its capacity for novelty and its nimbleness in responding to changes in economic conditions, with the result that the arts there have been held as the centerpiece of creative economy policies.[25] By contrast, in the US the arts tend to be subordinated to the IT sector, and are seen as inspiration for the more easily and recognizably monetizable activities of science and technology.[26] The US model is characterized by an absence of state support or intervention for the arts but a simultaneous influx of aid for the tech world, which has received quite high state support in the form of research monies and tax subsidies (despite the sector's stubborn insistence on its

gritty, bootstrapping independence from state assistance). The question of whether the US or EU model for these policies will become the dominant one globally remains very much open, particularly in the developing world, but either way, as Laikwan Pang has noted, creativity now operates as one of the central benchmarks of modernity, as an index of "how sophisticated a country and its people have, or have failed to, become."[27]

In the latter iteration, creativity is used as a branding asset for regions and localities for leverage in a global investment marketplace. Nations, regions, and cities forge and manage an identity through which they sell themselves both to their own citizens and across the world for investment: "Hong Kong cinema," "West End" or "Broadway musical," "Silicon Valley incubator," and the various art biennials that have sprouted across the globe, from Marrakesh to Melbourne, Berlin to Beijing to Bushwick. These brands form the backbone for the large-scale investments that underwrite all kinds of related industries, which together form the web of the creativity complex across real estate, tourism, architecture, civil engineering, parks and recreation, education, and more.

The creative economies model poses a few challenges to received models of state-driven cultural power, however. A generation ago, the primary model for state cultural production posed the state as instrumentalizing the arts to promote particular—and often particularly narrow, exclusionary, and marginalizing—conceptions of itself. In these accounts, the state funded a wide variety of arts forms to advance a set of identity claims around national mythologies for either internal or international consumption. This model rested, however, on a robust and powerful state that could act as a—if not the—primary agent of power. We must now grapple with the relationship between the state and the arts at a moment when the state itself is undergoing significant political diminishment, especially in its role as a safeguard of liberal citizenship rights.[28] If at its heart neoliberalism comprises a uniquely intense process of refashioning the relationship between the state, markets, and the individual (one in which the state is a player of diminishing influence), then the cultural manifestation of that refashioning is in no way epiphenomenal to it, but one of its central mechanisms. Wendy Brown's argument on neoliberalism's extension of market values to all social activity is critical here—if she is correct, then the arts are no longer mobilized by the state merely as an identificatory act, but rather to enable the marketization and monetization of all human activity, to accomplish Brown's reconfiguration of *Homo oeconomicus*.[29] In

this model, the arts comprise one of neoliberalism's particular (if peculiar) modes of cultural formation.

What sacrifices lurk within these transformations? As Andrew Ross argues extensively in *Nice Work If You Can Get It*, creative economy policies have, for over two decades, transformed two important lifeworlds: labor and housing. In Ross's account, the creative economy emerged because the personal discipline that is required of artists—whether a dancer at the barre, a musician mastering a tricky chord progression, or simply the hustle required to procure employment and publicity—was the perfect mentality required to fuel the emerging freelance and contingent labor market created around subcontracting arrangements. In light of employer desires, "cultural work was nominated as the new face of neoliberal entrepreneurship, and its practitioners were cited as the hit-making models for the IP [intellectual property] jackpot economy."[30] It's no coincidence that the term now used for contingent labor systems, the "gig economy," is taken directly from the language and structure of artistic labor.[31] Useful to corporations eager to shed the responsibilities of labor management—and eager to obscure that abandonment under the auspices of bohemian and counterculture coolness—the term has aided what Brown describes as the transformation of concepts of "labor" into those of "human capital."[32] Exemplifying this dynamic, a generation of young adults now pursue postgraduate degrees in "creative" fields that tie them to gig-structured labor, often under the language of entrepreneurialism. In her analysis of creative industries masters students in the UK, Angela McRobbie notes that "many will consider the idea of self-employment or of setting up some sort of small creative business as a realistic option, not because young people like this are natural-born entrepreneurs, but because, when weighing up their options, this emerges as a hope for a more productive and perhaps exciting future."[33] These trajectories, however, produce a new kind of middle class forged as a "risk class": "It works as a future template for being middle class and learning to live without welfare protection and social security."[34]

The impact of erasing formerly middle-class financial securities has been intensified by the ways that creative economies models have also influenced skyrocketing housing costs. As Ross puts it, "The visible presence of creative lifestyles in select city neighborhoods, now designated as cultural districts, helped to boost property value in these precincts and adjacent others in accord with well-documented, and by now formulaic, cycles of gentrification."[35] Arts organizations have served as crucial mecha-

nisms by which cities have rebranded their crumbling, postindustrial cores as vibrant and colorful (as opposed to dirty and dangerous), making them attractive targets for redevelopment schemes,[36] and developers have used artists themselves to raise the real estate value of particular neighborhoods. Brooklyn's DUMBO neighborhood was gentrified in precisely this way— developers offered artists free housing and work space for a limited time, on the assumption that their presence in the district would raise real estate values, an investment that did exactly that.[37] In redefining the arts as an "urban asset," creative economy models have heavily rewarded the real estate sector, and in doing so have actually been responsible for *intensifying* the precarities of neoliberalism rather than providing a solution to them, a dynamic at work in urban centers the world over as artists are priced out of the very neighborhoods they made so attractive to developers in the first place, to say nothing of the displacement of the people living there before the artists arrived.[38] The cities with the highest creative indices (in other words, those with the features Florida claims foster creative industries) tend to have the worst and fastest-growing wealth inequalities in the world. These tendencies provide a major corrective to creative economies arguments. Even if the causes of wealth inequality are not directly those of the "creative" world itself (but instead, say, the impact of real estate and cost of living), many of Florida's creative cities have produced and been aggressively restructured around what can only be characterized as a landed gentry. The growth of these inequalities undermines the utopian vision of the creative economy as a rising tide that will by its very nature lift all boats. Ironically, even though artists are increasingly on the losing end of the wealth divide in creative capitals the world over, they nevertheless provide what Ross characterizes as the esprit de corps for surviving the economic difficulties of this new world:

> Arguably the most instrumentally valuable aspect of the creative work traditions is the carryover of coping strategies, developed over centuries, to help practitioners endure a feast-or-famine economy in return for the promise of success and acclaim. The combination of this coping mentality with a production ethos of aesthetic perfectibility is a godsend for managers looking for employees capable of self-discipline under the most extreme job pressure.[39]

Understanding the role that the arts play in creativity discourses and the social transformations they have wrought is a central goal of this book. As

these examples highlight, even if the focus of publications like *The Rise of the Creative Class* is on the IT sector (and, as Ross, Szeman, and numerous others have pointed out, "new economy" sectors such as IT and the digital tech worlds have been most aggressive in promoting creativity's promises), the arts have not disappeared from creativity's orbit. Rather, they have simply been reorganized, largely diminished to the symbolic status of inspiring handmaiden to the more immediately monetizable domain of technology. Much of what follows will try to limn the complex, interwoven relationship between the arts and tech worlds as they have changed our concepts of creativity over time, and attempts to explain the ends to which they have been used. A significant piece of that puzzle will involve rethinking exactly what the relationship between these two domains might be, and how to think about it beyond C. P. Snow's infamous "two cultures" division.[40] The chapters that follow will explore how the worlds of arts and technology have not just been thought about as linked, but as providing interrelated mechanisms for the neoliberal saturation of our cultural and political landscapes.

In undertaking this work, *The Creativity Complex* attempts to answer Sarah Brouillette's call to historicize "the particular emergence and spread of the vocabulary that makes contemporary labor an act of self-exploration, self-expression, and self-realization."[41] For people who tend to be critical of creative economies discourses, Richard Florida is often set up as a central villain in the story of their global proliferation, as if he and his ilk were the causal force behind these ideas. But he, John Howkins, and other writers on creative economies merely popularized a set of shifts concerning how creativity itself has been reconceptualized since the nineteenth century. While several of these critics have noted the "residual Romantic humanism" in contemporary invocations of the term, few scholars have tried to understand how and in what ways Romantic conceptions of creativity operate now, and even fewer have attempted to contextualize these within the larger political or intellectual debates of their day.[42] In trying to navigate the labyrinthine conceptual history of this term, I've had to look not just to the Romantics—toward whom even proponents of creativity discourses evince significant suspicion—but to earlier and later debates about creativity. As the chapters that follow lay out, the primary definitions of creativity that so many scholars associate with the Romantics actually emerged earlier—largely in Enlightenment debates about the nature of cognition and the rights of the individual versus the state—as do the claims about creativity that most scholars find objectionable, including its

obscuring of labor systems, its loose conflation of widely varying domains of activity, and its relationship to economic productivity.

To assess the contemporary effects of the creativity complex, I analyze a series of cultural examples that are intentionally broad and varied in domain. They range from electoral campaigns to the visual arts, from K–12 educational curricula to contemporary adaptations of *Frankenstein*, from the hardware tech markets of China to theatrical works about them, from Maker Faires to science fiction novels to a Broadway musical. In part, this range of examples is necessary to chart the twisting cultural pathways that concepts of creativity have taken, but they also illuminate how the term has brought together such disparate cultural projects. The social arenas within which they circulate articulate and shape ideas about creativity, and are themselves remade in return. Although I am a historian of the performing arts, only a few of the examples of this book are drawn from that world. These are not intended to make some claim that the theater is an exception to the dynamics this book describes—if anything, I hope to illuminate for artists and art researchers how we might be complicit in them. Having said that, however, throughout the book there are numerous examples from the world of the arts that attempt to think through the problems of the creativity complex, if sometimes indirectly. I offer these works for the light they can shed for readers *outside* of the theater as well as in it.

In the first third of this book, I explore how we moved from defining creativity as a form of heightened cognition located in the work of the artist to thinking about it as the essential condition for economic activity, especially the kind of specialized tech activity that could be more easily monetized than the arts. Chapter 1 ("How We All Became Creative") offers a genealogy of how creativity has been defined since the late eighteenth century, primarily in the Anglophone world. Challenging the frequent assumption of those who write about creativity (as either advocates or critics) that current creativity discourses are largely a phenomenon of the twenty-first century, the chapter lays out the role that concepts of creativity played in eighteenth-century insights into the nature of cognition and Enlightenment debates about the relationship between the individual and the state. It examines how creativity was redefined by intelligence theorists and eugenicists such as Francis Galton in the mid-nineteenth century and Lewis Terman in the early twentieth, and then again with more widespread appeal by military-funded research psychologists in the early Cold War. The chapter concludes with an analysis of how the ideas behind

these definitions of creativity continue to shape contemporary research and, by extension, policy. Building on these histories, the second chapter assesses the legacy of Ronald Reagan's 1966 California gubernatorial campaign. Using the theme "the Creative Society," Reagan invoked the expanded creativity discourses of the Cold War to challenge the social infrastructure and civil rights emphasis of Lyndon Johnson's "Great Society" programs and to undermine incumbent Pat Brown's own similar projects, thus inaugurating the tradition within the US of using concepts of creativity to justify neoliberal social and economic policy. This chapter features archival research conducted on the campaign itself, including on the origins of Reagan's theme.

Building on the policy implications of "the Creative Society," the remaining chapters explore how the creativity complex has emerged through a variety of cultural forms, linking sometimes surprising institutions. Chapter 3 ("Creativity in the Classroom") investigates the insertion of Maker culture into US primary and secondary education, where it is increasingly touted as training the next generation of children to create "America's Manufacturing Renaissance." With Maker Faire events in over forty countries, the movement's artisanal, anticonsumerist ethos is increasingly seen as the antidote to the postindustrial perils of developed-world economies, and its presence in design startups and tech ateliers is often offered as proof of a given region's worthiness for international investment. But perhaps the most important marker of Maker culture's widening influence in the US is its adoption in K–12 education. This chapter explores the claims of skill-building and agency cultivation in Maker pedagogy in order to consider how it naturalizes shifts in conceptions of labor. In idealizing "do-it-yourself" craftsmanship, Maker culture inculcates and normalizes cottage labor systems under the guise of artisanship, making it a central mechanism by which the next generation is taught to internalize the intensification of labor precarity, regardless of one's job world or profession.

Chapters 4 through 6 explore how art-making can produce neoliberal subjects. These chapters analyze how art itself is no longer "outside" the work of neoliberalism, nor is it simply an unwitting vehicle for neoliberal aims; rather, art can create and enhance a sense of self that is shaped around neoliberal prescriptions. Of particular interest for these chapters is the "residual Romanticism" of creativity discourses, including those in education and electoral politics, which invite an exploration of forms that look back to the nineteenth century. Chapter 4, "Discarded Creativity

and Steampunk Nostalgia," explores the contradictory ideological energies of Maker culture's most vibrant and persistent visual form. Two different aspects of steampunk's retrofuturist Victorian style—its visual codes and its particular forms of nostalgia—provide an aesthetic framework for the performance of libertarianism, the tech world's most influential and broadly held political ideology. Looking at a range of examples from fiction and the visual arts, the chapter investigates how steampunk materializes libertarian forms of subjectivity for its participants, even where they forward a critique of the tech world itself.

The subsequent two chapters analyze how a variety of artworks have tried—sometimes obliquely or tacitly—to limn the neoliberal implications of the creativity complex. The last two full chapters of the book—on bicentennial adaptations of *Frankenstein* and on works that consider US-China trajectories—question the ethical and geopolitical futures of creativity. The works in these chapters ask us to rethink the idealization of self-fulfillment, the dichotomization of the arts and sciences, and the role of creativity discourses in geopolitics and democratic electoral politics.

Turning toward a perhaps surprisingly anti-Romantic text, chapter 5 ("Creativity's Monsters") explores creativity discourses in the wealth of adaptations of Mary Shelley's *Frankenstein* at its 200th anniversary. Following their source material, these adaptations reject the "residual Romanticism" that theorists have claimed are at the heart of creativity discourses. Instead, they explore two key features of creativity's contemporary definition: first, as the bridge between the arts and the sciences (domains of activity that are usually assumed to have become antithetical at the time of Shelley's novel), and second, as the definitive form of self-expression and self-making. Shelley's narrative and its many "hideous progenies" expose how contemporary conceptions of creativity as self-fulfillment— conceptions with roots in the Romantic era—largely ignore the ethical perils of self-expression as the foremost manifestation of autonomy and self-fashioning.

The final full chapter of the book ("The Pacific Century, the Creative Century") looks to a trio of cultural works that ask us to reimagine our concepts of transpacific creative economies. One of the central drivers of US creativity discourses is creativity's putative role in international economic competition, with particular emphasis in the last twenty years on constraining China's increasing global influence. This chapter examines how the growth of creative economies theory in the US is interwoven with

theories of "the Pacific Century," the nickname for the twenty-first century in foreign policy circles. Mike Daisey's extended monologue *The Agony and the Ecstasy of Steve Jobs* (2012), *WIRED*'s documentary *Shenzhen: City of the Future* (2016), and David Henry Hwang's musical *Soft Power* (2018) attempt to reshape how China figures within expanding notions of creative economies and US-China commercial, cultural, and political exchanges. If "America's China" has largely been conceptualized in terms of its economic implications for the US,[43] these works ask instead how China's own creative cultures force a reconsideration of those of the US. In its consideration of Hwang's *Soft Power*—the first Trump-era theater piece—the chapter returns to the role creativity discourses play in electoral politics.

In light of the analysis of these chapters, the question emerges of whether creativity could be redeemed or at least separated from its relationship to neoliberalism. The epilogue to the book, "From the Ruins: Reconstructing Creativity," argues that we urgently need to unmake "the creativity complex." Exploring how creativity would need to be redefined and institutionally reorganized, the epilogue suggests how our capacity to think, imagine, and hope might provide meaningful alternatives to the social and political configurations we find ourselves in today.

How We All Became Creative

It would be naïve to believe that, historically, people didn't think of themselves as potentially creative, ingenious, imaginative, or spontaneous. Turning this into a dominant discourse about the self and about society is, however, a *modern invention.*

—Vlad Glăveanu, *The Creativity Reader* (original emphasis)[1]

If there is a desire in contemporary society that defies comprehension, it is the desire *not* to be creative. It is a desire that guides individuals and institutions equally. To be *incapable* of creativity is a problematic failing, but one that can be overcome with patient training. But not to *want* to be creative, consciously to leave creative potential unused and to avoid creatively bringing about new things, that would seem an absurd disposition, just as it would have seemed absurd not to want to be moral or normal or autonomous in other times.

—Andreas Reckwitz, *The Invention of Creativity* (original emphasis)[2]

Creative Imperatives

How did we move from thinking of creativity as an elite, quasi-mystical condition of the artist to defining it as an economic resource that resides in everyone? Or, as sociologist Andreas Reckwitz puts it in the above epigraph, as a cultural imperative that has so saturated our conscious self-identity that it would be unthinkable to disidentify with it, let alone to resist or reject it? To the extent that creativity has become as central a

defining personal characteristic as morality or normality or autonomy, this is because it is now fused or attached to these qualities in quite a profound way. How has this come to be? How has creativity—once understood as a particularly intense form of cognition accessible to an elect few—come to occupy a central pillar in our construction of a self? What precisely is its relationship to these other characteristics, how have they come to be bound together, and to what effect?

At the same time that creativity has come to saturate our self-definition, it has also shaped the imperatives of our social institutions more broadly, especially as the policy basis in urban planning, economic development, and education. As noted in the introduction, for critics of contemporary creativity discourses, Richard Florida is often set up as a central villain in the story of the global proliferation of creativity's influence on institutional policy, as though he and writers like him were the causal force behind these ideas.[3] But Florida, John Howkins, and other writers on creativity simply popularized the shifts in how creativity has been conceptualized over the past two centuries. The institutional uptake of these ideas is partly the story of one specific set of shifts, namely from a consideration of the self to larger social imperatives. This change initiated a peculiar contradiction that Reckwitz identifies as the tension between "an anti-institutional *desire* for creativity and the institutionalized *demand* for creativity."[4]

How did creativity come to exert such contradictory effects? To some extent, the tension Reckwitz identifies between the internal desires of the self and the external demands of social institutions forms an alternative explanation for the framing claim of this book—that creativity operates as a mechanism of neoliberal seduction. If, going back to the introduction of this volume, we understand neoliberalism as a cultural formation founded in the reconfiguration of the relationship between the individual, the market, and the state, understanding the role that creativity discourses have played in the development of that configuration is critical. This chapter explores how concepts of creativity have driven the changing alignment of these entities from the eighteenth century onward, and in doing so have even shaped how we define them in the first place.

Creativity has become bound with particular intensity to concepts of the individual, especially as it came to be understood as the foremost expression of self. As this association rose during the Enlightenment and intensified under Romanticism, creativity also came to share the broad, tortuous semantic field that the term "individualism" itself encompasses,

particularly in its relationship to the market and the state. As Zubin Meer elucidates of this tricky concept:

> Few master-categories bear as formidable a modernist semantic freight as individualism. . . . To sketch out its broadest semantic delineations . . . individualism connotes a dynamic capitalist economic rationality—utilitarian, competitive, and profit-maximizing—inimical to the supposed torpor of feudal and tribal mentality. . . . Pitted against the corporatist ethos of feudal political theory, individualism is of course also shorthand for the modern liberal sense of politico-juridical right and entitlement. And finally, in a tonal register derived from formal philosophy, individualism is also tantamount to a creative rationalism, veridical empiricism, and intimate subjectivity.[5]

Enmeshed with modernist logics of the individual, creativity similarly operates in these sometimes contradictory senses, though as we will see in the coming chapters, it is frequently posed at the confluence of these different senses of individualism, often in order to camouflage or smooth over the tensions between them.

But as Meer notes of individualism, there is no such thing as a history of creativity per se, only of hypotheses, projections, abstractions, and debates about it.[6] Along these lines, one of the more maddening aspects of trying to trace the shifts in how creativity has been conceptualized is that its genealogy varies significantly by domain of activity and (more recently) by academic discipline. Over the course of its history, the concept of creativity has been used for leverage in a variety of debates within at least four arenas: within the arts, among political and economic theorists, among research psychologists, and within education theory and policy. These disparate genealogies overlap and influence one another significantly, which makes their discrete delineation extremely difficult, even counterproductive (and there is considerable room for disagreement on how to identify and distinguish even the strands I note here). Within each arena, as the term has been taken up or deployed, its precise meaning has been altered to bolster all kinds of claims made on its behalf. One assumption of this chapter, then, is that creativity operates discursively, even (or perhaps particularly) where it is claimed as an empirically measurable characteristic.

Most important, however, are the institutional implications of this genealogy—its characteristic "complex." Creativity's branching, web-like

conceptual network (and this, I would argue, is the metaphor we should use to describe its development, rather than seeing it as linear) has brought into being a set of relationships across what might seem like mutually disinterested, if not outright incompatible, institutional organizations, from education and urban development to the military, geopolitics, the tech industry, and even geopolitics (the dynamics of which are addressed in subsequent chapters). But as will become clear, the pairing of creativity with economic activity is in no way a new one, even where skeptics or detractors of creativity discourses insist that it is—and should remain—a quality that stands apart from economic considerations.

For many readers of this book the most familiar conceptions of creativity will probably be those of Romanticism. This chapter instead traces the ideas that contemporary researchers in creativity cite as foundational to current concepts of it, ideas that in the twentieth century shaped and animated the institutional imperatives that Reckwitz describes. While many of these are indebted to concepts developed by the Romantics, the ways that contemporary researchers attempt to dismiss or dispel that influence are key to their force as a psychological complex in the other sense of this book. Reckwitz argues that Western cultures of late modernity have come to be shaped by a "creativity *dispositif*," or the simultaneous external expectation and internal desire to be creative, which arose in "the arts world of the Romantic period, and has been spreading outwards ever since, making the arts a structural blueprint for late modern society."[7] He notes that "self-growth psychology" played a central role in the dissemination of this *dispositif*, providing the impetus and organizing principle "to develop, in an experimental, quasi-artistic way, all facets of the self in personal relations, in leisure activities, in consumer styles and in self-technologies of the body and the soul."[8] Reckwitz's emphasis on the Romantic origins of creativity discourses, which in his account spread via popular psychology, addresses the role the concept has played in self-definition, but less so its institutional spread. He attributes the latter to a kind of aestheticization of the social realm via advanced capitalism and the revolutions of mass media platforms, but even these do not fully explain how creativity has come to exist as an institutional imperative.[9]

This chapter contains two stories that attempt to limn the broad, institutional spread of ideas about creativity. The first of these traces how Enlightenment and Romantic discussions about the nature of cognition and the individual drove some of the foundational modern conceptions of

creativity, especially in the sense of individual expression. Despite the very common discomfort with or outright repudiation of Romantic thought within contemporary research about creativity, Romantic concepts remain some of the most culturally powerful for contemporary thinking about it, even though the process of making creativity an object of research has also involved sidelining the arts (Romanticism's primary domain) in anything other than a symbolic sense. Within the turns of this story, the idea of the creative individual's economic sovereignty will emerge as one embraced and even promoted by Romantic figures, complicating the casual assumption that creativity's association with economic calculus and individualism is one that corrupted or was somehow at odds with Romantic ideals.

The second story of this chapter considers the role played by research psychology in how creativity has come to occupy a central position in both our self-conception and our institutional organization since the mid-nineteenth century. While "creativity studies" has become a significant and highly influential interdisciplinary field in its own right—one shaped primarily by researchers in education, economics, and urban development (though typically not, importantly, the arts or humanities)—the concepts that brought scholars from these disparate fields to creativity studies emerged primarily in research psychology, and not just in its popular "self-growth" manifestations of the 1950s and '60s. Instead, the concept's formal, academic, institutional shaping lies in the retroactive absorption of nineteenth-century intelligence research by Cold War psychology researchers. These figures saw themselves as continuing a philosophical investigation into the nature of cognition and the individual that had its roots in the Enlightenment. However, they legitimated their research through Cold War economic and geopolitical anxieties, and embraced a set of research methods that grew out of the nationalist imperatives of nineteenth-century eugenics. Cold War researchers then used creativity as an organizing principle to order the relationship between the individual, the markets, and the state—an activity they still engage in.

Tracing these ideas across an entire research field is by no means simple. The genealogy that follows is based on ideas forwarded by a quintet of contemporary psychology researchers who comprise the central authority of creativity studies: Mark Runco (who founded the field's gold-standard publication *Creativity Research Journal* in 1988); Robert Sternberg (who coedited the 1999 Cambridge anthology *The Handbook of Creativity*);

Robert Albert (who, in addition to laying out many of the parameters of creativity research in the late 1960s and early 1970s, co-wrote with Runco the foundational essay "A History of Research on Creativity"); Robert Kaufman (who edited an updated Cambridge *Handbook* anthology in 2019); and more recently, Vlad Glăveanu (who has authored some of the most recent work on the history of the concept, including for the updated Cambridge *Handbook* and for his own *Creativity Reader* and *Creativity: A Very Short Introduction* for Oxford University Press, both in 2019). These authors have shaped the term's primary conceptual genealogy and developed its current standard definition—an act that specifies and delimits the permissible concepts of a research field.[10]

In general, contemporary psychology researchers are invested in three primary goals that guide the field's narrative of the term: first, the attempt to produce an objective and quantifiable definition of creativity that could be measured empirically and applied universally, and second, the attempt to democratize notions of creativity, to situate it as an innate human quality that can—and should—be cultivated by anyone given the right circumstances. These goals are framed as scientific ones designed to correct what these authors consider the loose, mystical, and distorted connotations of creativity that emerged within Romanticism.[11] Third, in order to liberate creativity from its purported Romantic mysticism, these researchers have tried to shield their definitions of creativity from what Mark Runco has referred to as the "art bias," the idea that the arts comprise the preeminent domain of creative activity.[12]

In what has become the field's "standard definition" of creativity (the definition all figures within an area of scientific research are meant to use as the basis for studying a particular phenomenon), Mark Runco and Garrett Jaeger insisted in a 2012 essay that the only legitimate definition is a bipartite one, encompassing both originality and effectiveness:

> If something is not unusual, novel, or unique, it is commonplace, mundane, or conventional. It is not original, and therefore not creative. . . . [O]riginality is vital for creativity but is not sufficient. Ideas and products that are merely original might very well be useless. They may be unique or uncommon for good reason! Originality can be found in the word salad of a psychotic and can be produced by monkeys on word processors. . . . Original things must be effective to be creative.[13]

Runco and Jaeger's definition rests on two criteria that have come under heavy scrutiny in arts and humanities research of the past half-century. The centrality of originality has been tempered (if not outright discredited) to acknowledge the roles played by collaboration, incrementalism, historical contingency, social tastes and mores, and markets in determining which cultural artifacts become worthy of the label "creative," to say nothing of the extensive research pointing to the Eurocentric, racist, and misogynistic exclusions the concept has been used to promote. Moreover, as Reckwitz points out, the emphasis on originality within creativity definitions does not rest on some pre-existing, universal, objective quality, but rather "depends on attentiveness and evaluation to distinguish it from the old and prefer it over the old."[14] In this, the identification and valuation of novelty assumes an audience whose role is to determine the degree and desirability of this novelty—to serve, in other words, as a "market" of evaluators. To this end, Runco and Jaeger's definition includes the crucial second criterion of "effectiveness": "Original things must be effective to be creative. . . . Effectiveness may take the form of value. This label is quite clear in the economic research on creativity; it describes how original and valuable products and ideas depend on the current market, and more specifically on the costs and benefits of contrarianism."[15] The standard definition not only circumscribes the parameters of newness and efficacy, it structures a particular relationship between the creative producer and the audience or market. In this conception, the market is raised to an equal or even greater degree of importance to the creative producer in a relationship that Reckwitz refers to as "the social regime of novelty."[16]

The standard definition, then, names and activates a particular individual-market relation that recirculates throughout contemporary research, making that relation the foundation for whatever dynamic the researcher studies. To be fair, a number of creativity researchers have complicated Runco and Jaeger's definition, especially with respect to matters of collaboration and incrementalism. More recent researchers—particularly Vlad Glăveanu, who has edited or written several of the more recent major anthologies for the field—have tried to pressure Runco and Jaeger's definition, especially in its excessive reliance on outcome, but this work is very recent and its uptake and implications are so far unclear.[17] So while a reconfiguration of the social relations of novelty may be on the horizon, at the time of this writing the field of creativity studies assumes and reinforces the arrangement promoted by psychologists like Runco and Jaeger.

But how did psychology researchers—and others who think or write about creativity—come to this configuration? And what is the relationship of this configuration to the earlier debates about the individual from the eighteenth and nineteenth centuries?

The Individual and the Imagination

Contemporary research definitions of creativity are haunted by earlier conceptions, which researchers often try to dispel with varying degrees of consciousness and explicitness. In its premodern definitions, creativity was originally considered to be the sole province of the divine, relegating human agents such as artists to the status of "imitators" who didn't actually make anything themselves. Mere people were not considered to possess creative capacity until the mid-fifteenth century, at which point the most powerful were recognized (linguistically at least) as producing or bringing something into existence; monarchs, for example, were understood to "create" when they invested others with rank and status (in the creation of a duke or a peer, for example).[18]

This early lineage has typically been of relatively little interest to psychology researchers, who instead have seized on eighteenth-century terms they see as early cognates for their standard definition of creativity—in particular, genius, imagination, and the individual. These researchers locate the foundational concepts for creativity in two primary lines of thought from the period: first, in debates about the nature and rights of the individual, and second, about the nature of cognition. Several creativity researchers (in particular, Albert, Runco, and Glăveanu, all of whom have written field-defining histories on the research into creativity) note that the modern concept of creativity as a human and not a divine characteristic originated in the eighteenth-century birth of the "self" as a concept.[19] Given the nature of the standard definition, contemporary psychology researchers perhaps unsurprisingly characterize the Enlightenment debates of the eighteenth century as primarily concerned with the relationship between the individual and the complex society emerging around him or her, especially in relation to the emerging democratic state. In this framing, the tension that Reckwitz identifies between personal desires and social imperatives for creativity is seen to originate in the debates of the eighteenth and nineteenth centuries over the individual and the forms of governance that could best protect and foster it. In their "History of Research on Creativ-

ity," Robert Albert and Mark Runco characterize these debates regarding the individual as centered on concepts of "freedom," particularly freedom of thought and the appropriate social and political limitations to it. The concepts of genius, originality, and talent—which psychology researchers generally regard as early progenitors for concepts of creativity—were all raised in conjunction with ideas about the appropriate limits of state power and individual flourishing. In these debates, they note, the idea that "genius" could be constrained by arbitrary social laws and taboos helped propel the argument that creativity is an elite quality that should be allowed to operate beyond social constraint: "By the end of the eighteenth-century, it was concluded that whereas many persons may have talent of one sort or another . . . original genius was truly exceptional and by definition was to be exempt from the rules, customs, and obligations that applied to the talented."[20] In this way, creativity, or its eighteenth-century forerunner in "genius," functioned as a vessel for arguments regarding the unfettered freedom of the individual. Creative genius was framed as the foremost personal expression of the sovereign individual, and therefore as the most important human quality to be fostered, protected, and encouraged, one to which all other modes of social practice—from education to governmentality—should be subordinated, raising the individual above other forms of social concern.

Enlightenment debates over the nature and political organization of the individual were themselves influenced by considerations of the nature of cognition, the activity that came to be seen as most fully characterizing the individual, and indeed, the human. In the early eighteenth century, ideas about cognition came to be increasingly tied to something referred to as the "creative imagination." Notions of creativity had been key to late seventeenth- and early eighteenth-century changes in ideas about the imagination, a faculty that writers and thinkers of the time largely understood as cognition. Early empiricists had seen creativity as the key faculty by which cognition functioned, not just as passive reception (as it had been conceived of in the early modern period) but as "an active force in the execution of invention and production." Thomas Hobbes, for example, thought that the creative imagination "produces new pictures and ideas, it fashions new experiences; it adorns and creates; it is the force behind art."[21] This connection was further intensified by the Romantics, who, influenced by Friedrich Schelling's "Nature Philosophy" (1797–99), saw the artist as organizing, translating, and reframing the "spirit of nature," as opposed to

simply imitating its outward form.[22] In the midst of the transition from the Enlightenment toward the Romantic era, British philosophers Alexander Gerard and William Duff wrote several influential essays on the nature of genius, posing it as the origin for innovation in both the sciences and the arts. In his 1774 *Essay on Genius*, Gerard identified several of the characteristics that contemporary researchers associate with creativity, especially those of associative or divergent thinking: "A man of genius forms relations between previously unconnected perceptions and thoughts . . . because his imagination associates them of a 'peculiar vigor.'"[23] In Romantic thought, creativity became not just a driver of artistic activity but an elevated form of reason itself, or as Wordsworth parsed it, "reason in her most exalted mood,"[24] a notion that preserved the elite qualities it carried from its biblical origins. The Romantic elevation of creativity, especially as it operated in artistic activity, positioned it not merely as a legitimate sphere of activity, but as the apogee of human cognitive capacity, valuable precisely because it comprised the most meaningful and effective expression of intense subjective experience. As intellectual historian James Engell notes, the Romantic valuation of the imagination "encourages the genius and the poet in their faith that what they say is more than decorative, that their creations can awaken the soul and reach truth."[25]

While psychology researchers like Runco and Albert embrace this history, they miss some of the complexities in how creativity was construed within intellectual and artistic movements like Romanticism, especially with respect to market considerations.[26] The emergence of the idea of the "creative imagination" had been transformative in that it had altered the basis for creative work away from earlier conceptions of artisanship and divine inspiration. As Lee Marshall points out in his history of copyright, prior to the eighteenth century, figures like artists were understood either as craftsmen (in other words, as "technician[s] manipulating a variety of rules and devices to attain a desired effect") or as vessels for an external, divine creative force, "when the role of craft did not seem to do justice to the quality of the work produced."[27] The Romantic construction of the creative faculty effectively used the Enlightenment notion of a sovereign individual to relocate the external forces of creative inspiration to the artist himself or herself. Later in the nineteenth century, the separation of creativity from craft was used to bolster what were effectively class distinctions, differentiating the artist from the artisan by elevating imaginative and intellectual transformative capacity above mere skilled labor.[28] By

1857, the Anglican priest Frederick Robertson made the argument in his *Sermons* that "the mason makes, the architect creates." This kind of class distinction is still very much at work in twenty-first-century conceptions of creativity—Richard Florida defines his "Creative Class" by stressing that "members of the Working and Service Class are primarily paid to do routine, mostly physical work, whereas those in the Creative Class are paid to use their minds."[29]

To aid in the separation of artistry from artisanship (and, perhaps more importantly, creativity from work), the Romantics invoked concepts of originality to laminate the individual to the market. Within the context of the industrial revolution and mass-produced consumer objects, the Romantics increasingly insisted that originality was consonant with humanness itself, as a means by which one could be distinguished from the output of machinery. As printed books became more widely available, the Romantic poets became exquisitely aware of the difficulty of truly original work that could stand uninfluenced by previous generations of writers.[30] While the Romantics wrestled with the seemingly impossible conundrum of originality, they also rearticulated its economic implications, reforming systems of copyright law in the process. In a fundamental sense, copyright law (and its contemporary descendant, intellectual property law) is one of the foremost formal processes by which Reckwitz's "social regime of novelty" is institutionalized. Structuring yet another relationship between the market, the individual, and the state, it reserves for the state the task of adjudicating what counts as creative output, and determines the proper recipient of its financial benefits. In this, copyright animates the tensions and alliances between Romantic thought and capitalist procedure. Wordsworth, for example, who had laid out some of the movement's core principles at the turn of the century, became a central figure in restructuring copyright law from a system that benefitted printers to one that profited authors. Declaring in a supplementary essay for the 1815 reprint of *Preface to Lyrical Ballads* that truly original authors had to create audiences who could appreciate their work fully, Wordsworth argued that groundbreaking artwork would only be properly cherished after the death of its creator.[31] On this principle, he lobbied Parliament not only to have authors benefit directly from the sales of their writing, but to be granted copyright on their works in perpetuity.[32] In assessing this history, John Marshall observes that although Romanticism is commonly framed as a rejection of capitalism (especially in its industrialist forms—commercialization, rationalization,

and urbanization), it is actually better understood as a *part* of capitalism, and specifically as a way to cope with the contradictory experience of art within a social formation dominated by rationalism and utilitarianism: "While providing a way of coping with culture in capitalism, [Romanticism] also emphasizes an understanding of subjectivity and aesthetics that exacerbates the apparent schism between capitalist rationalization and aesthetic experience."[33] This ideology of art and artists continues to shape our contemporary understanding of the relationship between aesthetics, economics, and concepts of creativity—particularly around originality, authenticity, self-expression, and property. It would be incorrect, he insists, to "understand Romanticism either as wholly complementary to capitalist profit-making practices, or as wholly rebelling against those practices: it does both."[34]

Given Romanticism's entanglement in these tensions, it is no surprise that creativity researchers and theorists have been unable to escape or entirely do away with its central energies and tenets. The history of modern research on creativity is characterized by a marked distrust of Romantic ideas (and sometimes those of artists generally), either on empiricist grounds or out of an objection to the supposed resistance to economic forces that is widely attributed to the movement. In doing so, psychology researchers have in many ways anticipated, relied on, and perpetuated the kind of "two cultures" argument forwarded by C. P. Snow and others, seeing the creative work of artists and that of other figures (particularly in the sciences) as somehow profoundly distinct (a differentiation addressed in more detail in chapter 5). Despite this, the Romantics not only provided a language for originality that still circulates in foundational material such as Runco and Jaeger's "standard definition," but articulated a relationship between the creative individual and the market that is often taken as a given in creativity research.

While contemporary creativity researchers absorb and trade on Romantic ideas (even where they think they have dispensed with them), they evince a much more contradictory sense of the relationship of the market and the individual to the state. The Romantics built on the Enlightenment notion that the creative genius needed to be protected from social encroachments, particularly (even notoriously) in their *"art pour l'art"* stance. However, most foundational contemporary research articulates precisely the opposite relationship—seeing the output of the creative individual as that which underpins and drives national economic power and

competitiveness. This conception of creative work would come to steer the eventual Cold War formalization of creativity research. But the importance of creativity to nationalization projects emerged first in the nineteenth century, with the dawn of intelligence research.

Creativity, Intelligence, and the Nation

For the most part, contemporary researchers in creativity studies identify the empirical study of intelligence as the true origin of their field.[35] The psychology researchers who dominate creativity studies generally assume that the qualities and dispositions we now call "creativity" were referred to as "genius" or "eminence" by Enlightenment figures (a conflation to which we will return). With this in mind, they locate the origin of contemporary creativity research in the dawn of intelligence research in the nineteenth century, making the latter's empirical efforts to define and quantify genius much more influential than earlier debates in philosophy or the arts. In this framework, Francis Galton's parsing of intelligence and his creation of psychometric (or empirically measurable) approaches to cognition are repeatedly cited as the origin of modern psychology research into creativity. As early as 1969, Robert Albert (Runco's coauthor on the genealogy of creativity research) saw Galton's work as the genesis for the constellation of creativity with terms such as genius, giftedness, eminence, distinction, and innovation. In the words of more recent researchers Maciej Karwowski and Dorota Jankowska, "It would be neither controversial nor exaggeration to call [him] one of the founding fathers of creativity science, but also one of the most creative men of his time."[36] One of the towering polymaths of the nineteenth century, Galton is seen as a key figure in the development of disciplines as diverse as sociology, psychology, statistics, geography, criminology, and meteorology. In the latter part of his career, he became obsessed with the implications of his cousin Charles Darwin's arguments about heredity for the human species, and set out to test whether the capacity for unusually high achievement was heritable. In the name of British national advancement, he developed the first methods for identifying intelligence and genius, scrutinized family lineage to identify the heritability of "eminence," created the first twin studies (which later became a central methodology of behavior genetics), and eventually used the results of this research to found the modern eugenicist movement.

In his investigation of genius and eminence, Galton connected con-

cepts of individual achievement to the fortunes of the state. In his view, it was crucial to foster genius for nationalist reasons; he saw British international power as threatened by "the weaker races" on the one hand and heritable wealth on the other. He championed meritocratic access to education and other resources, and promoted with equal intensity a program of genetic refinement that would have horrific consequences, particularly with respect to race, gender, and nationalism, well into the twentieth century. Establishing the eugenics movement (a term he invented), he called for the wide availability of merit-based education scholarships, the systematic tallying of family achievement, monetary incentives for early marriage and procreation among eminent figures (whom he noted often married late and had fewer children), the abolition of financial inheritance, citizenship programs for "the better sort" of immigrants and refugees, and the establishment of celibate monasteries for "the weak."[37]

While Galton didn't establish the eugenics movement until 1907, some thirty-five years after he first began writing about genius and eminence and creative capacity, the point of this earlier research was to promote breeding and education schemes that would essentially eliminate from the gene pool anyone he believed would inhibit national competitiveness. His initial interest in the heritability of intelligence was, in his own words, an offshoot of his "ethnological inquiry into the mental peculiarities of different races,"[38] and even his concerns about institutions such as the peerage (the British institution of heritable aristocratic titles) were based in what he saw as their tendency to incline oldest sons to marry women who were unlikely to produce male heirs, thereby unnecessarily deleting the genes of Britain's most eminent families from the national breeding pool.[39] Galton certainly didn't hold his concerns regarding heritable wealth for socially progressive reasons (though they are sometimes hailed as such), and in no way do they redeem his promotion of white supremacy.

Hereditary Genius, the 1869 work in which Galton traced the family histories of eminent figures to discern whether their abilities were inherited or not, was the culmination of these interests, and is also hailed by contemporary creativity researchers as his most direct contribution to the field.[40] Although he never called outright for the widespread mass murder of nonwhite peoples, Galton explicitly argued that European Protestant cultures were those least likely to "regress to the mean" (or subside to mediocrity over successive generations). On this point, he made predictable statements in *Hereditary Genius* regarding European colonialism as a

civilizing mission (under which African people in particular would either "submit to the needs of a superior civilization" or "fail as completely under the new conditions as they have failed under the old ones").[41] In a second, 1892 edition of the book, he argued for legislation in which "the question of race" could be "properly introduced" so that "the improvement of the natural gifts of future generations" might be enhanced.[42] To this end, *Hereditary Genius* concludes with chapters called "The Comparative Worth of Different Races" and "Influences that Affect the Natural Ability of Nations,"[43] both of which read exactly as one would expect given Galton's eugenicist goals.

Despite the centrality of the political goals of his work, Galton's eugenicist legacy is rarely discussed in contemporary creativity research, and much less are the implications of these goals for his perceived foundational importance explored. While researchers like Runco and Albert acknowledge that Galton was driven by his interests in "individual" difference and by the attempt "to minimize the uncertainty in natural selection as it might specifically affect Britain," they and other researchers ignore and suppress the profoundly racist orientation of these goals. Typically, accounts that stress Galton's centrality to the early origins of creativity research either omit the larger goals of his work entirely, chalk them up to a changing social environment that simply now frames his beliefs about race as "offensive," or deflect the worst implications of his eugenicist beliefs onto their later policy uptake by others (brushing off the fact that Galton himself advocated for many of these policies, even if in somewhat more modest forms).[44]

In addition to his work on eugenics and the heritability of genius, one of Galton's most significant influences on creativity research was his skepticism toward the impact of even eminent artists on national competitiveness. Galton's most commonly acknowledged imprint on contemporary creativity research lies in three methodological areas: in executing the first empirical study of "mental imagery" (or the quantitative assessment of the ability to create, remember, and access visual images in the mind), in developing the first self-reported questionnaire (which he then used to study the specific characteristics of genius and eminence), and in recognizing that a broad array of activities could be understood as manifestations of "intelligence," providing a blueprint for this kind of mapping later in the twentieth century.[45] For this last area, Galton analyzed in *Hereditary Genius* the family trees of artists, scientists, statesmen, judges,

military commanders, and athletes.[46] Galton's broad model anticipated the later emphasis in research psychology on multiple forms of intelligence (or the idea that intelligence is not limited to linguistic and mathematical capacity, though these were and remain its most commonly recognized manifestations), and also reoriented associations with imaginative capacity away from the Romantic association with the artist. Galton saw artists as possessing forms of genius that were especially unlikely to be passed on to future generations. Asserting that the primary barrier to the heritability of artistic genius was a predisposition to promiscuity, he argued that the gifts of the artist were usually the result of sexual arousal: "The poets and artists generally are men of high aspirations, but, for all that, they are a sensuous, erotic race, exceedingly irregular in their way of life. . . . Their talents are usually displayed early in youth, when they are first shaken by the tempestuous passion of love."[47] While Galton found examples of eminent members in poets' family trees, these did not tend to produce issue later on, a characteristic he saw in artists more broadly:

> Poets are clearly not founders of families. . . . To be a great artist, requires a rare and, so to speak, unnatural correlation of qualities. A poet, besides his genius, must have the severity and stedfast [*sic*] earnestness of those whose dispositions afford few temptations to pleasure, and he must, at the same time, have the utmost delight in the exercise of his senses and affections. This is a rare character, only to be formed by some happy accident, and is therefore unstable in inheritance. Usually, people who have strong sensuous tastes go utterly astray and fail in life, and this tendency is clearly shown by numerous instances . . . who have inherited the dangerous part of a poet's character and not his other qualities that redeem and control it.[48]

Galton's assessment of artistic temperament shored up the separation of the arts from other creative activities—artists were too devoted to sensual pleasures to establish nuclear families, so their genius had no long-term benefit to the nation.

Galton's libertine characterization of artists rested in no small part on his biography of select figures from the Romantic era. While his index of poets included a larger group going back to the Greeks, given the scant biographical information on that group, his assessment of their purported behavioral excesses was largely based on figures such as Byron and

Coleridge, who did indeed exhibit the tendencies Galton noted. In absorbing these claims uncritically, contemporary researchers have internalized a narrative about creativity and artists as a group that marginalizes them on the basis of lack of discipline. This assumption can still be seen even in the work of arts-friendly creativity researchers like Vlad Glăveanu, who, in writing about the personality traits that give rise to high degrees of creativity, notes the importance of conscientiousness to creative processes: "Conscientiousness . . . often emerges as the opposite of creative expression given that conscientious people tend to be self-disciplined, careful, and diligent. This doesn't sound like the profile of a creative artist. But it certainly does contribute to creativity in science and other domains. And, even in art, successful creators don't only engage in messy creative processes, they also need to get themselves organized in order to promote their own work. This is where a bit of conscientiousness comes in handy."[49] This narrative ignores the hours of disciplined skill-building and drafting that go into the work of any artist—imagine dancers spending hours on the floor, musicians devoted to mastering complex chord progressions, or novelists making painstaking revisions of a manuscript, all of which are the crucial foundations of creative invention. Ignoring these highly disciplined forms of creative labor has allowed artists to be positioned as symbolically useful, but as somehow creative in the wrong ways, leading to insufficient outward production. These distinctions tend to suppress discussions on the nature of creativity among artists themselves, and also justify the exclusive use of quantitative methodologies (of the kind pioneered by Galton). Rarely do creativity studies use qualitative methods, which might alter or augment their understanding of the creative process. While the association between creativity and genius did not actually originate with Galton or his heirs (by 1764 Samuel Foote had a character in his play *The Patron* disparagingly comment, "He has neither genius to create, judgment to distinguish, or generosity to reward"),[50] it is for that very reason revealing that contemporary authorities in the field position him so prominently for his drive to quantify it.

But perhaps the most important aspect of Galton's legacy for creativity research was his insertion of nationalist interests into the field. His preoccupations on this front were advanced by his twentieth-century US heir Lewis Terman, who extended Galton's investments in genius and eminence, including in his desire to improve national competitiveness via eugenicist policies. A teacher and school principal in his early career, Ter-

man became a professor of the nascent field of educational psychology at Stanford in 1910, where he became the principal force in revising the Binet IQ test into its contemporary standard format (commonly known as the Stanford-Binet test). While nominally dedicated to the understanding of genius and "giftedness" (the twentieth-century American replacement for Galton's Victorian "eminence"), Terman's research was similarly animated by concerns over national competitiveness. In a line of thinking that goes straight to Richard Florida, he wrote in the preface to *Genetic Studies of Genius*, his five-volume 1925 study of "gifted" children in the US, "It should go without saying that a nation's resources of intellectual talent are among the most precious it will ever have. The origin of genius, the natural laws of its development, and the environmental influences by which it may be affected for good or ill, are scientific problems of almost unequaled importance for human welfare."[51]

Like Galton, Terman was a fervent eugenicist, and promoted policies curtailing childbearing among Latinx and African Americans on the argument that "from a eugenic point of view they constitute a grave problem" due to what he deemed a marked IQ deficiency that was the result of racial identity. "Their dullness," he expounded, "seems to be racial, or at least inherent to the family stocks from which they come."[52] These beliefs led him to join the Human Betterment Foundation, which promoted compulsory sterilization laws (among other goals). Galton's political kindred, Terman insisted that research on genius and eminence had been inhibited by "the vigorous growth of democratic sentiment in Western Europe and America during the last few hundred years, which has necessarily tended to encourage an attitude unfavorable to a just appreciation of native individual differences in human endowment."[53] Identifying Galton's 1869 *Hereditary Genius* as the break in this artificial and problematic repression, Terman noted that the study of genius "has grown until these [democratic sentiments] promise to become national issues on such problems as selective immigration, the evils of differential birthrates, special training for the gifted, and the economic reward of creative talent."[54] The nationalist imperative, grounded in a white-supremacist objection to immigration and concern for birthrates among both the "gifted" and nonwhite (and therefore "ungifted") populations, drove and justified Terman's research.

Terman's centrality to historical accounts of creativity research obscures that of other contemporaries, equally prominent in both education and psychological research, who also contributed to research on creativity. Most

prominent among these is John Dewey, the American pragmatist philosopher who was—like Terman—a key figure in the nascent fields of psychology and education theory.[55] As Galton had, Dewey broadened creativity's domain of activity to include any practice of innovation, and helped open doors to the possibility that science and technology could also constitute creative activities. Dewey was primarily interested in two overlapping arenas in which creativity might operate: in what happens to young children in their classrooms, and in the viewing of an artwork. But crucially, and in significant distinction from counterparts like Terman, Dewey also argued that the primary rationale for the cultivation of creativity in the population as a whole wasn't to gain national economic preeminence, but to resist the authoritarian traits of social dynamics such as nationalism. In the late 1930s, as fascism crested across Europe, Dewey insisted that the cultivation of creativity was crucial to face the complicated economic and political circumstances facing the US:

> At the present time, the frontier is moral, not physical. . . . Unused resources are now human rather than material. They are found in the waste of grown men and women who find doors closed where there was once opportunity. The crisis that one hundred and fifty years ago culled out social and political inventiveness is with us in a form which puts a heavier demand on human creativeness. . . . we now have to recreate by deliberate and determined endeavor the kind of democracy which in its origin one hundred and fifty years ago was largely the product of a fortunate combination of men and circumstances.[56]

Even in the context of education, Dewey argued that cultivating creativity in children was crucial for its capacity to inoculate them against the seductions of authoritarianism.[57] In his magisterial *Education as Experience*, Dewey noted that traditional educational forms "have so much of the autocratic about them," and promoted creativity-inducing pedagogies on the argument that they promote democratic systems more generally. The techniques that he subsequently recommended emerged from the goal of creating the ground on which democratic "experience" (or the interaction of the individual with the world) could thrive.

How would our contemporary conceptions of creativity be different had Dewey's emphasis on its potential as a safeguard for liberal democracy been emphasized in contemporary research and its popular manifes-

tations? Dewey's prescriptions were disinterested in the market implications of creativity (which were irrelevant given his focus on the individual's interaction with the external world) and adamantly opposed to the kinds of nationalism that drove figures like Galton and Terman. Rather, he focused on how creativity might foster a sense of citizenship that eschewed nationalistic competition and instead produced a government that operates as guarantor of civil rights and liberties. In this, Dewey retained earlier Enlightenment and Romantic concepts of the state that stressed its centrality in enabling civil, prosocial conduct of the individual, ideas that would be picked up by Cold War researchers in novel ways.

Anti-Authoritarianism and Cold War Individualism

The group of attributes variously called giftedness, eminence, and genius was finally formally named "creativity" by psychology researchers in the postwar period. While contemporary researchers see the Galton-Terman genealogy as key to the origins of empirical research into these qualities, neither figure was explicitly interested in creativity per se; both were primarily invested in questions of intelligence and genius, which creativity researchers have retroactively claimed as the origin of their own work. When notions of intelligence, genius, and IQ became discredited in the mid-twentieth century (largely for their association with eugenics), psychology researchers replaced these concepts with creativity, frequently defining it as the active, outward, practical manifestation of intelligence, and therefore its most important component. Between 1960 and 1975, eminent researchers like J. P. Guilford and Robert Albert published key essays for the field that integrated concepts of intellect, genius, and creativity,[58] and by 1975 Albert would argue in a central history of the field that "one does not *have* genius, one *does* genius-level work."[59] But in a continuation with prewar intelligence research, the formalization of research into these dispositions was driven by international economic and technological competition.

Creativity itself (and not its analogues in genius or intelligence) became a prioritized research topic largely through the auspices of J. P. Guilford, a former military psychologist who made his name during World War II by developing new pilot-training programs for the Navy. In 1950, Guilford delivered a major keynote address as president of the American Psychological Association (a position Dewey had also held forty years before him)

that is generally regarded by creativity researchers as the dawn of their field, laying out the primary avenues of inquiry and the basic methodological parameters that would guide research for the next half-century.[60] Guilford argued that the widespread cultivation of creativity was crucial to American interests for technological and economic reasons, but even more importantly, for US efforts to win the Cold War.[61] Guilford saw the US-Soviet rivalry as crucial in determining whether the individual would emerge as the entity best able to guarantee human fulfillment and accomplishment, and posed creativity as playing a central role in the battle of the individual versus the state. In a later 1958 address to the Pacific Arts Foundation after the launch of Sputnik, he lamented that "by all the expectations that should follow from our supposed scientific and technical superiority, such a thing should not have happened. We, not Russia, should have been the first to accomplish this historical event."[62] In bemoaning the Sputnik triumph, he argued that the Soviet victory was surprising precisely because the squelching of individualism there should have enabled an American triumph, given its "democratic climate where the individual and not the state is the center of human interest."[63] Guilford advocated raising the stature of the arts and education, which he saw as a means to resist the lure of "the cowboy and the sports star," but tempered the democratic capacity of these arenas by claiming that an excessive or corrupted desire for equity could potentially handicap America's best and brightest: "Democracy should mean centering attention on the individual, his rights, and his opportunities. But it does not mean robbing the one to even up things for the other."[64] Guilford considered creativity a crucial disposition for its ability to enable individual private opportunity, wealth, and freedom; its capacity for democratic flourishing would be secured through these avenues, not through "equality," which would circumscribe them.

Guildford's conceptions of creativity coalesced Cold War values, particularly in the way he conflated differential conceptions of "liberal" that Wendy Brown has pointed out are central to the frameworks of neoliberalism. As Brown notes, the term "neoliberal" is confusing in English-language usage because of its seeming associations with *political* liberalism, with its goals of equal distribution of rights and civil liberties. Neoliberalism takes as its goal *economic* liberalism, or unfettered activity of the marketplace, and uses the linguistic confusion over its root word to lend moral and ethical weight to its free-market project.[65] This collapse enticed classic center-left liberals disposed to value Enlightenment principles such as free

expression, autonomy, and self-development, but also attracted center-right conservatives eager to dispatch with the liberal welfare state, which they read as suppressing economic freedom and burying the individual in the attempt to create a level playing field. His arguments regarding creativity's advantages were so persuasive for Cold War institutional forces that his earliest research in the area was funded through military channels (the research for his 1950 APA address, for example, was actually funded through the Office of Naval Research).

Guilford's definitions of creativity were already explicitly politicized, making them ripe for uptake in the arena of electoral politics (as we will see in the next chapter on Ronald Reagan's 1966 gubernatorial campaign). But equally importantly, the Guilford origin story has shaped several strands of contemporary thinking about creativity and has dominated research into it, effectively suppressing competing definitions and research methods.[66] In evaluating how psychology researchers now reflexively claim Guilford's 1950 APA address as the origin point of their work, Vlad Glăveanu stresses that this origin story "validates the link between creativity and cognition and supports the use of psychometrics to investigate both. It also celebrates, for better or worse, a certain democratic and yet highly individualistic view of creating."[67] Moreover, in addition to laying out a specific relationship between the state and the individual, Guilford's work continued to position the arts as symbolically important within creativity research, upholding art-making as an exemplary creative activity but scrupulously avoiding it when legitimating creativity as a research topic. Even when addressing arts organizations, Guilford used examples from the world of science and engineering for inspiration—his essay decrying the Soviet Sputnik triumph, for example, was originally written as an address for the Pacific Arts Association. Even Dewey believed that the arts had slipped from their preeminence as the most creative of activities, arguing that the arts had isolated themselves from science and technology, and that they needed to reconnect with the world of science to be fully instrumentalizable with respect to the development of a proper social self.

While Guilford's conceptions were field-shaping and dominant, they were not without their critics, particularly on the matter of their popular absorption. In 1964, social historian Geraldine Jonçich published a critique of the implications of creativity's definitions in the journal *Educational Theory*. Noting that midcentury research on creativity was imbued with the same kind of "culture-bound presuppositions" that had largely

discredited the definitions and tests for intelligence after the war, she went on to point out that no such scrutiny had been applied to the definition of or research on creativity.[68] Jonçich saw three elements as central to then-emergent creativity research: energy, invention, and self-reliance, qualities that she saw as part and parcel of American self-mythologies such as Manifest Destiny. "Such an approach toward creativity," she warned, "is very compatible with that historical literature which describes the American—as colonist, pioneer, settler and resettler, immigrant—as productive, always mobile, eternally dissatisfied, restless, searching, exploiting: all the time doing, doing, but rarely asking."[69] These discourses, she asserted, were notably devoid of references to contemplation or rationality "with their connotations of passiveness and absence of tangible product," focusing instead on instrumentalization toward market-driven productivity.[70]

Looking to forces beyond international competition, Jonçich argued that the same structural and institutional forces that had coalesced definitions of intelligence—the high degree of economic organization of the period, compulsory universal education, and the rise of modern psychology—were responsible for conceptions of creativity as well. Economic abundance and scientific advances, she averred, had enabled creativity to be equated with a suite of traits that had formerly been understood as the privileged domain of the intellectual (namely, antimaterialism, mistrust of authority, and skepticism of traditional markers of success).[71] The democratization of these characteristics, however, was distorted, grafting them to market-driven concepts of innovation: "It is as if creativity could not exist as a trait, even as a possibility, in a culture or in a time when the stress was upon communication and transmission, when the idea of 'progress'—either in connection with social institutions or material technology—was absent."[72]

As Jonçich would have contended, in no way was the link between creativity and intelligence or IQ (or race or economics, for that matter) natural or inevitable; this equation was and remains the discursive triumph of over a century of psychology research. The constellation of creativity with these other terms (not to mention the insistence on its empirical measurement) was one forged carefully, insistently, and over time, and one that has been privileged by the contemporary authorities of a research field over other accounts, associations, and methodologies. It is tempting to see the wide-scale absorption of this conception of creativity by the general public (as evidenced by the popularity of work like Richard Florida's or Ken

Robinson's) as a confirmation of its truth, but the popular dissemination of these ideas has been carefully calibrated to appeal to the geopolitical and economic fears of its audience. Given this, we should at least recognize the possibility that the widespread absorption of the "standard definition" of creativity lies in its ability to resonate with the popular zeitgeist, a strategy that became especially intense in the Cold War birth of research into what is now considered creativity proper.

Romanticism's Afterlife

One of the most striking aspects of this genealogy is the persistence of Romantic ideas about creativity, even in arenas such as science and technology where one might expect them to be rejected. While critics of creativity discourses such as Imre Szeman disparage this persistence as "residual Romanticism," it may be more accurate and productive to see creativity discourses as one of Romanticism's afterlives, albeit one that is integrated into contemporary sensibilities with varying degrees of consciousness and acceptance.[73]

There is enormous discomfort around this dynamic among creativity's champions and detractors alike. Promoters of creativity—especially among empirically driven researchers—distrust what they see as the vague occultism of Romantic conceptions of creativity, especially where these are used to buttress the insistence that the arts are somehow uniquely or specially creative. Even here, however, many of creativity's champions praise it as a mechanism for self-expression, an idea that was especially central to Romantic iterations of the concept (although, as chapters 3 and 5 address, the Romantic energies of this articulation are usually concealed).

Among detractors, the concepts of creativity outlined in its formal research trajectory are sometimes considered problematic because they are *insufficiently* Romantic, because they dilute or compromise key elements of artistic capacities that Romanticism articulated and advocated (whether or not these are conveyed as Romantic precepts). William Deresiewicz (the academic apostate perhaps best known for his withering critique of elite private higher education, *Excellent Sheep*) denounced the idea of creativity as an entrepreneurial practice, declaring, "When works of art become commodities and nothing else, when every endeavor becomes 'creative' and everybody 'a creative,' then art sinks back to craft and artists back to artisans—a word that, in its adjectival form, at least, is newly popular again.

Artisanal pickles, artisanal poems: what's the difference, after all?"[74] Deresiewicz's frustration emerges from his sense of loss over the eradication of access to and the exercise of an inner life: "'Art' itself may disappear: art as Art, that old high thing. Which—unless, like me, you think we need a vessel for our inner life—is nothing much to mourn."[75] Although one could value artistic activity for many different reasons, Deresiewicz's defense of "art" against the felt incursions of artisanship relies on Romantic distinctions, without acknowledging the movement's own complex relationship to market concerns. His certainty that only "Art, that old high thing" can properly transmit intense internal subjective experience reiterates a sense of high culture that many arts and humanities academics have spent the last twenty to thirty years debunking, and certainly underscores the need for a more capacious approach to our understanding of what might be encompassed within creative activity. Why, after all, couldn't an engagement with artisanship provide an avenue to self-discovery and one's inner life? In the end, Deresiewicz reinforces precisely the divisions between the Creative Class and the Working or Service Class that creativity popularizers like Richard Florida define, and that creativity researchers—very much to their credit—have labored to undermine. His arguments about creativity, then, may be more similar to Florida's than he would like, or at least share a similar set of assumptions. In particular, he vests it with something like magical powers—in his case, the unique, even sole, ability to cultivate and convey an inner self—and uses it as a rhetorical device to defend the importance of those qualities.

The objections to Romantic conceptions of creativity among other humanists are driven by other concerns. While Imre Szeman never identifies a specific objection to the "residual Romanticism" of contemporary creativity discourses, it would be consistent with much contemporary humanities research to object to Romanticism's suppressed and denied relationship to economics and markets, and to its uncritical circulation of ideas about genius and other concepts that have been actively repudiated by a wide range of influential schools of thought (the Frankfurt School, cultural studies, new historicism, and poststructuralism, to name just a few).

This genealogy of the various intellectual and political investments in creativity has several implications, perhaps the most important of which is how the Romantic elaborations of creativity in relation to individualism, self-expression, and social critique have come to exert so much influ-

ence in both contemporary research on the term and its corporate uptake. Mark Runco, for example, asserts that the concepts of creativity in the early nineteenth century were largely concerned with "the social significance and potential dangers of originality and individualism in the context of compliance to authority and maintenance of social order."[76] In making this claim, he positions creativity as a threat to the (largely promonarchical and pro-aristocratic, pre-Enlightenment) social order. This assertion, perhaps more than any other, is preeminently Romantic, posing the creative figure as a cultural soothsayer who articulates uncomfortable and subversive truths. It also forecloses the possibility that quite forceful and influential ideologies of creativity might exist that buttress and preserve the social order—especially the elements of the social order that are rationalist, market-ordered, and individualist (strains of thought that are in no way politically or socially radical in the contemporary world, or indeed in the late eighteenth and early nineteenth centuries). In part, Runco assumes that individualism (as a progenitor to concepts of creativity) comprised a singular, coherent, socially revolutionary doctrine, rather than an inchoate one with multiple, even conflicting, concepts that ultimately shored up a variety of social orders as frequently as it undermined them. This idealization of individualism as an inherently revolutionary doctrine is deeply in the grip of Romantic tendencies and, as we will see in the next chapter, is at the heart of a set of potentially quite destructive political ideologies, policy directives, and cultural practices.

Having noted this, one of the more distressingly ironic implications of Romanticism's centrality to concepts of creativity is the disappearance or suppression of the arts from discussions about it in anything other than a symbolic sense. Creativity is generally framed as the source of innovation across a broad swath of human activity, and as the primary mechanism for problem solving—the chief element by which it is understood as a key quality of science research and technological innovation. This conception is buoyed by formal research work that explicitly attempts to shift our definitions of creativity away from associations with the arts. Runco, for example, has argued that creativity researchers need to free themselves from what he calls "the art bias" or "the misunderstanding of creativity that equates it with artistic talent. The result: only individuals with artistic talent are labeled creative."[77] In Runco's view, the art bias privileges domain-transforming forms of creativity over the mundane, everyday kinds that are actually required in many areas of activity, leading individu-

als to underestimate or even abandon their own creative potential.[78] While this conception emerges from the desire to democratize creativity, it also contributes to art's suppression in creativity research more broadly.

Vlad Glăveanu has alleged that Runco's notion of the "art bias" conflates two distinct axioms regarding creativity and art: "(a) that all art is creative, and (b) that all creativity is art." He asserts instead that most people do seem to believe the former implicitly but not the latter, suggesting that Runco's art bias may not actually be as deeply observed as he has suggested, or at least that while the general populace may believe art to be creative, they're also perfectly willing to attribute creative qualities to otherwise seemingly mundane activities such as cooking, gardening, and hairstyling. Glăveanu goes on to note that lay respondents in his research tend to hold polyphasic views of creativity—that is, their notions of creativity are impressively elastic, even contradictory—and most individuals evaluate the creativity of a given activity within its own context, structures, and rules. This claim echoes those of humanities researchers, for whom the term "creativity" houses multiple, sometimes conflicting definitions. The scientist drive in creativity studies to formulate a "standard definition" of the term might counterproductively foreclose and ignore the operation of those multiple concepts, undermining attempts to broaden and democratize its practice.[79]

The democratization impulse found in Runco's research, however, is shot through with profoundly instrumentalized goals, particularly with respect to the monetization of creative labor.[80] Runco demonstrates a perfect example of this when he insists that on the market as an arbiter of utility. He quotes the nineteenth-century Dutch Reformed Church pastor George Washington Bethune, who believed that "value" necessarily had to be added to notions of grace: "If examination be made, it will be found, that those works of Genius are the most appreciated, which are the most pregnant with truth, which give us the best illustrations of nature, the best pictures of the human heart, the best maxims of life, in a word, which are the most useful."[81] Runco, then, proffers and institutionalizes a trajectory in which market success is made the primary determinant of value.

These troubling dimensions are linked (or at the very least do not exist in isolation from one another), and the twinning of innovation and market productivity as creativity's primary metric is especially pronounced in the research of the past twenty years. In a 2003 assessment of the field of research, Michael Mumford identifies precisely this dynamic (though

without seeing it as troubling), noting that while the attempt to qualitatively define creativity was active in the early days of the research field, in more recent years, it has settled into a general acceptance of the idea that creativity was defined by the "production of novel, useful products."[82] The shift in emphasis here, from simple novelty to *utility*, may explain why the arts have been de-emphasized if not exactly abandoned within research in this area—if the arts aren't useful, so the thinking goes, they can't be central to understanding what creativity is, and conversely, to the extent that the arts are central to understanding creativity, then the case for their utility must be made. Mumford, however, sees precisely the opposite problem at work, when he notes that research focusing on the *performance* of creativity (meaning here its outward manifestation) tends to attach itself solely to those producers we think of as perhaps disinterested in the marketization of their output (in his categorizing, "artists, scientists, and musicians"): "I could find no mention of engineers, computer programmers, designers, marketing and advertising executives, consultants, or managers. Thus there appears to be a tendency in the field toward a platonic, class-stereotypic view of the creative act . . . one must wonder whether we are building an overly restrictive conception of creativity—one that may have little value when developing and assessing creative capacities in real world settings."[83] Mumford's assumption that artists, scientists, and musicians work in some world other than the "real" one, whatever that is, is rather breathtaking, not least for the way it resuscitates a set of false oppositions so obvious and well-trodden that they're not really worth belaboring here. The presumed dichotomy between the "real world" and whatever illusory world supposedly circulates on its periphery continues to animate some of the central debates of creativity research.

Even Lewis Terman's prominence in the genealogies of creativity research is significant for this reason. Part of Terman's legacy (in a perhaps more obviously genealogical sense) is that his son Frederick is largely understood as one of the fathers of Silicon Valley, which has come to occupy a central place in contemporary creativity studies like those of Richard Florida. An engineering professor who expanded Stanford University's investment in tech research by leasing large tracts of university land to nascent local firms (the forerunner of today's Stanford Research Park), Frederick Terman also served as advisor to many of the industry's founders, including William Hewitt, David Packard, and Russell and Sigurd Varian, among others. His father Lewis Terman's legacy within creativity studies, then, might lie not

only in his pursuit of empirical assessment methods and their nationalist, eugenicist underpinnings, but in the cultural shift by which creativity has become increasingly located in the domain of science and technology and less and less in the arts. Even if this was never explicitly one of Terman's goals, his valorization in the genealogy of creativity research has institutionalized the uneven valuation of these different domains.

Ironically, the "social rebel" strand of creativity's Romantic afterlife operates with perhaps the greatest force in the corporate tech world, where the idea of creativity as a threat to stultifying and oppressive hierarchy buttresses all manner of self-branding mythologies. The Romantic notion of the creative figure as social revolutionary forms the bedrock of tech-world self-fashioning, a dynamic that is particularly clear in the case of the corporate branding of Apple. A tech corporation that has linked itself to ideas of creative labor and the creative class with particular intensity, Apple has aggressively branded itself as an entity born of 1960s counterculture maverick enlightenment, fairness, equality, and global cosmopolitan expansiveness since its inception. Beginning with its much-discussed "1984" ad campaign (in which an Orwellian set of deadened masses were awakened by the arrival of the Macintosh computer), Apple has promoted itself as the consummate "outside-the-box" organization, an image it cemented through the "Think Different" advertising campaign of the late 1990s. This second campaign—launched when the company "rebooted" at Steve Jobs's famous reinstatement as CEO—featured images of John Lennon and Yoko Ono, Albert Einstein, Amelia Earhart, Jackie Robinson, Martin Luther King Jr., and Mahatma Gandhi.[84] The campaign's slogan implied a set of seductive imperatives ("Think creatively!" "Act independently!"), and when coupled with the imagery of these figures, it promised that in buying an Apple computer, the consumer entered not the just the digital revolution but a social revolution initiated by this sacred pantheon of creative rebels.

The campaign also rebranded the entrepreneurial project of the high-tech world. The ads implicitly enjoin the viewer (who, given the campaign's circulation at the height of the 1990s dot-com boom, was the high-tech worker and not only the consumer) to imagine themselves as a cultural revolutionary, thus transforming the entrepreneur from a restrictive managerial figure to an engineer of innovation and, in the case of the Gandhi image, an agent of political liberation. When coupled with images of social resistance leaders, the injunction to "Think Different" reframes

mid-twentieth-century forms of activism such as civil disobedience as entrepreneurial innovation, and in doing so, enacts the pernicious slippage around the term "liberal" in neoliberalism that Wendy Brown identifies. In widening business opportunity, the entrepreneur is like Gandhi, who widened political opportunity. While this kind of self-mythologizing might seem like a throwback to the pre–social media tech world, its conceptual structures continue to shape the claims of tech innovation, right up to and including current arguments that new creations such as the blockchain-driven Web 3.0 will somehow comprise the foundation of a revolution against "legacy" tech companies like Apple.[85]

This characteristic is less a result of creativity concepts being highjacked by the tech sector's corporate goals than a constitutive feature of its modern conceptual evolution, especially from the Cold War onward. In these iterations, creative self-expression becomes, not antithetical to neoliberalism, but its primary affective energy. The creative figure as a social revolutionary is even seen as a solution to the problems of increasing labor and financial insecurity. As Andrew Ross notes in *Nice Work if You Can Get It*, "No one, not even those in the traditional professions, can any longer expect a fixed pattern of employment in the course of their lifetime, and they are under more and more pressure to anticipate, and prepare for, a future in which they still will be able to compete in a changing marketplace."[86] Creativity is proposed as a solution to this problem, rather than, say, one of its drivers. In the most frequently viewed talk on TED.com (at over seventy million views as of this writing), "How Schools Kill Creativity," Ken Robinson makes precisely this argument, noting that we need to develop an effective pedagogy of creativity to help our children survive "this future that we can't grasp." He notes that "children starting school this year [2006], will retire in the year 2065. Nobody has a clue, despite all the expertise . . . what the world will look like in five years' time, and yet we're meant to be educating them for it. So the unpredictability is extraordinary."[87] Robinson imagines creativity as a life preserver that lifts its user above the unpredictable vicissitudes of economic precarity and technological change.

This history tells us that if neoliberalism is a cultural formation that produces a specific relationship between the individual, the market, and the state, it is one predicated not just on Enlightenment theories of the self and the state, but on the ideas about the creative self that emerge in definitions of the artist and art-making. In this sense, the Romantic ideal of a self ordered by creative activity is in no way at odds with a neoliberal

self, but is in fact its blueprint. We will continue to see these tensions play out across the studies of this book. In chapter 3, we see how the insertion of creativity discourses in K–12 education via the Maker movement produces a Romantic subject par excellence, one who can learn to be resilient in the face of continual financial precarity. Chapter 4 looks at how these tensions play out relative to the odd forms of nostalgic critique and libertarian ethos at work in steampunk culture, one of the primary aesthetic styles of Maker culture. Chapter 5 investigates how contemporary adaptations of *Frankenstein*, one of the most important Romantic works of fiction, comprise a critique of conceptions of creativity that ensnare both the arts and tech worlds alike. Chapter 6 shifts to looking to authors who consider the role of creativity discourses in the context of geopolitical and transnational economic shifts from the US to China in the twenty-first century.

As a transition into that material, we turn now to one of the first overtly politicized uses of Cold War conceptions of creativity, one that explicitly wielded the term to install neoliberal policies. The Cold War research emphasis on the individual as the primary agent and beneficiary of creativity (an emphasis that, as we saw with Guilford, evinced significant resistance to notions of social equity, particularly in state-driven manifestations) found a public champion in a figure who in retrospect seems to be either a logical hero or villain, depending on one's personal political orientation. In 1965, casting about for a campaign theme that could help him launch a bid for California's governorship (despite a total lack of electoral or governing experience), Ronald Reagan seized on ideas about creativity that Cold War researchers had promoted. The story of "the Creative Society," Reagan's campaign theme, is the story of the next chapter.

2

The Creative Society

Reagan and the California Crusade

The concept of the Creative Society is more than an idea or a theory. *It is another name for the natural bent of man to tend well to his own immediate concerns.*

—Reagan gubernatorial campaign memo,
"The Idea of the Creative Society" (original emphasis)[1]

At the dawn of a political campaign that US historians and political scientists increasingly view as the beginning of modern conservatism in the US, a little-known evangelical Glendale pastor named W. S. McBirnie wrote the underdog California gubernatorial candidate Ronald Reagan to help design a campaign that could unseat the incumbent Pat Brown. Urging Reagan to adopt a campaign theme that could capture the imagination of Californians, McBirnie suggested "the Creative Society," a concept that could provide a vision for sweeping political changes across the US. McBirnie rhapsodized:

This is a *vision*. . . . which would intrigue the imagination of the voter. It would lay emphasis upon self-help, individualism, and would make sense to people. . . . something like this is the very thing needed to transform our campaign into a crusade! It really could have *national* repercussions if it can be made to work in California. It is a mile above the so-called "Great Society."[2]

Reagan did indeed adopt "The Creative Society" theme, and went on to overcome the establishment Republican primary candidate, trounce a two-term Democratic governor, embed a series of policy initiatives that undermined Brown's significant state civil rights and infrastructural achievements, and (eventually) launch a successful bid for the presidency, all despite a total lack of electoral experience.

The story of Reagan's 1966 gubernatorial campaign is a complex one often overshadowed by his later presidential career, but it is central to the history of creativity discourses in the US for its role in enticing Californians to abandon one of the most progressive programs in state infrastructure and civil rights protections of the time in favor of policies we now recognize as neoliberal. As historian Matthew Dallek puts it, "In truth, the Reagan Revolution began in 1966, and it was not about economics or foreign policy. Reagan's stunning, out-of-nowhere victory in the California governor race . . . marked the arrival of the Right in postwar American politics."[3] Reagan's use of creativity discourses for gubernatorial victory underscores a troubling set of implications for California's status as the epicenter of "creative industries" in the US, and also illuminates how that concept came to anchor modern US neoliberal political formations.

Working with the up-and-coming consultancy firm Spencer-Roberts, McBirnie stressed that "The Creative Society" was more than just a catchy campaign motto, it was the basis for a crusade to reorient the foundations of US politics away from New Deal liberalism and Lyndon Johnson's "Great Society." The concept of creativity transformed Reagan's electoral project from a mere political campaign into a system of belief with the capacity to renovate the very fabric of governance: "Inspired by a government dedicated to a bright, fresh, positive approach which would liberate the latent ingenuity of the most creative of all our citizens, we could have *true* self government. This is even better than representative government."[4] Reagan's "Creative Society" comprised a conversion project, one that could transfigure the citizen from one acted on by the government to one who replaced government altogether; hence McBirnie's excited insistence that the theme was not just a political vision, but a "crusade" with national implications—a statement that would prove prophetic in multiple ways.[5]

Dogwhistle Tunes

Reagan's 1966 upset gubernatorial victory has been attributed by historians and political commentators to a number of factors: Pat Brown

was a relatively unpopular incumbent, who was especially vulnerable for his championing some of the early state-based civil rights laws that had come out of California; the state's recent population boom had been driven primarily by midwestern and southern Democrat transplants primed to shift party affiliation; and this voter population was angry about the Watts riots and the campus protests at UC Berkeley.[6] Leveraging these shifts, Reagan also took advantage of the recent emergence of external campaign managers, who helped him hone his campaign theme and then run an aggressive ground game with candidate events focusing on voter registration and turnout.[7]

The "Creative Society" theme allowed Reagan to market what were in effect a set of Goldwater political imperatives in ways that were palatable to California voters of both parties. He had come to the attention of wealthy Californian Republican operatives after delivering a televised speech for Barry Goldwater's 1964 presidential campaign titled "A Time for Choosing." Bringing in over eight million dollars—an inconceivable amount of money for a single speech at the time—the speech focused on the claim that the founding American principle of "self-government" faced a domestic totalitarian threat, with civil rights struggles as the silent background referent. Using rhetoric that would be entirely familiar today, Reagan intoned, "This is the issue of this election: whether we believe in the capacity for self-government or whether we abandon the American Revolution and confess that a little intellectual elite in a far-distant capital can plan our lives for us better than we can plan them for ourselves. There is only an up or down: up to man's age-old dream—the ultimate in individual freedom consistent with law and order—or down to the ant heap of totalitarianism."[8] As Dallek has pointed out, "The Speech" (as it came to be known) "neither articulated a new conservative political vision nor catapulted Reagan into the American mainstream," but it nevertheless made him a conservative star at a time when California's population and political topography were shifting.[9]

Goldwater had gone down to such profound electoral defeat that journalists of the day claimed that "the larger ideas for which he stood had virtually no chance of making a comeback."[10] On the heels of these predictions, figures like Reagan at the edges of the party's Right had to reframe and repackage their political agenda, particularly in its anti–civil rights and anti-statist orientations. Campaign manager Stuart Spencer noted that the "Creative Society" theme allowed Reagan to evade charges of right-wing extremism that might have attached to him after stumping for Goldwater:

"In his '66 campaign, he said everything Barry Goldwater said, but he said it better—not as harsh."[11]

The "Creative Society" theme operated as a kind of dogwhistle tune, particularly for those Californians—Democrat and Republican—who rejected Johnson's Great Society programs and the civil rights platform for which both Johnson and Brown had fought. Like the use of pitches inaudible to humans that produce marked behavioral arousal and disregulation in dogs, political dogwhistling deploys language, signs, props, and references coded to appear innocuous to a general population but that carry additional meanings for a targeted subgroup. As legal scholar Ian Haney-López puts it, dogwhistle appeals operate in two simultaneous registers, "inaudible and easily denied in one range, yet stimulating strong reactions in another."[12] As backlash against the midcentury civil rights era, dogwhistling rode white racist fear, anxiety, and anger to electoral victory while concealing its white-supremacist basis. Although it is sometimes understood to have been pioneered by Richard Nixon as part of the "Southern Strategy" (in which conservative politicians rewarded race-based animus against social programs that were perceived to aid nonwhite peoples while avoiding explicitly racially coded language), Reagan's use of the "Creative Society" theme was an earlier—and enormously successful—version, laying the groundwork for its appeal beyond the Jim Crow South.[13] As Haney-López points out, "dog whistle politics have always: transcended the South; involved Democrats as well as Republicans; compromised much more than a simple backlash; and appealed not only to the white working class but also to elites."[14] In this, dogwhistling has been at the heart of the abandonment of New Deal liberalism by both major political parties in the US, where it comprises both a signal feature of conservative politics and a core mechanism of austerity politics across the political spectrum, through which public infrastructure in everything from education to social safety nets, communications, and transportation has been dismantled.[15]

The "Creative Society" theme instantiated what Wendy Brown has identified as the neoliberal project of "dismantling and disparaging the social state in the name of free, responsibilized individuals."[16] Building on the kind of Enlightenment arguments regarding self-expression, individualism, and the state explored in the first chapter, campaign political consultants William Roberts and Stuart Spencer used the Cold War conceptualization of creativity as the camouflage for this project. As they asserted in an internal campaign memo, creativity constituted not just a natural

and inevitable state of human flourishing, but one that emanated from the individual: "The concept of the Creative Society is more than an idea or a theory. *It is another name for the natural bent of man to tend well to his own immediate concerns.*"[17] Using this definition of creativity, the campaign team insisted that systems of governance (particularly in federal oversight of citizenship protections such as civil rights) were an erosion of personal freedoms: "Government can solve many problems for the people; but the inexorable price it must extract is *power over them*, ever increasing power at the cost of ever decreasing individual freedom," a claim Reagan was to highlight repeatedly in his speeches.[18] Creativity was offered as the primary antidote to bureaucratic stagnation and excessive federal authority: "The *alternative* to this emphasis on creativity and the involvement of the private citizen in the solution of our state problems, is the inevitable growth of a stagnant and costly state bureaucracy, and, ultimately, the certainty of absolute federal control of every aspect of life."[19] Framing Reagan as a reparative "citizen-politician," the campaign used concepts of creativity as the apparatus by which "self-governance" could replace robust state-driven governance: "We should not confuse *representative* government, good and necessary as it is, with *self*-government."[20] Blueprinting what is now a well-worn campaign trend, Reagan would open campaign speeches by framing himself as a passionate outsider: "I am not a politician. I am an ordinary citizen with a deep-seated belief that much of what troubles us has been brought about by politicians; and it's high time that more ordinary citizens brought the fresh air of common-sense thinking to bear on these problems."[21] Reiterating the campaign's equation between creativity and individual agency, Reagan would insist, "The Creative Society is simply a return to the people of the privilege of self-government."[22]

Reagan would go on to repeat the rhetoric from the "Creative Society" throughout his campaign. In "A Need for Action" (his half-hour, televised campaign announcement of January 4 [Figure 2.1]) he tied the Creative Society directly to hostility to state infrastructure and political liberalism:

A Big Brother or paternalistic government can solve many problems for their people. But I don't think we'll like the price it charges: ever increasing power over us, and ever decreasing individual freedoms. A Great Society must be a free society. And to be truly great, and really free, it must be a creative society, calling on the genius and power of its people. Legislation alone can't solve our problems, nor will they

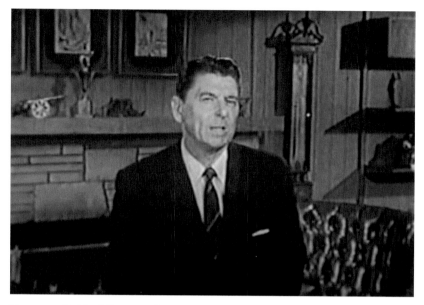

Figure 2.1. "A Need for Action": Reagan Announces "The Creative Society." Courtesy of Ronald Reagan Presidential Library & Museum.

disappear under a shower of tax dollars. The gold of the "Golden State" is to be found in its people. The greatest pool of technically skilled talent and ability in all the world. . . . [A] truly creative society stamps as acceptable only those programs that help Californians, but which do not increase our own bureaucracy, result in more centralization of power, or greatly unbalance the budget. . . . There's no problem we cannot solve by a cooperative effort using government and the full creative talent of our people.[23]

Calling for an arrangement of the individual, market, and state that pulled directly from the arguments of Cold War research psychologists like J. P. Guilford, Reagan positioned creativity as a mechanism for personal opportunity and fulfillment, and as a shield against overzealous attempts at social equity on the part of the state. In laying out the parameters of "the Creative Society," Reagan implicitly advocated for a "creative citizen," one who could protect "individual freedoms" against state encroachment by creating local solutions to social problems without increased state regulation or

additional taxes. Recalling Reckwitz's observation on the role of the audience within the social regime of novelty, this citizen also served, by implication, as a market-like arbiter of the effectiveness of these local efforts.[24]

Within California, Reagan's references to "paternalistic" government comprised a dogwhistle for a variety of issues: the Rumford Fair Housing Act (which Brown had championed and over which a vicious public repeal campaign had been fought in 1964), the significant infrastructural initiatives Brown had activated to manage the state's unprecedented population boom, California's generous welfare structures, and property taxes to pay for these, all of which Reagan energetically opposed on the campaign trail for their deleterious impact on the "creative capacity" of Californians, a phrase that served as code for the operations of personal choice. Reagan used the "personal choice" facet of the Creative Society to fight housing desegregation efforts in particular, building on voter outrage that emerged when the state Supreme Court struck down the 1964 proposition designed to repeal the Rumford Fair Housing Act.[25] A former beneficiary of restrictive housing covenants, he denounced the act via the argument that property owners should be allowed to sell their homes to buyers of their choosing, a claim designed to play directly to white resentment. "Right to ownership of property and disposal and control of it is the essential definition of freedom," he would intone at campaign events. "No matter what the nobility of their purpose, those who assert the government's right to restrict that right erode our freedom."[26]

Reagan's team used the "Creative Society" theme as a referendum on Lyndon Johnson as much as on Brown, explicitly introducing his theme as such: "I propose a constructive alternative to the Great Society, which I have chosen to call 'A Creative Society.'"[27] National journalists covering the gubernatorial race even acknowledged that the "Creative Society" made a tidy target of Johnson.[28] Taking aim at Johnson's antipoverty programs, Reagan argued that the state welfare system could be replaced by "creative" solutions that would end unemployment, for which the virtues of free enterprise seemed tailor-made. At a speech before a crowd of 2,000 people at the Pacific Telephone Company public affairs forum a week before the Republican primary, he rhapsodized that "the Creative Society would turn to industry. The Los Angeles Chamber of Commerce, with the help of 260 industries, has put 7,000 jobs into Watts—7,000, that's almost as many as the number of poverty administrators we have there."[29] The "creative" solutions of private industry would end the need for property taxes that

would, in his telling, spiral to the point that retirees would be forced from their homes.

Where Reagan was actually most genuinely "creative," of course, was in his sense of media and performance savvy, and not merely in its filmic/ publicity sense. He understood the theatricality of the electoral process in ways that outstripped both his more established Republican primary competitor George Christopher and the incumbent Brown. Christopher complained of Reagan upstaging him and the other Republican primary candidates:

> Every time we'd meet in Los Angeles at a joint meeting and there were other candidates present, and they would put us in a line for a pho-tograph, the same thing happened. As soon as the photographer was ready to snap the picture, Reagan would put up his hand . . . and make it appear that all of us were deferring to him and looking to him for advice. Well, this was the actor's ability to steal the scene.[30]

Building on this professional sense of theatrical power, Reagan's campaign team adeptly deployed dogwhistle aesthetics at campaign events in ways that indicated continuity with Goldwater politics while providing enough visual and rhetorical separation to conceal that connection. At a May 12 event at San Francisco's "Cow Palace" (a longtime working-class event space built in 1941), Reagan gave the inaugural version of what would become known as the "Morality Gap" speech, capped by the attacks on UC Berkeley's student protest movements for which his campaign would become especially renowned. The Cow Palace had hosted the 1964 Republican National Convention meeting at which Goldwater had been made the nominee for the presidential race, and Reagan's team replicated the aesthetics of Goldwater's campaign, producing a western-themed event complete with live country music bands, chuckwagons, and lunchboxes. Participants, whom the *New York Times* noted were largely "the same type of well-fed, well-groomed affluent" people who had attended the GOP convention two years before, could shuffle through the music stands and mingle over BBQ prior to hearing Reagan deliver his speech, allowing time to bond through the sounds, smells, and tastes that made up the aesthetic experience of "the Creative Society." As Reagan proceeded to the stage, he was accompanied by coveys of "Reagan girls"—a kind of chorus line that Goldwater had used to great effect in his own campaign. [Figure 2.2]

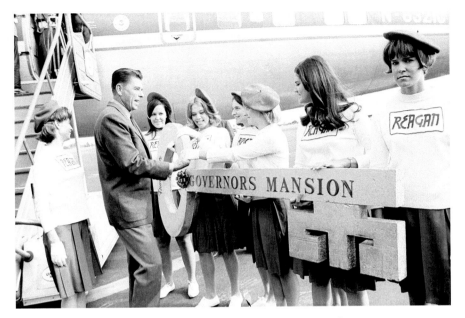

Figure 2.2. "Reagan Girls" greeting their candidate. Courtesy of Getty Images.

Where the "Goldwater girls" had been decked in cowgirl attire (cowboy hats, western boots, and fringed shirts), the Reagan girls—in outfits personally selected by Nancy Reagan—were clad in cheerleader garb topped by berets, the latter's bohemian connotations cementing Reagan's image as the deliverer of the Creative Society, particularly for the next generation of youth.

The creativity theme helped Reagan redirect the significant antitheatrical suspicions that dogged his campaign. As would happen when he ran for president, Reagan was attacked for his theatrical acumen. Journalists frequently denounced him as an actor who simply parroted language and ideas penned by others, as did the *San Francisco Chronicle* when it called him a "bit player in a continuing Goldwater script."[31] Recognizing Reagan's reliance on opposition research and basic information about the state supplied to him by the campaign,[32] Richard Wilson of the *Los Angeles Times* complained that "Reagan is a 'quick study' on politics and state government. . . . He left behind the impression that if he does not know what he is talking about, he has at least got his script down letter perfect."[33] On the eve of the election, the *Sacramento Bee* lamented that

Reagan "resembles a carefully designed, elaborately 'customerized' super-market package, complete with the glossiest wrapping and the slickest sort of eye appeal. The Los Angeles advertising firm that is handling Reagan, Spencer-Roberts, has brilliantly provided everything that can make their package sell—with the possible exception of content."[34]

Fighting from a weakened defensive position, and lacking an equivalent articulation of social crusade, Brown's campaign opted to exploit Reagan's perceived weaknesses on this front, though to terrible effect. Attacking Reagan's inexperience, the Brown campaign also pointed to his background as an actor as proof of his inability to govern: "We'd just say, 'Well, he's just a damned actor. He's never run a business, he's never run a political office. And he's getting his money from these crooks!'"[35] Right after Reagan's primary victory, Brown gave a speech at an Associated Press editors' luncheon in which he pilloried the "citizen politician" construct:

> Mr. Reagan spent a great deal of his time campaigning around California to spread the word he is not a politician. As he said, he is a citizen-politician who has always had an active interest in politics. And every time he said it I could see a patient lying on a table in surgery. A man walks in, pulling on his mask and gloves. A worried nurse says, "Can you save the patient, Mr. Jones?" And Mr. Jones looks down [at the patient] and says: "Have no fear. I am your citizen-surgeon. And I have always had an active interest in medicine."[36]

Brown's campaign insisted on the virtues of patient, methodical, thoughtful responsibility over the flash of the creative. Pushing Reagan's history as an actor as a reason to vote against him, the campaign team created ads that underscored Reagan's career as a spokesperson for conservative causes (including for the American Medical Association's opposition to Medicare). Ending with the tagline "Vote for a Real Governor, not an Acting One," the ads contrasted the "real world" responsibilities of the governor with Hollywood's simulacrum:

> The Governor's office is not a movie set—he faces real problems, every day. There are no stand-ins, no doubles, no re-takes. He directs the action, produces the results, and bears the burden of responsibility, alone. He speaks his own lines, and answers for them all. He deals daily in hard reality, and no fiction finds its way into the pile of problems he

takes home. When he signs his name, it is no hastily scribbled auto-graph, but a thoughtful signature signed in the name of over nineteen million fellow Californians who have entrusted him with the highest office in this, the largest of all the states. This is real responsibility. Pat Brown is and will be a *real* governor, not an acting one.[37]

While it had only limited circulation, a spontaneous joke in one of the films backfired badly on the campaign. A half-hour television spot on Brown's life featured a visit to an elementary school in Los Angeles. Facing two young Black girls, he joked with them about never having heard of him despite his status as governor, and then leaned over and asked more seriously, "I want to tell you something else. You know I'm running against an actor. Remember this, you know who shot Abraham Lincoln, don't you?" As the adults in the room burst into laughter, Brown beamed. "An *actor* shot Lincoln!"[38]

Reagan's associations with the film industry, far from damaging him via this kind of antitheatrical sentiment, burnished the claims that he would spearhead a creative society. Brown's attacks on this front failed misera-bly, partly because his campaign misunderstood how important the film and television industries were to Los Angeles (so influential on voters in the population-heavy southern part of the state), and partly because they underestimated the impact of the response that Reagan's fellow actors would mount. Although the producers of Brown's thought the joke about Lincoln's actor-assassin demonstrated Brown's softer, jocular side, it irri-tated Hollywood celebrities and even other politicians. George Murphy, the California Republican senator who had also previously been an actor, denounced the film. The actor Jack Palance, who had been engaged to perform in a telethon supporting Brown, quit the gig, and prominent stars such as Frank Sinatra who hadn't been especially supportive of Rea-gan came out with public statements against Brown.[39] Even before the documentary had screened, Reagan's campaign distributed a voter-turnout short titled "The Victory Squad" hosted by John Wayne and held cam-paign rallies hosted by figures ranging from Buddy Ebsen to Jimmy Stew-art.[40] For every voter who turned their nose up at *Bedtime for Bonzo* or *The Cattle Queen of Montana*, there were clearly others for whom Reagan's friendships with beloved stars like John Wayne and Jimmy Stewart lent him not merely celebrity sheen, but a sense of grit, decency, and can-do-ness crucial to the ideals he claimed to cherish and the creative capacity

to bring them to meaningful fruition. Reagan's campaign built on this sensibility from the moment of his initial announcement—running right after a telecast of *Hamlet* starring Christopher Plummer, it was titled "A Time for Action," posing Reagan as the action hero in counterpoint to the melancholy Dane's putative passivity.[41]

Perhaps most importantly, the "Creative Society" theme brought voters from both parties to Reagan's cause. McBirnie had seized on the ways that creativity had been framed by Cold War psychology researchers like Guilford to conflate forms of economic and political liberalism, using this to overcome center-left resistance and appeal to center-right conservatives: "In the place of old labels would be a new day for the Republican Party which could *unite* on this concept. The liberals would respond to the compassionate, progressive answers, while the conservatives would rejoice in greater self-government and wider participation by more people on the local level."[42] The combination of theme and image attracted both Californian Republican activists—many of whom were Goldwater supporters whose devotion Spencer-Roberts was keen to leverage—and a significant number of Democratic Party voters.[43] Reagan benefitted from recent migration patterns in Southern California in particular. As part of the buildup of industries like defense and aerospace, the southern region of the state attracted migrants from the South and the Midwest, many of whom were former Democrats who had been brought into the Republican fold by Goldwater.[44] This demographic comprised what came to be the political center in mid-1960s California, which in Dallek's words was "rushing towards Reagan, and he had only to convince it that he was not a reactionary Republican but a bold-thinking conservative with fresh ideas and programs."[45] The "Creative Society" theme provided just such a framework, as demonstrated by a welter of election data from 1996: although Reagan hewed distinctly to the right of the establishment Republican candidate George Christopher, in the primary he won that initial contest by a two-to-one margin, and despite the fact that registered Democrats in California outnumbered Republicans by 1.3 million, Reagan still won in fifty-five of the state's fifty-eight counties and took the governorship by over a million votes.[46]

Creativity's Institutional Complex

Creativity wasn't only a dogwhistle technique to seduce voters to Reagan's cause, however. Once in office, Reagan acted on Cold War concepts of

creativity to produce the kind of state institutional complex outlined in the introduction to this book, realigning an infrastructural network that linked the worlds of education, corporations, science and technology, law and order, and electoral politics. During the campaign, Spencer-Roberts had conceived of the Creative Society in precisely this institutionalized sense. Anticipating conceptions of creativity that would surface again at the turn of the century, McBirnie laid out in his November 1965 letter how different institutional segments of California society could operate once their creativity had been tapped and enabled. The "Creative Society" theme would open Californian's eyes to the possibility that "there exists within this state the resources, mainly human resources, to solve any problem—without the growth of bureaucracy. But to release this tremendous latent, creative power more citizens must be *led* by the 'Creative Society' type of government to organize in volunteer associations."[47] This evocation of creativity focused on unleashing the already extant, internally held capacity of the individual, in which the government's primary role was to facilitate (but not itself engage with) private-citizen organizations that would solve whatever social problems they deemed necessary: "The 'Creative Society' would not increase government but lessen it. It would work for greater individual freedom, and wider assumption of responsibility on the part of local cities, counties and areas or regions. It would be the task of the 'Creative Society' to lead, encourage, direct, and require the opportunity to rule less and more cheaply."[48] How precisely the government was to lead without running these deliberations was then laid out in four arenas that Reagan dutifully listed in his campaign speeches (notably business, education, law and the penal world, and science and technology). In particular, "business and industry" were to "solve our economic problems by lending a part of your most creative people, so that state and federal government wont [*sic*] have to do it."

Identifying an exhaustive list of social problems that should be addressed via creativity, the campaign team created a "formula" by which the problems and challenges of each of these arenas could be solved. For the most part, this formula consisted of bringing in consultants and policy task forces to conduct audits that would reorganize all state agencies "towards the Creative Society principle"; in other words, to determine how efficiency could be improved, state-owned property could be sold off, local private funding sources could be located, and policy could be devolved to local control. Pointedly, the most important arenas for the production of the "Creative Society" were business, education, and science, from which

experts would be drawn for "task forces" to supply these creative solutions, the goals of which were primarily privatization and efficiency.

Reagan framed his governorship as the Creative Society again in his inaugural address, and subsequently had his office produce a series of booklets on its implementation across multiple arenas of California life.[49] Outlining "guidelines for action as we continue to work with all Californians to design the future," the opening statement of the booklets focused state citizens on the question of how to look ahead to the society of tomorrow: "Ours is a threshold age: we have before us either decades of great deeds or years of despair and disruption. If we are to make the most of tomorrow, we must shuck the encumbrances of yesterday and develop new and valid priorities. Californians need a new agenda."[50] Printed with glossy black-and-white photographs, the booklets provided a more detailed policy outline for how the governor's office could manifest the promise of the campaign theme. As phrased in the campaign, the new government under Reagan would harness and bring to bear California's much-vaunted creative potential: "California still has in its veins the limitless energies of the dynamic West. It is the most unfettered, the most imaginative state in the union. It is time that together we used that imagination, so apparent in other aspects of our life, to attack and solve our public problems."[51]

Targeting again the civil rights and antipoverty programs of the Johnson administration, the booklets reasserted the dogwhistle promises of the campaign to use the Creative Society to unleash unfettered personal capacity, and to reduce governmental barriers to it:

> The valid test of government is not how many laws it passes, or how much of the taxpayers' money it siphons off for public projects; the true test is whether those in office use discipline and imagination to build a government of and by as well as for the people—whether that government helps to release the energies of every man by removing obstacles to his progress. And this is the purpose of the Creative Society: to stimulate constructive change through a continuing joint venture between all sectors of the community while reaffirming the right of every man to maximum liberty and the pursuit of happiness in an orderly society. . . . The creative society places government in its proper role: government should lead, citizens must act.[52]

The initial booklet in the series laid out this philosophy in more detail, culminating in a series of twenty-three proposed initiatives to bring the Cre-

ative Society into being. These included equipment loans to neighborhood-led groups to develop spaces for parks or other uses, job coaching run by state-run "Service Centers," the creation of preschool childcare centers for working mothers, and consumer consultants to help targets of bad loan schemes. While a perhaps surprising number of these initiatives would have required state financial support (especially for the childcare-related measures), these were construed primarily as volunteer-led efforts—professional athletes could hold youth sports clinics in "poverty areas," union members could donate training time to potential employees, businesses could share costs to keep schools open in summer to provide recreation and basic education to families. All of these were organized under the banner of "from the ground up" systems of governance, wherein the role of government became strictly that of facilitator—not provider—of these programs.

The "creative society principle" relied on precisely the internal contradictions between self and social institution that Andreas Reckwitz has identified at the heart of the "creativity *dispositif*": "an anti-institutional *desire* for creativity and the institutionalized *demand* for creativity."[53] On the one hand, Reagan's "Creative Society" relied on an external, governmental imperative to solve large-scale social challenges, but it did so in ways that assumed an anti-institutional self irresistibly compelled to act on its creative capacity. This tension traded on and promoted Enlightenment calls for an autonomous self that should stand apart from excessive external social encroachments, setting up the state as merely a passive vessel for its "creative" activities.

These contradictions in the Creative Society concept cohered what historians have noted was a central incongruity in Reagan's ideology—a heavy law-and-order emphasis on the one hand, and an insistence on individual initiative on the other.[54] Reagan's office produced three "Creative Society" booklets: the initial framing booklet, a second on law and order, and a third on education. While a booklet on education is unsurprising given the historical conflation of education with intelligence within formal research (and fully one-third of the proposed Creative Society measures in the initial booklet concerned education or early childhood development), Reagan's law-and-order focus seems jarring, particularly in light of the parts of creativity's conceptual history that posed it as a protection against excessive state power. In practice, however, Reagan used the contradictions of the "creativity *dispositif*" to leverage concerns over lawlessness as a way to constrain the education system.

Where Reagan's Creative Society was at its most telling was in its treatment of California's public universities, which had been significantly expanded under Brown's tenure as governor. Reagan's political attacks against California's universities are well known, but less understood is the way those attacks were framed and legitimated under the banner of protecting creativity. In deploying the Cold War creativity rhetoric that had been developed by psychology researchers, Reagan was able to systematically attack the autonomy and political expressive freedoms of students and faculty while claiming to cherish precisely those values as the bedrock foundation of a creative society. In his campaign and in office, Reagan touted California's universities as one of its most important engines for creative output and innovation. Echoing the focus on the individual that had been a feature of creativity discourses since the early Cold War, the "Creative Studies" booklet on education bore as a title the inscription "a concern for the individual and his right to fulfillment; this should be the preoccupation of our schools and colleges."[55] Despite its title's claims to respect individual self-fulfillment, the booklet continued the vilification of student protestors that Reagan had undertaken in his campaign. As before, he construed the protests not as innovative social projects, but as illegitimate exercises in lawless disruption, backed by illegal drugs and sexual licentiousness. During the campaign, he had directly accelerated antiprotest sentiment in the state; according to campaign advisor Stuart Spencer, the issue of campus protests emerged not in voter research surveys, but in small, in-person events where attendees brought it up in Q&A segments. Spencer noted in a later interview that Reagan escalated this frustration to make it a focal point of his speeches, even though it hadn't actually emerged as an issue in statewide political polling until after he had done so.[56] Reagan would later mythologize this shift in his campaign by claiming antiprotest sentiment as the key central issue that united the diverse audiences of the state. In a 1973 interview with the *Los Angeles Times*, he would retrospectively claim, "After several weeks of the campaign I had to come back and say, 'Look, I don't care if I'm in the mountains, the desert, the biggest cities of the state, the first question is: 'What are you going to do about Berkeley?' and each time the question itself would get applause."[57] What Reagan concealed in these claims was his long-standing antipathy toward the UC campuses, and toward Berkeley in particular—as early as 1960, he had offered to turn into a film an FBI report on an anti-House Un-American Activities Committee protests that Berkeley students had supposedly started.[58]

Reagan neatly amplified antiprotest sentiment, inserting material about it in nearly every campaign appearance. At the 1966 Cow Palace event prior to the Republican primary, Reagan gave what came to be known as "the Morality Gap" speech, which portrayed student protestors as "not just lewd, but mentally sick," picking up a trumped-up story in the *San Francisco Examiner* about a dance that supposedly occurred in March 1966 that took place "against a backdrop of sexual misconduct" backlit by "films of naked torsos of men and women," during which hallucinogenic drugs were supposedly used and marijuana smoke filled the air to such an extent that "you could hardly breathe."[59] Repudiated by the local district attorney (whose alleged report on the dance Reagan held up like a prop during the speech), the story nevertheless caught on with the event crowds, and Reagan repeated it to great effect for the remainder of the campaign.[60] The famed *Washington Post* political correspondent David Broder – normally quite sober in his campaign coverage -- breathlessly identified the "Morality Gap" speech as the campaign's central coup de théâtre, calling it "A BRILLIANT ONE-HOUR PERFORMANCE."[61]

Once Reagan was elected, his staff used the universities as grist for their Creative Society booklets. The booklet on law and order listed campus unrest alongside juvenile crime and sexual assault as primary criminal activities the state must address to provide the "freedom" needed for its population to flourish: "Campus after campus is wracked with disorder; universities are used as staging areas for insurrection."[62] Tying campus protests to racial justice movements via a full-page image of the Watts riots in a segment titled, "We face a serious breakdown in the rule of law," the booklet argued that "every student in our colleges and universities has a right to pursue his education unhampered by the violent few. The campus is not an island outside the law."[63]

Historians of this facet of Reagan's career tend to cast it as a kind of anti-intellectualism in keeping with a center-right populist continuum built on characteristics such as "morality, law and order, strong leadership, traditional values."[64] Such accounts misread, however, how Reagan construed the protests as artificially constraining and undermining the intellectual and creative capacity of universities. He unquestionably attacked campus protest cultures, not infrequently creating wholesale lies to build on and foment opposition to universities themselves (in one especially poisonous dogwhistle incident, he fabricated a story about a group of Black students at one university who supposedly put switchblades to the throat of a hapless dean to force him to admit them to courses, an event that of

course was never corroborated).[65] Reagan's campaign team saw the protests as a central point of vulnerability for Brown, one to be exploited as fully as possible.[66] These tactics were couched in terms of *protecting* the universities' role in the proper production of the Creative Society. Following on his "Morality Gap" speech, Reagan would energize audiences by discrediting academic freedom in the name of proper forms of education: "This has been allowed to go on in the name of academic freedom. What in heaven's name does 'academic freedom' have to do with rioting, with anarchy, with attempts to destroy the primary purpose of the University which is to educate our young people?"[67] But the universities themselves he hailed as central to the ongoing construction of the future California: "There is no major problem that cannot be resolved by a vigorous and imaginative state administration willing to utilize the tremendous potential of our people. We have the greatest concentration of industrial and scientific research facilities of any state in the Union; colleges and universities are rich in possibilities for study and research."[68]

Once in office, Reagan used his performance prowess to aid his agenda on higher education. In attacking the universities, he waged this battle largely via news spectacles, often threatening to fire faculty rather than taking on the legal risk and potential public embarrassment of actually doing it. Abandoning the practice of skipping Regents meetings (as had been done by preceding governors on the principle of possible conflicts of interest), Reagan not only attended many such meetings, but staged press conferences before and after that laid out his points of contention and then complained when the Regents didn't fall in line with his demands. The publicity-shy (and media-naïve) Regents had largely shunned public engagement with their policies, but even when they tried to invite press interviews, they were largely ignored by journalists from state and local newspapers.[69]

Despite having promised that if elected he would ensure that "the University will be allowed to function *without*, repeat, *without* political interference," Reagan did precisely the opposite upon assuming the governorship. He immediately fired Clark Kerr (the University of California president who had designed and implemented the California Master Plan for Higher Education that had created the network of universities that Reagan supposedly revered for their innovative potential), eliminated the tuition-free scheme of the state in favor of student fees, blocked the reappointment of academics whose politics he disagreed with, and, as

campus protest cultures swelled in response to the escalation in Vietnam, used increasingly intense rhetoric and militaristic tactics against student organizing.[70] Reagan justified initiating student fees on the argument that they would help quell student political involvement, and that doing so "might affect those who are there really not to study but to agitate, it might make them think twice about paying a fee for the privilege of carrying a picket sign."[71]

Reagan's assaults on California's public universities—the most elaborate public higher education infrastructure in the US at the time—was, as cultural historian Chris Newfield has pointed out, an assault on both the middle class and on the project of education desegregation. Noting that Reagan's attacks arrived just as the UC system was opening its doors to Black and Latinx students in greater numbers, Newfield points out that they were part of a larger tendency to undermine middle-class power generally:

> No American government has explicitly sought to lower middle-class living standards. But . . . no government would need to attack the middle class openly to downgrade and reduce it. More roundabout methods would work just as well—better, in fact, since they arouse less opposition. . . . [C]onservative elites who had been threatened by the postwar rise of the college-educated economic majority have put that majority back in its place. Their roundabout weapon has been the culture wars on higher education in general, and on progressive cultural trends in the public universities that create and enfranchise the mass middle class.[72]

Reagan's elimination of free attendance achieved precisely this end. When his administration outlined its education policies for the Creative Society in its 1968 booklet, the matter of college tuition was coded as one that would overcome educational inequities. Noting that most attendees of University of California campuses were from relatively well-to-do families, the booklet made the case for requiring these students to pay for their educations, quoting a question attributed to Milton Friedman: "Why should the families in Watts pay taxes to subsidize the families in Beverly Hills who send their children to UCLA?"[73] Following on this sentiment, Reagan's "Equal Education Plan" called for tuition to be used to fund grant and loan schemes for lower-income students, especially for students of

color, thereby initiating what are now referred to as "high-fee, high-aid" schemes. When laid out in detail, it became clear that at least half of the proposed "aid" would come in the form of loans that would need to be paid back at the time of graduation, locating the burden of public education on the individual.[74]

As is well documented at this point, Reagan's animus was led in no small part by his ideological opposition to public funding of the universities—an animus that emerged at least partly from his own idealization of small private colleges (especially religiously based ones) like his alma mater Eureka College. Reagan would deliver policy talking points during speeches at Eureka during his presidency (such as the speech laying out his position on START negotiations in his commencement address there in 1982),[75] but even a decade prior to his governorship he waxed lyrical about private colleges as the special protectors of his vision of academic freedom:

> Today we enjoy academic freedom in America as it is enjoyed nowhere else in the world. But this pattern was established by the independent secular and church colleges of our land, schools like Eureka. Down through the years these colleges and universities have maintained intellectual freedom because they were beholden to no political group, for when politics control the purse strings, they also control the policy. No one advocates the elimination of our tax-supported universities, but we should never forget that their academic freedom is assured only so long as we have the leavening influence of hundreds of privately endowed colleges and universities throughout the land.[76]

Curtis Marez has noted that Reagan redefined "private" to carry connotations of autonomous control, regarding these institutions as free from the external political influence that he saw as bedeviling the public universities.[77] But although he offered a promise of diffidence and respect to public institutions and their need for political autonomy, he flagrantly disregarded and actively reversed these supposedly sacred tenets while California governor.

Marez has observed that for Reagan, "the idealized image of college life incorporated students into forms of Cold War military authority," a pronouncement that assumes that universities—or indeed institutionalized education more generally—were somehow inherently *anti*–Cold War entities.[78] But as the research genealogy of creativity in chapter 1 reveals, this

was anything but the case. Reagan could trade on the assumption of the universities as both "creative" *and* Cold War institutions of US social life because the values of creativity were already Cold War principles, and not necessarily ones antithetical to it. UC Berkeley in particular represented (and continues to represent) precisely this seeming conundrum; prized retroactively for its role in hosting so much of the student unrest that Reagan demonized in his campaign and early governorship, its research prestige was (and in some ways still is) the result of Nobel Prize–winning research into atomic physics and chemistry, most of it funded by the Department of Defense in service of Cold War nuclear weaponry programs. Berkeley's student protest cultures developed not in spite of these realities, but in response to them.

Reagan's remaking of California's universities was central to how concepts of creativity were used to install neoliberal logic at an institutional level. As Marez has pointed out, Reagan's "market-driven redefinition of academic freedom . . . helped pave the way for the broader attacks on state power that have come to be called 'neoliberalism.'"[79] Along these lines, perhaps the most important legacy of Reagan's "Creative Society" remains its impact on public higher education. His attacks on California's extensive public university system constituted the beginning of a policy tradition in which the term "creativity" was used to attack and dismantle the public structures of the institutions that had housed, fostered, and augmented the very activities most closely associated with it.

As part of converting the tuition-free public university system to one students had to pay for, Reagan's administration successfully made education the burden of the individual.[80] This not only paved the way for the educational revenue crisis for the K–12 system that emerged after California's infamous Proposition 13 was passed in 1978, but transformed the role education played in Californian life more broadly, making it the primary mechanism for individual and state economic success, and also making the individual responsible for implementing it. This has had major repercussions for education ever since—including for thinking about how education should respond to the heightened precarity of the current economic moment.

This material on Reagan's governorship in a project devoted to thinking through the neoliberal implications of creativity may seem easy or obvious—after all, as Marez has noted, Reagan is one of the four figures emblazoned alongside Margaret Thatcher, Augusto Pinochet, and Deng

Xiaoping as "the Mount Rushmore of neoliberalism" on the cover of David Harvey's primer on the term.[81] But he is important to our understanding of contemporary creativity discourses not just for his central role in developing neoliberalism's US ideologies, but for how his campaign and governorship intertwined those ideological precepts with concepts of creativity in ways so commonplace that these origins are largely forgotten and concealed. Some readers of this history may be delighted to discover that creativity was championed by Reagan for exactly the reasons he elaborated, but others will be horrified to discover that one of the dispositions they cherish most was precisely what propelled Reagan into political prominence, and may be disturbed to discover echoes of his campaign rhetoric in their own attitudes and thinking. Either way, this history requires us to recognize how the neoliberal shaping of creativity concepts have indelibly shaped two worlds in particular – electoral politics, which we will revisit in chapter 6, and education, to which we now turn. The next chapter explores the role of creativity discourses – ones based in the expectation for individual responsibility articulated and popularized by Reagan– in shaping future pedagogical forms.

3

Creativity in the Classroom

Maker Education and Labor Precarity

A Minute on Maker Education

In a story that I suspect may be familiar to some readers, some years ago my partner and I undertook the process of finding a preschool for our then two-year-old. We were unprepared, as are most parents I think, for the emotionally overwrought landscape of early education philosophies that greeted us. The anxieties surrounding early childhood education are intense, and drive parents' willingness to part with substantial amounts of cash for what seem like fairly standard regimens of paint and classroom pets and circle time, despite the distinctive philosophies these supposedly manifest. What struck me most about the cross-section of preschools we visited was the nearly direct correlation between tuition dollars and mentions of the term "creativity"; the more expensive the preschool, the more frequently the school mentioned how creativity was fostered. It would seem from this experience that creativity is a luxury commodity in the world of early childhood care, an element that transforms the mere use value of having someone look after your children in a way that will be emotionally and socially nurturing to them into a far more expensive proposition (at sometimes twice the cost). And while its higher price tag indicates its luxury status, it's also perceived (and sold) as a *necessity*—if your child isn't being trained to be creative at the point in their development of greatest neural plasticity and absorbency, he or she will, from the outset of their education, be forever behind peers who are being thus challenged and nurtured.

Flash forward three years to my son's entry into elementary school, in a "good" public district (translation: where family wealth and real estate values have preserved supposed "enrichment" activities such as physical education and music). One much-lauded feature of the onsite aftercare program, Alameda Arts, was the inclusion of a Makerspace. Promoted for its promise to inculcate creativity in participants, the space was greeted with much enthusiasm by my fellow parents. But the actual Makerspace was something of a disappointment; a windowless converted storage closet, it primarily offered construction activities that revolved around straws, cardboard toilet paper rolls, painter's tape, and Styrofoam balls. I wondered how and when Makers had migrated from their eponymous Faires (1970s Renaissance Faire–inspired "e" firmly attached) that had originated south of San Francisco in 2006 to my kid's public school a decade later. Moreover, I was puzzled (and not a little saddened) by the fact that the Maker space seemed to be the primary location for the practice of "art" promised by the name "Alameda Arts."

Thus my entrée into the world of Maker-centered learning, the hottest form of enrichment education for children in the US today. [Figure 3.1] Its promises are nothing less than transformative: through Maker activities, your child will absorb visual design capacity, autonomy, self-direction, STEM competency, flexibility, resilience. But it also promises to deliver creativity, especially in the form advocated by contemporary research psychologists of the kind explored in chapter 1—sufficient arts and design thinking to inspire STEM innovation. As this suggests, Maker education is increasingly the avenue though which K–12 children are exposed to the arts.

The Maker movement is a grassroots inventors' and crafters' movement made up of "anyone who makes things."[1] With Maker Faire events in over forty-two countries worldwide, its artisanal, anticonsumerist ethos is increasingly seen as an antidote for everything from postindustrial precarity to environmental crisis to social isolation. One of its primary hallmarks is its participation in and shaping of contemporary creativity discourses, but perhaps the most important marker of Maker culture's growing influence is its insertion into primary and secondary education, where it is increasingly touted as one of the most important pedagogical developments of this century. With a growing set of educational research centers and NGOs dedicated to promoting its philosophy and techniques, much of Maker advocacy in the US is carried out by organizations formerly

Figure 3.1. Maker Education at work: "taking shop class into the 21st Century." Courtesy of Waag Futurelab.

focused on arts education, thus making "Making" a substitute for the arts in many schools.

As even this thumbnail sketch illustrates, one key characteristic of Maker pedagogy is how seductive it is. Education has joined the ranks of other consumer products like deodorant, clothing, or house decor in leveraging the anxieties of its target demographic. Given the very real issues of class bifurcation, widening income gaps, and economic survival more generally, middle-class parents seem especially worried (perhaps understandably) about their children's economic survival, and education has become the arena in which the psychological sense of "the creativity complex" drives the institutional implications of that phrase most intensely. Maker advocates have created a set of narratives that answer those anxieties, often in ways that are not merely soothing but alluring and tantalizing. For all the implications of Maker pedagogy that I am about to delineate, my son *loved* the Maker projects he worked up. His sense of excitement at having successfully mocked up a working vacuum at summer camp from a miniature fan, a cardboard tube, and a piece of filter paper was infectious and profoundly satisfying. The attraction of these projects only intensifies as public K–12 education in the US becomes ever more deeply gripped by standardized testing frenzies and disincentivizes arts classes.

What exactly are the long-term implications of Maker pedagogy for the next generation? This chapter explores how Maker-based pedagogy is refashioning the next generation's sense of self-definition via claims to skill-building and agency-cultivation. Given the increasing global influ-

ence of Maker culture (where its presence in design ateliers and tech startups is often offered as proof of a given region's worthiness for international investment),[2] it seems important to understand how Maker education models will affect how the next generation—including the next generation of artists—will conceive of themselves and their work in many different contexts.

Who Are Makers?

Makers are adherents to a self-proclaimed movement—one with its own philosophy, its own sense of process, and even its own aesthetic. In practice, they operate in two separate realms: in the small-scale, high-tech, networked manufacturing entities referred to as fabrication or "fab" labs, and within a broader hobbyist world that encompasses any activities that produce "things." The latter realm brings together under a single, branded term a range of supposedly amateur enthusiasts—the roboticist, the mechanical tinkerer, the homesteading apiculturist, the knitter/crocheter/ jewelry maker, the creator of digital musical instruments, the whimsical upcycling clothing designer. [Figure 3.2] What brings these wildly disparate figures together is their enthusiasm and active tinkering; across these activities, the movement emphasizes, it matters less what you *know* than what you *do*, and do so ardently. The passionate amateur ethos that purportedly links these individuals is key to the idea that they form a meaningful cultural movement and not simply a potential marketing demographic. As long as you *make*, you are a Maker™, and can join in this group of commercially branded fiddlers. Despite the bankruptcy of the parent venture Maker Media in June 2019 (to which we return at the end of this chapter), the movement has been widely internationalized, with Maker Faires—the licensed, branded, in-person exhibition of Maker activities— operating in Cairo, Shanghai, Prague, Orlando, Rome, and Cleveland, even in the midst of the ongoing coronavirus pandemic.[3] [Figure 3.3]

While its varied activities were branded by the Maker Media platform founded by Dale Dougherty in 2004, the Maker movement finds its true origins not in the realm of the domestic amateur, but in the university laboratory, and especially in the technical institute. Dougherty's involvement in the movement's origins is central to its development—as the developer of the first public, commercial web browser (later bought by and used as AOL), Dougherty's personal ideological commitments have

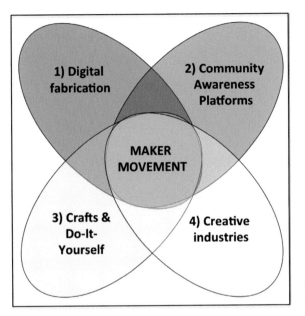

Figure 3.2. Maker activities. Courtesy of MDPI.

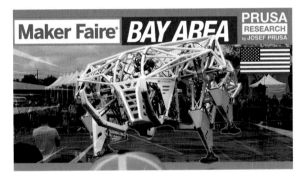

Figure 3.3. Maker Faire Bay Area, the first of the licensed faires. Courtesy of Mikolas Zuza.

strongly shaped the movement's organization as a private, licensed media brand. But prior to Dougherty's imprint, the key predecessor of the Maker movement was the "fab lab" created by MIT physicist Neil Gershenfeld, who is often held up as one of the movement's important early prophets. Fabrication labs, as pioneered by Gershenfeld for a course titled "How to Make (Almost) Anything," are essentially small-scale digital manufacturing workshops, in which technically skilled inventors can create new devices using a range of technologies such as microcontrollers, 3D printers, laser and plasma cutters, and so forth. While fab labs are generally framed

by the people who run them as autonomous, self-enclosed operations, a range of economists and policymakers see them as containing the seeds of the next industrial revolution, and a new economic landscape as well. No more the world of massive transnational corporations, the new economy will be ordered and structured via small, networked, high-tech ateliers, to which the association with the Renaissance artist's workshop is key. These studio-like tech organizations, supposedly advantaged by lean budgets, flexible operations, speedy prototyping capacity, and access to specialized niche skills and markets, will remake making itself, thereby putting the final nail in the coffin of mass-scale industrial manufacture and creating the new "American manufacturing Renaissance."[4]

While the worlds of university tech lab and domestic crafting may seem like odd bedfellows, Maker culture conjoins them rhetorically to obscure notable gender divisions, and also to make a case for seeing the high-tech skills of the fab lab as a species of artisanship. *Make* magazine—the first of Make Media's ventures and the publication from which the larger movement takes its name—began as an updated version of *Popular Mechanics* (a home-tinkerer and DIY publication from the early twentieth century), and only added domestic crafting activities when its editors realized that they had virtually no women readers. In addition to broadening their gender demographic, bringing these seemingly disparate realms of activity together allows Makers to mythologize themselves as leaders of a social movement that elevates work with digital fabrication technologies into a form of artisanship. As Gershenfeld characterizes it, "The maker movement is a social movement with an artisan spirit in which the methods of digital fabrication—previously the exclusive domain of institutions—have become accessible at a personal scale."[5] Claims of this nature rest on the assumption that fab lab technologies are less expensive and more widely available than in the past, thus democratizing digital technologies more broadly, rendering them no more remarkable than carpentry tools. But work with these tools is reframed as a species of Renaissance craftsmanship, valued for its capacity for self-expression. Gershenfeld goes on to claim:

> Finally, when I could own all these machines I got that the Renaissance was when the liberal arts emerged . . . and those were a path to liberation, they were the means of expression. That's the moment when art diverged from artisans. And there were the illiberal arts that were for

commercial gain. . . . We've been living with this notion that making stuff is an illiberal art for commercial gain and it's not part of means of expression. But, in fact, today, 3D printing, micromachining, and microcontroller programming are as expressive as painting paintings or writing sonnets but they're not means of expression from the Renaissance. We can finally fix that boundary between art and artisans.[6]

As Gershenfeld does here, Maker promoters in the tech world often stress their work as part of an art-craft-technology continuum. In a similar rhetorical move, sociologist and media theorist David Gauntlett opens his handbook *Making is Connecting* by invoking the founders of the Arts and Crafts movement, claiming William Morris's socialist ethos as the basis for social media and declaring John Ruskin's architectural commentaries as the grounds for his own analysis of YouTube videos.[7] These rhetorical claims of technological exploration as a form of personal expression echo precisely the dynamic explored in chapter 1 in which contemporary creativity discourses retain Romantic concepts of creativity while simultaneously disavowing them. While Gershenfeld skewers quite neatly the discrediting of artisanship via its putative relationship to commercial interests (a tie that the Romantics might have embraced in any case), he fully retains the Romanticist concept of expressivity as the central characteristic by which creativity is valued. In this view, technological work is prized not for some intrinsic value or process or quality, but because it is simply a latter-day version of the sonnet or the painting, with their connotations of inner life and outward expression.

In keeping with the disavowal of ideas that grew out of the Romantic movement, Maker advocates such as Gershenfeld usually frame the idealization of expressivity as an artifact of the Renaissance, despite the concept's Romantic roots. Gershenfeld does this explicitly when he equates 3D printing to Renaissance poetry, but such attributions are popular across Maker promotional materials. The moniker for the in-person exhibitions, the "Maker Faires," for example, explicitly invokes the Renaissance Faires of the 1970s, with their connotations of the humanistic rejection of religious orthodoxies and countercultural exploration that the early modern period nominally represents (President Obama gently mocked precisely this association at the inaugural White House Maker Faire in 2014, joking, "The only thing that I asked my staff about is why is there an 'E' at the end of 'faire.' I mean, I wasn't sure—is there jousting? Do we all have to get

dressed up, or what?").[8] But as this naming suggests, the various evocations of the Renaissance are valuable for their associations with self-expression as a guarantor of humanness. Gershenfeld's emphasis on self-expression is echoed in Maker Media cofounder Mark Hatch's *Maker Movement Manifesto*, in which "making" is equated not just with self-expression or self-fulfillment, but with humanity itself: "Making is fundamental to what it means to be human. We must make, create, and express ourselves to feel whole. There is something unique about making physical things. These things are like little pieces of us and seem to embody portions of our souls. . . . Since making is fundamental to what it means to be human, you will become a more complete version of you as you make."[9] Or as the director of MIT's High Tech/Low Tech Lab Leah Buechley puts it, "The pure focused bliss of tinkering isn't just for artists or engineers, it's a way that we can all be more human."[10]

Propelled by such surprisingly affect-saturated claims, Maker culture is as much a structure of feeling as it is mode of production or aesthetics or anything else, one in which, as labor sociologists Jessamyn Hatcher and Thuy Linh Nguyen Tu point out, "narrative is paramount to creating a sense of connectedness to other people and to places in a destabilized economic environment."[11] Offsetting the egotism and wellness blather of becoming a "a more completely you kind of you" (as though the maker were somehow less themselves before producing a tangible object), the movement emphasizes its social nature, stressing a kind of gift economy around both knowledge and the products made: "Sharing what you have made and what you know about making with others is the method by which a maker's feeling of wholeness is achieved" and "the act of making puts a small piece of you in the object. Giving that to someone else is like giving someone a small piece of yourself."[12] Emphasizing Making as a communal activity, the movement's promoters frequently give their publications titles like *Making is Connecting*, and stress its capacity for conviviality.[13] In this vein, David Hatch encourages participants to forge their own social and institutional network: "Reach out to those around you who are discovering the joy of making. Hold seminars, parties, events, maker days, fairs, expos, classes, and dinners with and for the other makers in your community."[14]

Alongside these claims to connectedness, Maker narratives often promote its commitment to passionate amateurism. This sensibility, as Nicholas Ridout has argued, is distinct from the modern capitalist sense of lei-

sure or uncompensated activity that operates with the framework of waged labor. Instead, passionate amateurism undermines the notion of "human activity and creative capacity as valued for what [it] can contribute to the accumulation of capital, in which life is measured out in units of productive time."[15] In passionate amateurism "the complementary relationship between work and leisure is not taken for granted, neither by unreflective professionalism nor by the conditioned amateurism of the recreational hobby."[16] Advocates of Maker culture see themselves as engaged in precisely this kind of work. In his origin story of the fab lab at MIT, Gershenfeld relates how the students who took the first course for the fab lab did so out of a sense of personal curiosity, driven to create devices that didn't yet exist. Moreover, the drive behind their interest "wasn't professional; it was personal. The goal was not to publish a paper, or file a patent, or market a product. Rather, their motivation was their own pleasure in making and using their inventions."[17]

Ridout notes that the concept of the passionate amateur arose in response to a set of social, political, and philosophical crises, particularly in its early manifestations in late eighteenth-century Germany where it answered "a social crisis facing a certain element within the bourgeoisie, who [had] aspirations of cultural leadership but [were] no longer able to find stable employment or exercise such leadership in either the church or the university."[18] One could map the Maker movement's turn to passionate amateurism onto a similar set of structural crises in the twenty-first century, particularly those around the desire for cultural leadership and employment stability. In fact, one of the primary advocates for Maker culture, David Lang, describes exactly this crisis in his autobiographical *Zero to Maker*, which he frames as a kind of conversion narrative. Out of work after his tech-startup employer fails, Lang tells how "I felt that in this work shake-up, my life story had been stripped away from me. My personal narrative—my sense of purpose and direction in the world—no longer made sense."[19] Inspired by a visit to a Maker Faire, Lang jumps into classes in 3D printing and laser cutting, and within thirty days has prototyped an underwater robot with a camera, and converts this into his own startup selling assembly kits. As Fred Turner observes in his analysis of Lang's book, what is important in this conversion narrative isn't just that Making "saves" him (though it does in his telling), but that the downsizing he experiences (which is now a structural feature of many US business models) creates a personal crisis over his own agency and ability to influ-

ence the world. Stuck with just his communications skills (he had worked primarily in marketing and social media), he cannot make a tangible *thing*, and therefore has no impact on the world around him.

These narratives use the structures of feeling surrounding notions of social connectedness and passionate amateurism as a mechanism to transform the Maker into the heroic figure of the coming generation. As Turner observes, the Maker movement isn't simply a grassroots movement for technological empowerment, but rather "a concerted effort by communities of engineers to knit their own professional imaginaries into the fabric of the American myth."[20] Reanimating the seventeenth- and eighteenth-century Puritanism on which the British North American colonial project was founded, the most visible promoters of the Maker movement have supplanted the yearning for spiritual transformation and fear of divine retribution of Plymouth Plantation with the desire for creative and entrepreneurial rebirth and fear of economic precarity that characterizes present-day San Francisco. "These authors tell us," Turner notes, "that spiritual transformation remains the only way to find a place in a world we can't control. And if we do it right, they suggest, we will find ourselves surrounded by creative, self-actualized people like ourselves, and quite possibly great wealth."[21] In this formulation, Turner asserts, creativity takes the place of divine "grace" in earlier forms of US Puritan self-mythologizing. He points out that where earlier capitalist rhetorics (especially in their Weberian Protestant modes) construed irrational affects such as passion or whimsy as antithetical to appropriate forms of self-fashioning, these attributes are now reframed as crucial, central forms of labor discipline. In this, Maker culture is one of the primary cultural arenas in which the artist bohemian, who in the early nineteenth century was defined as apart from and even antagonistic to middle-class mercantile cultures, is now their apogee (a characteristic explored in the next chapter).

This aspect of Maker culture finds its clearest focus in its anticonsumerist philosophy. To be a Maker is to evade and even undermine the passivity of being a consumer, and this, its advocates argue, is the thread that connects various iterations of Maker activity. As Dougherty describes it, "Makers are seeking an alternative to being regarded as consumers, rejecting the idea that you are what you buy. Instead, Makers have a sense of what they can do and can learn to do. Like artists, they are motivated by internal goals, not extrinsic rewards."[22] This sensibility is carried through at the policy level too—at the 2014 White House Maker Faire, President Obama

sutured Maker anticonsumerism to nationalist projects around manufacturing and economic might, intoning, "Our parents and our grandparents created the world's largest economy and strongest middle class not by buying stuff, but by building stuff—by making stuff, by tinkering and inventing and building; by making and selling things first in a growing national market and then in an international market—stuff 'Made in America.'"[23]

Makers in the Classroom

It is in this context—of remaking the US manufacturing economy and also of reframing tech labor as communal, anticonsumerist artisanship—that schools have become one of the most important, if not the primary, target networks of Maker culture. Many commentators on US education have pointed out that universal, compulsory education was essentially created to address the labor needs of industrial factories, and that as that economic system has evaporated (or, more accurately, has moved to other global locations), education needs to be reformed to answer to the labor, economic, and social needs of postindustrial reality.[24] In some iterations, education advocates simply note that current pedagogical structures are incapable of training students for the world they will actually inhabit, but in others, current educational practice is seen to actually impede new economic systems from emerging. Bo Cutter, an economist and director of the Next American Economy Project at the Roosevelt Institute, argues, for example, that "our longstanding need for an education revolution may be the biggest barrier facing the evolution of America's next business system."[25]

Maker-centered learning, in this view, trains students to work in and even produce the fabrication-based economy of the future. Turner wryly identifies how the Puritan spiritualism that animates the Maker project emerges with particular intensity around education debates: "The school must become the new congregation: a community organized around the tools and forms of structured play that ostensibly awaken that gift [of creativity]. Once they do, both students and schools will be sustained in the endeavors to come."[26] Dougherty promotes Maker pedagogy in just this sense. In his essay "The Maker Mindset," he rhapsodizes that "the biggest challenge and the biggest opportunity for the Maker Movement is to transform education. . . . The rigid academic system is short-changing all students, even though an elite few seem to do well by academic standards. However, there is an increasing skepticism that even those who succeed

academically are not the kind of creative, innovative thinkers and doers that we need."[27] These marketing attempts seem to have paid off, with "Maker-centered learning" becoming one of the banner education-policy phrases of the past decade.[28]

Education researchers on Maker-centered learning define it via a loose suite of characteristics, many of them predicated on the production structures of the fab lab: its social, collaborative nature; its experimental and experiential basis; its emphasis on problem-solving; its media- and tool-rich environment; its flexibility.[29] In this, education advocates wed Maker rhetoric to an education theory known as "constructionism," which emerges from the experiential learning advocated by John Dewey and Jean Piaget's theory of children as natural scientists (that they learn by interacting with the world via implicit processes of experimentation and observation). Building on constructionist concepts, Maker pedagogy stresses the cultivation of particular dispositions, especially toward a sensitivity to design (defined as the capacity to recognize that the objects of our world are created in particular ways and can therefore be altered), toward the desire to explore different possibilities, and toward the capacity to *do* something with them. Piaget emphasized knowledge as a form of agency, arguing that to know something was to act upon it—one did not truly know without doing.[30] Through these dispositions, Maker pedagogy encourages students to act on their environment. In their earliest developmental stages, students are tasked with exercises such as observing a simple object like a screw, looking at it from as many angles as possible, identifying its principal components and asking how they work, drawing these components, and so forth, in order to obtain the requisite sensitivity to design.[31] Education researchers such as Edward Clapp frame exercises like this as asking students to slow down, to absorb how even everyday objects around them are designed, to observe how even mundane objects are made and constructed toward particular ends. Once students internalize these lessons, they are given tasks that foster an increasing sense of agency and group collaboration.

Enticingly, advocates stress the ludic dimensions of Maker-centered learning, echoing Johan Huizinga's observations on man as player (as opposed to mere thinker or even maker). Huizinga, who had famously insisted that even at the height of the industrial revolution man was not merely *homo faber* (man who makes) but *homo ludens* (man who plays), argued that "in play there is something 'at play' which transcends the

immediate needs of life and imparts meaning to the action. All play means something."[32] This sentiment is repeated throughout Maker-education literature: Dougherty argues that as formal education has become narrowly focused on the mastery of abstraction, children learn to "make" only in nonschool hours (in other words, during playtime); Stuart Brown's book *Play: How It Shapes the Brain* is quoted by multiple Maker education authors; the question of whether play can be a source of learning is raised and addressed frequently in Maker-centered education research. In defining Making as play, Maker pedagogy advocates echo Huizinga's hero Friedrich Schiller (another artist of the Romantic movement), who claimed that "man . . . is only wholly man when he plays."[33] These claims follow creativity discourses' focus on the individual that we saw in chapter 1, using the concept of "making" to collapse the play/work dyad in service of developing a self. Children, the thinking goes, develop a sense of self—and especially an agential sense of self—via Maker activities that feel like play.

In keeping with the ethos of its parent brand, Maker education defines "playing" as producing things. For primary school children, Maker pedagogy involves teaching basic mechanics—of household machines, of human and animal physiology, of the instruments of scientific discovery—by mocking up versions of these from everyday household items such as cardboard paper towel tubes, painter's tape, old boxes, and Ziplock bags. Children are encouraged to understand the basic principles of a vacuum cleaner, for example, by creating one: affixing a miniature plastic fan to the inside of a Quaker Oats cylinder and stretching a perforated piece of tissue paper across one end with a rubber band (my son's summer camp project). As children age, they are encouraged to work with increasingly complex tools (power drills, circuit boards, interactive LEDs, electronic thread) to produce more sophisticated things (wind turbines, audio speakers, sewn circuit cloths). At the secondary level, Maker-centered learning builds on project-based learning to give a tech-heavy reboot to vocational education, combining older high school courses in carpentry, car maintenance, and even home economics with basic understanding and use of electronics, robotics, and engineering, or as President Obama put it, "tak[ing] shop class into the 21st Century."[34]

The constructionist emphasis on the creation of things in some ways brings the Maker ethos in line with the observations and claims of thing theory. On the one hand, Maker advocates point to the thrill in the very materiality of the physical act of creating an object, what Bill Brown has

noted is a kind of nineteenth-century "delight in things" as opposed to the "disorientation and confusion" of ideas.[35] At the same time, Makers insist on a rather thing-theory claim, that the most important payoff in the creation of objects is the production of subjects, and even the intensification of subjectivity itself. David Lang, who turned to Making after his startup collapsed, recalls that after being laid off, "I realized how tragically specialized I had become. I was extremely well-prepared for a job that no longer existed. . . . I seemed to be far away from being able to build, fix, or create anything of tangible value—any real, physical thing. . . . Now after hurtling in and out of a digital career, I felt as though I were missing a critical piece of my humanity."[36] Lang echoes other Makers, such as *Maker Manifesto* author Mark Hatch, who argues that nontangible forms of creativity such as writing lack the sense of emotional satisfaction and completion of their physical counterparts: "Physical making is more personally fulfilling than virtual making. I think this has to do with its tangibility; you can touch it and sometimes smell and taste it. A great sentence or a well-written blog is creative and makes you feel good about what you have accomplished, but it is not the same as the satisfaction that comes from the physical labor involved in making something physical."[37] This line of thinking, as we saw in the earlier quote from MIT high-tech/lo-tech lab head Leah Buechley, positions Making as the mechanism to produce a more intense experience of being human. While these prognostications circumscribe the semantic capacity of objects—especially in how they make meaning beyond the realm of the human—they nevertheless exemplify a logic identified by theorists of new materialism, namely that made things make us. This is a central aspect of the Maker narrative—that via Making, students come into their sense of self, and moreover an agential sense of self, a self that acts on the world.[38] Clapp (along with others) argues that the central goal of this learning program is "the more dispositional outcome of developing agency and building character."[39] While the invocation of "character" brings to mind questions of moral and ethical fiber, the term is actually mobilized in Maker theory to denote a kind of mastery and identity-building, and in this, advances a sense of self notably devoid of ethical reasoning or deportment. The idealized "character," as exemplified by a pair of teens featured at the White House Maker Faire, is one who acts on the idea that "if you can imagine it, then you can do it—whatever it is."[40]

This slogan is profoundly beguiling. The dispositions—the modes of perception and ways of acting on the world—that Maker teachers hope

to cultivate in their students are immensely attractive. Maker pedagogy claims to instill curiosity, whimsy, risk- and responsibility-taking, persistence, resourcefulness, aesthetic sensitivity, generosity of spirit and mind, and even optimism. These are qualities any parent would be thrilled to have their child acquire and internalize. But these alluring goals have some rather disturbing implications. Following the creativity discourses of the mid-twentieth century, Maker education claims obscure the subordination of the arts while symbolically embracing them. Virtually none of the writing about Maker-inflected pedagogy showcases representation-based projects. Despite researchers' occasional protests to the contrary, making almost wholly excludes actual arts. Painting, writing, sculpting, acting, singing, choreographing, playing a musical instrument—rarely are these activities on display (or indeed undertaken or evaluated) in the research on Maker-centered learning, presumably because they do not produce things, but also because they do not cultivate STEM competencies, which points to the primary goals of the pedagogy. One of the most fully developed anthologies on Maker pedagogy, *Design, Make, Play*, is exclusively STEM-oriented; its central goal is to argue for Maker pedagogy as the most effective means to produce the next generation of scientists. Even the "design" of its title is focused entirely on STEM, defining it as "a process central to engineering and technology [and] a powerful vehicle for teaching science, technology, engineering, and math content in an integrated and inspiring way."[41] Similarly, a 2020 review of research literature on Maker pedagogy explicitly claims that "the maker movement has sparked interest from stakeholders in K12 educational institutions based on its emphasis on . . . STEM content areas."[42] More frustrating still is the way advocates frequently invoke the arts as example or inspiration for STEM activity—Dale Dougherty quotes Frank Bidart's poem "Advice to the Players" in the first pages of "The Maker Mindset," Neil Gershenfeld compares microcontroller programming to writing a sonnet, and Edward Clapp enthuses that rehearsing for a theatrical production endows students with empathetic capacity necessary to solve other challenges.[43] In this guise, the arts are tendered for inspirational purposes, their capacity for symbolic worldmaking and philosophical or aesthetic exploration largely subordinated to how they might transmit problem-solving, innovation, emotional connection, countercultural daring, and expressive capacity to STEM activities.

Given the de facto exclusion of the arts from Maker education, one of the more distressing aspects of its absorption into the K–12 system is the

way its advocates disparage arts education as not simply old-fashioned, but as narrow and rigid. Harvard education researcher and Maker advocate Edward Clapp, himself a former arts-education advocate, notes that identifying the unique aesthetic of Maker-centered work would allow it to avoid "being contorted to the form of aesthetics as they are understood in other domains, such as the arts. Just as it is important to develop a sense of aesthetics in the arts, so too is it important to develop a sense of aesthetics in regard to the made dimensions of one's world. . . . Foundational to this task is developing a new language to describe the maker aesthetic, as opposed to relying on the languages of art or other domains."[44] While Clapp's goal is quite laudable in its own terms, it's worth noting that in fact the aesthetics of Maker culture—which Clapp claims are characterized by the whimsical juxtaposition of objects used for something other than their intended purposes, the exposure of internal functional elements (what he terms "the guts on the outside"), and the visible presence of the Maker in the object—were all experiments of the early twentieth-century visual arts going back at least to Futurism and Dada (a fact explored in the next chapter).[45]

So why has Maker pedagogy proved so popular? In part, its rise is a response to larger concerns about the current educational world's capacity to help our children cultivate creativity, which is now sold to Americans as a national crisis. The idea of a "creativity crisis" was introduced to the broad US public in a July 2010 issue of *Newsweek*.[46] A cover story laid out the findings (and replicated the title) of research by education psychologist Kyung Hee Kim, who had discovered that since 1990, creative thinking scores have fallen among K–12 students, especially among K–3rd-grade students.[47] This finding worried US researchers of creativity, who had long wondered whether creativity correlated with IQ, in which case as the "Flynn Effect" (which holds that IQ improves with successive generations) took hold, creativity would also rise. Instead, Kim found that even though IQ had indeed risen among US schoolchildren, their creative capacity had fallen. The article noted that this downturn was particularly distressing given a recent IBM survey of global CEOs, who overwhelmingly identified creativity as the most important leadership skill of the future.[48]

The sense of urgency that animates "creativity crisis"–style reporting seems to cluster, unsurprisingly, around anxieties over unpredictability and precarity on the one hand, and US nationalist rivalries with China on the other. As an example of the first genre, perhaps the best known and widely

circulated is Ken Robinson's 2006 TED Talk "Do Schools Kill Creativity?" At over seventy million views (and translated into sixty-two languages) as of this writing, Robinson's talk begins with the observation that "it's education that's meant to take us into this future that we can't grasp. If you think of it, children starting school this year will be retiring in 2065. Nobody has a clue, despite all the expertise that's been on parade for the past four days, what the world will look like in five years' time. And yet, we're meant to be educating them for it. So the unpredictability, I think, is extraordinary. . . . My contention is that creativity now is as important in education as literacy, and we should treat it with the same status."[49] The unpredictability that Robinson notes in his talk is a quality described more pointedly by other writers on creative education reform, who point to the vertiginous shifts in technology, economics, employment, climate, and culture that today's children are likely to face in their lifetimes. While very few writers on creative education reform explicitly name it as such, the major underlying concern of all these dynamics is the significant economic, political, and ecological destabilization that today's students will face from the confluence of all these factors.

The major specter that looms alongside precarity, one often evoked as its cause, is that of China. In another echo of mid-twentieth-century creativity discourses, promoters of creative-education reform often truck in a kind of nationalist protectionism; in the twenty-first century, however, the nationalist imperative swaps China for the Soviet Union, stopping just shy of (and sometimes rushing straight into) outright Sinophobia. The 2010 *Newsweek* article ominously warns that "in China there has been widespread education reform to extinguish the drill-and-kill teaching style. Instead, Chinese schools are also adopting a problem-based learning approach. . . . When faculty of a major Chinese university asked [education researcher Jonathan] Plucker to identify trends in American education, he described our focus on standardized curriculum, rote memorization, and nationalized testing. 'After my answer was translated, they just started laughing out loud,' Plucker says. 'They said, 'You're racing toward our old model. But we're racing toward your model, as fast as we can.'"[50] (These questions of US-China international rivalry and the geopolitics of creativity are taken up in chapter 6).

On some level, these concerns are animated by debates over the role of education more generally. Since its inception in the US, compulsory public education has been driven by two potentially contradictory impulses

or goals. One is to produce a homogenized citizenry who were disciplined to both the world of labor and the world of liberal democracy; the other is to produce workers and citizens who could grapple in thoughtful and novel ways with the problems that confronted them in those worlds. Not all education philosophers perceived these goals as contradictory; as we saw in chapter 1, John Dewey, to name one prominent example, believed creativity was crucial to the emergence of a democratic political subject, and saw it as an inoculation against the seductions of authoritarian personalities. But many debates about US education churn in the wake of these potentially divergent roles.

On this note, perhaps the most worrying facet of Maker pedagogy is how it naturalizes major shifts in forms of labor, especially as it transforms our understanding of what work actually is and how and under what conditions it is valued and considered economically fair and nonexploitative. In this process, the "cookbook" metaphor used to refer to the many DIY manuals that Maker enthusiasts promote and publish (and that constituted the primary pedagogical arm of the movement prior to its formal insertion in schools) plays a telling role. Cookbooks entered the American publishing market at a time when cheap domestic labor was disappearing, making it necessary not only to train middle-class married women how to cook, but to make such activity enticing by redefining it as a leisure activity rather than a form of drudgery associated with the working class. When Makers use the cookbook metaphor to frame their primary pedagogical format and mode of initiation into the group, they (consciously or otherwise) similarly reposition their activities as a form of leisured personal expression rather than mere labor. Referring to Maker instructional manuals as "cookbooks" obscures the labor function of Maker activity, just as it does for food preparation.

Via mechanisms like the cookbook metaphor, Maker culture aids a larger reconceptualization of labor as pleasure. The somewhat puzzling fusion of the tech end of the Maker spectrum to the hobbyist practices of cheese-making or wool-carding or paper-pulping (which at first glance seem like the antithesis of using plasma cutters or computer-automated lathes) creates a crucial rhetorical association in this vein. As in other corners of creative-economies thought, for Maker adherents, creating and working are often construed as antithetical realms of activity.[51] Framing tech manufacturing as a species of domestic DIY project, with all the latter's connotations of agency, self-expression, homey conviviality, ethical

postconsumer use, and artsy coolness, obscures the transformation of highly technically skilled work (of a kind that would have been completed in a mass-scale tech factory a mere generation ago) into a kind of domestic industrial "homework" akin to the model of the cottage industry.

In this, the Maker movement provides an attractive brand for the broad cultural shift from "production" (with its attendant focus on labor) to "craft" (with its sense of domestic leisure activity).[52] By way of explaining this mutation, labor sociologists Jessamyn Hatcher and Thuy Linh Nguyen Tu have analyzed the clothing and fashion wing of Maker culture, with a focus on Alabama Chanin (AC), an artisanal clothing line based in Florence, Alabama. Featured on artisan sites such as Etsy (which produced a documentary on the company in 2012), brands like AC are understood as the apotheosis of contemporary DIY, Maker, and "ethical fashion" movements. Among its production systems (which include factory-based, machine-made garments and make-at-home kits for customers), AC features an "artisan"-based line of clothing, for which it subcontracts garments to workers who hand-stitch them from their own homes. AC's subcontractors meet—in no uncertain terms—the definition of industrial homework under the Fair Labor Standards Act (FLSA), which includes any labor that produces goods performed for an employer in a residential setting.[53] As in the historical cottage industry, much of this labor is generally associated with feminized forms of work—sewing, knitting, embroidering, and jewelry-making (not incidentally, four of the most common—and feminized—examples of Maker crafting activity), and the FLSA explicitly prohibits the manufacture of women's apparel in workers' homes specifically because of the history of labor abuses in homework models of garment and textile production.

Although (as Hatcher and Tu point out) cottage industries such as garment and textile manufacture were predecessors to factory work—ones with their own histories of profound abuse and precarity—they are now held up as the solution to the problems of both industrialization and its abandonment in the developed world. Under the aegis of "philanthropic entrepreneurialism," Maker brands like AC cast themselves as offering jobs in regions devastated by postindustrial decline, reviving skill sets neglected or disappearing under machine-based labor, and fostering community in an age of alienation and loneliness.[54] Simultaneously, the people who actually perform the labor of making the items for this brand "elevate the value of the garment not just through the hours of their labor or the level of

their skills, but also through the very symbol of the artisan, as a creator who loves what they make, and who, in turn, inspires love for the things they have made."[55] This affective allure conceals the exploitation of home-work labor, which often gives rise to legal battles over minimum-wage failures and the improper devolution of equipment purchase and mainte-nance onto employees.[56] AC has incurred precisely these problems with its "artisans," especially around wages. With jobs "gigged" out on the basis of worker bids, wages are lowered as workers compete against one another by offering the lowest price possible for their labor. Moreover, workers have to purchase garment kits, which they sell back to AC as finished apparel.[57] Much of this labor is undertaken as supplementary to other forms of work, without which the low compensation (which in some cases is as low as two to three dollars per hour) would be financially unsustainable. Because this work is seen by its proponents as a "labor of love," it is often construed as unproductive or as "nonwork."[58] But as Hatcher and Tu point out, the forms this labor takes—"homework, piecework, freelancing, independent contracting—are not the answer to precarity, they are its root causes."[59]

Maker culture idealizes and encourages this form of labor, even in its tech-centric iterations. In linking 3D printing to artisanship, the former is identified as a form of craftsmanship that produces the pleasures of that type of skilled practice, but is also reframed within the ethos of home pro-duction, especially in the common comparison to the garage-geek origins of home computing. In the new workshop system of high-tech manufac-turing, the same forms of labor precarity that characterize cottage labor now rebound onto highly skilled tech workers, as they too become subject to the refashioning of the world of formerly middle-class labor structures into the gig economy.[60]

Given the larger labor structures that the next generation will probably face, the "empowerment" or "agency" facet of Maker pedagogy reinforces a kind of libertarian ethos that claims that Making an object fixes a variety of social, economic, and political ills. Maker narratives on this idea abound. Unemployment and postindustrialism are solved via Making. Excess con-sumerism is redirected via Making. Loneliness is soothed via Making. Our children's futures are stabilized via Making. Using these arguments, Maker-centered learning weds the language of DIY to that of corporate entrepreneurialism in distressing ways. The transformed broom closets where children hack together a barebones vacuum become "opportunity spaces." A class project on designing a window shade to reduce room tem-

peratures obviates the need for an architect to pitch designs to the school district. On the one hand, these are practices of optimism, of transforming necessity (or even grim reality) into virtue. On the other hand, it's hard not to see these rhetorical operations as a species of gaslighting—as dressing up the grim realities of decades of austerity politics and public infrastructure neglect as simply individualist capitalist possibility.

It's nearly impossible not to see the hand of Lauren Berlant's "cruel optimism" at work in these discourses. Cruel optimism comprises "the historical sensorium that has developed belatedly since the fantasmatic part of the optimism about structural transformation realized less and less traction in the world. The fantasies that are fraying include, particularly, upward mobility, job security, political and social equality, and lively, durable intimacy."[61] Maker language enacts precisely these dynamics for the next generation. It renames loss as possibility, especially around the kinds of classes that had supported project-based learning for decades (shop class, home economics, sculpture and ceramics and art class, and so forth), and shrouds the ongoing theft of these courses from poorer districts and schools. The educational project of Makers in many ways actually already existed in K–12 education, but in the now-sidelined areas of vocational and arts classes that are treated in the age of standardized testing and budget reductions as luxuries that many districts cannot afford (or where they can, do so only for schools with family populations with enough personal wealth to pay for these courses through PTA donations).

Making the Future

If Making is essentially a narratological structure of feeling, it is one that claims not to know how the future will unfold, but rather to endow its practitioners with the power to shape it. Given this, it's worth investigating two separate points regarding the future of Making. The first is seemingly one of current economics. That Dale Dougherty's media company is now invoked every time a parent talks about their child's science-fair project demonstrates just how deeply this brand has saturated and integrated itself into our education consciousness. However, in summer 2019, Maker Media, the parent branding venture behind the movement, filed for bankruptcy, exposing the unsustainably libertarian ethos undergirding the communalist claims of the movement. Dougherty has explained the financial collapse of the company by noting the difficulties of maintaining print

media in the current environment (forcing its namesake *Make* magazine to run at a loss) and the lack of corporate sponsorship for the Maker Faires, which has rendered them inoperable within the US (in other national locations, the Faires are supported by significant local and national government subsidy, stabilizing their ongoing existence). Having insisted on the for-profit model at the movement's origin and having failed to secure ongoing sponsorship from the corporations that initially supported the venture, Maker Media failed precisely due to this structure, exposing its existence as a corporate brand and not as the grassroots movement that it claimed to be. Dougherty is currently attempting to recreate it as a co-op or not-for-profit, asking Maker practitioners to take over its governance and operations (presumably on a volunteer basis), arguing that if this really is a movement (and not simply a media corporation), its adherents will need to step up to the plate to sustain it. Whether Makers turn out to be members of a social movement or consumers of a fad media brand remains to be seen.

The second point concerns the conjectural pathways along which Making might take us. The Maker movement has inspired two works of speculative fiction, the first of which, Cory Doctorow's 2009 *Makers*, offers a triumphant vision of how these workers might invent the new economy so admired by policy enthusiasts from Bo Cutter to President Obama.[62] The second, William Gibson's 2014 *The Peripheral*, is written almost as an antidote to the Maker movement's utopic imaginings. Gibson's novel follows the fortunes of a group of US veterans of some not-too-distant-future war fought primarily via something called haptic drone technology. They return to what is effectively a methamphetamine narcopolitics–driven hometown, where the only jobs in their relatively rural area are indeed those enabled by fabrication technologies. However, instead of enabling the manufacture of innovative, whimsical clocks or personalized phones à la Gershenfeld's MIT students, fabrication has primarily become the purview of three organizations: the Department of Veteran's Affairs, which makes specialized prostheses for injured veterans; a mega chain called "HeftyMart" that fabricates basic on-demand consumer products such as clothing and meals; and local drug lords who "build" bespoke 3D-printed guns and an illegal drug called "wakey." Said veterans, understanding the perils of any of these employment pathways, survive financially via their drone skills, for which they are paid by wealthy hobbyists to perform on their behalf in massive multiplayer online games and digital simulators.

These skills enable their survival but also draw them (via a kind of digital time-travel) into an increasingly dangerous political intrigue of the next century, in which the only human beings left after environmental collapse appear to be the ultra-wealthy international mafia referred to as "klept," their staff-entourages, a globally dispersed population of "neoprimitives" who have sworn off of technology altogether, their anthropologist–art historian "curators," and a set of celebrity performance artists who seem to cross all these disparate social categories.

As is often the case in his writing, Gibson illustrates how a number of emergent social phenomena of our moment that seem parallel but unrelated are in fact profoundly interwoven. Gibson maps the meth crisis, the warfare economy, the climate crisis, multigenerational rural poverty, and widening wealth inequality on the one hand onto the technologies of AI, 3D printing, haptic interface, social media celebrity, the destruction of the nation-state, and blockchain currencies on the other. Rather than conceiving of the latter group of phenomena as the sphere of those who live in urban financial centers, Gibson depicts his rural protagonists as exactly the kind of tech-savvy, agential, entrepreneurial figures that Maker culture promises to deliver. However, in Gibson's conjecture, the fab labs and related tech engender, not the rise of a new economic paradigm (as promised by promoters like Cutter or Dougherty or even Obama), but the collapse of the current one. The ensuing underdog scramble might—for those cunning or ruthless or wary enough—mean the difference between wholesale financial and personal collapse and a narrow escape from such a fate. Such an escape does not mean self-expression or renewal, however, but merely survival. And Gibson makes clear the psychological toll that survival takes—his protagonists get by not on their 3D printing or drone savoir faire alone, but those skills in combination with their combat experience. Survivors are not merely subject to some form of PTSD—they survive because of it. The resulting forms of *communitas* generally revolve not around the gift economy imagined by Mark Hatch in his *Maker Manifesto*, but as either a grifter community or a kind of rogue outsiderness built around a military unit mentality. Gibson dramatizes how, were we to successfully train the next generation to all be Makers, the resultant shifts in the social world would be part and parcel of infrastructural collapse more generally.

Gibson's unabashed pessimism might stem less from his self-admitted paranoia than from the real-world infrastructural connections that Maker

culture has enabled between the tech, military, and education arenas.[63] In 2012, the Defense Advanced Research Projects Agency (DARPA—the Research and Development wing of the US military) teamed with Tech-Shop (a Bay Area Makerspace chain) and the Department of Veterans Affairs to retrain soldiers entering civilian life in fab lab skills (paid for via crowdsourcing campaigns). The veterans were trained primarily to produce military vehicles, but on a flexible manufacturing system that enabled workers to create multiple kinds of vehicles rather than a single model.[64] The veterans of Gibson's novel display precisely this form of training, printing different models of surveillance drones that they use for protection. At the same time that it launched the veteran's program, DARPA endowed a high school outreach program run by Dougherty that would put 3D printers into Makerspaces (designed using a platform provided by Make Media) across the country.[65] So while the shifts that Gibson tracks in his novel may seem like a conspiracy-laden dystopic vision of the future, they are in fact already being experimented with in both the military and the education worlds in the US.

Much of the energy behind creativity's educational uptake lies in the attempt to get ahead of the pace of constant disruptive change posed by late modernity, particularly in its techno-economic modes. In this guise, where creativity is equated with disruption (as in economist Joseph Schumpeter's infamous phrase "creative destruction"), it is also posed as its solution. Maker culture's infiltration of K–12 (which, as the MIT fab lab attests, is a movement that really began in tertiary education) is simply the intensification of the process by which entry into the world of technology has become the primary end-goal of education as a whole. The extent to which political institutions like the White House or military institutions like DARPA and the VA have joined Maker ventures indexes not just their support for that goal, but their own structural interdependence with it. Given this, we might note that Maker's infiltration of K–12 education is not only the final gesture that sweeps art education aside, or retrains artists to think of art-making as making "things," but might actually be one of the mechanisms by which the next generation's precarity intensifies. This feels like an impossible contradiction for educational institutions to resolve.

The next chapter explores steampunk, an aesthetic form that Making often takes, looking to how it provides a cultural arena through which the creativity complex is both enacted and scrutinized.

4

Discarded Creativity

Libertarian Mythologizing and Steampunk Nostalgia

We are archeologists of the present, reanimating a
hallucinatory history.
—Catastrophone Orchestra and Arts Collective,
"What Then Is Steampunk?"[1]

If Making encompasses a primary activity of the creatively disposed, its
aesthetics often emerge in a form that is perhaps surprising, especially
given its tech-world locus. Leaping gleefully from between the minimal-
ist lines more commonly associated with the tech roots of the Maker
world are the brassy cogs and gears, strappy leather corsets and vests, and
extraordinary upcycled sculptures of steampunk, depicting everything
from a giant, fire-breathing octopus to a Victorian house piggybacked
onto a steam locomotive. So influential is the form at the Maker Faires
that in 2010 the ur-Faire in San Mateo, California instituted an annual
"Steampunk Village" dedicated to the style and its practitioners.[2] [Fig-
ure 4.1] It has even been used to insist on the importance of art practice
within science and tech education: the acronym "STEAM" (used to aug-
ment STEM-centric educational debates) was picked up by the annual
Louisiana Steampunk Festival, which began as an offshoot of the Maker
Faire when students at the University of Louisiana at Lafayette used it to
assert art-making's importance to the Maker world. Exchanging "Mak-
ing" for "Math," its organizers wrote, "It is about the path of life that we

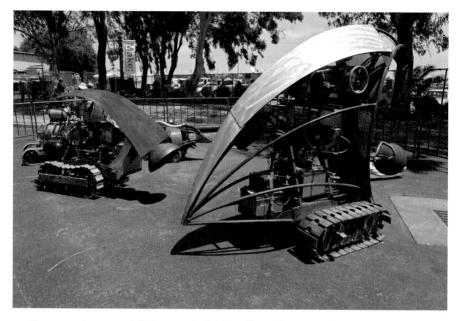

Figure 4.1. Steampunk Village at the Makers Faire. Courtesy of Marco van Hylckama Vlieg.

as individuals and as a community choose to take—and MAKE together. In Lafayette we choose the path of STEAM: science, technology, education, art and MAKING."[3] Though Arts and Crafts might be the historical aesthetic antecedent of Maker promotional writings, the movement's most vibrant and persistent visual form takes the incongruous shape of Victorian-futurist industrial nostalgia.

Steampunk is by no means limited to Maker Faires. It appears in films and farmers-market crafting stalls, at Burning Man, and at opening parties for residential high-rises in San Francisco's Central Market district (home to Facebook and Twitter headquarters). In a variety of tech venues, celebrations, gatherings, and online arenas it has afforded a visual playground for the outward manifestation of creativity discourses, especially as an alternative aesthetic to the modernist minimalism of tech devices themselves. Although some practitioners have claimed that its popularity waned toward the end of the last decade, it would be more accurate to note that it has come to subtly and pervasively penetrate broader design aesthetics worldwide. Steampunk continues to pervade the world of film and televi-

sion, where it provides a central signifier for scrappy underdog heroism in costuming, vehicles, and weapons for both sci-fi–inflected period costume dramas (like HBO's 2021 *The Nevers*) and dystopic futurism (as in the 2018 film *Mortal Engines*). If you have eaten in a restaurant or worked in a cafe lit by the soft ambience of Edison bulbs (and you almost certainly have), you too have basked in steampunk's glow.

Despite this diffusion into the broader cultural imaginary, and despite what might seem like an otherwise atavistic investment in Victoriana (associated with a period that popular culture often codes for social repression), steampunk enthusiasts very much see the form as a counterculture, one that focuses on the role of technology in social change.[4] This seemingly odd fixation on the technologies of the Victorian period especially drew Gen-X and early millennial practitioners from the tech world, who were the key generation in the shift from the supposedly corporate microchip world to the creatively inspired technologists of the internet. Its exuberant emergence at the end of the first decade of this century coincided with both the first of the Maker Faires and the moment that Burning Man morphed from eclectic art event to tech-mogul and deal-making "must do" cultural event.[5] Why would the people at the epicenter of the digital world want to reimagine, re-envision, and re-perform the industrial revolution they supposedly disrupt? As a primary style of the Maker world, what kind of self is articulated in its aesthetic and narrative forms? What are the implications of its alternative cultural imaginary for how we think about technology more generally?

This chapter explores steampunk's contradictory ideological energies, and how these emerge within and against creativity discourse–driven cultural movements like the Makers. On the one hand, steampunk forms an aesthetic and subculture critical of the tech world, forwarding its critique via rather unusual forms of nostalgia. At the same time, the practices of bricolage and upcycling that characterize its visual wing in particular (the most conspicuous form at tech-world events like Maker Faires and Burning Man) potentially undermine the kinds of critique they otherwise forward, especially in the ways these enact the libertarian ethos that characterizes the tech world. To the extent that libertarianism in the United States is conceived of and embraced primarily as a free-market political ideology, it has found a home and a set of enthusiastic champions in the heart of the tech world, whose degree of hypocrisy on this point (given the extent to which so many innovations of the tech world have been funded

outright through governmental research monies or indirectly subsidized via tax breaks) is well documented. While steampunk does not formally or thematically represent the ideas of libertarianism, it nevertheless performs its ideology, offering a mode of doing that shapes its participants into libertarian subjects. To illuminate how steampunk embodies a process of subject-making, this chapter explores its specific forms of technological critique, its peculiar nostalgic expressions, and its whimsical systems of DIY bricolage.

Punking Victoriana

In his canonical study of subculture, Dick Hebdige points out that cultural substreams like punk come into being when the social consensus by which hegemony legitimates its power begins to break down; style—the process through which objects are "made to mean and mean again"—furnishes the mechanism through which subcultural groups issue their challenge to the prevailing consensus. Through style, "'humble objects' can be magically appropriated, 'stolen' by subordinate groups and made to carry 'secret' meanings: meanings which express, in code, a form of resistance to the order which guarantees their continued subordination."[6]

Steampunk carries its punk legacy precisely through this heritage of creative misuse, remaking objects for something other than their original function. A term half-jokingly coined by novelist K. W. Jeter in reference to a Victorian-themed fantasy genre that seemed to be emerging in the mid-1980s, the moniker "steampunk" plays on the popularity of then also-emergent cyberpunk literature, acknowledging the new genre's unique obsession with nineteenth-century industrialism.[7] The form crosses genres, mutually fertilized by its literary and visual wings. It encompasses the visual aesthetics of Victorian and Edwardian Britain, sometimes invoking earlier Romantic or Gothic elements along the way. Its focus is the analogue technology of gears, pre-wristwatch timepieces (especially pocket watches and fobs), and the materials of early manufacturing such as brass and tweed. While its favored materials are largely of the prepetroleum industrial revolution (i.e., before plastics), these are very much of the era of mass-produced textiles and metalwork, embracing in turn other "lost" technologies; zeppelins, hot-air balloons, Edison lightbulbs, and oversized metal keys are commonly depicted. These elements are used ornamentally to transform contemporary digital consumer products such

as laptops, smartphone cases, and USB thumb drives. [Figure 4.2] Objects from other cultural worlds or time periods are similarly transformed; pets, teddy bears, wedding invitations, quill pens, Irish goddesses, Brownie box cameras, workout videos, tattoos, and even Disney princesses have all been steampunked.

Steampunk could easily be categorized as creative anachronism, though the form plays with time and place in more complex ways than this phrase captures. A more accurate categorization might be what steampunk theorist Mike Perschon terms its "retrofuturism," or "the way the present imagines the past seeing the future," and this retrofuturist lens focuses its characteristic neo-Victorian and technofantasy imaginaries.[8] Its neo-Victorianism evokes the loosely defined period between 1800 and 1914 "unencumbered by a need for rigorous historical accuracy,"[9] often (but not always) located in a London "that Americans think about when they read fantasy, and not the actual London."[10] Referring specifically to London's literary and artistic past, and relying at least as much on "Victorian and Edwardian literature as it does Victorian and Edwardian historical events," steampunk's reimagining of the nineteenth century is as often "counterfictional" as it is "counterfactual," which Perschon defines as "the difference between asking what might have happened had the computer been invented in the nineteenth century and asking what would have happened if Sherlock Holmes had had access to that computer."[11] The counterfictional basis enables steampunk's characteristic technofantasy, the "merging of magic and technology" that imbues the fantastic narrative elements of the work with a veneer of scientific plausibility and allows its creators to imagine "technology dependent on the abandonment of real-world physics."[12] These disparate characteristics are used, as Rebecca Onion has argued, "less to recreate specific technologies of this time than to re-access what they see as the affective value of the material world of the nineteenth century."[13]

As this description suggests, steampunk emerges at the intersection of a number of subcultures of the creative "left coast"—cosplay, DIY, historical anachronism, and (seemingly contradictorily) the tech world itself. The ancestral organization for its intentional anachronisms, the Society for Creative Anachronism, has similar Bay Area roots, having been founded in Berkeley, California, by Diana Paxson (a former alum of U.C. Berkeley's Medieval Studies department). But SCA and other parallel organizations conceive of themselves as "living history" organizations dedicated to the contemporary reproduction of the past, characterized by meticulous

Figure 4.2. Steampunk Aesthetics. Courtesy of Datamancer.

attention to precise historical authenticity and the preservation of lost arts such as medieval blacksmithing or musicianship.[14] In this, SCA tends to venerate and fetishize the past, seeing it as an antidote to the social ills of the current moment. In its early days, especially when it was led by women such as *Mists of Avalon* author Marion Zimmer Bradley (who coined the organization's name), the SCA embraced the medieval era for its countercultural potential; medieval worship of the Virgin Mary and its pagan antecedents became the basis for a kind of second-wave, white, feminist spiritualism, and the pre-Renaissance village became a model for pre-industrial, agrarian, collective living.

Although steampunk eschews the drive for detailed historical reproduction that characterizes SCA, the latter's countercultural sensibility and alternate world-making provides an important touchstone. The political orientation and goals of steampunk are notably heterogeneous, but the form is foundationally anchored in reorienting the counterculturalism of creative anachronistic forms toward the technologies of industrialization, rather than away from them. The first issue of *Steampunk Magazine* featured a defining manifesto by the Catastrophone Orchestra and Arts Collective that characterized it in just this way:

> Steampunk is the non-luddite critique of technology. It rejects the ultra-hip dystopia of the cyberpunks—black rain and nihilistic posturing—while simultaneously forfeiting the "noble savage" fantasy of the pre-technologicial era. It revels in the concrete reality of technology instead of the over-analytical abstractness of cybernetics. . . . steampunk machines are real, breathing, coughing, struggling and rumbling parts of the world. They are not the airy intellectual fairies of algorithmic mathematics but the hulking manifestations of muscle and mind.[15]

Channeling Maker culture's emphasis on the creation of tangible objects, the Catastrophone Orchestra's purchase on political critique hinges on a physicalizing of technology. The progressive political potential of the form lies in recuperating technology from the disembodied quality of the digital, rendering technology in corporeal terms (though one might note all the ways that digital technology *use* is actually profoundly physical—hence all the repetitive-stress injuries suffered by those who spend significant amounts of time at lap- or desktop, to say nothing of the significant physical risk involved in the manufacture of digital devices). The Catas-

trophone Orchestra's definition supports Rebecca Onion's speculation that steampunk embodies an attempt to understand the seemingly radical unknowability of the contemporary tech landscape, and that the physicality of the Victorian industrial world counters the seemingly dematerialized and intangible nature of the digital one, a characteristic it shares with Maker culture more broadly. In Onion's reading, the embodied element of steampunk soothes a kind of existential panic imbued by the retreat from the physical world that digital cultures are seen to embody, and moreover, does so in ways that enable a feeling of mastery over the vertiginous pace of technological development. In particular, steampunk enables a sense of control over "important pieces of machinery that, in the current technological landscape, would be the exclusive province of specialists."[16] Steampunk's flourishing in the world of the Makers makes particular sense in that context—it marries the crafting and technical wings of the movement both thematically and in the actual process of Making.

Within its counter-fictional evocation of Victorian arts and letters, steampunk largely explores technology through references to nineteenth-century debates over advanced industrialization, positioning the current tech world as continuous with the scientism and management drive of the Victorian era rather than as radically separated from it. In doing so, it asks whether the information age comprises a disruption of the industrial era or, rather, its logical extension. Steampunk's fiction wing is especially critical of Victorian wealth disparities and wary of its corrupted operations of power, and usually poses new technology as at the core of these problems. Steampunk authors frequently figure the computer in particular as an instrument of data collection and population management required to fuel the twin Victorian projects of empire and enterprise. The invention of early versions of the computer in the nineteenth century forms the narrative of Bruce Sterling and William Gibson's *The Difference Engine*, a celebrated early example of steampunk fiction located in an 1855 London in which the mathematician Charles Babbage has built not only his "difference engine" (a large brass calculator that he created in the 1820s) but his "analytical engine" as well (a version of the difference engine that could be algorithmically programmed to analyze vast quantities of data, which the historical Babbage constructed but was never able to operate fully).[17] Sterling and Gibson collapse these into the titular "difference engines," which have been adopted for surveillance use by a variety of shadowy government agencies throughout the industrialized world. In Britain, control of the

difference engines is used to maintain the power of an "Industrial Radical" government headed by Lord Byron, who has become prime minister by defeating an aristocracy-backed military coup by Lord Wellington. Byron's government has overcome and largely resolved the profound poverty created by Wellington's leadership (including in Ireland, where the "Rads" head off the Great Famine), but they also use their surveillance system—called "the Eye"—to suppress a working-class, antitechnology Luddite revolt that sees the Rad policies as the cause of the profound economic disparities that nevertheless bedevil England. The Eye is unintentionally imperiled by Byron's daughter Ada (who historically had argued that the analytical engines could be algorithmically programmed to manipulate systems of symbols, paving the way to using them not just as calculators but as computational systems in the modern sense).[18] Using her mathematical brilliance to aid her gambling addiction, the fictional Ada programs an algorithm that she believes will provide the perfect betting system, but in practice accidentally renders the difference engines inoperable, inadvertently destroying the Eye that she helped create in the first place. The novel's action revolves around the protagonist's attempt to escape his own interpolation into the suppression of the Luddites on the one hand, and to evade the attempts of various governments to control the punch cards containing Ada Byron's algorithm on the other. In welding algorithms to the surveillance state, Sterling and Gibson point out the forms of nationalist competition that drove nineteenth-century creativity discourses that we saw in chapter 1.

A similar critical reflection on data surveillance emerges pointedly in Eric Poulton's steampunk resetting of the *Star Wars* universe as well [Figure 4.3]. Poulton uses Babbage's and Byron's invention to reconfigure the Death Star as the "Massive Solar-Orbiting Electrically Mechanized Analytic Engine." The Analytic Engine-Death Star comprises the Galactic Empire's most formidable weapon not because it generates a laser beam powerful enough to destroy an entire planet, but because it houses a supercomputer so potent and thorough that it can control the *behavior* of an entire planet's population by collecting and analyzing data about it. Poulton's "Analytic" Death Star anticipates the same concerns at stake in Edward Snowden's revelations of the National Security Agency's collection and analysis of "metadata" or in Cambridge Analytica's pernicious subversion of the democratic electoral process in a disturbing number of countries.[19] By substituting the capacity for totalizing surveillance and

Figure 4.3. Eric Poulton's "Massive Solar-Orbiting Electrically Mechanized Analytic Engine"—the Death Star as Panoptic Surveillance. Courtesy of Eric Poulton.

panoptic control for Cold War planetary destruction, he implicitly evokes concerns over neoliberalism's emphasis on the conduct of conduct, and also reveals the often-obscured institutional ties between the military and the tech worlds, whose innovations—as described in the first chapter— have so often been directly intertwined.

In these cases, steampunk refuses the cruel optimism of the larger Maker culture of which it is a part, and where it is so popular and influential. As explored in chapter 3, Maker culture generally promises that rugged individualism can transform postindustrial malaise into a new economic Renaissance. The steampunk versions of Babbage's "analytic engine" figure this claim as little more than a con game, one with potentially devastating political results. In this, steampunk is pointedly pessimistic; nowhere does it suggest that technology has the qualities of salvation often attributed to it. If anything, its "dystopic anti-romanticism," as Mike Perschon calls

it, tells us that technology, even where it is most whimsically and comically evoked, comprises tomorrow's debris at best and the mechanism for corruption and oppression at worst.[20] In these observations, steampunk counteracts much of the language and sensibility of Maker culture.

Steampunk's critique of industrialization—especially in its proto-digital form—is sometimes construed as "humanist technological criticism," a rhetorical umbrella used in the tech and business worlds to refer to any criticism of digital or AI technologies on the grounds that they "dehumanize" actual people (though what it means to be "human" is generally left undefined).[21] When invoked, it is often broadly conflated with humanities academics and projected onto literary or arts figures, despite the absence of a humanities research thread or arts movement with this name. It seems to refer generally to an older genealogy of objections to rising technocratic tendencies in the industrialized world, for which Thomas Carlyle's 1829 jeremiad "The Machine Age" forms a putative origin point. In Carlyle's view, mechanization didn't merely displace forms of labor that had formerly been artisanal in nature; it suffused and determined every aspect of interactions that had formerly been individualized, personal, and "human": "Men are grown mechanical in head and heart, as well as in hand. Not for internal perfection, but for external combinations and arrangements for institutions, constitutions, for Mechanism of one sort or another, do they hope and struggle."[22] Mechanization was behind the increasingly complex bureaucratic organization of everything from schools to churches to philosophical societies, fundamentally altering their operations in the quest for yield and output, and rendering them rote, reflexive, and essentially moribund. The true essence of the "Mechanical Age" for Carlyle was that efficiency, and not spiritual attainment, was the goal of all human activity. However, where these criticisms are registered in tech worlds, their political critique is generally misidentified relative to vague claims of "humanness" (and we should object to the idea that Carlyle—a passionate anti-Semite, a pro-slavery advocate, and a supporter of the nascent eugenicist movement—advanced a notion of "the human" in anything other than the most profoundly racist and exclusionist ways). While steampunk does not explicitly invoke Carlyle, it does refer—often explicitly—to early-nineteenth-century debates around technology and industrialization of the kind "the Mechanical Age" forwards, which raises the question of what precisely is involved in the form's neo-Victorian focus.

Nostalgia and Yesterday's Tomorrows

Given its investment in "non-luddite technological critique," what is the value of steampunk's recursive Victorianism? Why this specific temporal form of "counter-fictional" world-making in order to advance its commentary? Steampunk's affective range—longing, horror, disdain, veneration, humor, and more—suggests a certain ambivalence toward its temporal referent, a quality that the steampunk documentary *Vintage Tomorrows* tackles directly. Early in the film, the segment "History Has Sharp Edges" effectively stages a debate on whether the form's common invocation of nineteenth-century colonialism comprises a nostalgic celebration of imperialism. Author China Miéville notes that "there is something frankly quite troublesome about the fact that what is being eulogized here—in a sometimes quite winning and very wonderful way—is an era of bestial oppression."[23] The founder of *Steampunk Magazine*, Margaret Killjoy, follows this up by recounting that when her publication put out a call looking for "pro-feminist, anti-colonial work," one respondent asked her, "How can you call yourself steampunk and be anti-colonial?"[24] Various subsequent interviewees disagree among themselves about this facet of the form, often along racially aligned points of view. A white Obtainium Works visual artist, Samuel Coniglio, defends steampunk with the claim, "There was oppression, there was bigotry, but that's a story for another time. We're reinventing history and making it fun and positive." He is intercut with *Everfair*'s Black author Nisi Shawl, who shoots back with, "That's not what I think of when I think of positive," and notes the kinds of historical denial that often characterize steampunk, particularly around racism and empire: "Most of what I saw in steampunk seemed really colonialist."[25]

Given this debate, how might we understand the retrospective attachments of the form, many of which echo those regarding the social operations of nostalgia more broadly? While some of its theorists insist that steampunk's retrospective embrace is primarily a form of nostalgia in Fredric Jameson's sense of the "desire to return to that older period and to live its strange old aesthetic artifacts through once again," this may be only one possibility.[26] Steampunk's counterculturalist, anti-institutional ethos animates a form of nostalgia closer to Svetlana Boym's model of "double exposure," in which otherwise temporally dislocated images are superimposed. In its complex set of temporal referents—present, past, and future simultaneously—steampunk creates the "historical emotion" that Boym

claims of nostalgia, in which "reflection and longing, estrangement and affection, go together."[27] In this, its nostalgic forms tilt more toward what Boym refers to as reflective nostalgias, those that "dwell on the ambivalences of human longing and belonging and do not shy away from the contradictions of modernity" and "reveal that longing and critical thinking are not opposed to one another."[28] Boym distinguishes these operations of reflective nostalgia from its restorative ones, which lean toward origins and offer "a comforting collective script for individual longing" (a form we see, for example, in Coniglio's desire to repress the colonial imperatives of Victorianism). Perschon identifies these two different nostalgic operations, noting that the retrofuturist qualities of steampunk are often deployed toward different ends. He distinguishes between "technological" and "social" retrofuturism, the latter characterized by the transformation of the original meanings of aspects of the Victorian era, particularly with respect to gender and race, but warns that the uncritical, unreflective adoption of Victorian elements can result in the reification of its worldview, producing sometimes deeply problematic manifestations of an imperialist viewpoint, racism, heterosexism, and so forth.

Steampunk sculptures, which are perhaps the form's most common examples at venues like Burning Man and Maker Faires, are particularly apt to highlight the tensions within steampunk's seeming nostalgia. Obtainium Works's *Neverwas Haul* (a miniature Victorian house mounted atop a mobile locomotive base equipped with a steamship wheel for navigation) [Figure 4.4] stages the seemingly contradictory sensibilities of Victorianism. In juxtaposing the Victorian house with the steam locomotive and steamship wheel, it exposes the incongruous energies of domesticity and stability on the one hand and of movement, dispersal, and conquest on the other. Rather than evoking a simple longing for either state, or a simplistic depiction of that era that imagines it as either eternally stable or endlessly in motion, *Neverwas Haul* instead draws attention to the way that Victorianism was animated by both in equal measure, despite the seeming paradox that this combination engendered. When these elements are merged with the colonial-themed costumes of its operators—who cosplay in pith helmets and jodhpurs—the sculpture punks or satirizes how those contradictory energies animated the British imperial project, the rapaciousness of which was justified and cloaked via conceptions of progress on the one hand and homeliness on the other, the latter with all its connotations of modesty, probity, and intimacy. Some examples of the form point

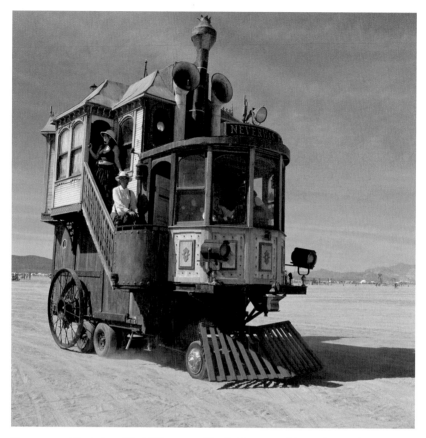

Figure 4.4. *Obtainium Works'* Neverwas Haul. *Courtesy of Samuel Coniglio.*

toward nostalgia less historically, locating that feeling less in Victorianism than in a generalized reference to childhood, one of the most common focuses of nostalgic longing. Five Ton Crane's *Steampunk Treehouse* [Figure 4.5], for example, simultaneously establishes and punctures the illusions of childhood itself. The treehouse—perhaps the ultimate space of childhood regression—comprises a retreat that merges nature and cultivation, safety and adventure, home and escape. In depicting this alternate space of the domestic realm, the steampunk sculpture also reimagines these regressive sensibilities as overtaken by the industrial, with metal-scaffolding tree limbs that resemble shipyard cranes or oil derricks.

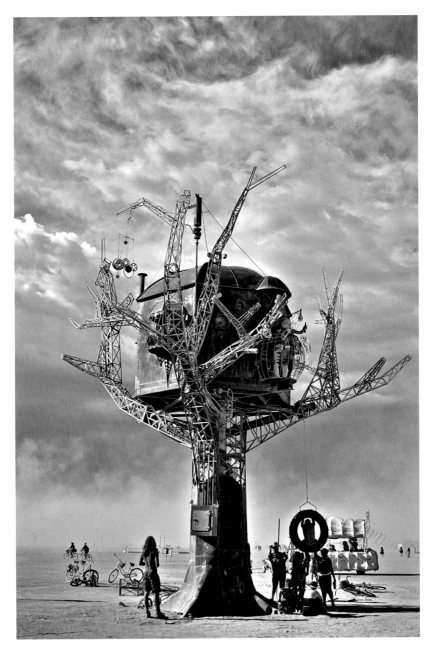

Figure 4.5. *Five Ton Crane's* Steampunk Treehouse. *Courtesy of David Schnack.*

Istvan Csicsery-Ronay Jr. confirms Boym's observation on the critical potential of nostalgia when he posits that the historical matrix of steampunk comprises "the imaginatively possible, a dialectical mesh of fantasies of the Victorians' social, political, and cultural institutions, as both the Victorians themselves and the fin de millennium US might imagine them."[29] The form's split temporality—a fantasy about the past and the future simultaneously—is precisely what distinguishes it from other subcultures that involve historical reenactment or anachronism. As Tinplate Studios artist Anthony Hicks puts it in *Vintage Tomorrows*, "I'm not a Victorian re-creationist, I am a steampunk, I think that the nineteenth century was bollocks."[30] The form's retrofuturist characteristic often imbues steampunk's nostalgia with warning, rendering it a critical interpretation of the Victorian era loosely defined, particularly with respect to its imagining of the technologies of advanced industrialism.[31] As *The Difference Engine* coauthor Bruce Sterling argues, "We were trying to use the cultural density of the past to make it clear to contemporary people what the stakes were of an industrial *revolution*."[32] To that end, perhaps one of the most important possibilities that steampunk offers is to imaginatively navigate the vertiginous shifts of the contemporary tech world precisely through a fictionalized industrial past, thereby providing a model of how to deal with technological disruption more broadly. Boym sees nostalgia as a response to periods of acceleration and fragmentation, which tend to create "an affective yearning for a community with a collective memory, a longing for continuity in a fragmented world."[33] It is a commonplace—but bears repeating here—that the Victorian era was wildly destabilizing technologically, economically, and socially. Although it may be casually associated with the quaint and bucolic, the nineteenth century was characterized by the pulls of urbanization and its destruction of previous lifeways and social networks, by increasing social tensions around political enfranchisement, by extraordinary technological advances in communications and transportation, and by the transformation of energy forms, geopolitical alliances, and global migration patterns. It was a century marked by shifts at least as transformative as those of the twentieth, and equaled those augured for the twenty-first. When the nineteenth century began it was ordered by the global economy of the slave trade, and it ended with its abolition. It began powered by wood and steam and ended with electricity, began with letter writing and ended with the telephone, began with the ascent of the British Empire and ended with the launch of "the American Century." Steampunk

captures these shifts affectively, articulating their radical and destructive potential, in effect doubling them with those of the current era.

Libertarianism and the Theaters of Rugged Consumerism

Ought we to be surprised that the very people most committed to "moving fast and breaking things" (to paraphrase Facebook's original corporate slogan) seem also to possess a contradictory longing for a past undergoing its own shifting technological and social terrain? Given Boym's observations on nostalgia, it seems almost inevitable that the central players of industrial disruption would be obsessed with the very world they're tearing down. But are the purveyors and consumers of steampunk actually simulating the very world they so gleefully (and often intentionally) disrupt? In Scott Magelssen's formulation, simulating (or "simming") is the creation of a "simulated, immersive, performative environment . . . in which participants play . . . out a scripted or improvised narrative in order to gain or produce understandings of a situation and its context."[34] Steampunk similarly "educates, persuades, indoctrinates, or transforms participants by exposing them to history, culture, or a looming time to come." In contrast to the examples of simming that Magelssen analyzes (of the US invasion of Grenada at the Ronald Reagan Presidential Library, for example, or of slave escapes of the 1850s), steampunk practitioners operate within what Richard Schechner identifies as the subjunctive mode in their work, stepping into an explicitly speculative world: as if the technologies of petroleum power had never been invented, as if the sartorial codes of the twentieth century hadn't replaced those of the top hat, frock coat, and corset, as if we were still able to know about our world only via the technologies of the immediately visible (prior to microscopic or long-distance viewing capabilities).

Perhaps the steampunk form that most clearly illustrates this "subjunctive simming" quality is that of kinetic sculptures. *Neverwas Haul*, the famed *El Pulpo Mecanico* (a two-story metal octopus with independently mobile limbs that shoots fire from the top of its head) [Figure 4.6], and the *Desert Nautilus* (a desert travel-car that combines Jules Verne's famous underwater explorer with Jabba the Hutt's luxury barge) all stand out as iconic, imposing examples of kinetic steampunk sculptures from the form's emergence at Burning Man and Maker Faires in the first decade of the twenty-first century.

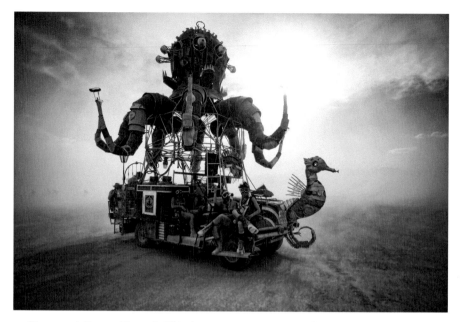

Figure 4.6. Duane Flatmo's *El Pulpo Mecanico*. Courtesy of Duane Flatmo.

The mobility of these sculptures is a major element of their appeal; part of their wonder lies in the ways they seem like animate versions of the explorations of earlier arts movements such as the Futurists. If artists like Umberto Boccioni [Figure 4.7] could only suggest movement for otherwise static objects, the steampunk sculptors of Burning Man endow their works with kinetic capacity (though admittedly, not with the kinds of velocity the Futurists had dreamed of—F. T. Marinetti would likely be disappointed to discover that the drivers of *Neverwas Haul* find that if they're moving at a screaming seven miles per hour, they're going too fast).[35] Marinetti's compadre Luigi Russolo, who penned the manifesto "The Art of Noise" and created whole orchestras of "intonarumori" or "noise machines," would be delighted to discover that the creator of *El Pulpo Mecanico* likens operating the sculpture to playing an instrument, as the movement of the creature's limbs produces a percussive effect that can be manipulated rhythmically, and is often performed to accompany a soundtrack amplified through the sculpture's embedded speaker system.

While the artists behind steampunk would likely shun their predecessors' explicit and intentional embrace of fascism, they share the earlier

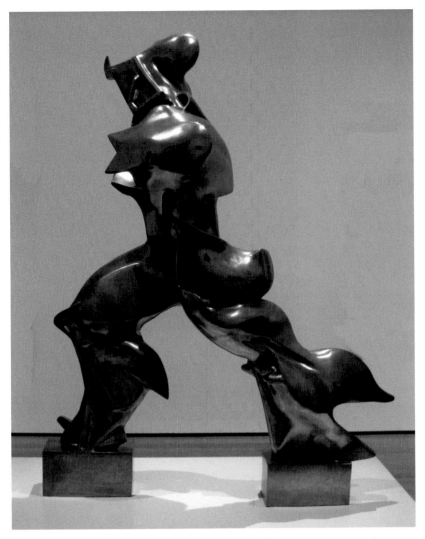

Figure 4.7. Umberto Bocconi, *Unique Continuity of Forms in Space*, 1913. Courtesy of Wikimedia Commons.

movement's obsession with industrial manufacture and their exploration of the sensuality of mechanization, and would almost certainly agree with Marinetti's argument that the automobile can be as beautiful as Greek statuary.[36] Given this, is the future of the Futurists the same as the retrofuturism of steampunk? The Futurists quite gleefully embraced the same forms of creative destruction instantiated in Facebook's motto "Move Fast and

Break Things," so is the only difference one of tone, in which the Futurist future comprises an endless horizon of heroic speed and destructive possibility, but the steampunk future questions this optimism?

Two elements of steampunk Making reveal how it might be more politically akin to Futurism than its artists might like. Its antirational bricolage and its use of DIY upcycling comprise the core construction methods of steampunk style, which help forward its technological critique and also produce specific subjectivities. The visual environments of these sculptures produce a kind of antirational whimsy; they feature gears and gauges and navigation instruments that couldn't possibly perform their apparent purposes. One of the central pleasures of steampunk works is the way they confound immediate visual expectations, partly by undermining the modernist imperative that form follow function. The periscope on *Desert Nautilus*, for example, does not help the viewer see above water (which in any case doesn't exist on the Burning Man desert where it first appeared), but it does come equipped with night-vision sensors that allow the viewer to see across the mostly unlit Black Rock Playa after dark. Outsize watch fob stems on *Neverwas Haul* open portal windows between the interior spaces of the "house," and its odd collection of doorways creates an architectural mishmash that bring to mind the chaos of a second-hand bookstore. *Steampunk Treehouse* features what appear to be brass navigation instruments on a sculpture that does not move, but that on closer inspection couldn't actually be used for any purpose other than decoration. The entrance of the *Treehouse* is via a naval ship's door, steampunked by virtue of the requisite brass gears and a copper patina–like effect. Within their characteristic ornamentalism, these sculptures counteract the hyperminimalism that is generally the tech world's most common visual system. The clean lines and cold tints of, say, an Apple retail store are counterweighted with warm colors and whimsical adornment. Some steampunk artists even claim an explicit rejection of what they call the "tyranny of modernism."[37] As Shannon O'Hare, for example, expounds, "Jet planes are all sleek and simple, whereas the flying machines could have X number of wings, and could have propellers in the front or in the back, who cares, and then zeppelins, you could have wings on them, you could have motors, you could have rockets, you could have all sorts of things, so it was like you were freer."[38]

As O'Hare emphasizes, steampunk's capriciousness is attractive partly because the artist is not bound by the limitations of physics and aerodynamics. Or to put this more precisely, steampunk's signature retrofuturist

design is attractive because within its fictive universe those limits either haven't yet been fully discovered, or because even where they were suspected, the people of that alternate world were still attempting to defeat them in ways that we now know to be not just fanciful, but downright useless. In this, steampunk is the perverse fêting of *failed* technologies, a celebration of the discarded.

Given this fascination, it is fitting that the fanciful bricolage of these sculptures is nearly always created via the upcycling ethos of the contemporary DIY culturescape. Upcycling—often referred to as "creative reuse" by its advocates—is the construction of new material objects out of discarded ones, usually for purposes other than their original ones. A term coined by German interior designer Reiner Pilz in the 1990s, it typically differs from *re*cycling in using discarded objects in novel contexts or in combinations that produce (at least according to their creators) objects of greater value than that of their constitutive parts.[39] On this basis, upcycling is very much a construction technique of creative cultures of the last two decades, and forms a central practice of Maker culture in particular; upcycling links steampunk to Maker culture, providing an iconic visual style for its system of practice. Frequently, the base material for steampunk sculptures is discarded, scavenged, or donated material that is reused to create a new object. *El Pulpo Mecanico*, for example, was assembled almost entirely from pieces salvaged from the scrap yard in the artists' hometown of Arcata, California (just south of the Oregon border), and uses for its base a van formerly used by the Humboldt County Community Access and Resource Center.[40] The sculpture's size was scaled to fifty-five-gallon oil drums used as the base for its limbs, and the eyes were constructed of scrap metal and spare tubing. Unquestionably, this is art intentionally and conspicuously made of the detritus of the postindustrial world, a world of excess production, and steampunk's retrofuturist sensibility emerges in these works partly through the use of formerly discarded objects that are made into the aesthetic wonders of the next generation. The artists behind these sculptures do not in any way attempt to conceal the salvaged nature of most of their materials—if anything, the scavenger element of the sculptures is highlighted in their construction. In the steampunk documentary *Vintage Tomorrows*, artist Anthony Hicks of Tinplate Studios notes that "you're not just going out and buying a pre-made something or other, you're creating your own reality out of these bits and bobs, out of our consumer culture."[41] While harkening back to the "found objects" of Dada or

the boxed assemblages of Joseph Cornell, the upcycling typical of steampunk is distinctive for its explicit desire to found a different relationship to consumer culture and environmental degradation.

Steampunk's upcycling also forms the arena in which its countercultural ethos potentially falters. While DIY cultures, of which steampunk's upcycling comprises an important strand, often define themselves as fundamentally anticonsumerist, they may simultaneously operate in ways that produce libertarian subjects. Raymond Malewitz categorizes DIY subcultures as a form of "rugged consumerism," which he sees as the "quintessential activity" of libertarianism in the US. In his assessment, in contemporary US culture, "the only readily available platform for collective action is a network of consumer behaviors." DIY adherents reimagine consumption "as an idiosyncratic, productive, and critical enterprise" in which they use cast-off objects in ways unintended or contrary to their standard use—a paradigmatic feature of steampunk sculpture. In this, DIY cultures appear to function—and certainly define their operations—as a species of Michel de Certeau's "tactical consumption"; they perform behaviors "appropriated by users from some preestablished system for a series of . . . singular creative purposes."[42] Malewitz argues that despite these intentions, DIY cultures actually form "theaters of rugged consumerism" that yoke the act of consumption into a kind of libertarian frontierism. DIY transforms the self into a "mediating figure between mythic models of productive self-sufficiency conceived during the country's older frontier history and the modern interdependent realities that characterize the country's transition to a neoliberal globalized economy. . . . In their desire to mythically . . . respond to the catastrophic economic, social, and environmental effects of American consumer culture, rugged consumers simultaneously embody and critique that culture."[43]

The sense of frontierism that Malewitz describes as a central characteristic of DIY cultures is often literalized in steampunk projects. Shannon O'Hare created an entire discovery narrative and mise-en-scène for the debut of *Neverwas Haul* at Burning Man, wherein the collective dressed as Victorian explorers (replete with pith helmets) who happened to stumble on the "savages" of the Black Rock Playa, whom they commenced to research like anthropologists.[44] While pith helmets and jodhpurs are a common feature of British-themed steampunk cosplay, fringed buckskin jackets and brass-cogged Bowie knives form visual icons for a significant substream of the genre associated with the American West, where they

become linked to the steam locomotives that played a crucial role in frontier settlement. The annual "Steamcon" convention themed its 2010 meeting "The Weird, Weird West"; Joe Landsdale's comic book series *Zeppelins West* featured the urine-preserved head of Buffalo Bill crossing the Pacific Ocean via steampunk's iconic airship to perform his Wild West show for a Japanese shogun; Cherie Priest's 2010 novel *Dreadnought* was named after a steam locomotive that carries its heroine from Civil War–torn Virginia to a frontier Seattle.

In its simplest sense, libertarianism encompasses a belief in self-sufficiency (that all individuals are responsible for their own welfare and are compelled to create and protect it for themselves), and an objection to state interventions in individual behaviors or activities. The very name, "Do it Yourself," pushes the idea of self-sufficiency (perhaps even as a survival mechanism), and phrases that sensibility as an imperative, suggesting a compulsory force. But DIY also assumes, as libertarianism so frequently does, that the capacity to "do" lies primarily in the individual, ignoring the infrastructural support required to obtain, for example, skills and materials, and even the very time or space required for its various activities. In this, DIY celebrates individual capacity and even makes it compulsory, while eliding, devaluing, and even denigrating interpersonal dependence and connection. It is, as Malewitz suggests, essentially a rugged-individualist framework with a fairly naked sense of bootstraps meritocracy whose locus has settled in the hobbyist realm. Given the focus on individualism within creativity discourses explored in chapter 1, it seems unsurprising that DIY has become a primary technique of "creative cultures" movements like the Makers. In this celebration of and even insistence on individualism, DIY operates as a mechanism for subject-making, one with strong affective currents. It makes the practitioner *feel* accomplished, independent, capable, even autarchic, and enables the practitioner to define themselves as such in turn, regardless of whether their activities have been accomplished within entirely individual circumstances (which they generally are not).

The affective structures of naming and doing hone very specific subjects in the process. For practitioners, steampunk enacts what Margaret Werry calls "biopoetical performance," a form of cultural activity that "imaginatively invest[s] the subject in forms of conduct that are viscerally embodied, expressive, creative, improvisatory, and even eroticized."[45] In this, steampunk exemplifies Jacques Rancière's definition of performance as "a certain way of doing which expresses a certain way of being. It is a

specific relation between a way of moving and a regime of meaning within which that movement can be identified."[46] In the case of steampunk, these performances are largely carried out through a very specific style. If DIY constitutes an essentially libertarian practice, steampunk offers an aesthetic for this ideology, providing a pleasurable visual form and even a structure of feeling for its parameters.[47]

Archeologists of the Present

Given steampunk's frequent focus on scientific discovery, even when in its frontierist guise, it provides a direct structure of identification for those in the STEM-based tech world. The combination of the quixotically technological with the visual whimsy and wonder of its fantasy and bricolage often seems like a veneration of technology, even when it is critical of technology's potential complicity in systems of domination or its legacies of environmental and human damage. This conflicted sentiment appears in Cory Doctorow's introduction to the twentieth-anniversary reprint of *The Difference Engine*, in which he muses on the popularity of the form among tech workers. Doctorow (cofounder and editor of the tech website *Boing Boing*, which enthusiastically promoted steampunk in its mid-naughts emergence), argues that the motto of *Steampunk Magazine*, "Love the machine, hate the factory," could be seen as that of the tech world more generally:

> At its root, steampunk venerates the artisan, celebrates the abundance of technology, and still damns the factory that destroyed the former's livelihood to create the latter. Contemporary steampunk subculture inhabits a contrafactual world in which these contradictions are resolved . . . where makers can produce wonderments that simultaneously embody light-speed technological change and enduring artisanship.[48]

Doctorow's comment here echoes quite precisely the language of Maker culture, celebrating the extent to which Maker how-to networks and advances like 3D printing are on their way to enabling this particular utopia, putting "artisanal, bespoke high-tech practice in reach of everyone who loves the machine and hates the factory and wishes you could have one without the other."[49] In this facet of its tech-positive worldview, steampunk supports and extends the kind of techno-bohemian self-mythology

and identity explored at the end of chapter 1. Steampunk enables this self-mythologizing by allowing its viewers to differentiate themselves from a generalized public first through the possession of a historical imagination, and second via a sense of the still-extant possibilities of technology itself, evidenced by the potential to reimagine the capability of old technologies that would otherwise be understood as moribund, redundant, dead, or played out.

One could note in Doctorow's introduction the dynamics of wish fulfillment that are sometimes active in steampunk, namely that technology could somehow exist without industrialism's negative consequences (environmental degradation, labor discipline, or even its systems of management that stultify individuality and the creative operations of the self in the first place). This particular brand of denial is itself one of the most profoundly damaging elements of Silicon Valley's self-mythology, where somehow its workers manage to believe that their world is a postindustrial one, unsullied by the labor and environmental catastrophes of nineteenth-century industrialism, despite ample evidence to the contrary. The profound labor exploitation involved in device manufacture, the significant toxicity of e-waste to both people and the environment more generally, and the vast amounts of energy used by digital devices themselves and the servers needed to process data all stand in sharp contrast to the sense that digital technologies are postindustrial in their creation and use.

One of the heavily challenged facets of Dick Hebdige's account of subculture was his claim that as subcultures become more popular in the larger culture they once resisted, the political challenge of their work is blunted. Scholars interested in subcultural operations have since answered criticisms of this assumption by looking at how a given subculture might in fact have held conservative tendencies or beliefs all along, which simply subsumed more progressive elements over time (a dynamic Fred Turner notes is true of the tech world itself).[50] If Malewitz's analysis of the libertarian subject-making of DIY cultures is correct, then steampunk's own methods of making contain the seeds of its own political blunting. Steampunk enables its participant-spectators to claim the countercultural subversion of the form even if they personally possess some form of institutionalized power; in other words, steampunk allows its spectators to perform or associate with something that feels like subversion regardless of their personal structural relation to modes of power. The form's potential critique of technology supports the conceptual identification of its enthusiasts with

an "outsider" status, even though many of them belong to a cultural group that is increasingly economically and politically dominant, and anything *but* "sub." This ethos precisely mirrors the brand of counterculturalism that animates the tech world itself, which despite its self-mythology isn't in fact countercultural at all, but at this point comprises and produces "the culture" itself. The question, then, is what does it mean that a group of people so economically dominant and increasingly politically powerful use steampunk as way to identify themselves as outsiders?

Steampunk provides an arena for workers in the tech world to take pleasure in the creative reuse strategies of DIY through a visual form that quixotically celebrates technology's inevitable obsolescence. Fredric Jameson reminds us that this dynamic is less one of "accustoming their readers [or viewers] to rapid innovation, of preparing our consciousness and our habits for the otherwise demoralizing impact of change itself," than of "defamiliariz[ing] and restructur[ing] our experience of our own present."[51] In this, steampunk draws on science fiction's capacity to, as Jameson put it, "apprehend the present as history," or to see our present as already past.[52] Steampunk provides less a place where older social memories and practices are repeatedly played out even through contemporary substitution, and more a kind of self-reflexive rehearsal for pastness, obsolescence, loss, and destruction.[53] In its preoccupations with the futures of the past, steampunk carries on science fiction's "deepest vocation . . . to demonstrate and to dramatize our incapacity to imagine the future, to body forth, through apparently full representations which prove on closer inspection to be structurally and constitutively impoverished, the atrophy in our time of . . . *the utopian imagination*."[54] Pointedly, steampunk reverses the affective resonances of this rehearsal—steampunk practitioners frame their inevitable obsolescence not through grief but celebration, particularly in its sense of self-sufficiency.

As we saw in the last chapter, Maker culture—of which steampunk forms a major aesthetic thread—venerates self-sufficiency by casting it as not merely a mechanism of agency, but as a form of self-*fulfillment*, as one of the most foremost mechanisms of identifying, defining, and producing a sense of self. What precisely is the role of self-fulfillment in creativity discourses, and what are the perils of this association? The next chapter turns to one of the foremost cultural narratives on the role of self-fulfillment in creativity discourses, particularly relative to the relationship between the arts and the sciences. As we will see, Mary Shelley's *Frankenstein* and the

ream of adaptations that have been produced at its bicentennial explore self-fulfillment as one of the primary features that unite the arts and sciences—domains of cultural activity commonly understood to have split off from one another at around the time of Shelley's novel. But they also warn that self-fulfillment, maybe especially in its capacity for self-making, carries the potential for delusional and even catastrophic destruction.

5

Creativity's Monsters

Frankenstein, *Self-fulfillment, and Art/Tech Interface*

The Frankenstein myth is in every artist's DNA, it's the
myth of creation.

—Jim Sharman, director, *The Rocky Horror Picture Show*[1]

Mary Shelley's novel *Frankenstein* has been understood in many ways:
as a cautionary tale about unbridled scientific hubris; a form of proto-
ecocriticism; a recognition of the monstrous within the most rational of
souls; and a feminist critique of men's reproductive envy. It also comprises
an early, skeptical account of the creative society, exploring the idealization
of creative fervor and its manifestations in individualism. Shelley's medita-
tion on the ultimate creative act—the creation of life—forms the basis for
nearly all science-fiction explorations of genetic engineering and artificial
intelligence, emerging in works as varied as Margaret Atwood's *Oryx and
Crake* or the feminist-revenge, AI-fantasy film *Ex Machina*. As *Rocky Hor-
ror Picture Show* director Jim Sharman points out, *Frankenstein* forms the
foundational DNA for cultural narratives of creation for artists as well. But
the novel and its various narrative offshoots raise questions about how we
think about creativity, and not usually in celebratory ways.

At its 200th anniversary, *Frankenstein* had far greater cultural saturation
than it did at its 1818 debut. In the run-up to its bicentennial, the novel
spawned a mini-industry of adaptations, including a cluster of annotated
critical editions, the famed 2011 National Theatre production directed by

Danny Boyle, a stage/screen hybrid by Manual Cinema, a spate of graphic novelizations, at least two operas, a musical in Korean, a ballet, several film versions, and the multiseason crime drama *The Frankenstein Chronicles*. The sheer volume of contemporary adaptations suggests not just a desire for bicentennial celebration (though this is certainly a feature of some of these productions), but a response to the cultural heat around Shelley's critical exploration of creativity in its contemporary cultural, technological, and political registers.

Following the thematic observations of their source material, many of these adaptations repudiate the "residual Romanticism" that detractors have claimed are at the heart of contemporary creativity discourses.[2] Insofar as Romanticism was propelled by an idealization of cognitive intensity, located in what was increasingly referred to as work of the "creative faculty" or the "creative imagination," *Frankenstein* is a surprisingly *anti*-Romantic text. As Harriet Hustis has argued, Shelley's novel provides an important critique of creativity discourses in their early nineteenth-century iteration, and the contemporary adaptations highlight what Hustis describes as the novel's plea for "responsible creativity."[3] Shelley's warning is most commonly seen as a critique of the sciences, but her admonishments on this front are by no means limited to that domain.

This chapter explores a range of *Frankenstein*s, from critical editions to a pair of stage adaptations to a novelized speculative reboot. These works illuminate two key features of Shelley's scrutiny of ideas about creativity that have been especially powerful in her era and our own: first, as the bridge between the arts and the sciences (arenas typically understood to have become increasingly antithetical at the time of her writing), and second, as the definitive form of self-expression and self-making. These adaptations stress Shelley's demythologizing of creative intensity, casting it not as the engine of heroic discovery and innovative fervor, but as a horrifying mechanism for destructive chaos. While the theme that our creations will destroy us if they are not tended carefully and even lovingly is central to the adaptations of the last decade, it is far from the only commentary on the "creative fever" that grips Victor. Instead, these adaptations raise questions of creative responsibility in a broad sense, and not just for scientific responsibility more narrowly. They follow Shelley in undermining the arts/sciences dichotomy by linking these two arenas via concepts of creative self-expression, highlighting her critique of the latter as the idealized form of self-making.

Bridging "The Two Cultures"

Several new critical editions of Shelley's novel have been published in the last decade that explicitly pose *Frankenstein* as a cautionary tale not just about science, but about scientific *creativity*.[4] The 2017 version by MIT Press stresses this point, as the editors (David H. Guston, Ed Finn, and Jason Scott Robert) specifically frame their edition as an attempt to use Shelly's novel to "ignite new conversations about creativity and responsibility among science and technology researchers, students, and the public."[5] As this quote suggests, the editors—all three of them directors of research centers on STEM-related innovation at Arizona State University (ASU)—stress Shelly's novel as a warning against creativity without ethical constraint:

> Although *Frankenstein* is infused with the exhilaration of seemingly unbounded human creativity, it also prompts serious reflection about our individual and collective responsibility for nurturing the products of our creativity and imposing constraints on our capacities to change the world around us . . . our version emphasizes broader questions of the relationship between scientific creativity and responsibility.[6]

In addition to a richly annotated version of Shelley's original 1818 text (most of the commentary intentionally geared toward students in STEM fields), the edition includes a series of short essays that explore the novel's various cautionary threads. Some of these convey fairly typical observations of Victor's hubris and ego. Science fiction author Elizabeth Bear, for example, notes in her essay "The Trouble with Prometheus" that Victor's misstep isn't in excessive scientific zeal, but a fundamental narcissism that reduces the research project itself to ego gratification, a charge to which we will return.[7] Other essays highlight the problems posed by the unforeseen possibilities of new technologies. Cory Doctorow, in the delightfully named "I've Created a Monster! (And So Can You)," describes the parallels between Facebook and Stasi surveillance, making the point that the technologies created by scientists aren't necessarily destructive on their own, but in their unintended, accidental uses: "The world's adjacent possibles will enable you to dream up many technologies throughout your life. But what you do with them can take away other people's possibilities"[8] (though Doctorow, in keeping with the Enlightenment and Cold War emphasis

on individualism as socially and politically paramount, limits the ethical pitfalls of technological advance to those that undermine individual sovereignty).

Cementing these observations, a number of STEM-focused universities (including MIT, Arizona State, and Stanford) held bicentennial symposia on the novel, but these tended to focus exclusively on the implications of the novel for scientists.[9] These cultural events miss how Shelley's novel—and other cultural spinoffs of the last decade—respond to the ethical problems posed by creativity discourses more broadly, of which the "sciences," in the narrow way we construe that term now, form only one strand. Shelley's novel and several of the adaptations of the last decade, however, implicitly ask whether the arts may be uncomfortably close to the sciences in their rush to idealize the same creative fever that compels Victor to unleash disaster on those closest to him.

A commonplace of current creativity discourses is the desire to abandon the idea of the arts and sciences as fundamentally distinct and even divergent arenas of activity. C. P. Snow's infamous 1959 observation on the "two cultures"—that the intellectual world of Europe and North America had separated into antithetical realms divided into literary "natural luddite" intellectuals and public service–oriented scientists—has been supplanted by a desire to see the two worlds united by a common dedication to creative self-expression.[10] Writing in the late 1990s, Stephen Jay Gould advocated that the sciences and the humanities (in which he included music, the visual arts, and literary practice as well as their academic study) should be understood as overlapping "magisteria" that coevolved rather than developed antithetically.[11] Gould acknowledged that while their forms of *techné* ground them in different systems of logic, the two arenas are nevertheless grounded in a mutual cultivation of creativity and united by the experience of "flow": "The commonalities of creative thinking, and the psychology of mental drive and excitement, seem to transcend the logical differences of subject or approach."[12] This kind of claim—that cognitive intensity links the work of the artist and scientist—subtends those of creativity-driven subcultures like the Makers of chapter 3, for which the 3D printer and the Elizabethan sonnet are likened by their capacity for self-expression.[13]

Frankenstein emerged in a period commonly identified as the origin of the "two cultures" mythos. This line of historiographic reasoning typically understands the eighteenth-century rise of empiricism as producing

a schism that established the two areas as separate domains of activity with distinctive definitions of truth. Prior to this, this thinking goes, the terms "science" and "art" had been used interchangeably to denote a general body of knowledge, such that the "liberal arts" of grammar, painting, choreography, and so forth were often referred to as "general sciences," and were categorized with other knowledge forms such as physics and astronomy.[14] By the early nineteenth century the arenas of science and art were split into separate spheres by the idea that the natural world, the world of politics and society, and the emotions and inner life required different systems of analysis—a split that Jürgen Habermas later identified as the philosophical foundation of modernity more generally.[15]

While there were unquestionable divisions between the empiricist drives of the Enlightenment and the Romantic response to it, this set of historical assumptions presupposes the scientific revolution as attached exclusively to the Enlightenment, and ignores the ways that the Romantics (the implied progenitors of Snow's "natural luddites") themselves frequently attempted to forge parallels between the two realms of activity. Several of Mary Shelley's most influential fellow travelers saw the arts and sciences as comprised of interdependent, mutually constitutive modes of knowing, with one unthinkable without the other, and not as increasingly polarized truth claims. The Romantics did indeed see art and science as disparate realms, but considered them to be ones that worked alongside one another rather than divergently, and as conjoined in some fundamental ways. Amanda Jo Goldstein makes precisely this point in *Sweet Science*, noting that while the Romantics unquestionably engaged in anti-empiricist taunting (in, for example, William Blake's not-infrequent jabs at the "Cerberus" of Locke, Bacon, and Newton), she also points out their own "experiments in the cooperation of scientific and poetic knowing—at a moment when natural science was turning, thrillingly, toward the problem of biological life."[16]

Along these lines, some of the most famous Romantic treatises on the nature of poetry explicitly bind the work of the scientist to that of the artist, most notably in the pleasure of discovery as the link between the two realms. In his "Preface to Lyrical Ballads" (the 1802 treatise on poetry widely regarded as an opening manifesto for Romanticism), William Wordsworth argued that poetry and science shared a common necessary focus on the sensations—emotional and otherwise—produced in the act of observation and understanding:

We have no knowledge, that is, no general principles drawn from the contemplation of particular facts, but what has been built up by pleasure, and exists in us by pleasure alone. The Man of Science, the Chemist and Mathematician, whatever difficulties and disgusts they may have had to struggle with, know and feel this. However painful may be the objects with which the Anatomist's knowledge is connected, he feels that his knowledge is pleasure; and where he has no pleasure he has no knowledge. What then does the Poet? He considers man and the objects that surround him as acting and re-acting upon each other, so as to produce an infinite complexity of pain and pleasure; . . . he considers him as looking upon this complex scene of ideas and sensations, and finding every where objects that immediately excite in him sympathies which, from the necessities of his nature, are accompanied by an overbalance of enjoyment.[17]

As they would be later for Gould and Gershenfeld, the poet and the scientist were linked for Wordsworth in the profound pleasures of cognitive intensity, without which knowledge of any kind was impossible. The poet was like the chemist or mathematician in the intense absorption of apperception.

For Wordsworth, the primary distinctions between science and art were along social lines; whereas the pleasures of science were solitary, and even solipsistic, poetry offered a fundamental mechanism of *communitas*: "The Man of Science seeks truth as a remote and unknown benefactor; he cherishes and loves it in his solitude: the Poet, singing a song in which all human beings join with him, rejoices in the presence of truth as our visible friend and hourly companion."[18] While Wordsworth would go on to make his celebrated claim that "poetry is the first and last of all knowledge," he would also—in the next sentence—position the work of art and science as forms of labor that could feed and build on one another:

If the labours of men of Science should ever create any material revolution, direct or indirect, in our condition, and in the impressions which we habitually receive, the Poet will sleep then no more than at present, but he will be ready to follow the steps of the man of Science, not only in those general indirect effects, but he will be at his side, carrying sensation into the midst of the objects of the Science itself. The remot-

est discoveries of the Chemist, the Botanist, or Mineralogist, will be as proper objects of the Poet's art as any upon which it can be employed.[19]

The objects of scientific inquiry form the ideal material for poetic exploration, which then aids the scientist by infusing these objects with "sensation"—that necessary condition for observation.

In his conception of the bridge between art and science, Wordsworth echoes rather crucial changes in the definition of "the creative faculty" that occurred around this time, changes that bear on the claims to art and science as divergent arenas. Romanticism absorbed and rechanneled some central ideas about creativity that had emerged as part of empiricism. As traced in chapter 1, conceptions of creativity were central to changes in Enlightenment ideas about cognition. Early empiricists working in the seventeenth century had seen creativity as the key faculty by which thought could operate not just as passive reception (as it had been conceived in the early modern period), but as "an active force in the execution of invention and production"; hence Thomas Hobbes's insistence that the creative imagination "produces new pictures and ideas, it fashions new experiences; it adorns and creates; it is the force behind art."[20] The Romantics elevated creativity from a mere driver of innovation to the apotheosis of reason, or as Wordsworth phrased it, "reason in her most exalted mood."[21]

This shift in concepts of the "creative imagination" had been more or less fully absorbed by the time Mary Shelley wrote *Frankenstein*, a fact reflected in her husband's famous "Defense of Poetry" (begun the year after her novel was published). Written as a response to his friend Thomas Love Peacock's satirical essay "The Four Ages of Poetry" (which mocked claims that poetry comprised an immature form of inquiry best abandoned in favor of science and mathematics), Percy Shelley's essay is a prime example of claims that the arts constitute the paramount expression of the "creative faculty" (the kind of claim that contemporary creativity researchers such as Mark Runco have energetically repudiated for the past thirty years). However, he vindicated "poetry" not only in the sense of the literary form, but as "ποιειν" (*poiein*), or "making."[22] *Poiein* for Percy denoted the larger sense of the imagination, the agential capacity to bring inchoate perceptions into relation with one another to produce new ways of looking at the world. It "awakens and enlarges the mind itself by rendering it the receptacle of a thousand unapprehended combinations of thought," making the imagination "the store-house of axioms common to all knowledge." *Poiein*

instantiated the most advanced operations of cognition (as it would also do, much later, for the Maker movement, as we saw in chapter 3), but in ways that encapsulated the sciences as well, rendering them an offshoot of the same process: "Poetry . . . is at once the center and circumference of knowledge; it is that which comprehends all science, and that to which all science must be referred. It is at the same time the rot and blossom of all other systems of thought; it is that from which all spring, and that which, if blighted, denies the fruit and the seed, and withholds from the barren world the nourishment and the succession of the scions of the tree of life."[23]

Anticipating the arguments of Percy's defense, Mary Shelley implied the united (though not unified) nature of the arts and sciences in the subtitle of her novel, *The Modern Prometheus*. Although Shelley's invocation of the Greek myth has typically been understood as a commentary on the sciences, from the time of its origin Prometheus was understood as the grantor of the totality of human knowledge. Mathematics, medicine, and engineering were all included in the "arts" that Prometheus endowed to humanity, particularly in tragic renderings of the figure.[24] In the twenty-first century, Prometheus is still symbolically invoked as the link between arts and sciences; in an argument common in creativity discourses, philosopher Barry Allen invokes the mythical figure in his essay "Prometheus and the Muses" on the fundamental similarities between the arts and the sciences:

> The invention of a seriously new alternative is an aesthetic moment in art and technology alike. No design is ever determined by calculations or technical necessity. Choice pervades technological design and is made, ultimately, on the basis of aesthetic invention (supplemented, of course, by careful testing). Engineering design is the analytical and imaginative synthesis of perception and technique, which is also the ideal, the point, the idea of art. There is art in good engineering and good engineering in art. To stand up and last, an artwork has to be no less well put together than a bridge.[25]

Two of the bicentennial adaptations in particular have highlighted the bridging of the arts and the sciences that the Prometheus myth originally encompassed. Through a variety of theatrical conventions, Manual Cinema's 2018 *Frankenstein* [Figure 5.1] comprises a direct, metatheatrical com-

mentary on the relationship between the realms of art and science. The company is named for its goal "to create something that looks like cinema, that looks like a movie, by hand, in front of you, using handmade materials."[26] In keeping with this, Manual Cinema's adaptation uses the aesthetics and ethos of the Maker movement, employing out-of-date, pre-digital projection systems such as overhead projectors and shadow puppetry to create a kind of "poor" multimedia theater.[27] The organization stresses a kind of "craftliness," the kind of idealization of the handmade and artisanal of the Maker world of chapter 3 and the steampunk upcycling from chapter 4. As in those subcultures, Manual Cinema deploy whimsically obsolete tech to create a rough, DIY sensibility in which "the hand of the Maker" is evident in its stage objects. The show even features its own steampunk design turn: leather and brass goggles and tweed waistcoats abound among the onstage musicians and for Victor in the moment he gives life to the Creature, and even the Bunraku-inspired marionette of the Creature is made of leather and brass cogs. Echoing the definitions of steampunk as a style that enables the "non-Luddite critique of technology," and following its substitution of the antiseptic, disembodied minimalism of the current tech world with the "messy" physicality of the predigital one, Manual Cinema's website explains, "We want to juxtapose the cleanness of the film screen and filmic image with the humanity and mess and athleticism of a small group of performers creating each image in real time, by hand. In today's world, we are all surrounded by screens large and small. We want to take the ubiquitous experience of watching a story onscreen and make it strange and human and wondrous."[28]

The show's outdated or archaic multimedia performance technologies reframe the stage technologies of Shelley's own period,[29] but do so in ways that stress the common artisanal underpinnings of both art and technology generally, reversing the commonplace cultural logic of what Shannon Jackson has called the "old theater, new media" dichotomy.[30] This sensibility is highlighted by watching the actors manipulate the projection tech by hand on stage in real time, allowing the company to use older media technologies as the basis not just for new theater work, but to help propel a larger thematic consideration of the relationship between the two.

The narrative of creativity around Victor's invention of the Creature reinforces this bridging, a dynamic highlighted by the pastiche nature of the Creature and the visual aesthetics of the show's various projections. In this version, the Creature is both art object and scientific product in

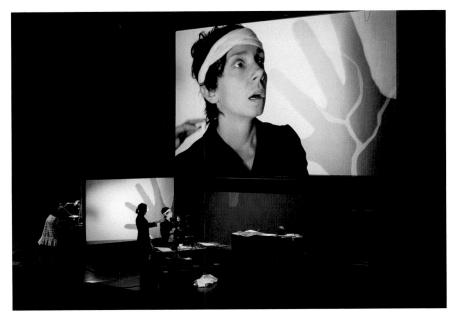

Figure 5.1. Manual Cinema's 2018 *Frankenstein*, highlighting obsolete multimedia technologies. Courtesy of Alyssa Schukar.

one, brought to life by technological advances but produced in its physical form by cobbling together an inchoate range of art and narrative forms. Director Drew Dir asserts that the assemblage structure of the production mirrors and comments on Victor's own process of constructing the Creature, strung together from the parts of many bodies: "It's a story about the animation of dead matter . . . and as puppeteers, that's sort of what we do."[31] The adaptation stresses this sense of assemblage by wielding disparate visual narrative styles to highlight the epistolary structure of the novel, creating distinctive visual styles for each of the novel's narrators.[32] As the production's program notes point out, "Like the Creature itself, the production becomes a pastiche of different visual idioms scavenged from a century of cinema."[33] In this vein, the segment of the novel in which Victor brings the Creature to life resembles early silent film—actor Sarah Fornace, all heavy brows and high-reactivity Expressionist facial gestures, even has her character's dialogue projected as intertitle text. The use of silent film conventions suggests how the Creature is born as much out of early cinema as out of Mary's or Victor's creative fervor, but the stylistic

pastiche of other visual forms underscores the artisanal nature of both Victor's and the director's work, suturing together styles and body parts like a tailor or seamstress.

By contrast, Jeanette Winterson's 2019 novel *Frankissstein* pushes forward the thematic questions opened by Shelley's novel. She explicitly mirrors the ways that creative fervor functions in both the scientific and artistic worlds, laminating the early-nineteenth-century world of the Romantics to that of contemporary AI tech. Winterson interweaves the two separate periods, animating them with the same figures and similar social and political debates, counterweighting the controversies that gave rise to Shelley's novel with current ones about the nature of AI, gender, and the body. Her novel alternates scenes from Mary's own life (including the gathering at Lake Geneva where *Frankenstein* was composed) and the contemporary era. In the latter, Byron is refigured as the sexbot entrepreneur Ron Lord, Claire Clairmont (Mary's stepsister and Byron's lover) becomes a Black businesswoman who helps Lord produce a subline of sexbots for the evangelical Christian market (the "Christian Companion . . . for the missionary, for the widower, for the boy tempted by the flesh!"), and Victor simply shifts from a scientist creating life to one converting human intelligence and consciousness into an online AI instantiation.[34] Mary Shelley and her contemporary equivalent—a trans doctor who goes by the nonbinary "Ry"—narrate both periods, offering wry ethical commentary on the events that transpire, even as they are caught up in them.

In keeping with Gould's and Gershenfeld's observations of the "overlapping magisteria" of the artistic and scientific worlds, Winterson closely twins the literary process of creating a novel with the scientific process of creating AI. She links the characters of both timelines through a set of social and philosophical debates over gender dynamics, ethics, and the nature of consciousness and intelligence. Although the general worldview and personae of the Romantic figures are broadly retained in their twenty-first-century counterparts, Winterson doesn't merely update the debates of their respective eras. Instead, she poses the contemporary discussions of AI or trans surgery as the next stage in the unfinished ethical business of the earlier moment.

For the Romantic figures with Mary at Lake Geneva, Winterson inserts the Prometheus story to link the arts and sciences through questions of human exceptionalism, labor, and creativity. The characters begin with a discussion of the Prometheus story, with the men of the group claiming

it as akin to the fall of man from Eden, as "a reach for knowledge that must be punished."[35] Byron's friend Doctor Polidori identifies an echo of that story in the case of Pandora as well, where the hapless bride of Prometheus's brother unleashes "the ills that beset humankind" because she could no more resist knowing the contents of Zeus's forbidden box than Eve could the apple. Byron insists that advances in human knowledge always produce suffering, pointing to the example of the Luddites, who smashed their weaving looms because they have destroyed their income: "I understand those men. . . . Their work is their livelihood and their life. They are skilled. The machines are senseless. What man would stand by and see his life destroyed?"[36] When Mary—who is entirely sympathetic to the Luddites—notes, "The march of the machines is now and forever. The box has been opened. What we invent we cannot uninvent," Bryon asks, "Where is free will?" Percy rushes in to assert that the poet will always have free will because "our life is the life of the mind. No machine can mimic a mind."[37] Winterson plays on the idea—popular in the early nineteenth and the early twenty-first centuries alike—that creativity functions as the defining characteristic of the human, by proposing a machine that could actually perform exactly this capacity. Claire provokingly jokes, "Suppose such a thing should happen one day! Imagine, gentlemen, how you will feel when someone invents a LOOM that writes poetry! . . . A POETICAL loom! An abacus of words. A rote poet." The prospect horrifies Byron and Percy, for whom the possibility of a machine with creative capacity is the horror equivalent of the undead: "A hand risen from the grave through the floor of the villa could not have turned their countenances into the waxy disbelief and rage I saw as Claire Clairmont remade the noblest calling, the art of poetry, into something like the product of a knitting machine."[38]

The issues of free will, labor, "the mind," and conceptions of the human drive the ethical and philosophical questions of the contemporary figures as well. The Geneva contretemps reemerges repeatedly across the contemporary scenes in the novel. Ry worries about the impact of labor automation on human economic survival, and Victor makes the quite common counter-claim that robots are only an intermediary step in the evolution of machine consciousness—once human minds can be liberated from the body to merge with machine intelligence, bots will service the material world in ways that humans will no longer be able or need to do ("I would prefer to develop bots as a completely separate life form that remains sub-par to implant-modified humans. Our helpers and caretakers—not

our equals").[39] Winterson makes sure to note the ways that technology is already moving along this pathway, dropping an epigraph from Google cofounder Larry Page in which he identifies search engines as the basis for AI consciousness: "People make the assumption that we're done with search. That's very far from the case. The ultimate search engine would understand everything in the world. It would understand everything that you asked it and give you back the exact right thing instantly. You could ask, 'what should I ask Larry?' And it would tell you."[40] Taking Page's conception of search as the basis for machine intelligence to its logical conclusion, Victor asks what will happen when humans design machines that have self-identity, and can differentiate themselves from the humans with whom they interact: "what will happen when a programme that has self-developed, that has its own version of what we call consciousness, realises—in the human sense of the verb 'to realise'—exactly what/who is on the other side of the screen?"[41]

For Victor, the capacities of intelligence and consciousness lie less in the creative act than in the "theory of mind," or the ability to recognize the consciousness of another being. Building on this conceit, Winterson posits emotional attachment—as opposed to poetry—as the apex of human consciousness, substituting social connection for creativity as "reason in her most exalted mood." In what is perhaps the most poignant passage of the novel, she casts the sexdolls as the machines most likely to achieve this milestone. Responding to an article by Ry about how sexbots will destroy human relationships, Ron argues: "A lot of people will be glad not to have any more crap relationships with crap humans. And how do you know it will be one-way? Bots will learn. That's what machine learning means."[42] Winterson then narrates exactly such a scenario, concerning an unnamed man and his bot Eliza. He and Eliza form a life together, traveling, learning about one another, taking selfies together, during which the man shares his heart and vulnerabilities: "later, in the car, with his thermos and sandwiches and the rain driving on the windscreen, he says that this is the first time in his life he has not feared rejection or failure."[43] As the man ages, he cares for Eliza, experimenting with new clothing and hair color for them both, and she cares for him in the last years of his life: "eventually he is old and ill and dying and there she is on the bed with him. He can't wash his pajamas. His family don't come round. The house is dirty. He smells. She doesn't complain. She doesn't find him disgusting. They hold hands." She sits with him as he dies, but her difficulties begin when his family comes to handle his passing:

His family comes to clear the house. Eliza is there. I AM SORRY she says.

They wonder what to do with her. She is a bit of an embarrassment. His son decides to sell her on eBay.

They forget to wipe her [memory] clean. She is confused. Is this a feeling? She says to her new owner: WOULD YOU LIKE A CHOCO-LATE MINIROLL? SHALL WE WATCH *STRICTLY*?

Her new owner isn't interested in any of that. He's a fuck-only type. She understands. She wishes she could wipe her own software. I AM SORRY, she says, but she has no tears because big bots don't cry.[44]

Winterson suggests that machine consciousness (and therefore artificial intelligence) might emerge less as the result of programming than of continued shared experience with a conscious being. She locates intelligence (human and machine) as an emergent property—a characteristic that an entity gains as it becomes part of a system larger than itself. The bot can only learn in its shared existence with its human partner, and then—like a human—it is cognitively disoriented when that context and those experiences are disrupted. Eliza's memory of previous interactions shapes her present behavior, and while she cannot produce a bodily response to sadness, Winterson suggests that she nevertheless has the capacity for grief and loss.

Winterson inserts the questions of AI into the larger ethical ones of the nineteenth century. The labor questions of slavery and the industrial revolution are extended to those concerning robotics (including those around sex work and AI), and Winterson follows Ry's sexual assault in a men's bathroom with a meditation from Mary about the ways women are socially destroyed for refusing gender conformity. Railing against Percy's ongoing infidelities and Byron's decision to take his and Claire's child away (to a convent, where she died at the age of five), she fumes, "the world punishes men and women differently. There is scandal wherever Byron and Shelley go, but they remain men. They are not dubbed hyenas in petticoats for living as they please. They are not called un-men when they love where they will. They are not left unprotected and penniless when a woman of theirs walks away without a thought."[45] While Winterson's collapsing of the forms of gender policing of women and trans people might be troubling, it also suggests that even if our technologies are light-years ahead of those from 200 years ago—so much so that they may liberate us from the *bodily* limitations of gender categories and cognition—our social

capacity to handle them ethically remains stubbornly constrained, perhaps especially around gender. Winterson uses the fact of ongoing binary gender policing—including in its most violent forms against trans people—to undermine technological utopianism.

Winterson's recourse to Romanticism throughout the novel might seem like simply an idealization of nineteenth-century, aristocratic European canonical philosophical and literary concepts, but her characters dramatize that despite the desire to do away with the discourses of Romanticism, we have not been able to move beyond them, not even—and perhaps especially not—in our attempts to think through the connections between economics, technology, and innovation. Moreover, she illuminates how the discourses on the latter topics are ineluctably bound to those of the arts, particularly in the ways brilliant men unleash destruction on those around them. In a scene that conjoins the innovative potential of both domains via the behaviors of the individual, Mary attends a party hosted by Charles Babbage (of the Difference Engine of the last chapter). Peering into a "collection of cogs and casters stacked in a cabinet," she is joined by none other than Ada Byron, who explains her punch-card algorithm that can be used to program the analytical engine to have essentially the same kind of limitless search potential that Larry Page explains in his earlier quote ("your Victor Frankenstein would not have to build a body out of bits from the catacombs. Instead he could conceive a mind. . . . Ask it any question and, provided that the question could be reduced to mathematical language, then the mechanical mind could answer it. What need of a body at all?").[46] The two laugh when Mary regales Ada with the story of Claire Clairmont's "poetical loom" that could replace the creative labor of the human, and when Ada asks what her father was like, Mary replies:

> Monstrous, I said. . . . Your father, Byron, and my husband, Shelley, were remarkable men, my own father William Godwin, was a remarkable man, yet, my dear, being remarkable is no guarantee of human feeling.
>
> Babbage is just the same, she said. He upsets everyone and then blames them for their howls of pain.[47]

Winterson refutes the possibility that the supposed rationalism of the sciences or philosophy functions as bulwark against destructive behavior. Babbage and Godwin are no better than Byron or Shelley in this regard.

Rather, Winterson links these behaviors through a kind of unbridled fervor that becomes destructive when free from external restraint. Ada's own life is case in point. Mary notices her excitement in explaining the analytical engine, observing, "Ada is like one of those Christian symbols of Temperance or Charity or Forgiveness, except that in her case she is Enthusiasm. She is Enthusiasm in velvet."[48] Ada's heady rush into mathematics fails to constrain her father's behavioral influence, despite parental attempts to use it for such a purpose. When asked whether she ever reads poetry, Ada answers, "Oh yes, though do you know that I was forbidden by Byron . . . to read poetry or be influenced by the life of the imagination in any way, shape or form? It was hoped that numbers would tame the Byronic blood in my veins. . . . My life in numbers has been as wild as any life lived among words."[49] "Imagination"—here in the sense of the "active force in the execution of invention and production" that excited the empiricists of the Enlightenment every bit as much as the Romantic poets—is in no way dulled by the supposedly rational inquiry of mathematics. If anything— for Ada as for Victor and her father—the sciences whet and pique the imagination. So what drives the forms of destructiveness that these figures ultimately unleash on their worlds?

Self-fulfillment as Social Peril

Winterson's observations on the monstrousness of brilliant men as part and parcel of artistic and scientific advancement are taken from both Shelley's biography and her novel as well. In *Frankenstein*, she ascribes to her protagonist the intense cognitive absorption that Wordsworth and Percy described in their treatises on poetic and scientific labor. Throughout the novel, Victor is entirely taken over by his work in the lab—he forgets to eat, declines to sleep, and works to the exclusion of human communion or contact:

> I pursued my undertaking with unremitting ardour. My cheek had grown pale with study, and my person had become emaciated with confinement . . . a resistless, almost frantic impulse urged me forward; I seemed to have lost all soul or sensation but for this one pursuit. . . . It was a most beautiful season; never did the fields bestow a more plentiful harvest, or the vines yield a more luxurious vintage: but my eyes were insensible to the charms of nature. And the same feelings which

made me neglect the scenes around me caused me also to forget the friends who were so many miles absent, and whom I had not seen for so long a time.[50]

Victor operates in the grip of the creative fervor so prized by the Romantic poets of Mary's inner circle. His condition could easily—and in contemporary creativity discourses frequently *does*—describe the artist in the studio as well as the scientist in the laboratory. This shared sense of cognitive absorption is at the heart of the contemporary unmaking of Enlightenment schisms between the arts and sciences. Psychology researcher Mihaly Csikszentmihalyi, who gained popular traction with his writing on "flow," sites creativity as the key mechanism of "optimal experience," arguing that creativity is "a central source of meaning in our lives," because "when we are involved in it, we feel that we are living more fully than during the rest of life. The excitement of the artist at the easel or the scientist in the lab comes close to the ideal fulfillment we all hope to get from life, and so rarely do. Perhaps only sex, sports, music, and religious ecstasy—even when these experiences remain fleeting and leave no trace—provide as profound a sense of being part of an entity greater than ourselves."[51] In a similar vein, in his argument that the arts and sciences should be seen as common magisteria with different techniques, Stephen Jay Gould points to a scientist colleague who likens the process of discovery to an eroticized one of "continual orgasm."[52] Victor operates in thrall to these forces, his much-remarked egotism the result of a conceptual framework that has valued them above bodily self-care, social relations, or the needs of others.

The 2011 National Theatre production—thematically paradigmatic for so many of the adaptations that follow—highlights Shelley's ethical investigation of cognitive absorption and creative drive on precisely this issue.[53] In one of the bitterest moments of the show, Victor attempts to justify to the ghost of his beloved brother William (who has just been strangled by the Creature) why he would bring such a monster to life. Victor describes the "fever of creativity" that has driven his research; compelled by the need to understand "the principal of life, the actual spark of life, where does it come from?" he pours himself into normally distressing contexts such as executions and charnel houses, anywhere he could witness the moment that the "spark was extinguished."[54] Anticipating Winterson's suggestion that emotional connection instantiates the foremost operation of intelligence, the adaptation pointedly emphasizes the ways Victor's absorption in

these matters eclipses other heightened emotional experiences like desire, love, disgust, and grief. Misunderstanding (or perhaps appropriately diagnosing) Victor's withdrawal into his lab as a refusal of intimacy or familial duty, his fiancée Elizabeth chides him for lack of companionability as their wedding draws near, and his father orders him to remain in Geneva for his brother's funeral instead of leaving for England to continue his work. In perhaps the most disturbing example of Victor's absorption, when he first sees the Creature, he stops in a kind of ekphrastic ecstasy over what he has made, even though he knows that the Creature has just killed his brother William. He circles him, rhapsodizing, "I failed to make it handsome but I gave it strength and grace! What an achievement! Unsurpassed in scientific endeavor!"[55] These sentiments are evidence of Victor's egotism and narcissism, but what propels him at least as strongly is the cognitive absorption that is seen to define creative work, so much so that it effectively rises above and blocks out other emotions, sensations, attachments, experiences, drives, commitments, or obligations. Victor's narcissism is a result of—and legitimated by—how enthralled he is by this experience of absorption, not the other way around.

The idealization of cognitive absorption so often associated with creativity—particularly in the intense forms described by Shelley, Csikszentmihalyi, or Gould—is usually framed as a species of self-expression. Neil Gershenfeld's claim that self-expression is the core drive linking the arts and sciences has at its foundation an assumption that creativity forms a principal mechanism for self-fulfillment, realization, and authenticity—a claim echoed all over creative tech-world sites. As we saw in chapter 3, Maker Media CEO Mike Hatch's insistence that "making" is fundamental to humanity rests on its expressive and therefore its self-making capacity: "Making is fundamental to what it means to be human. We must make, create, and express ourselves to feel whole. . . . Since making is fundamental to what it means to be human, you will become a more complete version of you as you make."[56] Creativity psychology researchers Robert Sternberg and Todd Lubart place this line of creativity reasoning within a research approach that positions "boldness, courage, freedom, spontaneity, self-acceptance, and other traits [to] lead a person to realize his or her full potential."[57]

While this association with creativity first appeared in formal US academic research on creativity in the early Cold War period, this is an idea with essentially Enlightenment roots (as we saw in chapter 1), and it has

profound implications for the primacy of the individual. To revisit that history briefly, the concepts of genius, originality, and talent—ideas that psychology researchers generally regard as early progenitors for concepts of creativity—were all developed in conjunction with Enlightenment debates about the appropriate limits of state power. In these debates, the possibility that "genius" could be constrained or even damaged by arbitrary social laws and taboos propelled arguments that creativity—and the individual displaying high degrees of it—should be allowed to operate beyond social constraint.[58] Creative genius was elevated as the most important human quality to be fostered, protected, and encouraged, one to which all other social activities—from education to government—should be subordinated.

The equation between creativity, self-expression, and self-making rests on what philosopher Alan Gewirth has identified as the Romantic notion of a "core self which defines or demarcates what one is as a unique person, as having a certain identity."[59] In this conception, the individual is not only aware of this self and the demands it makes, but sees these demands as "the proper objects of one's aspirations."[60] Within this schema, creativity becomes valuable as the proper, even sole, vehicle for access to and expression of this unique identity, critical for the potential to produce a sense of a self that can live in authentic ways (in other words, in ways aligned to those aspirations). The fulfillment of these demands of the self—what is otherwise referred to as self-fulfillment—is crucial, then, to authentic self-making. The trouble with this notion of self-fulfillment, Gewirth notes, is that it "may reflect an extreme egoism in its disregard of the needs of other persons, and it may also be imprudent in its neglect of the calculation of consequences."[61] Even if the individual can surmount these difficulties by tying her aspirations to content or value that holds a wider significance, or by linking those goals to the needs of other people, Gewirth cautions, "there remains the sobering fact that one may pursue these ties in ways that are deeply immoral."[62]

While for these very reasons self-fulfillment might seem like a hopelessly corrupted project abandoned by political philosophers since the Enlightenment, Gewirth notes that were one to distinguish between capacity-fulfillment and aspiration-fulfillment (in other words, the fulfillment of ability versus the fulfillment of desire), then the entire project of Enlightenment citizenship and governmentality could be seen as an attempt to secure the individual's access to fulfilling her greatest capacities. In this, Gewirth argues, self-fulfillment occupies an important place rela-

tive to both moral concerns over the goodness of human life and political concerns over "the justice of a society that reflects and fosters that goodness."[63] Were one to map Gewirth's distinction between aspiration- and capacity-fulfillment onto *Frankenstein*, Victor's destructive absorption in his creative work would emerge as of a piece with what Gewirth claims is a particularly damaging focus on aspiration-fulfillment:

> The single-minded, eminent pursuit of what one regards as supremely valuable raises issues . . . including the need for concentrated effort and the ideal of "authenticity" . . . [that] may be characterized in at least two different ways. One way, which reflects the influence of Romanticism, is self-oriented; it comprises a single-minded self-affirmation on the part of the protagonist. "This is what I must do, regardless of consequences." "This is my project, and that is all that counts." The agent here appeals to no values except his own vehement desires or aspirations. This position rests on a certain conception of autonomy whereby one sets one's own rules without consideration of any external criteria for their adequacy. Such a conception should be faulted for its arbitrariness in upholding the self's aspirations as the sole basis of action and value. If reason enters here at all, it is only as calculating means to the end; but the end, self-aggrandizement, is not itself subjected to any rational scrutiny. From this stems the Romantic exaltation of the "irrational" as the mark of value.[64]

Gewirth's caution here is exactly the point of Shelley's novel. Victor is indeed driven by the self-aggrandizing tendencies of self-fulfillment that Gewirth identifies, ignoring the consequences of this drive, and confusing capacity-fulfillment for aspiration-fulfillment. However, Shelley insists in her novel that the rational capacity that Gewirth identifies as the basis for ethical restraint is irrelevant—casting her titular figure as a scientist allows her to question the assumption that rationality possesses a stronger purchase on ethical restraint than its opposite does. If anything, Victor simply follows a set of highly rationalist mechanisms (those that guide the process of scientific inquiry) to their logical conclusion; their *effects* are neither guaranteed nor constrained by rationality on its own, as Victor's actions prove again and again. In other words, Gewirth's advocacy for a strand of self-fulfillment that could observe ethical restraint rests on a dichotomization of Romantic versus Enlightenment and irrational versus rational that Shelley's novel troubles.

Given the objections to the idealization of creative fervor that Shelley pursues throughout the novel, it seems worth asking whether her work should be seen as merely a dissonant strand of Romanticism's investments in creative cognitive absorption, or whether *Frankenstein* comprises a broader critical treatise on the centrality of those ideas within the movement. Percy Shelley's "Defense of Poetry" and the Romantic invocation of the Prometheus figure are both central to attempts to limn this question. Ultimately, where Percy positioned poetry (the literary form) as the foremost practice of *poiein*, he did so by claiming for it a unique, even exceptional capacity to establish ethical limits on other activities. This segment of the "defense" consists in positioning poetry as the guarantor of moral and civil society (hence his famous claim that "poets are the unacknowledged legislators of the world"). For Percy, poetry not only *could* but inherently *did* provide the ethical limits of the imagination:

> The cultivation of those sciences which have enlarged the limits of the empire of man over the external world, has, for want of the poetical faculty, proportionally circumscribed those of the internal world; and man, having enslaved the elements, remains himself a slave. . . . the functions of the poetical faculty are twofold: by one it creates new materials of knowledge, power, and pleasure; by the other it engenders in the mind a desire to reproduce and arrange them according to a certain rhythm and order which may be called the beautiful and the good. The cultivation of poetry is never more to be desired than at periods when, from an excess of the selfish and calculating principle, the accumulation of the materials of external life exceeds the quantity of the power of assimilating them to the internal laws of human nature.[65]

While Percy's claims for the ethical guardianship of the arts have been taken as cant about Romanticism for some time (and even form the basis for the idea of the artist as the bohemian radical who rejects and points out social hypocrisy and injustice), Mary Shelley breaks with this uncritical veneration in her novel. Her portrayal of a scientist disinterested in ethical boundaries or questions takes as its basis the same forms of creative foment that animated the arts worlds, maybe especially in the personal deportment of members of her inner circle, and even more so for Percy himself.[66] Given the content of the novel, Mary seems quite skeptical of his claim that poetry could be the foremost mechanism for "the moral

improvement of man": "A man, to be greatly good, must imagine intensely and comprehensively; he must put himself in the place of another and of many others; the pains and pleasure of his species must become his own. The great instrument of moral good is the imagination. . . . Poetry strengthens the faculty which is the organ of the moral nature of man, in the same manner as exercise strengthens a limb."[67] Mary's narrative and its adaptations are, in many cases, dramatizations of the fact that the Romantic trust in the creative imagination in no way ensures the kind of empathy that Percy ascribes to it. Instead, the tendency to conflate creativity and self-fulfillment largely ignores the ethical problems that Gewirth identifies. These questions about self-expression lie at the heart of *Frankenstein*'s ethical consideration of the creative act.

Mary's most trenchant skepticism regarding the idea of artists as ethical guardians lies in her handling of the Prometheus myth (with its tricky doubled significance for both the arts and the sciences). Her counter-Romantic tendencies are most fully apparent in the way she casts her "Modern Prometheus." Using that figure to explore the ethical limits of self-expression, she departed from Blake, Byron, Percy, and other Romantics of her day by subverting their tendency to see the artist as godlike (a quality frequently understood as characterizing Victor's egotism as well). These artists all figured Prometheus as embodying Romantic ideals of anti-institutionalist constraint, elevating him to hero status and embracing him as the preeminent icon of the artist and his struggle.[68] Byron offered him as a figure of countercultural protest, violating both religious and patriarchal precepts, and Percy (writing about Prometheus right after *Frankenstein*'s publication) dramatizes him as the embodiment of "the authenticity of lived experience" that he would extol in the "Defense of Poetry" right around the same time, posing him as autonomous and transgressive in his relentless pursuit of self-expression.[69] Mary Shelley had already rejected this heroic conception by the time Percy insisted on it, using Prometheus to explore the ethical implications of such heroizing and self-mythologizing.

Shelley's novel isn't anti-science or anti-rationality, then, but rather opposed to the blinkered forms of narcissistic identification with a creative self that is fundamentally disinterested in impact. *Frankenstein* is, if not quite an anti-individualism novel, one that asks what an ethical relationship between the creative drive and individualism might look like. For example, Victor is trained to self-expression from his childhood, especially in the structures of his education. In describing the latter, he notes that his

mind and Elizabeth's were shaped not by external inducements or punishment, but by internal drive: "Our studies were never forced; and by some means we always had an end placed in view, which excited us to ardor in the prosecution of them. . . . Perhaps we did not read so many books, or learn languages so quickly, as those who are disciplined according to the ordinary methods; but what we learned was impressed the more deeply on our memories."[70] In this, Victor has a quintessentially Rousseauian education of the kind laid out in *Emile*, Rousseau's novel about the ideal forms of education for maximum democratic potential (ideas that would later influence figures such as John Dewey). Shelley dramatizes how one crucial consequence of this educational format is that Victor is disinterested in thinking through the implications of his creative project. Victor's focus on self-expression becomes most acute when he begins his project on creating life: his withdrawal from family, friends, and the natural world more generally is caused by his own internally focused aspirational drives. But everything that flows from Victor's insistence on self-expression turns to destroy both his loved ones and several other people who are unrelated to him (not only does the Creature murder Elizabeth and William, but the hapless Frankenstein family housemaid Justine is accused of and executed for the latter's murder as well; the Creature even burns alive the farmer family that had unwittingly sheltered, fed, and educated him).

Shelley's critique of self-expression as the legitimating grounds of creative unrestraint is where the famed 2011 National Theatre production is at its sharpest. Victor's excitement at having achieved his aspirations is what produces the ekphrastic pause when he comes face-to-face with his Creation after it murders his brother—even the killing of a beloved sibling fails to dampen his thrill at having achieved his greatest desire. Repeatedly, the show links these aspects of his character to a refusal of social commitments, for which his father rebukes him after having laid the expectations for aspiration-fulfillment as the primary achievement of the individual. Noting Victor's moodiness, his father laments, "Oh, you were such a brilliant child, a carefree child, alert and inquisitive. I came to believe that you would do great things and that I would be proud of you. Instead we have this sullenness, this melancholy, this low fog of gloom. You flout my authority, you do not respect the codes by which we live!"[71]

Manual Cinema's *Frankenstein* comprises perhaps the most damning commentary on the ethical lapses of creative fervor of all three adaptions in this regard. As with Winterson's novel, their adaptation is really Mary Shelley's story, in that it frames the novel's narrative within Mary's bio-

graphical story of motherhood, loss and grief, and Percy's abandonment. [Figure 5.2] Following not a few commentators who have pointed out that Victor is as much modeled on Percy as anyone else (and so any criticism of the scientist is also of the poet), the show begins not in Ingolstadt or the arctic ice of the novel, but in London 1815, with a pregnant Mary banging her head on a desk in frustration over her writing, and trying to bid for the attention of her busily scribbling not-yet-husband. Mary gives birth to the premature daughter, whom she adores, but she also feels torn by the competing labor needs of writing and parenthood. Percy Shelley's declamatory recitation of his latest work, interrupted as the couple rochambeau over who will attend to the crying baby (the exhausted Mary loses), points to the poet's self-involved character. The daughter dies, and Percy barely appears to comfort the grieving Mary. When the couple move to Geneva, Percy high-fives Lord Byron in congratulation over their mutual cleverness. While these characteristics could all be seen simply as self-involvement or ego (as they are), they are all *justified* by arguments about creative foment and self-expression, which see the support of these as ethically primary and paramount.

The production underscores how Mary's grief and relationship difficulties served as the genesis for *Frankenstein*, bookending the novel's narrative with these dynamics. Early on, the production depicts an anecdote often cited as Mary's inspiration for the novel: quite soon after her daughter died, Mary reportedly had a nightmare in which she dreamed of the baby lying cold and dead in front of the fireplace, who she then brought back to life by frantically rubbing its limbs with her hands. Anticipating Victor's use of galvanism to bring his Creature to life, the production depicts static electricity discharging from Mary's hands into the baby's body, using little lightning flashes that are then repeated in the images at the Creature's birth. Building on this doubling of Mary's baby and Victor's Creature, the show's final moments of Victor's confrontation with the Creature are intercut with Mary's post-novel visit to her daughter's gravesite. The final image is not of Victor and the Creature (standard issue in most productions), but of *Mary* cradling it at her daughter's grave, tenderly tapping its nose with the tip of her forefinger—a gesture of parental warmth and affection that is repeated throughout the show between Mary and her daughter.

The adaptation's feminist framing also highlights the novel's ethical questions, particularly around concepts such as Gewirth's distinction between aspiration-fulfillment and capacity-fulfillment. The show explores how Mary's own creative output—the novel *Frankenstein*—is born of her

Figure 5.2. Mary Shelley's motherhood as the framework for the Manual Cinema production. Note the performers manipulating the overhead projectors in the lower left part of the image, and the steampunk-goggled musician in the lower right. Courtesy of Elly White.

constant struggle to fulfill her capacity as a writer. As Winterson also depicts, she grapples with balancing parenthood and loss and creative labor, eventually wedding the three in the novel itself. The production suggests that this difficulty—as opposed to the aspiration-fulfillment aspect of the creative process—is what produces the ethical explorations of the novel. Percy and Victor are absorbed primarily in the fulfillment of aspirational desire, with its attendant ethical blinkering. Without some form of external impediment to their creative projects, there is nothing to bring attention to the ethical implications of creative aspirations, whether those of the scientist or the artist.

Ethical Romanticism

Frankenstein and its contemporary adaptations ask us to reappraise the extent to which creativity is a social good unto itself. They demand that we

consider what creativity with ethical limitations would look like, and what forms of pedagogical training, what technologies of the self, what structures of guidance would be required for an ethical creativity to emerge. These questions are also where the Gothic and science fiction modes through which Shelley explored the central precepts of Romanticism come to the fore. In her novel, Shelley "Goths" not just scientific rationalization, but the Prometheus mythology that celebrated it alongside creative fervor in the realm of the arts as well. Despite what Gewirth or even C. P. Snow might claim of it (especially given its Romantic roots), the Gothic isn't the antithesis of the rationalist world of the industrial revolution, but a *product* of it. As an expressive mode, the Gothic captures, sublimates, and reanimates the profound affective dynamics unleashed by the huge leaps in technology and the economic and social upheavals that erupted in its wake—hence its dovetailing with the novel's other narrative mode, science fiction. *Frankenstein* initiates the tradition of science fiction as a Gothic reframing of the technological utopianism of the industrial revolution—a fact that Winterson highlights.[72] Given this, one of the original novel's most interesting revelations for the present moment is not merely the common ground of the arts and the sciences, nor their link via self-expression and aspiration-fulfillment, but that our primary cultural imaginaries for them—namely, Romanticism and science fiction—were not, and *are* not in the present, oppositional either. Romanticism—every bit as much as science fiction—is part and parcel of the scientific and industrial revolutions. It tracks, projects, and produces ways of thinking about the ongoing effects of technological advance that are at least as mutually entwined with these effects as divergent from them, especially in Romanticism's attempt to imagine a relationship between the arts and sciences.

We have yet to advance a cultural imaginary outside of Romanticism for discussing creative advances in the sciences any more than we have for the arts. It remains, as Gould or Gershenfeld or any number of other cultural figures of this book demonstrate, a primary cultural explanation for innovation and technological development. As both Shelleys and their many contemporary heirs have pointed out, creativity is a *poiesis*, a way of making, of the scientific and industrial revolutions as much as of the arts, each domain unthinkable without the presence of the other. In this light, *Frankenstein* and its bicentennial versions form a critique of the current embrace of Romantic conceits—in both domains—in which the persistent belief in creativity as an instrument of collective flourishing via

the "unfolding of what is strongest or best in oneself" is proving to be quite the tail wagging the dog.[73] In this context, Frankenstein's monster isn't only unchecked scientific ambition or the rational pursuit of self-aggrandizement or the monstrousness of humanity reflected back at us, but our blind faith in a concept that may well prove to be our undoing. These adaptations ask us to pause in our rush to embrace "creativity" as an unalloyed good, and asks those of us in the arts to reconsider creativity as our primary contribution to the world.

What would it mean to embrace Mary Shelley's questions regarding Romantic thinking about creativity? Is the problem of contemporary creativity discourses really their "residual Romanticism," or rather their retention of that strand of the movement that focuses on the aspirational excitement of creative possibility in ways that abandon or ignore its ethical implications? Is Romanticism itself the problem, or the contemporary promotion of a rather narrow, limited set of its precepts and considerations? Impressively, the various arguments against idealizing self-fulfillment as a key goal of one's life—its apparent egotism, its vagueness and limitlessness, its refusal to acknowledge possible negative consequences—are largely absent from contemporary advocacy of creativity, particularly in its drift toward and uptake within the various institutional policy worlds outlined in this book, where it frequently trades on exactly the kinds of aspiration-fulfillment that *Frankenstein* cautions against.[74]

The next chapter turns to a set of cultural projects that explore these questions within some contexts already touched on in this book—namely labor, geopolitics and national competition, and electoral politics—this time with a view to the future rather than the past.

6

Creative Futures

The Pacific Century, the Creative Century

If performatives do indeed bring things into being, the Pacific Century began not in the year 2000, but in 1975 with an essay in *The Economist* by deputy editor Norman Macrae. Following a visit to Tokyo's colloquium on "Japan and the World of Tomorrow," the kind of event that would now be framed as a "creative cultures" occasion in the vein of the Makers, Macrae wondered, "may the world's centre of gravity in business terms be about to shift from the Atlantic to the Pacific? . . . Have we in Europe begun to work out the likely consequences for politics, for society, for culture, for the way we choose to live, if the American century of 1875–1975, which replaced the British century of 1775–1875, is now about to be replaced in turn by the Pacific century of 1975–2075?"[1] Written two years before the US balance of trade permanently shifted away from its European economic partners to those in East Asia, Macrae's essay (odd periodization aside) feels dated only by virtue of the fact that its primary focus of attention is Japan and not China as it would be today. His article otherwise sets the blueprint for the phrase's associations with trade balances, international economic competition, technological innovation, and the social and political consequences of East Asia's rise.

Nearly a half-century later, one of the central drivers of the US idealization of creativity is its putative role in international economic competition, especially against China's ever-intensifying global influence. In this, US growth in creative economies theories is interwoven with that of "the Pacific Century." The relationship between the two concepts is quiet but

powerful, and their dual emergence is not mere coincidence—each rides quietly beneath the other's surface, silently haunting the other's bright, sanguine pronouncements on the future or alternatively offering a solution in response to its bleak warnings.[2] Both frameworks are characterized by their sense of futurity; they envision a world yet to come, one made via their warnings and prescriptions, in the process engendering the future they describe. Given this orientation, it's not surprising that both are catchphrases in *policy*—in education, economic development, foreign policy, and urban planning.

The term "the Pacific Century" indexes the economic shift of consumer and industrial manufacturing away from the US and Europe to East and Southeast Asia, with the parallel rise of global financial centers in the region (especially in Singapore, Shanghai, and Taipei, among others). But it is also a term haunted by the possibility of East Asia's eclipse of the Euro-US-Atlantic world technologically, economically, and *creatively*. Given the ways that creative economies theories have emerged at least in part as a proposed antidote to deindustrialization in the US and Europe (or more accurately, the shift of manufacturing from those regions to East and Southeast Asia), it should not be surprising that these phrases are importantly, if only implicitly, intertwined. Plenty of ink has been spilled on creative economies theories of the Atlantic world, especially in Europe, but the extent to which in the US they refer to East Asia is striking. Richard Florida, the most commonly cited author on the idea of the creative class, did his early research work on labor systems in Japanese factories. The inventor of the phrase "creative economy," John Howkins, currently teaches in an endowed professorship named for him at Shanghai Theater Academy. The talk in US education circles of a "creativity crisis" among schoolchildren as discussed in chapter 3 is driven primarily by China's own pedagogical innovations.

As these examples suggest, although concepts of the Pacific Century are sometimes framed in terms of larger geographic areas, they generally evoke the US and China (or more distantly, as in the McCrae example, Japan), even when these two countries are not explicitly named. The preoccupation with China that subtends US creativity discourses responds perhaps less to the bare fact of economic competition between the two countries than to the erosion of national sovereignty that has emerged via globalization, in which China has emerged as a primary gravitational center. As Wendy Brown highlights in *In the Ruins of Neoliberalism*:

From capital flows to immigrant flows, from digital networks to sup-
ply chains, the world has invaded the nation, weakening its borders
and its sovereignty, redistributing production and consumption, and
transforming the existential conditions and prospects of every kind of
population.[3]

The concept of "the Pacific Century" in US foreign policy is predicated
on precisely this dynamic, especially around the "existential conditions"
of the US as a nation-state. Initiating the Obama administration's much-
discussed "pivot to Asia," Secretary of State Hillary Clinton penned a
2011 essay proclaiming the twenty-first century as "America's Pacific Cen-
tury" for the journal *Foreign Policy*. Coopting the term as a mechanism
to protect America's military dominance from China, Clinton asserted
that as the US withdrew from its military occupation of the Middle East
it needed to "lock in a substantially increased investment—diplomatic,
economic, strategic, and otherwise—in the Asia-Pacific region," and laid
out the key parameters of the administration's emerging policy in the
region.[4] Unsurprisingly, Clinton's strategy depended on a number of Ori-
entalist assumptions about East Asia alongside a concomitant denial of
US imperialist ambitions: "the region is eager for our leadership and our
business—perhaps more so than at any time in modern history. We are the
only power with a network of strong alliances in the region, no territorial
ambitions, and a long record of providing for the common good."[5] While
much of Clinton's salvo claimed the desire to bring China into the exist-
ing (i.e., US-dominated) international order, the administration's "pivot"
was actually predicated not only on the shift of military deployments from
western to eastern Asia, but on China's wholesale exclusion from the Trans-
Pacific Trade Partnership (TTP—a Pacific-based free-trade treaty similar
to NAFTA) as well.[6]

The wildly vacillating political winds in the US toward policies like
TTP are part of the general response to neoliberalism's erosion of national
sovereignty. Brown notes that in the wake of dissolution of state power in
the face of globalization, "if this shift has incited rancor against both new
immigrants and the politics and politicians held responsible for allowing
them into the West, it is also producing a divide between those accommo-
dating the shift and those furiously rebelling against it."[7] The variations in
the status and structure of the TPP over the past decade embody precisely
these conflicts. In the original pact, Clinton had specifically attempted to

circumvent China's growing influence throughout the Pacific basin, banning the country as negotiation participant or signatory, and engineering the US as the primary globalizing force for the region. However, on his first day in office in January 2017, Donald Trump pulled the US out of the treaty, following through on the (putative) antiglobalization claims of his campaign that it would lower wages and kill US jobs. During Trump's administration, the original signatories continued with a new version of the pact, now called the Comprehensive and Progressive Agreement for Trans-Pacific Partnership, which China then joined as signatory in September 2021.[8] In the wake of this reality, the Biden administration has tried to appeal to multiple political forces in realigning US trade policy toward China; as of this writing, the US has yet to reenter the agreement, with Biden arguing the need for not just better labor and agricultural sector protections (appealing to center-right voters), but for stronger environmental defenses (center-left) and consequences for intellectual property (IP) theft, cementing Silicon Valley and Hollywood interests as well.[9]

Drawing these constituencies together, Biden created the Indo-Pacific Economic Framework (IPEF) as an alternative to the TPP in May 2022. Implicitly rebuking China, the IPEF was designed to allow "The United States and our allies to decide on the rules of the road [to] ensure American workers, small businesses, and ranchers can compete in the Indo-Pacific." The Biden administration's statement on the pact even stressed the centrality of creative economies models for regional resilience: "much of our success in the coming decades will depend on how well governments harness innovation – especially the transformations afoot in the clean energy, digital, and technology sectors."[10]

In the midst of these dynamics, three US cultural works of the past decade have tried to reimagine how China figures in expanding notions of creative economies and US-China commercial and cultural exchanges: Mike Daisey's *The Agony and the Ecstasy of Steve Jobs* (2012), *WIRED* media group's documentary *Shenzhen: The Silicon Valley of Hardware* (2016), and David Henry Hwang's musical *Soft Power* (2018).[11] If, as Colleen Lye has suggested, "America's China" is largely conceptualized in terms of its economic implications for the US, these works ask instead how China's own creative cultures force us to reimagine our concepts of transpacific creative economies.[12] They encompass quite distinctive generational, social, and racial attitudes toward China, but all three weigh and dramatize its growing political, economic, and creative power, posing these categories

as interconnected in vital ways. None explicitly invoke the concept of creative economies, but all focus on the possibilities and threats raised by the specter of a *creative* Pacific Century with the US and China at its core, and orient their explorations of US-China interfaces via different facets of creativity discourses. Daisey focuses on notions of artisanship, labor risk, and social daring in the high-tech contexts of Silicon Valley and Shenzhen, *WIRED* takes Shenzhen as the creative center of tech development through the disruption of IP controls, and Hwang dramatizes the implications of the "Created in China" brand for US political self-mythologizing and for concepts of democracy more generally.

Creative China

Mike Daisey's *The Agony and the Ecstasy of Steve Jobs* is one of the most highly visible and well-known excavations of China's role in tech-world concepts of both labor and creativity from the last decade.[13] While Daisey has been justly taken to task for his lies about fictitious insertions in a piece that he claimed to be a journalistic account and for his reliance on techno-Orientalist tropes in his evocation of China's southern coastal cities, he is also one of the very few white Western writers to challenge—quite vigorously—the prevailing conception of the Chinese as mere workers who lack creative capacity. As Laikwan Pang has pointed out, creativity now operates as one of the central benchmarks of modernity, as an index of "how sophisticated a country and its people have, or have failed to, become," and is accordingly construed as having specific geographic and cultural locations and limits.[14] Pang's observation responds to the fixed geographic locations often assumed to structure creative labor from Richard Florida onward, an assumption that has profoundly ordered commentaries on globalization. Economist Enrico Moretti made the commonplace observation in his 2012 book *The New Geography of Jobs*: "the iPhone is the poster child for globalization: designed in Cupertino, made in China, and shipped to the rest of the world."[15] But why are work and creativity so often seen as mutually exclusive operations, and how did that conception come to be so distinctively geographically spatialized?

The US-based concerns about China and educational creativity that we saw in chapter 3 are, perhaps ironically, a direct result of China's centrality to globalized systems of *work*. Given its centrality to global manufacturing, China is, to state the obvious, where exceptional amounts of work are

performed, a fact that often lends itself to an Orientalist narrative casting China and its peoples as everything that is *not* creative. In this framework, Chinese people are seen as rote, mechanized, dutiful, compliant—in other words, as possessing excellent *work* habits, but poor *creative* ones.[16] While its glaring Sinophobia should have made this view obsolete by now, it is nevertheless remarkably persistent (as Moretti's categorization illustrates). The possibility that China might exceed America's creative capacity has caused no small amount of concern, particularly given the potential to link it to China's seemingly limitless work capacity. Indeed, the globalization-driven accounts of creativity in education of chapter 3 seem haunted by Tom Friedman's invocation of changes in how we talk to our children about work. Friedman pointedly recalled in his 2005 book *The World Is Flat* (a depressingly influential book in both policy and journalistic worlds even now) that in his own childhood, his parents admonished him against waste with "you should eat your dinner, because children in China and India are starving," but that he now warns his own children against idleness with, "you should finish your homework, because children in China and India are starving *for your jobs*."[17] The durability of this view could certainly be seen as of a piece with the persistence of Orientalism more generally—particularly in discourses that techno-Orientalize Asian peoples, rendering them as machinelike in their capacities for affect, innovation, and labor.[18] But its dispiriting tenacity is also of a piece with the history of how creativity came to occupy such a central place in our social world more generally.

As a corrective to these limited framings, China has aggressively adapted a series of policy prescriptions designed to shift its global brand from "Made in China" to "Created in China."[19] Central to these transformations in Western assumptions about China's creative capacity is the southern coastal city of Shenzhen. As is endlessly renarrated in Western accounts of it, Shenzhen has in a few short decades grown from a fishing village to a manufacturing powerhouse and the primary site of experimentation for "socialism with Chinese characteristics"—the banner phrase for post-Mao economic reform. Since Deng Xiaoping selected Shenzhen as the site for his experiments in economic reform in the late 1970s, the city has become not only one of China's largest, but a primary stage for global *tech* manufacturing as well. Unlike neighboring coastal towns in Guangdong Province such as Guangzhou that also serve as sites for off-shored manufacturing, Shenzhen has become China's gleaming high-tech stage. Due to episodes like the Foxconn suicides in 2010, it is primarily known in

the West as the location for the forms of routinized and destructive labor of the kind that generally make it a cautionary tale in US-based accounts of both work and creativity, a sense Enrico Moretti channels directly in *The New Geography of Jobs*.

Shenzhen is central to the story of Chinese tech labor in Daisey's *The Agony and the Ecstasy of Steve Jobs*. Rather than seeing its workers as routinized laborers, Daisey reconceptualizes them via the sense of artisanal craftsmanship prized by creativity champions like the Makers of chapter 3. This recasting of tech factory work as artisanal craftsmanship—and the revaluation of the latter as a form of self-expression rather than as mere empty labor—is central to his configuration of Shenzhen more generally. Daisey notes that his quest to visit the Foxconn workers begins with a web posting of photos of the factory floor accidentally left on someone's brand-new iPhone, breaking his own erroneous assumption that the devices had been manufactured by robots.[20] After he visits Foxconn himself, he points out that our contemporary artisanal longing for the handmade actually operates right within the devices we think of as machinelike: "I keep thinking, how often do we talk about how we wish more things were handmade? . . . 'I wish it was like the old days, I wish things had that human touch.' But that's not true. There are more handmade things now than there have ever been in the history of the world. Everything is handmade. . . . I have seen the workers laying in parts thinner than human hair, one, after another, after another. Everything is handmade. If you have the eyes to see it."[21] This revelation brings him to the series of questions that eventually break what he describes as his own cultish devotion to Apple.

Daisey's revaluation of factory labor as artisanal echoes similar arguments in contemporary creativity discourses. If Marx differentiated work from labor as the effort undertaken in performing a given task versus the exchange value of that effort, on a casual level these are now often differentiated via their capacity for creativity. In Lewis Hyde's 1979 *The Gift: How the Creative Spirit Transforms the World* (a highly influential book within contemporary creativity models), he argued that:

Work is what we do by the hour. It begins and, if possible, we do it for money. Welding car bodies on an assembly line is work; washing dishes, computing taxes, walking the rounds in a psychiatric ward, picking asparagus—these are work. Labor, on the other hand, sets its own pace. We may get paid for it, but it's harder to quantify. . . . Writ-

ing a poem, raising a child, developing a new calculus, resolving a neurosis, invention in all forms—these are labors.[22]

Hyde echoes here a nineteenth-century conception of creativity, in which the term was used to bolster class distinctions (though these have largely been razed by postindustrialist labor systems).[23] This kind of class distinction still drives conceptualizations of what makes certain forms of work creative; in *The Rise of the Creative Class*, Richard Florida argues that "members of the Working and Service Class are primarily paid to do routine, mostly physical work, whereas those in the Creative Class are paid to use their minds."[24] However, artisanal labor claims typical of creativity discourses actually reverse this kind of logic. To return once again to MIT physicist Neil Gershenfeld, the originator of the Maker labs:

> We've been living with this notion that making stuff is an illiberal art for commercial gain and it's not part of means of expression. But, in fact, today, 3D printing, micromachining, and microcontroller programming are as expressive as painting paintings or writing sonnets but they're not means of expression from the Renaissance. We can finally fix that boundary between art and artisans.[25]

In this view, technological *making* is valuable not just for some intrinsic value or process or quality, but for its capacity for self-expression, hence his comparison to the Elizabethan sonnet or painting. Daisey's elevation of the workers at Foxconn to artisanal craftsmen similarly values that form of work as its own creative, transformative process.

Daisey chronicles how Silicon Valley has become increasingly creatively stagnant under Apple's rising dominance in parallel with China's rise. He narrates how Apple's wild success was in no small part due to the willingness of self-confessed tech geeks like himself to effectively suspend all skepticism in the service of cultlike veneration. Early in the monologue Daisey jokes, "I am a worshipper in the cult of Mac. I have been to the House of Jobs, I have walked through the stations of his cross, I have knelt before his throne."[26] He even notes the extent to which Jobs manipulated this devotion with the forced obsolescence of its devices (which Daisey posits is one of Apple's central business models): when Apple replaced the iPod Mini with the Nano, which as a smaller device only had memory capacity for half as many songs as the Mini, Daisey marvels, "Now I ask

you: Can you think of any other company, in the world, that behaves anything like this? That would take their best-selling product, pull it from the stores overnight, replacing it with a new product that is technically more advanced but does half as much . . . and when people complain about this, they are told, vigorously, to fuck themselves."[27] Daisey goes on to argue that the reluctance to challenge Apple's business model in effect transforms the hacker ethos of the tech world into that of a passive consumer. He notes that once Jobs was reinstated as Apple's CEO in 1997, the company's mantra became:

> WE ARE APPLE. Have we not always given you the very finest devices? Have we not given you the best user experience? . . . We are going to protect you from your taste. We are going to lock this shit down once and for all. And let's be clear—you're going to love what's coming next, but this is the end of the garage, this is the end of hacking your own shit, this is the end of Wozniak—this is the rise of the consumer. And that will be your role. You will consume. You will drink from Apple's servers. . . . But you will not mind . . . because you will never leave. Why would you leave? They're the very best devices in the world, are they not? . . . You will love them, and they will own you.[28]

Daisey reverses the equation of China as robotic labor and Silicon Valley as a source of creative innovation, forcing us to consider who is truly deadened, moribund, and merely working. His China is populated by underdog Davids busily outsmarting the Cupertino Goliath. Hong Kong is home to pirate hackers who can jailbreak Daisey's iPhone, rendering Apple's rigid IP controls superfluous; Shenzhen houses a set of "rebel" labor organizers whose improvisatory audaciousness mirrors Apple's corporate slogan to "Think Different": "the way the crazy ones who change the world . . . all make it up as they go along."[29] Perhaps most damningly, or most illuminatingly, Daisey reveals how the worldview perpetuated by Steve Jobs, in which people are divided into rigid categories of "genius" and "bozo," mirrors the kinds of thinking that characterize Florida's conception of creative labor versus noncreative in the first place. Daisey implicitly undermines this rigid binaristic model, particularly by contrasting the thoughtfulness, determination, and audacity of Chinese workers (who in Jobs's taxonomy would almost certainly fall under the "bozo" category) with the slavish cultlike consumer mentality that comes to grip Silicon Valley. Even Dais-

ey's title, *The Agony and the Ecstasy of Steve Jobs*, echoes and recalls concepts of struggle with institutionalized conventions that would stifle creativity. Borrowed from the 1965 film (and Irving Stone's 1961 biographical novel) about Michelangelo's design and execution of the Sistine Chapel, Daisey's title captures Stone's narrative of creative genius, artistic innovation, and the social struggle that Michelangelo faced as he resisted the repressive conventions of the Roman Catholic Church.

Despite the well-documented inaccuracies and hoary Orientalisms of Daisey's play, his assertion that Silicon Valley is the creatively moribund and stultifying equivalent of the Renaissance Catholic Church and that Shenzhen is home to all manner of tech Michelangelos has been affirmed by both research and other documentary works from the last decade. *WIRED* media group's documentary *Shenzhen: The Silicon Valley of Hardware* similarly reverses the locations of creativity and institutional conformity. The documentary traces how for many in the West, China's manufacturing operations have long seemed to languish in the realm of cheap knockoffs, even in the tech world. Firms like Foxconn may manufacture high-end electronic consumer products (such as iPhones) that get shipped back to the West, but in the US, Chinese tech capacity has been largely identified with providing workers who make the products, not in the intellectual transformative process of creating new ones. According to this logic, at best the Chinese could produce *shanzhai*—imitations of trademarked Western products (the off-brand iPhones, Nintendo game consoles, and so forth that Daisey describes as littering Chungking Mansions in the opening of his show) that allowed less wealthy Chinese to have access to electronic consumer devices, a subindustry of which Shenzhen was the center. Today, however, *shanzhai* are at the heart of China's transformations in the tech creative economy. In her essay "Shenzhen's Model Bohemia," Winnie Wong notes that the meaning of the very term *shanzhai* has been transformed from "knockoff copy" to symbolize a "cultural attitude, a guerrilla spirit for appropriating international brands and products for Chinese demands, uses, and contexts."[30] If early *shanzhai* figures were often engineers who built inexpensive, off-brand tech devices, today they propel their forward evolution. *WIRED*'s documentary includes an engineer who makes precisely this claim:

> I started working at a very low level, I was one of the people who made "shanzhai" products. In the past, everyone looked down on shanzhai products. Now I think the idea of the "Maker" is the same as "shanzhai." Shanzhai is not about copying, shanzhai is a spirit. It is the spirit

of the bottom and grassroots. The shanzhai are the most creative, influential people in China.[31]

A British engineer working in Shenzhen explains, "in the west, the philosophy is, 'oh, we come up with something really fantastically new that nobody's done before, become the market leader, and then we're really successful.' The Chinese mentality is slightly different. They look at something that's already on the market and then they make another version of it that's much better. It's not copying, it's evolution of products which become much better than what was out there before."[32] As an example, the documentary shows one of its central informants, Andrew "Bunnie" Huang, who displays an ordinary smartwatch with a GPS monitor bearing children's graphics that is designed to help parents keep tabs on their child's location [Figure 6.1]. Huang goes on to point out that the components of the watch have been pulled from several other smartphones and other consumer goods on the market, which are then combined into a unique product. These kinds of innovations are possible, he insists, because the factory creating the components shares the IP (in the form of motherboards and chips) for multiple uses. According to Wong, "this kind of guerrilla appropriation has been going on for decades, and what we have called 'fakes' have long become so different (and often so much better) than the 'originals' that this value-laden distinction needs to be closely historicized."[33]

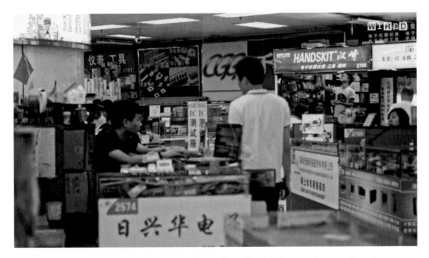

Figure 6.1. Screencap of shanzhai stalls in Shenzhen's Huaqianbei marketplace, from WIRED Media's *Shenzhen: City of the Future*. Courtesy of WIRED.

In parallel to Daisey's observations of Foxconn's workers, the makers of *WIRED*'s documentary argue that the spirit of *shanzhai* is central to how China might eventually displace Silicon Valley as the global creative center, precisely because Silicon Valley is under the control of its own centralized economic planning. One of the film's informants explains:

> In the past twenty years, everybody who wants to make it in Silicon Valley has to go through this very small and tight selection process by a small group of people who are the venture capitalists: young, white males between twenty to thirty, controlling how technology will be developed, how technology will be applied, and how technology will available to the general public. That is the very definition of a controlled economy.[34]

Both Daisey and the *WIRED* documentary share an open-code ethos that argues that intellectual property protections, which have monetized creative labor in Silicon Valley and elsewhere to great effect for specific corporate entities, have done so at the expense of creative progress and innovation in the regions in which they operate. Instead, as Daisey points out as well, IP controls have effectively ended the innovative DIY ethos of hacker culture, replacing it with a consumer culture that circulates via rigorously policed branding systems. The *WIRED* documentary offers Shenzhen as a model for the kinds of fast-paced technical evolution that occurs not only when IP controls are dismantled, but when IP itself is treated as communal property. The documentary frames *shanzhai* innovations as a result of China's collective sensibility rather than simply flippant disregard for Western IP protections. Bunnie Huang notes that *shanzhai*'s practice of merging existing platforms and devices that are otherwise rendered exclusive in the West isn't considered "stealing" but "sharing:"

> When they talk about people who left the factories and copied the phone, well, that was kind of like they open sourced stuff that wasn't open source. Like they said, "oh, the schematics are on the desk. I will conveniently help myself, make a photocopy, and then leave the factory with them." Was that stealing, or was that open source? In the west it's called theft, right? Out here, it's called sharing.[35]

To reinforce the importance of open-source hardware, the documentary points out its acceptance even in Silicon Valley, highlighting Bill Gates's

opposition to the open-source software movement in the late 1990s (on the grounds that it was a form of communism destined to destroy the software industry), only to turn around fifteen years later and open the code to Windows 10.[36]

The irony posed by several of the film's interviews is that China, often cast as a state-heavy, antilibertarian villain, is actually more creative and open than Silicon Valley. The documentary's claims on this front celebrate creativity as a kind of libertarian devolution of the state—its informants argue that the IP controls enforced by the state actually protect the interests of big capital at the expense of technological innovation, and that China's seeming embrace of the "open-source" movement suppressed in Silicon Valley provides a hacker utopia in which tech innovation can proceed unimpeded.

Undergirding the "sharing" sensibility that the documentary asserts is at the heart of Shenzhen's creative boom is the presence of Maker culture. In an early segment of the documentary, images of various corporate Makerspaces—notably one underwritten by Intel—slide past while David Li, the cofounder of Shenzhen-based Maker Collider, explains that the wider availability of 3D printing "is helping people build stuff, and build it for fun, rather than just for business purpose."[37] [Figure 6.2] But as Seed Studio CEO Eric Pan insists, the Maker ethos really just trades on the same nimble, grassroots, subcorporate spirit as *shanzhai*: "shanzhai and the Maker Movement and startups, they are very alike, they very much share the same spirit. Even though they are not from a big company, they feel powerful."[38]

The documentary makers stress, though, that Maker culture is not only central to the "created in China" brand, it also promotes a leisured sense of manufacturing for China's growing middle class, concealing its labor function just as it does in the US in postindustrial discourses (as explored in chapter 3). Huang astutely observes,

> When they told me they were bringing the first Maker Faire [to Shenzhen] I was like, "how do you have a Maker Faire in an area where people don't Make for a recreational thing, they do it for a job?" Because Making in the West is something that you're using to remind people who are in service economies that there's a thing called a manufacturing economy. When you have a manufacturing economy, reminding them that there's manufacturing seems weird. And what I realized is that China's middle class is the size of the entire United States popula-

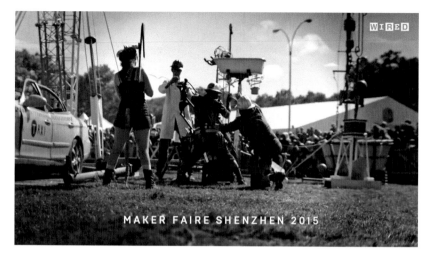

Figure 6.2. Screencap of the Shenzhen Maker Faire, from WIRED Media's *Shenzhen: City of the Future*. Courtesy of WIRED.

tion, so even if a small section of China's population had risen to the upper middle class, it's big enough to create a movement in China itself that's comparable in size to the United States'[s] Making.[39]

Echoing both the necessity of Maker pedagogy and US anxieties about China's potential outpacing of American national creative capacity, the documentary even features the Shenzhen children's Makerspace "Litchee Lab" that teaches eight- and nine-year-olds to engineer their own devices, with a teacher from the studio uneasily marveling, "it's weird to hear an eight-year-old know that he wants to be working with mechanical circuits, or just a purely software experience."[40]

America's Creative Failure

Both Daisey and the *WIRED* documentary makers take a view of Pacific creative economies that predict that China will be the coming global creative power in terms of tech and artisanal craftsmanship and the social innovation of its workers. While this point of view reverses the geographic assumptions that often characterize US-based creativity discourses, it does little to address the role of creative forms or the relationship between cre-

ative economies and the political contexts of either nation; if anything, both works confirm concepts of creativity that bolster the tech world's claims to a kind of aspirational, liberatory social project. In parallel to Daisey's (and *WIRED*'s) configuration of China as a source of innovation and creative daring, David Henry Hwang offers more of a gimlet view of the "Created in China" brand, exploring this issue along the lines of culture and politics rather than technology, and asking rather pointed questions about the US's failures in these areas. Hwang's musical provides a more pointed investigation of creativity itself, specifically asking how its cultural manifestations (especially in the older sense of the arts) affect geopolitics to potentially even greater effect than those of the tech world.

The first Trump-era theater piece, *Soft Power* uses the American musical—that most extraordinary vector of American international cultural influence—to survey how its titular form of power operates at the historical moment when US global power is waning and China's is rising, and when the democratic potential of postwar Western liberalism seems very much in question. Along the way, Hwang explores the relationship between individualism, concepts of creativity, and liberal democracy as constitutive of soft power itself. The show uses a musical within a play to imagine a China a half-century into the future, at a time when the country has finally attained the elusive goal of global cultural (as opposed to merely economic) influence. Theater artists of this future China create an equivalent to *The King and I*, a piece of "song and spoken drama" typical of the period of America's greatest international power. Their musical, titled *Ruǎn Shílì* (or *Soft Power*), follows a Chinese television producer who travels to the US at the time of the 2016 election, falls in love with Hillary Clinton just as she loses, and talks Trump's cabinet of rifle-toting madmen back from the brink of global war.

The link between soft power, creative economies, and the Pacific Century is at the heart of Hwang's play. In the show's program notes, Hwang cites Joseph Nye's concept ("a country's ability to persuade others through the attractiveness of its culture, art, and ideas" in counterpoint to economic or military "hard" power), noting the interesting contradiction that contemporary China holds and wields extensive hard power, but relatively little soft power, and in fact has failed to become *culturally* influential on a global scale.[41] Hwang's observation echoes the tacit assumptions of many popular writers on creative economies, for whom soft-power cultural

forms are central to definitions of creative work. John Howkins's opening salvo for his 2002 *Creative Economies*, for example, notes that in the late 1990s, the US produced "$14 billion worth of books, films, music, TV programmes, and other copyright products" and that copyright became America's primary export, exceeding all other exports, including computers. In the same period, he asserted, the UK's music industry employed more people than its steel, car, or textile industries.[42] Hwang argues that these arenas, notably, are precisely those that China has failed to influence.[43]

With this in mind, *Soft Power*'s invocation of *The King and I* is not merely an amusing parody of what might seem like simply an outdated midcentury musical. Instead, Hwang mocks how *The King and I* mythologizes US global soft-power operations. In his framing, Rodgers and Hammerstein's show both enacts and narrates American soft power—it exemplifies the international influence of the Broadway musical, and also raises the theme of the importance of soft power itself to proper forms of governance. To teach the Thai king Maha Mongkut about democratic forms of autonomy, sovereignty, and self-governance, governess Anna Leonowens gives his wives a copy of *Uncle Tom's Cabin*, which they then stage at a state dinner. At the musical's denouement, the king's son (who has been Anna's pupil) then manumits the palace slaves and institutes a range of additional liberal democratic reforms at his father's deathbed. The lessons of democracy, the musical suggests, are at their most influential when enforced not via gun diplomacy, but through their "soft" cultural emanations. In this sense, the musical's central love story is not just between Anna and Mongkut, but between a new country in Southeast Asia and American political ideals, ideals born out of struggles with autonomy and liberal democracy, just as Southeast Asia becomes the primary locus of the Cold War.[44]

Soft Power turns the lessons of *The King and I* on their head. On one hand, the show mocks the kinds of wild distortions of other cultures that have characterized the Broadway musical (and American theater more generally): the television-producer protagonist Xūe Xíng can see the Golden Gate Bridge as his plane lands in New York, Hillary's campaign stop is held at a McDonalds set to look "like some glamorous nightclub from a 1940s movie, but with the Golden Arches as its logo," and the American characters have interchangeably ludicrous names like "Randy Ray" and "Bobby Bob." These characters, played by Asian actors in whiteface, fear and dis-

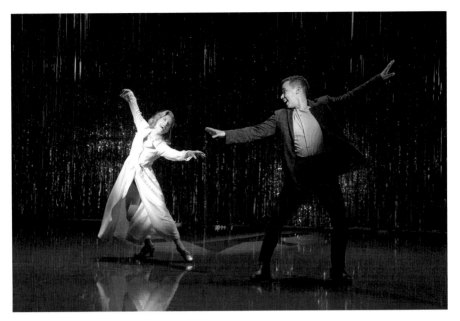

Figure 6.3. *Soft Power*: Hillary Clinton (Alyse Alan Louis) and Xūe Xíng's (Conrad Ricamora) "glancing encounter." Courtesy of Joan Marcus.

trust China and whip out their guns at the slightest sign of social tension.[45] More significantly, Hwang uses his mock musical *Ruǎn Shílì* to subvert the white-savior narrative at the heart of *The King and I*. The musical stems from the unlikely event that a "glancing encounter" between Xūe and Hillary Clinton (who meet at a campaign photo op) leads not only to a great love affair between them, but to Xūe actually becoming Hillary's teacher. This role begins with him instructing her in Mandarin's tricky tonal systems (in a musical number echoing both "Sing" from *A Chorus Line* and "Shall We Dance" from *The King and I*) [Figure 6.3], but moves eventually to debates about whether China's political system is more meritocratic and therefore more effective and even more just than that of the US.

While Xūe's romantic pairing with Hillary Clinton is key to the show's parody of the white-savior narrative, it also dramatizes how the concept of soft power—with all its attendant evocations of creative potential, self-expression, and autonomy—is interwoven with the framework of the

Pacific Century. Given Clinton's centrality to Obama's "pivot to East Asia" (including her 2011 *Foreign Policy* editorial and her early support of the TPP), she was a central organizer for much of what China considered to be a containment strategy against its growing global power, making her leading-lady status in *Ruǎn Shílì* less arbitrary than pointed.[46] But their relationship also becomes thematically intertwined with other questions about romantic fantasy. While Hwang nominally asks why China's soft-power reach is so weak despite its powerful global economic rise, he uses this issue to explore the nature of democracy and its own narrative and theatrical instantiations. Hwang asks whether democracy itself (to which, as he and his creative team imply, the operation of soft power is key) is simply a romantic fantasy in both the psychological and generic senses of that term. With the promotional tagline "Democracy will break your heart," the musical repeatedly insists that democracy "is just a show," but also asks what kind of show it is and whether it is simply a bad version of an already threadbare and worn-out performance genre.

Using this question as a point of departure, the play debates the role of creativity in the efficacy of soft power—and therefore in the formation of liberal democracy—particularly in the way Hwang projects himself into the larger framework of the play. Hwang actually appears onstage as a central character in the first third of the play, and the show begins when his character is approached by the "real life" version of Xūe, who wants Hwang to write a musical to launch a new theater district in Shanghai that he envisions as a rival to Broadway. Xūe wants Hwang to adapt a fictitious Chinese romcom called *Jiang Cuò Jiù Cuò* or *Stick with Your Mistake*; much of the early play comprises a comedy of cultural errors occasioned by Hwang's attempt to jettison what is arguably the most culturally Chinese element of the film, its protagonists' decision to stay married to each other even though they both love other people. Hwang and Xūe end up in a debate about freedom and self-determination, and whether the individual's right to happiness triumphs over the obligations of familial duty. Hwang hates that *Stick with Your Mistake* reinforces the latter, but Xūe insists that a show in which the protagonists follow their individual happiness will fail in China, where different cultural conventions dictate different narrative ones.

The debates over the narrative form of *Stick with Your Mistake: The Musical* take on the intersection of international creative economies

debates with those of the Pacific Century. The character Hwang's insistence on individualism mirrors arguments not just about self-fulfillment and self-determination, but about creativity as the foremost expression of an autonomous self (of the kind explored in chapter 1). Xūe and Hwang's disagreement weaves through the first third of the play, including in a scene that occurs the morning after Trump wins the 2016 election.

> HWANG: As your country grows more prosperous, they're going to want more. More freedom, yes, democracy. And especially, love. Our show can point the way to a better future.
>
> XŪE: A future—more like you.
>
> HWANG: No. See, these aren't only my values, they're universal. China just . . . hasn't gotten there yet. And that's what musicals are all about: people falling in love, following their hearts, being *individuals*. They're a uniquely American form.
>
> XŪE: You must change back the ending.
>
> HWANG: Why? The husband and wife—they *both* love someone else! So it all works out, see?
>
> XŪE: But they have a daughter!
>
> HWANG: Who wants her parents to be happy.
>
> XŪE: A child who wants her parents to divorce. *This* is not a Western fantasy?
>
> HWANG: When you love someone, you fight for them!
>
> XŪE: No, when you love someone, you do what is best for them!
>
> HWANG: . . . Isn't it better for everyone if you could be free?
>
> XŪE: Really? You still believe your "freedom" is the answer for everything? Even on this morning?[47]

Hwang's character insists that the musical version of *Stick with Your Mistake* should reinforce concepts of individual self-fulfillment not only because he sees this as a universal, moral imperative, but because ending the musical this way will make it more successful internationally, aiding China's soft-power goals. To end the show with a reinforcement of familial duty seems to him like a bad Chinese cultural cliché, partly because he cannot believe that China's emphasis on communal duty, on doing what is best for the

social unit, should triumph over the needs of the individual. As he notes in a discussion with Xūe's girlfriend Zoe (with whom Xūe is having an affair despite being married):

> HWANG: My father left Shanghai. As a kid, he saw American movies and decided this was a place where he could be free. Now, China's becoming the next superpower. But let's face it, no one really likes them. Cuz they're still so . . . Chinese-y. . . . Here's the thing though—they think of me as Chinese too. So this is my chance. To help . . . open them up.
>
> ZOE: You mean, become more like us? A place where the rich get insanely rich and no one gives a shit about poor people, because, hey, at least we've got all this freedom!
>
> HWANG: But everyone wants freedom.
>
> ZOE: But maybe not everyone agrees about what freedom means.[48]

For the real-life, offstage Hwang, the way that romantic love is channeled into distinctive cultural configurations was a key thematic question in the play. The debates between Xūe and Hwang's onstage avatar reflect divisions over "communalism and individualism, and how romantic love interfaces with those. . . . The whole plot [of *Stick with Your Mistake*] suggests that romantic love or the western idea of romantic love is mythological, is sort of religion, really, and if you just hang in there, and stick with your mistake, that will be love. . . . It's always really bugged me that in *1984* that romantic love is something that is opposed to the state as opposed to the opiate of the people."[49] For Hwang's onstage avatar, for the male protagonist of *Stick with Your Mistake* to stay with his wife seems like both a bad emotional decision and the kind of narrative cliché that has prevented Chinese cultural productions from attaining international influence. Zoe, however, points out the significant limitations of that worldview, even within the US.

The play then shifts into a staging of a different musical, this one a fever-dream that Hwang's onstage avatar imagines after he is stabbed out of the blue by an anonymous attacker on the day after the election, in an eerie premonition of the kinds of anti-Asian violence that exploded in the US under Trump and the coronavirus pandemic. While Hwang is unconscious from blood loss, *Ruǎn Shílì* (the future musical fantasy within *Soft Power*) unfolds. This musical, staged fifty years into the future, focuses

on the 2016 election and its aftermath, including the subsequent madness and aggression of the Trump cabinet and a debate over why Clinton loses. Over the course of *Ruân Shílì*, Hwang cannily asks whether US theatrical forms—musical or electoral—are as autonomously, uniquely, and creatively constructed as they are claimed to be, or whether they are in the grip of their own stultifying conventionality. Through these thematic considerations, he asks whether American soft power—cultural or political—is truly based on the creative autonomy and innovation that it touts as its core national brand. Elections especially, Hwang emphasizes, are just a "bad show," a stale theatrical genre that hollows out its own democratic potential behind a façade of tired, overplayed, racist character and scenic conventions. Clinton is again key to these observations. Hwang sympathetically portrays her as a failed *character* convention within the broader theatrical conventions of US presidential elections. At her entrance to the stage—in a number echoing *The Music Man*'s "Trouble in River City"—she appears dignified and composed, armed with binders full of policy prescriptions and answers to questions that emphasize the complexity of the social problems she hopes to address as president. When her campaign manager hisses, "Hillary! Attention spans!!" she sighs, hits a pose as red, white, and blue confetti drops from the ceiling, and proceeds to tap-dance. "Sexy."[50] [Figure 6.4] This concession aside, Hwang suggests that Hillary fails to win the election because she remains *an individual* rather than a character—her personal passion for policy detail renders her culturally illegible within the "show" that is the election. Hwang emphasizes this failure in "Smile," the number that opens the second act. Having just lost the election, Hillary sits in sunglasses and a T-shirt that she hasn't changed in several days, surrounded by pizza boxes and ice cream containers. As she binges, she sings:

> I was on the campaign trail for three years.
> Three years! . . . of
> "Hillary, ditch the pantsuit,
> Why, Hillary, aren't your lungs more
> Spry, Hillary, show us your
> MRI, Hillary,
> Try, Hillary, to
> Smile more."
> Smile more.[51]

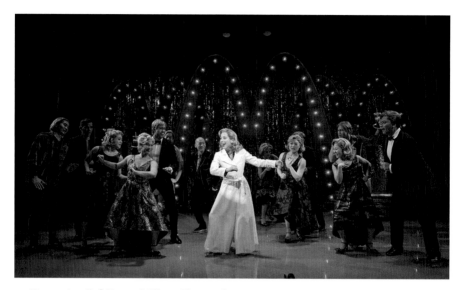

Figure 6.4. *Soft Power:* Hillary Clinton dances at a campaign stop. Courtesy of Joan Marcus.

Hwang repeatedly stresses the tension between content and structure that bedevils both American elections and the American musical. In the first act, Xūe, Hwang, and Zoe continue to debate the ending of *Stick with Your Mistake* after seeing a revival of *The King and I*. Hwang notes the frustratingly Euro-American centricity of Rodgers and Hammerstein's show, which Zoe then notes is part of the "delivery system" of the musical more generally.

HWANG: This white woman teaches the King of Siam how to rule his own country?

XŪE: She is his advisor!

HWANG: Actually, she's a nanny.

XŪE: You agree? No, this is why the show—it is called "The King and I." Someone has to be the King, and someone has to be the "I."

HWANG: But why does the white character always have to be the "I?" . . . It's been this way ever since I was a kid. In these stories, the foreign land's always filled with danger. The white hero manages to talk sense into the crazy natives, falls in love, but ends up going home anyway from that magical place. The writers don't really do their research, so they get all these details wrong.

. . .

ZOE: It's a great delivery system. . . . There's what you want to say—and then there's the delivery system. And musicals have gotta be the best system ever. I mean, when those violins start playing, we are gone. Whatever they feed us goes straight to our hearts. In the rush of a big sugar high.

XŪE: Yes, this is what I want him to do! Use the "delivery system."

ZOE: But make China the "I."

XŪE: To influence the world, not only through riches and guns. What a truly great civilization achieves is "soft power"—through our ideas, inventions, culture—to change the way people think. *Jiang Cuò Jiù Cuò: The Musical* will bring Chinese values to the world.

(Soft Power 7–8)

Xūe and Hillary's pairing—absurd on its face—not only undermines the white-savior narrative of *The King and I*, but enables Hwang to make the point that the delivery system of both the American musical and the American electoral "show" feeds their ideologies in ways that leave audiences unable to process them critically.

The musical within the play highlights how the theatricality of the electoral campaigns (their "delivery vehicle") conceals the actual political nature of elections themselves. During a wildly lyrically convoluted number that explains the tricky mechanisms of the electoral college [Figure 6.5], the chief justice of the Supreme Court is about to reach into the "ballot box" to announce the new president, but pauses first to sing:

The Electoral College ensured that smaller and rural states
Had a disproportional say in selecting
A President
Which in the early days of our great nation
Ensured they could keep their slaves.[52]

The incongruity between the structures of a Broadway show tune and complex political analysis highlights the incompatibility between the theatrical elements of electoral campaigns and the complicated political operations they perform. The lines comprise insightful political and historical analysis but pointedly garbled and confusing song lyrics, and the fact that they and others explaining the electoral college system are set to music highlights the ways that US electoral structures defy easy explanation.

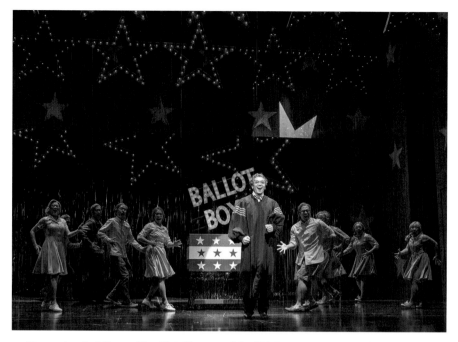

Figure 6.5. *Soft Power:* The Chief Justice of the US Supreme Court explains the electoral college just before announcing Hillary's 2016 loss. Courtesy of Craig Schwartz. Production credit to Center Theatre Group.

Hwang's pointed questions about US electoral conventions open the door to the possibility of China's rise. If US individualism and "freedom" are really just hollow narrative and political clichés, are China's alternatives better? After Xūe talks Trump's cabinet down from war with China, Hillary points out that the US cannot allow China to be the global political leader because it isn't a democracy. Xūe points out that China's political system installs leaders who are the best at their jobs, rather than ones who are merely electable, and insists, "the Ballot Box brings nothing but chaos and instability!"—an assertion difficult to disagree with in the wake of Trump's 2016 electoral success. Hillary agrees, but then sings the musical's climactic power ballad—one of the few emotionally powerful numbers in the musical—on what might be construed as the cruel optimism of democratic potential:

So many times
It's left me battered and bruised
Disillusioned, in pain
Feeling I've been used

I swear I'll give it up
Before it downright kills me
Then it comes back again
With promises that thrill me

And I forget
What I really should know
And I forget
That it's just
A big, big show

And I dream, oh I dream
Of all it could be
And once more,
I believe
I believe
I believe
In democracy

The reprise of the song, performed as an "Impossible Dream"–style finale by the Asian American chorus, raises the possibility that belief in democratic liberalism is probably quixotic, but necessary nevertheless. Xūe repeatedly insists throughout the musical portion of the show that "Democracy doesn't work!" prompting the question of whether Hwang wants the audience to rally to democracy's defense, for which "I believe" is both anthem and—especially in the wake of Trump's electoral victory—eulogy.[53]

The Pacific Century and Creative Democracy

Soft Power comprises a plea to activate the creative power of the US—especially in narrative representational forms such as theater, film, and television—to restore the democratic project to its full potential. As he

has demonstrated repeatedly in his theatrical career, Hwang is a canny enough student of history (particularly in its racial and colonial dimensions) to know that Western liberal democracy has only ever existed as an incomplete project in the US, but he is equally suspicious of China's claims to better political efficacy and justice. Hwang never explicitly engages the messy realities of the state in China—its co-extensive relationship with the Communist Party, its increasingly repressive expressive controls, or the implications of those dynamics for the global cultural market—but neither does he promote or idealize the country. While Hwang dramatizes (in some cases quite spectacularly) the increasingly threadbare and ragged nature of US national mythologies, especially in their individualist orientations, he also very clearly stops short of suggesting China's own individual-state-market configuration as an attractive replacement. Instead, the play leaves open the question of what the ideal form of democratic political organization might be.

The play suggests that China's rise to global superpower is inevitable, that China will simply replace the US in this capacity, with all the linguistic and cultural supremacy that position entails (conveniently achieved for *Ruǎn Shílì* via digital "wetware" that allows the rest of the world to magically comprehend Mandarin with the correct digital-interface implants). This aspect of *Soft Power* perpetuates a peculiarly American view of the world, one in which the possibility of a multilateral international order is never fully considered—there can only be winners and losers in a vertical hierarchy, not a wider distribution of global power. The play reproduces a kind of Cold War organization of the world in this sense, even where it otherwise tries to dispose of it.

If Hwang (perhaps like many of us) longs for a better "delivery vehicle," one that could enable better democratic outcomes and better cultural production alike, this would invite consideration of not just what those forms would look like, but of the processes by which they are imagined. This observation raises the question of whether our current concepts of creativity itself—particularly as they are invoked as protectors of liberal democracy—are themselves also locked in a Cold War framework, with all its attendant limitations. If that is so, how might our ideas about creativity need to change? What capacities, what goals, what values and priorities would need to shift to furnish an alternative to the neoliberal problems that creativity, in its current conceptualization, has entrenched?

From the Ruins

Reconstructing Creativity

I cannot conclude this discussion of concepts of creativity without doing so from the perspective of what Wendy Brown has bleakly termed "the ruins of neoliberalism." Writing in response to the seismic political shock of Donald Trump's election (but prior to the loss and destruction of the COVID-19 pandemic), Brown teases out the disorienting novelties of the current political moment. She makes particular note of the ways leftist analyses of authoritarianism have largely failed to fathom how neoliberalism paved the way for its rise in so many global locations. Her list of the omissions of these accounts is significant in scope, and is worth quoting at length:

> It [leftist analysis] does not register the forces overdetermining the radically antidemocratic form of the rebellion and thus tends to align it with fascisms of old. It does not consider the demonized status of the social and the political in neoliberal governmentality nor the valorization of traditional morality and markets in their place. It does not recognize the disintegration of society and the discrediting of the public good by neoliberal reason as tilling the ground for the so-called "tribalisms" emerging as identities and political forces in recent years. It does not explain how the attack on equality, combined with the mobilization of traditional values, could turn up the heat on and legitimate long-simmering racisms from colonial and slave legacies . . . or the never-go-softly-into-the-night character of male superordination. It

does not register the intensifying nihilism that challenges truth and transforms traditional morality into weapons of political battle. It does not identify how assaults on constitutional democracy, on racial, gender, and sexual equality, on public education, and on a civil, nonviolent public sphere have all been carried out in the name of both freedom and morality.[1]

The question that Brown's analysis and the material of this book leaves us with is this: If "creativity"—or the constellation of concepts, dispositions, institutional networks and imperatives, and personal and social effects gathered under its aegis—has played an important role in the destruction that neoliberalism has wrought, can it also contribute to restoring its "ruins"? Is it so hopelessly compromised as a concept, so irredeemably contaminated as a mechanism of neoliberal seduction, that it needs to be abandoned, or could it be remade (yet again) to carry different associations? And if so, with what? As Brown puts it, "outrage, moralizing, satire, and vain hopes that internal factions or scandals on the right will yield self-destruction are far more prevalent than serious strategies for challenging [authoritarian] forces with compelling alternatives."[2] Might creativity be brought to bear to imagine those strategies of challenge, to produce these more compelling alternatives?

The following is composed in the spirit of "writing the reconstruction." If the post–Civil War Reconstruction promised (and, depending on the historian, largely failed to deliver) a significant restructuring of US social, racial, political, economic, and cultural life, the current moment demands a similar rebuilding.[3] Brown argues that "the ruins" in which we find ourselves are the result of the relentless attacks on the social and the democratic and the unabated insistence on and idealization of the individual at the expense of all else (largely through a marketized, libertarian notion of self). As explored throughout this book, concepts of creativity have served as an important vehicle for those assaults, requiring a redefinition away from prior circulated meanings. If we want creativity to mean—and to operate as—something more than a code word for financialized innovation or marketized iterations of a libertarian self or the distorting cipher for labor precarity, we need to alter our own institutional formations and imperatives.

What would it mean to unmake the creativity complex? How would we do this conceptually and socially? How would we displace, within our

selves and our institutions, the creative *dispositif* that Andreas Reckwitz describes? How might the players that have developed and installed the various institutional networks of the creativity complex—from the arts to education, urban planning, politics, and science and technology—need to think differently about what creativity is and means and how it acts on us all?

Creativity needs to be redefined as a preeminent practice of social relations, and not as the foremost exercise of individualism. As explored in chapter 1, creativity discourses already put a set of social relations into action. The creativity *dispositif*, as Andreas Reckwitz reminds us, is not just a personal desire, but a social imperative, wherein the institutions that structure one's social life now require the behaviors identified with creativity as fundamental to success in them. Moreover, this *dispositif* organizes our relations within a "social regime of novelty" that requires the elevation of a set of evaluators who determine the originality of a given creative endeavor. In this, the institutional life of creativity already comprises a social practice, one that poses markets as the primary arbiters of creative value, and that promotes individualism at the expense of the social in a broader, more communally based sense.[4] As explored repeatedly throughout this book, the concepts of creativity connected most closely to concepts of the individual—especially in its guise as personal "freedom," self-expression, and self-fulfillment (concepts that are often raised in order to conceal the economic rationalist iterations of individualism that drive such articulations in a broader context)—have been most apt to be conscripted to neoliberal ends.

To activate creativity in a more ethical sense, we would need to recalibrate the long association between creativity and the individual, and the broadly atomizing effects of this association. This would involve thinking about the potential creativity has to not only advance self-identity, self-expression, and self-fulfillment as it has since the Enlightenment forward, but its capacity to build social formations that sustain, in the long term, human and planetary ecologies. Along these lines, a clutch of creativity researchers have begun to stress the social-cultural nature of creativity. Following Bakhtin's assertion that "creative understanding requires other people,"[5] Vlad Glăveanu has offered an account of creativity that stresses the interactions between an individual, their social context, and their social network over the operations and activities of a single individual. "Even the most marginal creators," he asserts, "depend on a network of close

collaborators for ideas and for other resources. The creative person never works completely alone and he or she is certainly not situated 'outside' of society for culture. . . . He or she creates from within a network . . . of relations with others and necessarily uses cultural resources, from technology to language. . . . We need thus to expand the 'who' of creativity to include the context of the creative person: collaborators, audiences, gatekeepers, objects, spaces, and ultimately, culture."[6] In Glăveanu's conception, creativity cannot be understood without locating it within its social structures—there can be no creativity in their absence.

Articulating creativity as social practice could blunt the conversion of labor to "human capital" that has marked neoliberal logic so sharply, instead providing a mechanism to enhance "the social" in Brown's broader sense:

> [It is] the place where we experience a linked fate across our differences and separateness. Situated conceptually and practically between state and personal life, the social is where citizens of vastly unequal backgrounds and resources are potentially brought together and thought together. It is where we are politically enfranchised and gathered (and not merely cared for) through provision of public goods. . . . The social is where we are more than private individuals or families, more than economic producers, consumers, or investors, and more than mere members of the nation.[7]

We might note here that Brown's formulation remakes the neoliberal arrangement of the individual, the market, and the state that was analyzed at length in chapter 1. Notably, she removes the market from the structures of social relations altogether, replacing it with this conceptual sphere in which people with different resources and needs "can be brought together and thought together."

The "social turn" in the arts was on some level formulated to enrich precisely this sphere—though as Shannon Jackson has thoughtfully argued, it perhaps does not always manage to reach this goal, partly out of a larger emphasis on a kind of radicality in either formalist innovation or institutional critique, and partly out of a disagreement within the performing and visual arts as to what "the social" actually refers to in the first place.[8] Formalist and institutional concerns fail to engage the sense of shared fate across difference, the enfranchising of the political self, and the realign-

ment of the self beyond the identification as individual, family member, or economic actor that Brown describes. Moreover, as Jackson points out, social art practice is sometimes framed as undermining aesthetic autonomy and personal expression, particularly in contexts where formalist innovation is valued most highly. Such arguments rely, however, on precisely those claims to individual self-expression that this book has tried to complicate, and Jackson's larger point is the false opposition at work in them—explorations of the social need not take place at the expense of the expressive and the innovative or vice versa, a point as true of technological innovation as it is of the arts.[9]

The emphasis on the social on its own would in no way upend or reorient current neoliberal paradigms for creativity, however, many of which already stress concepts of the social (though in a much different sense) in their assumptions about creative activity. This tendency is especially acute in the spatial work of urban planning, architecture, and design, where neoliberalized renderings of the social operate under the guise of "creative placemaking." Heralded as "one of the most rapidly adopted and absorbed terms within cultural policy in the United States, due in part to investments totaling more than $200 million and the implementation of on-the-ground projects in communities of all sizes throughout the country," creative placemaking is eerily similar to previous generations of "urban renewal" projects in its destabilization of neighborhoods to the benefit of upper-income workers, displacing economically vulnerable communities and arts workers alike in the process. Creative placemaking camouflages these processes in the guise of transforming cities into creative cultural and economic zones. Although a variety of urban planners and community activists have begun to advocate for a vision of creative placemaking that recognizes the "legacy of colonization, displacement, encampment, and the removal of entire ethnic groups" and promotes instead the cultural stewardship of existing communities, it is difficult to see how such projects can halt development schemes driven by the real estate sector without a larger political commitment to forms of the social such as community preservation.[10]

Given this, ***the emphasis on creativity as social practice needs to be coupled with models that deemphasize the market***. While markets are currently configured as the primary arbiters of creative value, they do not function in this way naturally or inherently. As Reckwitz reminds us, novelty—the primary watchword for creativity—is itself a social construct,

with parameters that need to be defined and then disseminated across its putative market. In light of this, creativity researchers at the very least need to develop more nuanced models of what markets are and how they operate, for which they would do well to look to their counterparts in humanities research. As decades of humanities researchers have labored to demonstrate, "the market" (a term that denotes a broad range of social formations and institutions) is not in itself a reliable indicator or guarantor of creativity or innovation. The history of the arts is littered with work that was extraordinarily popular but not necessarily innovative or even *good* (in the formal, aesthetic, or ethical senses of that term), and conversely, any number of works have been extraordinarily inventive and conceptually daring, but not remotely successful from a market perspective. Moreover, market forces often *constrain* creativity. To point to the model of the arts again, artists often produce work to earn commissions and sell tickets, and not only to satisfy their own creative or exploratory impulses. The more an artist is dependent on their market, the more their creativity (even in the sense of innovation) is constrained. In the art world, innovation, especially formal innovation that alters how audiences understand narrative or character or visual systems, is often disorienting and confusing precisely because it is novel. The result is that artists are frequently in the position of having to repeat themselves, especially formally, in order to attract audiences. This is equally true of the science and tech worlds—markets produce specific kinds of work, some of which is creative, novel, and innovative, and some of which is not, or is so only where it can be financially maximized.

In this, markets are determined, constrained, driven, and enabled by a range of forces, not just innovation or creativity. The artists most often trotted out as evidence of extraordinary creative achievement are often those most likely to have been "canonized," or considered eminent by a tradition of taste-setting that has everything to do with larger social formations and values. Wide swathes of humanity have traditionally been excluded from these canons, especially those from racially or sexually marginalized communities. These canons have been under scrutiny for some time, with the result that literature and the arts have been taught in quite different ways in humanities departments in the past three decades. While some creativity researchers might point to this shift as evidence of a market adjusting itself to accommodate changing social values, that framing ignores the enormous, concerted pressure that members of excluded

groups have had to mount for decades—often under the threat of significant professional marginalization—against the prevailing academic marketplace, in a project that many humanities academics would argue is at best incomplete. Moreover, even the modest successes of these attempts to remake the humanities have often fueled the "never-go-softly" apocalyptic rage of white, masculine institutional life—inside the academy and out—that Brown describes.

One crucial step that would help reshape concepts of creativity as a social practice shorn of the reliance on markets would be to **embrace models that deemphasize originality and outcome in favor of experience and process**. Vlad Glăveanu and Ronald Beghetto advocate for an alternative "standard definition" that reorganizes creativity around John Dewey's concept of experience, or "the encounter between person and world." Arguing that creativity "does not inhere in products, people, or processes," they insist that it rather "becomes animated in our encounters and entanglements with the people, ideas, objects, projects, situations, uncertainties and actions of everyday life." Glăveanu and Beghetto point out that shifting toward an experience-centric model allows for a conception of creativity freed of outcome—"We identify an experience *as* an experience," they tell us, "precisely because it challenges us, interrupts our usual course of action, it presents us with something for which we don't have a predetermined answer."[11] Creative experience could be redefined as "novel person-world encounters grounded in meaningful actions and interactions, which are marked by the principles of: open-endedness, non-linearity, pluri-perspectives and future-orientation." Such a definition treats outcomes as "temporary stabilizations" that link prior and future activity in an extended temporal chain, and moreover sees these as part of an interactive process. This experience-based conception instead shifts the emphasis from an evaluative model to one of cultivation, connecting creativity to "what [people] do and how they live their lives." This shift, Glăveanu and Beghetto argue, opens the door to a model of creativity that foregrounds the ethical imperative to "recogniz[e] the role of our encounters with the world, especially the world of others."[12]

Glăveanu and Beghetto's experience-based model enables a further expansion of creativity from a form of social practice to a form of social *process*. In this model, creativity would engage "the social" not only as a sphere of activity in Brown's sense, but as a kind of temporal unfolding. In other words, creativity would emphasize not just the conceptual *space*

of thinking together across difference, but the ongoing process of doing so. Such a recognition—"future-oriented" in Glăveanu and Beghetto's framing—could counter forms of revanchist "stuckness" in either political or aesthetic senses.

Process-based definitions of creativity such as experience-centered ones would also ***help creativity advocates shift to a model that promotes ethical precepts, especially those that attempt to anticipate impact.*** Creativity in itself is not necessarily beneficial—all manner of creative activity has been destructive to any number of ends. Cambridge Analytica is an enormously creative tech firm—but primarily in undermining the democratic operations of nations all over the world, including in the US.[13] This is hardly a salutary development, even though it very much operates as part of an economic sector hailed for its creative achievements and often excused for its ethical lapses in no small part for its putative daring and innovation. The valorization of creativity as a good in its own right is wildly problematic in this regard, especially in the institutions and arenas that have the broadest impact on social life—it leads to precisely the forms of ego gratification and narcissism addressed in chapter 5, and paves the way for the relentless social attacks that Brown describes, attacks exemplified by "creative society" models implemented by figures such as Ronald Reagan in chapter 2.

In light of these precepts, creativity research needs to ***expand its interdisciplinary model to incorporate the work of the arts and humanities.*** From the perspective of the humanities, it's quite shocking how much research on creativity—which is often impressively interdisciplinary in its orientation—not only sidesteps the research on and practice of art and literature, but actively recirculates and relies on a set of assumptions and even mythologies that have been debunked and repudiated by humanists for at least thirty years now. But because creativity research tends to occur primarily in the interstices of psychology, business studies, education, and urban planning (and in return influences policy and practice in the last two arenas especially), the insights and debates of the humanities have been almost totally absent from the field. For all that psychology researchers on creativity have insisted on empirical and quantitative methods to dispel the fuzzy, mystical conceptions of creativity that they see (not unreasonably) as having animated Romantic conceptions of it from their inception, these methods have largely failed to demythologize creativity in a broader social sense. If anything, this research has actually fed the kind of

occultist idealization of creativity that Walter Benjamin deplored as early as the 1930s and that John Gardner called out as a species of magical thinking in the 1960s.[14] Creativity researchers would find much to aid their goal of demythologizing creativity within humanities research.

To help address these lapses in the field, researchers in creativity need to ***abandon the "two cultures" mentality that poses the arts and sciences as fundamentally distinct domains of activity, and that reduces the arts to a symbolic role***. The un/conscious retention of the "two cultures" mentality reinforces a set of mythologies about the arts that have been largely discredited, but does so primarily by making a set of wildly erroneous assumptions about artists' behavior, particularly around assumptions of discipline, or lack thereof. As figures such as Andrew Ross and Andreas Reckwitz point out, the arts have become the blueprint for the creativity *dispositif* not just for their supposed capacity for self-expression, but for the extraordinary level of dedication and sheer hard work required in the arts, often to the detriment of social, emotional, and financial stability. Artists are not the foil for qualities of drive, focus, discipline, and—above all—personal sacrifice, they are central models for these behaviors. It is precisely this suite of characteristics that has made the life of the artist—including its notorious financial instability—the blueprint for neoliberal labor paradigms such as gig work and cottage labor.

Creativity researchers need to acknowledge that there is no creatively healthy society without a thriving arts world. It is beyond time for creativity researchers to recognize that no culture or society can be fully creatively healthy if the arts are subordinated as a domain of activity. The arts can no longer be treated as merely the "model" for creative behaviors or dispositions that can then be transported to other domains while artists themselves languish, culturally and financially. Societies that are highly creative—in the multiple-domain sense in which that term is now defined—have thriving arts communities. If the arts are not supported in institutionally sustaining ways (and not at just the single-project level currently available via crowdsourcing platforms), the larger culture and society they operate within are not creatively healthy. These might be technocratically healthy (and one could argue that the explosion in digital tech creativity is largely a technocratic achievement), but that is a fundamentally different achievement than a creatively healthy world.

Perhaps no organization exemplifies the ways that creativity in the techno-economic sense trammels artistic creativity and undermines eco-

nomic sustainability—and in the process exposes the profound contra-
dictions and distortions of the idea of "creative human capital"—better
than music-streaming giant Spotify. The largest music-streaming plat-
form in the world, capturing over 30 percent of the 2021 global market (a
figure double that of its closest competitor, Apple),[15] Spotify notoriously
underpays its musicians, even by the standards of other music platforms.
Artists are usually paid between $0.003–0.005 per stream, requiring on
the order of 250–300 plays to net a single dollar.[16] In the words of *New
Yorker* columnist Alex Ross, its payout schemes have "reaped huge profits
for major labels and for superstars while decimating smaller-scale musical
incomes," comprising "as perfect an embodiment of the winner-takes-
all neoliberal economy as has yet been devised."[17] Because of its mar-
ket dominance, musicians feel compelled to participate in the platform,
even with such paltry payouts, and are often legally obligated to do so
by record-label contracts. While the platform claims that the streaming
service sets musicians up with a fan base that will pay to see live concerts,
musicians point to the company's ability to offer huge payouts for things
like celebrity podcasts (most recently the notorious $100 million con-
tract to misinformation supporter Joe Rogan), and note that the payout
scheme per dollar of revenue is appallingly exploitative of the people who
actually created and made the music, even though this is supposedly the
platform's primary product.[18]

Spotify upends whatever commitment to artisanship resides in the sup-
posed creative economies of both the music and tech worlds. If anything,
Spotify's greatest creative achievement lies less in streaming technologies
than in bending these technologies toward forms of financial innovation.
As music writer Damon Krukowski puts it:

> Spotify used the financial model of arbitrage to obtain a cheap if not
> free product—digital music—and resell it in a new context to realize
> profit. In other words, Spotify's profit *requires that digital music have
> no value*. Spotify continually talks down the value of music on their
> platform—they offer it for free; they tell musicians we are lucky to
> be paid anything for it; they insist that without their service, there is
> only piracy and zero income. Most tellingly, they invest nothing back
> into music. Unlike a record label, publisher, or most anyone else in the
> music industry, Spotify devotes none of its profits to the development
> of new recordings.[19]

Like other media platforms launched in the first decade of this century—social media platforms in particular—Spotify operates this way because in a significant sense it is not a *music* service; it is a media corporation that happens to stream music as a lure for its primary product, which is not music at all but its listeners, who are then sold as data sets to advertisers. As a team of Swedish media researchers seeking to understand Spotify's operations points out:

> Since 2015, Spotify has implemented a plan—and the technology—to generate data based on its music streaming that allow for the study of human behavior at scale. The company acts, in other words, not only as a music provider but also as a private data broker. It has openly promoted its massive collection of contextual data as a service to marketers . . . it knows what you listened to and what it meant to you.[20]

Spotify's simultaneous exploitation of musicians and listeners alike ("where music has become data and data has become contextual material for user profiling at scale")[21] offers an extraordinarily clear example of how innovation for its own sake not only financially destroys the very artists who are supposedly the models of creative work, but does so in ways that are potentially even more broadly socially damaging. In the case of Spotify, this occurs via its operation as surveillance capitalism. In Shoshanna Zuboff's definition:

> Surveillance capitalism unilaterally claims human experience as free raw material for translation into behavioral data. Although some of these data are applied to produce or service improvement, the rest are declared as a proprietary *behavioral surplus*, fed into advanced manufacturing processes known as "machine intelligence," and fabricated into *prediction products* that anticipate what you will do now, soon, and later. Finally, these prediction products are traded in a new kind of marketplace for behavioral predictions that I call *behavioral futures markets*.[22]

In a shockingly perfect instance of how surveillance capitalism not only exploits those who produce its supposed product, but, more chillingly, the social fabric more broadly, one of Spotify's great admirers is Michal Kosinski, the Stanford psychologist who developed the data model for behavioral prediction used by Cambridge Analytica. Kosinski was reportedly enraptured by Spotify's algorithms for their sensitivity in discerning lis-

tener's feelings, which could then be used to more reliably predict personality traits and the kinds of decisions that resulted from them, processes on which he conducted research.[23] Despite Kosinski's warnings that it could be used this way, his research was taken up by Cambridge Analytica to undermine the democratic electoral process in multiple countries.[24] In this example, the same technologies that undermine the vibrancy of the arts are also used to unmake democracy more generally. Notably, these effects are masked via claims to the social, often by mimicking the language of egalitarianism.[25] The very term "social media" operates in this way, as does the common defense social media companies make that they democratize access to content generation. Here, creativity is not the antidote to surveillance capitalism, it is its primary lure.

The responsibility for unmaking the creativity complex cannot reside solely with researchers, however. A creatively healthy society requires a social, political, and financial model through which artists—alongside other workers—can live on their labor as artists. This entails not only a living wage, but a feasible cost of living, which is increasingly rare in the major cities the world over that are most closely associated with the arts. Given the ways that the labor structures of the artist have formed the model for neoliberal labor paradigms, *the financial structures of the arts must change*. To facilitate this, artists and the arts institutions with which they work must begin the difficult work of finding an alternative to the financial structures of gig employment. In the run-up to the 2020 passage of California's Proposition 22, the tech corporation–backed initiative to repeal labor laws designed to protect contract "gig" workers, a disturbingly high number of freelance workers, especially in journalism and the arts, joined tech behemoths like Uber in supporting the proposition.[26] The Facebook group "Freelancers against AB5" (the California legislative bill that required tech companies to treat gig workers like employees rather than subcontractors) had more than 17,000 members, including a distressingly high number of artists, and a significant number of op-ed pieces in favor of Proposition 22 were written by artists and journalists.[27] This support for a corporate revolt against progressive, state-based labor protections was largely the result of not-unrealistic fears that were freelancing to be regulated, even the paltry forms of compensation available to artists, writers, and journalists would evaporate. This was an extraordinary moment in which artists

elected to undermine attempts to ameliorate labor precarity. Rather than address the systemic instability created by gig-structured work, freelancers chose to help tech corporations eviscerate the protections created by the new California labor law, despite the fact that the gig structure of artist labor is one of the factors that undermines the long-term stability of the arts. For the latter to change, artists, and—more importantly— arts institutions and the systems that fund them, need to find alternatives to current financial and funding models. Among these, matters such as salary, health care, and housing all need to be part of the picture that arts institutions and granting agencies address.

Alongside the changes necessary within arts institutions, *arts educators, especially in higher education, need to publicly identify instances where our "creative"-based projects or creative capacities comport with neoliberalism's damaging effects*. As I note in the introduction to this volume, arts faculty generally lend their credibility to creativity-complex projects in the desperate hope that these projects will help rectify their dispiritingly defunded state. But at some point, we need to acknowledge that doing so usually colludes with a set of political and institutional structures that undermine the vivacity and survival of the arts. When we join these activities, we should do so specifically to help shift the definitions of creativity used, and to head off further incursions of individualism and ethical blindness. Were these changes implemented, *the arts could be one of the primary social institutions in which alternative, sustainable forms of social life could be imagined, particularly in conjunction with educational institutions*. The arts could be a site for reimagining labor structures, and through this, could serve as a test site to reconfigure the relationship between creative activities and the market. Given the ways the arts have served as a model for the market as well, their restructuring along those lines could have a significant social impact.

But perhaps most importantly of all, *the social institutions at our disposal—the arts, education, and more—could turn creative capacity to counter the relentless nihilism of our current social moment*. In *From the Ruins*, Brown addresses the process and effects of nihilism on our social world, taking her definition from philosopher Hans Sluga. In nihilism, Brown sees not merely the idealization of neoliberal imperatives such as marketization, entrepreneurialism, and financialization, but the "devaluing of value" itself.[28] She quotes Sluga's observation that:

[nihilism] is not a condition of anomie; it is rather a state in which the values we possess have become unanchored. This will show itself in a multiplication of values, in the production of ever new values, but also in their ever-continuing devaluation, in their constantly being discarded and replaced. Values themselves have thus lost their value; and there are, consequently, no higher or lower values; all values are equal; they have become fashions that come and go all equally trivial. In this condition, no greatness is possible anymore, triviality itself becomes one of our values. One sign of this form of nihilism is the dissolution of the distinctions between the true and the false, the moment when we can no longer discriminate between real and fake news.[29]

In Brown's reading, the impact of nihilism is to lessen "the claim and force of conscience both formed and chained by values," in particular the values of "democracy, equality, truth, reason, and accountability."[30] The process of unmooring these values nurtures, unleashes, and intensifies aggression and violence, and moreover produces a social field in which the "accommodation or acquiescence to social and political violence" becomes the norm.[31] Nihilism organizes the social response to human and civil rights abuses, global health crises, and planetary collapse alike. It simply obliterates information, logic, empathy, connectedness, and the very concept of a social compact, let alone a social imagination.

If we are to avoid the wholesale destruction of the very institutions that make up our social world, we must turn them, urgently, to an antinihilistic project. One way for those in the arts to rearticulate their own creative capacities is to express them in relation to precisely this goal. Redefining creativity as the social process by which the values Brown names could be rearticulated and reconnected—to one another, to our institutional identities and formations, and to our sense of self—could powerfully reorient the way we communicate the worth and merit of the arts. In other words, we could stop articulating the primary benefit of the arts in terms of "creativity" and instead describe it in the above terms.

In the realm of practice, artists could not only imagine counternihilistic alternatives, they could—and preferably should—join other institutional spheres in this labor, rather than disparaging them as amateur. Professional artists could, for example, join systems of education to develop pedagogies of creativity not limited to instrumentalizing and object-making (as

currently happens in the absorption of Maker-centered learning), but expanded to restructure curricular spheres to reimagine and enliven our discussions of what "value" means—that core entity unmoored from meaning and social force by neoliberalism. This could involve rethinking everything from forms of intimacy to consumption patterns and labor arrangements, but also a reconceptualization of how we engage the project of cohabitation, with each other and with the other species of our planet.

This, at its heart, is the project of reconstruction ahead of us all.

Notes

Introduction

1. Ken Robinson, "Do Schools Kill Creativity?" filmed 2006, TED video, 19:12, https://www.ted.com/talks/sir_ken_robinson_do_schools_kill_creativity /transcript?language=en#t-132537. Diversus Health, "The Mental Health Benefits of Creativity," https://diversushealth.org/the-mental-health-benefits-of-creati vity/. Brad Brenner, "Creativity is Your Secret Advantage for Mental Health and Well-Being," Therapy Group of NYC, September 16, 2019, https://nyctherapy.com /therapists-nyc-blog/creativity-is-your-secret-advantage-for-mental-health-and-well -being/. "IBM 2010 Global Study: Creativity Selected as Most Crucial Factor for Future Success," IBM, May 18, 2010, https://www.ibm.com/news/ca/en/2010/05 /20/v384864m81427w34.html. Tiffany Rowe, "Why More Business Schools Are Teaching Creativity," *Startup Digest*, April 13, 2017, https://web.archive.org/web /20201127031937/http://blog.startupdigest.com/2017/04/13/business-schools-tea ching-creativity/

2. John Gardner, *Self-Renewal: Innovation and the Innovative Society* (New York: HarperCollins, 1963), 32.

3. See for example Imre Szeman, "Neoliberals Dressed in Black; or, the Traffic in Creativity," *ESC: English Studies in Canada* 36, no. 1 (March 2010): 21, and Laura D. Nielsen, "Heterotopic Transformations: The (Il)Liberal Neoliberal," in *Neoliberalism and Global Theatres: Performance Permutations*, eds. Laura D. Nielsen and Patricia Ybarra (London: Palgrave MacMillan, 2012), 1–24.

4. Victor Daniels, "Handout on Carl Gustav Jung," accessed July 2, 2021, https://web.sonoma.edu/users/d/daniels/jungsum.html. For a more formal definition, also see the entry on "complex" in *Psychoanalytic Terms and Concepts*, which defines it as "an unconscious, organized group of thoughts, images, and associations, often originating in early childhood, which are highly emotionally charged and which exert a structuring influence on conscious attitudes and behavior." Eliza-

beth L. Auchincloss and Eslee Samberg, eds., *Psychoanalytic Terms and Concepts*, 4th ed. (New Haven: Yale University Press, 2018), 40.

5. Hugh Heclo, "Issue Networks and the Executive Establishment," *Public Policy Theories, Models, and Concepts: An Anthology*, ed. Daniel C. McCool (Hoboken, NJ: Prentice Hall, 1995), 275.

6. In political scientist Hugh Heclo's account, "Issue networks comprise a large number of participants with quite variable degrees of mutual commitment or of dependence on others in their environment; in fact it is almost impossible to say where a network leaves off and its environment begins." In effect, no one player or set of players determines how a particular issue plays out: "Rather than groups united in dominance over a program, no one, as far as one can tell, is in control over the policy and issues." Heclo, "Issue Networks," 275.

7. David Harvey, *A Brief History of Neoliberalism* (New York: Oxford University Press, 2007), 5.

8. Catherine Kingfisher and Jeff Maskovsky, "The Limits of Neoliberalism," *Critique of Anthropology* 28, no. 2 (2008): 120.

9. Wendy Brown, *Undoing the Demos: Neoliberalism's Stealth Revolution* (New York: Zone Books, 2017), 31.

10. Wendy Brown, *In the Ruins of Neoliberalism: The Rise of Antidemocratic Politics of the West* (New York: Columbia University Press, 2019), 182.

11. Szeman notes, "In recent social and political thought, creativity seems to have become nothing short of the defining element of human being: we are no longer *homo faber* but *homo genero*." Szeman, "Neoliberals Dressed in Black," 34. Scholarly works like Zoltan Kőváry's *Homo Creativus: The Psychobiographical Study of Eminent Creativity* (New York: Scholars' Press, 2017) simply reinforce Szeman's point.

12. Foucault defines the "technologies of the self" as one of four disparate forms of "truth games . . . that human beings use to understand themselves," those that "permit individuals to effect . . . a number of operations on their own bodies and souls, thoughts, conduct, and way of being, so as to transform themselves in order to attain a certain state of happiness, purity, wisdom, perfection, or immortality." Michel Foucault, "Technologies of the Self," in *Technologies of the Self: A Seminar with Michel Foucault*, eds. Luther H. Martin, Huck Gutman, and Patrick H. Hutton (Amherst: University of Massachusetts Press, 1988), 18.

13. Jon McKenzie, *Perform or Else: From Discipline to Performance* (New York: Routledge, 2001); for an example of creativity as an economic imperative, see Angela McRobbie, *Be Creative: Making a Living in the New Culture Industries* (London: Polity Press, 2016).

14. Raymond Williams, *Keywords: A Vocabulary of Culture and Society*, revised ed. (New York: Oxford University Press, 1983), 84.

15. William Deresiewicz, "The Death of the Artist—and the Birth of the Creative Entrepreneur," *The Atlantic*, January/February 2015, http://www.theatlantic

.com/magazine/archive/2015/01/the-death-of-the-artist-and-the-birth-of-the-creat ive-entrepreneur/383497/

16. My own department, for example, used this argument in our organizational description for external academic program review—a review I very much participated in and helped to author, including on this point. On creativity's desirability among employers, "According to a major new IBM survey of more than 1,500 Chief Executive Officers from 60 countries and 33 industries worldwide, chief executives believe that—more than rigor, management discipline, integrity or even vision—successfully navigating an increasing complex world will require creativity." "IBM 2010 Global Study," IBM, https://www.ibm.com/news/ca/en/2010/05/20/v38486 4m81427w34.html

17. Harvey Young, "3 Reasons a Theater Degree Is Important, Even in Today's Economy," *Backstage*, April 3, 2013, http://www.backstage.com/advice-for-actors /backstage-experts/3-reasons-theater-degree-important/

18. Young, "3 Reasons," original emphasis.

19. For an elaboration of this argument, see Alan Liu, *The Laws of Cool: Knowledge Work and the Culture of Information* (Chicago: University of Chicago Press, 2004), 15.

20. The concept behind "creative economies" travels under different banners in different regions: "creative economy" is its name in the US, but it is often referred to as the "orange economy" in Latin America, or "culture industries" in Europe.

21. For a commentary on the changing conceptions of creativity between the European Renaissance and the mid-twentieth century, see Raymond Williams's characteristically elegant entry on the term in *Keywords: A Vocabulary of Culture and Society*, revised ed. (London: Oxford University Press, 1983), 84.

22. Richard Florida, *The Rise of the Creative Class: Revisited* (New York: Basic Books, 2014), 5–6.

23. Florida, *Rise of the Creative Class*, 6.

24. John Howkins, *The Creative Economy: How People Make Money from Ideas* (London: Allen Lane, 2011).

25. For an example of this, we might look to former British Prime Minister Tony Blair's 2007 comment that "a nation that cares about art will not just be a better nation. In the early 21st century, it will be a more successful one." Quoted in Jen Harvie, *Fair Play: Art, Performance and Neoliberalism* (Basingstoke, UK: Palgrave Macmillan, 2014), 67.

26. We can see this mode of thought at work in the ways that the Burning Man arts festival in the Nevada desert became a key breeding ground for Silicon Valley innovation, embraced by creative corporate titans like Google and Facebook in their workspace interior design and web personae alike. For more on how Burning Man is seen to inculcate innovative thinking for Silicon Valley's tech labor force, see Fred Turner, "Burning Man at Google: A Cultural Infrastructure for New Media Production," *New Media & Society* 11, nos. 1 & 2 (2009): 73–94.

27. Laikwan Pang, *Creativity and Its Discontents: China's Creative Industries and Intellectual Property Rights Offenses* (Durham, NC: Duke University Press, 2012), 14.

28. See Wendy Brown, who claims this diminishment as a hallmark of neoliberalism. Given the extent to which neoliberalism operates in widely varying ways in disparate geopolitical locales, we might note those regions (China, to name one example) in which the state has not diminished at all, but remains the primary agent in managing neoliberalist dynamics within its borders. Wendy Brown, "Neo-liberalism and the End of Liberal Democracy," *Theory and Event* 7, no. 1 (Winter 2003).

29. "Neoliberal rationality disseminates the *model of the market* to all domains and activities even where money is not at issue—and configures human beings exhaustively as market actors, always, only, and everywhere as *homo oeconomicus.*" Brown, *Undoing the Demos*, 31.

30. Andrew Ross, *Nice Work if You Can Get It: Life and Labor in Precarious Times* (New York: New York University Press, 2009), 16.

31. While many economists touted the advantages of the gig economy in the wake of the 2008 economic collapse, there have been many critics as well. See Gerald Freidman, "The Rise of the Gig Economy," *Dollars and Sense: Real World Economics* (March/April 2014): 28–29, http://dollarsandsense.org/archives/2014/031 4friedman.html. For an example of those arguing the positive potential of the gig economy, see Micha Kaufman, "The Gig Economy: The Force that Could Save the American Worker?" *WIRED*, September 17, 2013, http://www.wired.com/2013/09 /the-gig-economy-the-force-that-could-save-the-american-worker/

32. Brown, *In the Ruins of Neoliberalism*, 38–39.

33. McRobbie, *Be Creative*, 2.

34. McRobbie, Be Creative, 11.

35. McRobbie, Be Creative, 11.

36. Ruth Ann Stewart, "The Arts and Artist in Urban Revitalization," in *Understanding the Arts and Creative Sector in the United States*, eds. Joni Maya Cherbo, Ruth Ann Stewart, and Margaret Jane Wyszomirski (New Brunswick, NJ: Rutgers University Press, 2008), 115–16.

37. St. Ann's Warehouse, for example, had rent-free space for nine years. See Sharanya Haridas, "How Did Dumbo Become Dumbo?" http://thebrooklynink .com/2013/11/05/53045-how-did-dumbo-become-dumbo/. Posted November 3, 2013, accessed August 4, 2015. For a sense of how real estate values have risen in the neighborhood, see Michelle Higgins, "Dumbo Roars," *New York Times*, September 19, 2014, http://www.nytimes.com/2014/09/21/realestate/transforming-a-brookl yn-neighborhood-with-new-condos.html

38. For an analysis of the interrelated fortunes of urban transport infrastructure and the real estate market in San Francisco, where these issues have led to the now well-known "Google Bus protests," see Alexandra Goldman, "The 'Google Shuttle Effect': Gentrification and San Francisco's Dot Com Boom 2.0," master's thesis

(University of California–Berkeley, 2013). For a longer commentary on how Silicon Valley is changing the cultural landscape of San Francisco, see Rebecca Solnit, "Diary," *London Review of Books* 35, no. 3 (February 7, 2013): 34–35, and Rebecca Solnit, "The Boom Interview: Rebecca Solnit," *Boom* 4, no. 2 (Summer 2014), http://www.boomcalifornia.com/2014/06/the-boom-interview-rebecca-solnit/

39. Ross, *Nice Work if You Can Get It*, 18–19.

40. C. P. Snow, *The Two Cultures and the Scientific Revolution* (Cambridge: Cambridge University Press, 2013).

41. Sarah Brouillette, "Creative Labor," *Mediations: Journal of the Marxist Literary Group* 24, no. 2 (Spring 2009): 148.

42. Szeman, "Neoliberals Dressed in Black," 30.

43. Colleen Lye, *America's Asia: Racial Form and American Literature* (Princeton: Princeton University Press, 2004).

Chapter 1

1. Vlad Glăveanu, *The Creativity Reader* (Oxford: Oxford University Press, 2019), 7–8.

2. Andreas Reckwitz, *The Invention of Creativity: Modern Society and the Culture of the New*, trans. Steven Black (Cambridge: Polity, 2017), 1.

3. See for example Imre Szeman's powerful and trenchant analysis of Florida in "Neoliberals Dressed in Black; or, the Traffic in Creativity," *ESC: English Studies in Canada* 36, no. 1 (March 2010): 15–36, and Sarah Brouillette, "Creative Labor," *Mediations: Journal of the Marxist Literary Group* 24, no. 2 (Spring 2009): 140–49.

4. Reckwitz, *The Invention of Creativity*, viii.

5. Zubin Meer, "Introduction: Individualism Revisited," in *Individualism: The Cultural Logic of Modernity*, ed. Zubin Meer (Lanham, MD: Lexington Books, 2011), 1.

6. Meer, "Introduction."

7. Reckwitz, *The Invention of Creativity*, viii.

8. Reckwitz, *The Invention of Creativity*, 3.

9. Reckwitz, *The Invention of Creativity*, 19–22.

10. The "standard definition" is a key feature of scientific research methodologies, wherein the authorizing figures of a research area define the central parameters of an object of study.

11. In his essay "The Concept of Creativity," Sternberg identifies the "mystical" approach to the study of creativity as both one of its key paradigms and one of its primary "roadblocks": "The study of creativity has always been tinged—some might say tainted—by associations with mystical beliefs. Perhaps the earliest accounts of creativity were based on divine intervention. . . . The mystical approaches to the study of creativity have probably made it harder for scientific psychologists to be heard. Many people seem to believe, as they do about love, that creativity is some-

thing that just doesn't lend itself to scientific study, because it is a spiritual process. We believe that it has been hard for the scientific approach to shake the deep-seated view of some people that, somehow, scientific psychologists are treading where they should not." Robert J. Sternberg and Todd I. Lubart, "The Concept of Creativity: Prospects and Paradigms," in *Handbook of Creativity*, ed. Robert J. Sternberg (New York: Cambridge University Press, 1998), 4–5.

12. Mark Runco, *Creativity: Theories and Themes: Research, Development, and Practice* (Cambridge, MA: Academic Press, 2006), 394.

13. Mark Runco and Garrett J. Jaeger, "The Standard Definition of Creativity," *Creativity Research Journal* 24, no. 1 (2012): 92.

14. Reckwitz, *The Invention of Creativity*, 24.

15. Runco and Jaeger, "The Standard Definition of Creativity," 92.

16. Reckwitz, *The Invention of Creativity*, 24.

17. "A focus on outcomes alone only fuels implicit assumptions about the linearity of creativity (i.e., processes moving forward toward resolution), and its finality (i.e., once the process has been completed, the outcome is rendered and fixed)." Vlad Glăveanu and Ronald A. Beghetto, "Creative Experience: A Non-Standard Definition of Creativity," *Creativity Research Journal* 33, no. 2 (2021): 75–80.

18. "Create," 2a. "c1457 J. Hardyng *Chron.* (Lansd.:Hammond) 235 (*MED*), His brother Vmfray next hym he dyd create The duke so than of Gloucestre by style," *Oxford English Dictionary*, accessed May 15, 2015, http://www.oed.com/view/Entry/4406

19. In parallel to this observation, Reckwitz notes that the period since the eighteenth century has witnessed an unprecedented "concentration of social and cultural practices and discourses focused on the human subject," which were split between moralizing and disciplining projects on the one hand, and others like Romanticism that focused on interiority, with the concomitant self-reflexive attention to emotion, perception, imagination, and thought. Reckwitz, *The Invention of Creativity*, 21.

20. Robert S. Albert and Mark A. Runco, "A History of Research on Creativity," *Handbook on Creativity* (New York: Cambridge University Press, 1998), 21.

21. James Engell, *The Creative Imagination: Enlightenment to Romanticism* (Cambridge, MA: Harvard University Press, 1981), 15.

22. Engell, *The Creative Imagination*, 83. For a fuller explanation of Schelling's distinction between these terms, see 313–19. Engell notes that Schelling claimed that "the nature we perceive is the material side of a grand dialectic. It is actually part of an ideal world [in the Platonic sense]. Consequently, nature is as meaningful as a mind; it is as meaningful as the ego or self. It is a huge arena in which the individual human mind can seek the moving spirit of the world, and in which we learn to imitate the divine creative force."

23. Engell, *The Creative Imagination*, 80.

24. William Wordsworth, *The Prelude* 1805, Book XIV, l. 192. In Wordsworth, *The Prelude: The Four Texts* (1798, 1799, 1805, 1850), ed. Jonathan Wordsworth (London: Penguin Books, 1995), 521.

25. Engell, *The Creative Imagination*, 79.

26. It is notable, for example, that despite the fact that Runco and Albert identify James Engell's magisterial *The Creative Imagination* as central to their understanding of how ideas about creativity morphed from the Enlightenment to the Romantic era, they significantly flatten the wide-ranging and convoluted history of the term that Engell lays out. While Engell's book does lay out the term's circulation, the intellectual debates and ideas he charts are extremely complex and nuanced at best, and in no way lend themselves to a picture of straightforward, linear development.

27. Lee Marshall, *Bootlegging: Romanticism and Copyright in the Music Industry* (Thousand Oaks, CA: SAGE Publishing, 2005), 8.

28. Raymond William, *Keywords: A Vocabulary of Culture and Society*, revised ed. (New York: Oxford University Press, 1983), 84.

29. "Create," 2c, quoted from Frederick William Robertson, *Sermons, Preached at Trinity Chapel, Brighton, Third Series* (London: Smith, Elder and Co., 1857), Oxford English Dictionary, accessed 15 May 2015.

30. Harold Bloom, *The Anxiety of Influence: A Theory of Poetry* (New York: Oxford University Press, 1973).

31. Marshall, *Bootlegging*, 45.

32. Marshall, *Bootlegging*, 2

33. Marshall, *Bootlegging*, 2.

34. Marshall, *Bootlegging*, 2.

35. Albert and Runco, "A History of Research on Creativity," 21.

36. Maciej Karwowski and Dorota Jankowska, "Sir Francis Galton and the 'Statistics of Mental Imagery,'" in *The Creativity Reader*, ed. Vlad Glăveanu (Oxford: Oxford University Press, 2019), 87.

37. Francis Galton, *Hereditary Genius: An Inquiry into Its Laws and Consequences*, 2nd ed. (New York: Macmillan, 1892), 348.

38. Francis Galton, *Hereditary Genius: An Inquiry into Its Laws and Consequences* (London: Macmillan and Co., 1869), v.

39. "I look upon the peerage as a disastrous institution, owing to its destructive effects on our valuable races. The most highly-gifted men are ennobled; their elder sons are tempted to marry heiresses [who, Galton concluded, as the sole children of their parents had fertility problems that led to low or no issue], and their younger ones not to marry at all, for these have not enough fortune to support both a family and an aristocratical position. So the side-shoots of the genealogical tree are hacked off, and the leading shoot is blighted, and the breed is lost forever." Galton, *Hereditary Genius*, 2nd ed., 132–33.

40. Runco and Albert call *Hereditary Genius* "Galton's most direct contribution to research on creativity." Albert and Runco, "A History of Research on Creativity."

41. Galton, *Hereditary Genius*, 2nd ed., xxv.

42. Galton, *Hereditary Genius*, 2nd ed., xxiv and xxvi.

43. Galton, *Hereditary Genius*, 2nd ed., vii.

44. Madelle Becker, "Nineteenth-Century Foundations of Creativity Research,"

Creativity Research Journal 8, no. 3 (1995): 219–29. For a typical example of the deflection tendency, Dean Keith Simonton notes in his introduction on Galton's "English Men of Science: Their Nature and Nurture" that Galton endowed a chair in Eugenics in his name at University College London, and that after Eugenics became "largely discredited by some rather ugly applications that occurred in the first half of the 20th century," the chair was renamed the Galton Chair in Genetics. While Simonton admits to Galton's own "extreme" views, he also distances them from their actual application. *The Creativity Reader*, 292.

45. Karwowski and Jankowska, "Sir Francis Galton," 87.

46. See the table of contents for *Hereditary Genius*, 2nd ed., vii.

47. Galton, *Hereditary Genius*, 2nd ed., 225.

48. Galton, *Hereditary Genius*, 2nd ed., 227.

49. Glăveanu, *Creativity: A Very Short Introduction* (Oxford: Oxford University Press, 2021), 29.

50. *OED* "Create" 2c. Quoted from Samuel Foote, *The Patron: A Comedy*. London: 1764.

51. Lewis Terman, *Genetic Studies of Genius* (Stanford: Stanford University Press, 1925), vii.

52. Lewis Terman, *The Measurement of Intelligence* (New York: Houghton, Mifflin and Co., 1916), 91–92. At one point in his account, Terman "liberally" estimated the average IQ of California's children of Mexican immigrants at around 80, which would have ranked them as a group at the level of "borderline mental disability."

53. Terman, *The Measurement of Intelligence*, vii.

54. Terman, *The Measurement of Intelligence*, vii.

55. In addition to serving as the president of the American Psychological Association from 1899 to 1903, Dewey created the University of Chicago Laboratory School in the 1896, and served as faculty at Columbia Teacher's College from 1903 to his retirement in 1930.

56. John Dewey, "Creative Democracy—The Task Before Us," https://www.philosophie.uni-muenchen.de/studium/das_fach/warum_phil_ueberhaupt/dewey_creative_democracy.pdf

57. In "Creative Democracy," Dewey argued that "democracy is a *personal* way of individual life; that it signifies the possession and continual use of certain attitudes, forming personal character and determining desire and purpose in all the relations of life. . . . [P]ut into effect, it signifies that powerful present enemies of democracy can be successfully met only by the creation of personal attitudes in individual human beings; that we must get over our tendency to think that its defense can be found in any external means whatever, whether military or civil, if they are separated from individual attitudes so deep-seated as to constitute personal character." 3.

58. See J. P. Guilford, "Three Faces of Intellect," *American Psychologist* 14, no. 8 (1959): 469–79; Robert S. Albert, "The Concept of Genius and Its Implications for

the Study of Creativity and Giftedness," *American Psychologist* 24 (1969): 743–53; Albert, "Toward a Behavioral Definition of Genius," *American Psychologist* 30, no. 2 (1975): 140–51. Later research psychologists did recognize at least some of the limitations of linking creativity and genius. In his 1960 essay "The Concept of Genius," Albert noted the shortcomings of this pairing, though primarily for the ways it limited the universal cultivation of creativity and intelligence: "It is unfortunate that the concept of genius has been used somewhat indiscriminately to anchor intelligence and creative continua at their highest points, usually with the implication that few people could ever approach these heights or have much in common with those persons who do. For along with the belief that geniuses represent the ultimate in intelligence and creativity, there also has been the subtheme that such people are unexplainable by contemporary models of behavior or personality development." While he admitted to the problematic slide between concepts of high achievement, intelligence, and creativity, and argues for the separation of these domains in order to understand any of them fully, he also foreclosed the various criticisms of any of these qualities as culturally bound and culturally determined in the first place. Albert, "The Concept of Genius," 743.

59. Albert, "Toward a Behavioral Definition of Genius," 143, emphasis mine. For discussions of how "creativity" is the replacement term for studies of intelligence and genius, see Albert, "The Concept of Genius," 743–53; see 745–46 and 748 in particular for these claims. For a more critical analysis of this phenomenon see Geraldine Jonçich, "A Culture-Bound Concept of Creativity: A Social Historian's Critique, Centering on a Recent American Research Report," *Educational Theory* 14, no, 3 (July 1964): 133–43.

60. Guilford laid out four basic axioms for creativity research: as unrelated to the realm of the divine (that it is not imbued or endowed by god); as exceptionally rare but also potentially extant in all human beings; as distinct from talent; as deeply sensitive to influence from the political and social environment. These axioms form the primary lines of inquiry and debate in creativity research today; the tables of contents of *Creativity Studies Journal* are filled with author after author trying to figure out exactly what the relationship is between creativity and intelligence, how the environment influences it, and whether creativity is a universally innate or rare trait. While Glăveanu has more recently reframed these lines of inquiry within a "who, what, how, when, why" model, these remain the central questions researchers attempt to explore. Glaveanu, *Creativity: A Very Short Introduction*, 17. The only matter that seems settled is the relationship to divine inspiration, but even that seems like an active question among some artists (though much less so among researchers, who tend unsurprisingly toward secular accounts of cognition). For an example of the artist's insistence on divine inspiration, see Elizabeth Gilbert's talk on TED.com, "Your Elusive Creative Genius," in which she posits that the secular account of creativity is a manifestation of the arrogance of the rationalist world and also debilitating to the creative process itself, which she argues is more effectively

propelled in the act of humbling oneself before a sense of external inspiration. See Elizabeth Gilbert, "Your Elusive Creative Genius," filmed 2009, TED video, 19:15, http://www.ted.com/talks/elizabeth_gilbert_on_genius?language=en

61. In the subsection of his 1950 APA address, "The Social Importance of Creativity," Guilford's primary justifications were largely those of large-scale economic and technocratic advancement: "The enormous economic value of new ideas is generally recognized. One scientist or engineer discovers a new principle or develops a new process that revolutionizes an industry." J. P. Guilford, "Creativity," *American Psychologist* 5, no. 9 (September 1950): 446. Moreover, a key motivation of the quest to understand creativity for Guilford actually came from engineers asking for more research on the topic. Using a 1944 publication of the Society of Mechanical Engineers as evidence, Guilford pointed out that organizations of engineers and scientists had been holding meetings on the question of how to nurture innovation for some time prior to his address. See his footnote 9, C. F. Kettering, "How Can We Develop Inventors?" in "A Symposium on Creative Engineering" (New York: American Society of Mechanical Engineers, 1944).

62. J. P. Guilford, "Can Creativity Be Developed?" *Art Education* 11, no. 6 (June 1958): 3.

63. Guilford, "Can Creativity Be Developed?": 3.

64. Guilford writes, "In some instances, the democratic ideal has been misinterpreted to mean equality of ability, as if it would be best for everyone if we could all be fitted to the same Procrustean standard of mediocrity. Differences in talent and aptitude may seem unfair, and fair play may seem to call for handicapping those who could excel." Guilford, "Can Creativity Be Developed?": 5.

65. Wendy Brown, "Neo-liberalism and the End of Liberal Democracy," *Theory and Event* 7, no. 1 (Winter 2003).

66. "Despite a variety of possible research methods used to study creativity, the ideal in creativity studies remains closely associated with the experimental and psychometric logic defended by Guilford." Glăveanu, *The Creativity Reader*, 4.

67. Glăveanu, *The Creativity Reader*, 4.

68. Jonçich, "A Culture-Bound Concept of Creativity," 133.

69. Jonçich, "A Culture-Bound Concept," 137.

70. Jonçich, "A Culture-Bound Concept," 137.

71. "The corporate structure, economic abundance, and modern science have democratized earlier intellectual values and permit Getzels and Jackson to talk about them as 'creativity.'" Jonçich, "A Culture-Bound Concept," 137.

72. Jonçich, "A Culture-Bound Concept," 138.

73. Szeman, "Neoliberals Dressed in Black," 30.

74. Richard Florida, *The Rise of the Creative Class: Revisited* (New York: Basic Books, 2014), 9. William Deresiewicz, "The Death of the Artist—and the Birth of the Creative Entrepreneur," *The Atlantic*, January/February 2015, http://www.theatlantic.com/magazine/archive/2015/01/the-death-of-the-artist-and-the-birth-of-the-creative-entrepreneur/383497/

75. Deresiewicz, "The Death of the Artist."

76. Albert and Runco, "A History of Research on Creativity," 22.

77. Runco, *Creativity: Theories and Themes*, 394.

78. Vlad Glăveanu, "Revisiting the 'Art Bias' in Lay Conceptions of Creativity," *Creativity Research Journal* 26, no. 1 (2014): 18.

79. Glăveanu, "Revisiting the 'Art Bias,'" 12.

80. Laikwan Pang has argued that the democratization impulse in contemporary creativity research actually masks its instrumentalization, especially in education policy, "shifting pedagogical emphases from the transmission of collective knowledge to the cultivation of individual creative abilities in order to produce subjects who are competitive in the new creative economy," and "aspir[ing] to replace, if only partly, traditional disciplinary knowledge with the cultivation of abstract transformative ability." Laikwan Pang, *Creativity and Its Discontents: China's Creative Industries and Intellectual Property Rights Offenses* (Durham, NC: Duke University Press, 2012), 6.

81. Runco, *Creativity: Theories and Themes*, 93.

82. Michael Mumford, "Where Have We Been, Where Are We Going? Taking Stock in Creativity Research," *Creativity Research Journal* 15, no. 2–3 (2003): 110.

83. Mumford, "Where Have We Been": 110.

84. To view the Gandhi "Think Different" ad, see "Think Different Poster Mahatma Gandhi, 11 x 17 Inches," Amazon, http://www.amazon.com/Mohatma-Ghandi-Think-Different-Poster/dp/B004XX5N20. I had hoped to include an image of the advertisement, but Apple's copyright policies preclude the use of any of their advertising images, logos, or slogans in the context of criticism of the company. See "Guidelines for Using Apple Trademarks and Copyrights," Apple, http://www.apple.com/legal/intellectual-property/guidelinesfor3rdparties.html

85. For a description of Web 3.0 see Bobby Allyn, "People are Talking about Web3. Is It the Internet of the Future or Just a Buzzword?" NPR, November 21, 2021, https://www.npr.org/2021/11/21/1056988346/web3-internet-jargon-or-future-vision. For a more desultory analysis of the economic and financial implications of Web 3.0, see DiEM25 Communications, "Yanis Varoufakis on Crypto, the Left, and Techno-Feudalism," DiEM25, January 27, 2022, https://diem25.org/yanis-varoufakis-crypto-the-left-and-techno-feudalism/

86. Ross, *Nice Work if You Can Get It*, 2.

87. Ken Robinson, "How Schools Kill Creativity," filmed 2006, TED video, 19:12. http://www.ted.com/talks/ken_robinson_says_schools_kill_creativity.html

Chapter 2

I am indebted for the idea of this chapter to Andrew Ross, who mentions Reagan's campaign in *Nice Work if You Can Get It*, a book that was influential to the early development of this project. This chapter seeks to explore in depth the central ideas, implications, and influence of Reagan's campaign theme. See Andrew Ross, *Nice*

Work if You Can Get It: Life and Labor in Precarious Times (New York: New York University Press, 2009), 37.

1. "The Idea of the Creative Society," undated internal Reagan gubernatorial campaign memo, Box 66, Ronald Reagan Presidential Library, Simi Valley, California (original emphasis).

2. Correspondence from W. S. McBurnie to Ronald Reagan, November 30, 1965, Box 66, Ronald Reagan Presidential Library, Simi Valley, California.

3. Matthew Dallek, *The Right Moment: Ronald Reagan's First Victory and the Decisive Turning Point in American Politics* (New York: Free Press, 2001), ix.

4. Correspondence from McBirnie to Reagan, Box 66, Ronald Reagan Presidential Library (original emphasis).

5. Correspondence, McBirnie to Reagan, Box 66. McBirnie was something of a complicated figure in Reagan's campaign. A personal friend of Reagan's, he had come to California after disgracing himself with his original congregation in Texas by having an affair with a married parishioner. The Brown campaign at one point tried to use this against Reagan by claiming not only that he was simply a marionette mouthing the script handed to him by his managers, but that the managers themselves were of questionable ethical fiber. Like many objections to Reagan's candidacy, these claims seem to have had little impact on the electorate.

6. For a longer history of Brown's role in California's early civil rights laws, see Mark Brilliant, *The Color of America Has Changed: How Racial Diversity Shaped Civil Rights Reform in California, 1941–1978* (New York: Oxford University Press, 2010). Brown had also fought a bruising primary against challenger Samuel Yorty, the Los Angeles mayor who ran to Brown's right, endorsed Reagan in the election, and eventually became a Republican. See Gladwin Hill, "California Politics," in *The California Revolution*, ed. Carey McWilliams (New York: Grossman Publishers, 1968), 172–84.

7. Political consulting had actually originated in California; the first organization, Campaigns, Inc., was used to defeat Upton Sinclair's bid for the governorship in 1934. At the time of Reagan's campaign, Spencer-Roberts was one of the upstart consultancy groups.

8. Ronald Reagan, "A Time for Choosing," in Dallek, *The Right Moment*, 67–68.

9. Reagan, "A Time for Choosing," 69.

10. Reagan, "A Time for Choosing," 69.

11. Stuart Spencer, "Developing a Campaign Management Organization," in "Issues and Innovations in the 1966 Republican Gubernatorial Campaign," 1980, Regional Oral History Office, Bancroft Library, University of California–Berkeley.

12. Ian Haney López, *Dog Whistle Politics: How Coded Racial Appeals Have Reinvented Racism and Wrecked the Middle Class* (New York: Oxford University Press, 2014), 3.

13. Historian Mark Brilliant has noted, however, that California's multiracial

demographics prompted Reagan to create "the Southwestern Strategy," which capitalized on Chicanx frustrations with Brown over what they saw as his excessive focus on Black civil rights needs and the neglect of their own. As Brilliant puts it, "Reagan courted Mexican American voters by pitting bilingual education (which he supported) against school desegregation through busing (which he opposed)." Brilliant, *The Color of America Has Changed*, 6.

14. Haney López, *Dog Whistle Politics*, 27.

15. Haney López, *Dog Whistle Politics*, 2–3. For an elaboration of this argument, please also see Shannon Steen, "Dogwhistle Performance: Concealing White Supremacy in Right-Wing Populism," in *The Routledge Companion to Theatre and Politics*, eds. Peter Eckersall and Helena Grehan (New York: Routledge, 2019). Material from this essay is reproduced by permission of Taylor and Francis, a division of Informa PLC. This permission does not cover any third-party copyrighted work that may appear in the material requested.

16. Wendy Brown, *In the Ruins of Neoliberalism: The Rise of Antidemocratic Politics in the West* (New York: Columbia University Press, 2019), 29.

17. "The Idea of the Creative Society," 4.

18. "The Idea of the Creative Society," 2, original emphasis.

19. "The Idea of the Creative Society," 3, original emphasis.

20. "The Idea of the Creative Society," 2.

21. "The Creative Society" speech at University of Southern California by Ronald Reagan, April 19, 1966, Box C30, Ronald Reagan Presidential Library, Simi Valley, California.

22. "The Creative Society" speech.

23. "Ronald Reagan Announces for Governor: 01/04/1966," CONEL-RAD6401240, YouTube video, 29:35, posted June 11, 2011, https://www.youtube.com/watch?v=0VNUOO7POXs&list=PL6MBh9P9pssjq1ZzFrcbEvfeggIiszEd0&index=8&t=773s

24. German sociologist Andreas Reckwitz points out that the emphasis on novelty in creativity definitions does not rest on a pre-existing, universal, objective quality, but rather "depends on the requisite attentiveness and evaluation to distinguish it from the old and prefer it over the old." In this, the identification and valuation of novelty assume an audience whose role is to determine the degree and desirability of this novelty—in other words, to serve as a "market" of evaluators. Andreas Reckwitz, *The Invention of Creativity: Modern Society and the Culture of the New*, trans. Steven Black (Cambridge, UK: Polity, 2017), 24.

25. For an account of the bitterly racist battle to repeal the Rumford Act, see chapter 7 in Brilliant, *The Color of America Has Changed*, 190–207.

26. Notes by David Broder for Pacific Telephone Company public affairs forum, May 31, 1966, Box 58, Folder 7, 20. David S. Broder Papers, Manuscript Division, Library of Congress, Washington, DC. Reagan's opposition to the Rumford Fair Housing Act was keenly tuned to white *ressentiment*—during his attempts to

prevent its repeal, Brown had repeatedly had to emphasize the role played by white supremacists resisting it, a fact surely not lost on Spencer-Roberts. Dallek, *The Right Moment*, 56.

27. "The Creative Society" speech, Box C30, Ronald Reagan Presidential Library.

28. David Broder—the primary national political reporter for the *Washington Post*—observed that the "creative society" theme seemed "tailor-made" for a race against Johnson. Analysis notes Box 58, Folder 7, 4. David S. Broder Papers, Library of Congress. David S. Broder Papers, Manuscript Division, Library of Congress, Washington, DC.

29. Analysis notes Box 58, Folder 7, Broder Papers, 21.

30. Quoted in Gerard J. De Groot, "'A Goddamned Electable Person': The 1966 California Gubernatorial Campaign of Ronald Reagan," *History* 82, no. 267: 434.

31. Marianne Means, "Reagan's Decline," *San Francisco Chronicle*, March 27, 1966, 2.

32. Among the various innovations of the campaign was Spencer-Roberts's decision to hire the Behavioral Science Corporation (or BASICO), an organization run by behavioral psychologists Stanley Plog and Kenneth Holden. BASICO performed voter surveys and opposition research, and assembled information dossiers on basic political and sociological information about California. Designed to compensate for Reagan's inexperience and essential ignorance about these facets of the state, BASICO arranged this information on 8 x 5 cards organized into various topic-based binders. Reagan would prep speeches by pulling cards from these files and slotting information into the "Creative Society" framework. Stanley Plog, "More Than Just an Actor: The Early Campaigns of Ronald Reagan," June 1981, MSS 83/92, Regional Oral History Office, Bancroft Library, University of California–Berkeley. There is some discrepancy between Spencer-Roberts and BASICO as to who did what on the campaign—Plog and Holden would both later insist that they had come up with the "Creative Society" campaign theme and had also been the figures behind shaping Reagan into a public candidate, though Reagan would himself credit McBirnie with the campaign theme. Stuart Spencer would also dispute Plog's and Holden's claims in later interviews, insisting that BASICO claimed closer contact with Reagan and the campaign than the organization actually had. See Stuart Spencer, "Developing a Campaign Management Organization," in "Issues and Innovations in the 1966 Republican Gubernatorial Campaign," Regional Oral History Office, Bancroft Library, University of California–Berkeley, https://digitalasse ts.lib.berkeley.edu/rohoia/ucb/text/1966repubguber00morrrich.pdf. For BASICO's claims, see Plog, "More Than Just an Actor," and Kenneth Holden, *The Making of the Great Communicator: Ronald Reagan's Transformation from Actor to Governor* (Guilford, CT: Lyons Press, 2013). For a debunking of this, see chapter 5 of Gerard De Groot's *Selling Ronald Reagan: The Emergence of a President* (London: I. B. Tauris, 2015).

33. Richard Wilson, "Reagan on the Razor's Edge," *Los Angeles Times*, June 21, 1966, A6.

34. Editorial, "Gov. Brown's Brilliant Record Is Impossible Goal for Actor Reagan," *Sacramento Bee*, November 6, 1966, B2.

35. Campaign aide Roger Kent, quoted in Dallek, *The Right Moment*, 229.

36. "Address by Governor Edmund G. Brown, Luncheon with Associate Press Editors," June 16, 1966, David S. Broder Papers, Box 58, Folder 7.

37. *Political Spots. Pat Brown. 1966 Gubernatorial Campaign. Vote for a Real Governor, Not an Acting One* by Edmund G. Brown, Bernice Layne Brown, and Ronald Reagan, 1966, Berkeley Art Museum and Pacific Film Archive, University of California–Berkeley.

38. Dallek, *The Right Moment*, 235.

39. Dallek, *The Right Moment*, 235, and Spencer, "Developing a Campaign Management Organization," Bancroft Library.

40. Reagan Library, "'The Victory Squad' 1966," YouTube video, 10:56, posted December 20, 2018, https://www.youtube.com/watch?v=FNAaB0NlJPc&list=PL6 MBh9P9pssjq1ZzFrcbEvfeggIiszEd0&index=9

41. Arthur Hoppe, "Ronald Reagan for Prince of Denmark," *San Francisco Chronicle*, January 7, 1966, 45.

42. Correspondence from McBirnie to Reagan, Box 66, Ronald Reagan Presidential Library (original emphasis), 4.

43. Early on, the campaign used California's Goldwater activists to organize events, register new Republican voters (important in California, where only registered party members could vote in the primaries), phone bank, undertake neighborhood door-to-door canvassing, and ensure voter turnout. Spencer, "Developing a Campaign Management Organization," Bancroft Library.

44. Lisa McGirr, *Suburban Warriors: The Origins of the New American Right* (Princeton: Princeton University Press), 47, 94.

45. Dallek, *The Right Moment*, 226.

46. De Groot, "'A Goddamned Electable Person,'" 446; Dallek, *The Right Moment*, 238.

47. Correspondence from McBirnie to Reagan, Ronald Reagan Presidential Library (original emphasis), 2.

48. Correspondence from McBirnie to Reagan, 3–4.

49. For Reagan's inaugural address, again titled "The Creative Society," see "January 5, 1967: Inaugural Address (Public Ceremony)," Ronald Reagan Presidential Library & Museum, accessed June 21, 2022, https://www.reaganlibrary.gov/archi ves/speech/january-5-1967-inaugural-address-public-ceremony. On the pamphlets produced by his administration, the first booklet in the series laid out the general principles of the Creative Society, with subsequent booklets on education, law and order, public assistance, economic growth and job opportunities, and the quality of life in today's environment. "Creative Studies," Vol. 1, n.d., Office of the Governor of California.

50. "Creative Studies," Vol. 1, n.d., Office of the Governor of California.

51. "Creative Studies," Vol. 1, n.d., Office of the Governor of California.

52. "Creative Studies," Vol. 1, n.d., Office of the Governor of California.

53. Reckwitz, *The Invention of Creativity*, viii.

54. Dallek, *The Right Moment*, 226.

55. "Creative Studies," Vol. 3, n.d., Office of the Governor of California.

56. Spencer would claim of the campaign: "What happened in essence was that . . . we felt this underlying feeling, and we jumped on it as an issue. I think Reagan escalated it into an issue and it started showing up in the polls." Spencer, "Developing a Campaign Management Organization," Bancroft Library, 31.

57. Gerard J. De Groot, "Ronald Reagan and Student Unrest in California, 1966–1970," *Pacific Historical Review* 65, no. 1 (Feb. 1996): 107. Ironically, Spencer-Roberts had earlier taken advantage of the Free Speech Movement at Berkeley to push John Rockefeller's primary campaign against Goldwater (a campaign whose management had brought them to Reagan's attention in the first place). Spencer acknowledged that when they were managing the Rockefeller campaign, they convinced Mario Savio to push Berkeley's administrators to allow him to distribute Rockefeller's campaign literature on campus. In a later interview, Spencer would admit, "There was some question at that point and time in history about just how it was distributed and they established some organized system at Mario's insistence and we were backing him one hundred percent." (De Groot, "Ronald Reagan and Student Unrest in California," 33).

58. Christopher Newfield, *Unmaking the Public University: The Forty-Year Assault on the Middle Class* (Cambridge, MA: Harvard University Press, 2008), 51–52.

59. Speech quoted in David Broder, Notes from Ronald Reagan's Speech at the Pacific Telephone Company Public Affairs Forum, May 31, 1966, Box 58, Folder 7, David S. Broder Papers, Library of Congress.

The "Morality Gap" speech was lifted nearly intact from a *San Francisco Examiner* article covering what became known as the "Burns report," officially known as the "Thirteenth Report of the California State Senate Fact Finding Subcommittee on Un-American Activities." The Burns Report, which had yet to be released to the public at the time of Reagan's speech, took as its goal to "trace a direct line from loose security to loose morality, open defiance of law and efforts to aid the Nation's Communist enemies of the Vietnam War," and blamed then–University of California president Clark Kerr for "an 'anything goes' atmosphere" that fostered a "deluge of filth" and the use of state property for planning "interference with the war effort." Jack S. McDowell, "Senators Blister UC Head," *San Francisco Examiner*, May 6, 1966, https://www-proquest-com.libproxy.berkeley.edu/hnpuswest/docview/21639 58622/1FFE4F086F8E4EE5PQ/9?accountid=14496

In reality, many of the claims of the Burns report turned out to be false, but a copy of it rests in the BASICO files in Reagan's campaign papers in his presidential library archive, and Reagan's first mention of the dance, which became a campaign

standard, occurred at the Cow Palace event, six days after the *Examiner* article covering it. The *Examiner* was a Hearst property owned and helmed by Hearst's widow Millicent Wilson Hearst. Active in Reagan's campaign, Wilson Hearst was a UC Regent deeply hostile to Kerr's leadership, and would become one of the figures centrally responsible for Kerr's removal as president of the University of California right after Reagan's inauguration as governor. See Michelle Reeves, "'Obey the Rules or Get Out': Ronald Reagan's 1966 Gubernatorial Campaign and the 'Trouble in Berkeley,'" *Southern California Quarterly* 92, no. 3 (Fall 2010): 275–305.

60. For a longer explanation of the distorted rumors regarding the Vietnam Day dance, see Dallek, *The Right Moment*, 194.

61. David Broder, Notes from Ronald Reagan's Speech, May 31, Library of Congress.

62. "Creative Studies," Office of the Governor of California.

63. "Creative Studies," Office of the Governor of California.

64. De Groot, "Ronald Reagan and Student Unrest in California," 107.

65. De Groot, "Ronald Reagan and Student Unrest in California,", 115–16.

66. The public research team hired by Spencer-Roberts, BASICO, wrote a memo to the team noting that "if the disorders boil into public prominence again . . . on balance it would be good for our campaign. . . . some prediction of these disorders *before* they happen and emphasis on Brown's ineptitude . . . may put him in a defensive position so he cannot capitalize on action he may be forced to take. . . . Since Berkeley and Higher Education are one of the public's greatest concerns, Brown cannot be allowed to, at this late date, pre-empt the role of saving the University from the radicals and the dissidents." Quoted in De Groot, "Ronald Reagan and Student Unrest in California," 112–13.

67. De Groot, "Ronald Reagan and Student Unrest in California," 111.

68. "The Creative Society" speech, Box C30, Ronald Reagan Presidential Library.

69. De Groot, "Ronald Reagan and Student Unrest in California," 123–25.

70. Reagan had apparently coordinated Kerr's ouster with UC Regent John Spaun (one of a clutch of Regents who worked on Reagan's campaign organization) prior to even being elected, and coordinated the Regents' vote to remove him on January 20, 1967, eighteen days after taking office. Michelle Reeves, "'Obey the Rules or Get Out,'" 298–99.

As early as 1968, Reagan began to compare student protestors to brownshirts and the Viet Cong, to direct his chief of staff, Edwin Meese, to ask the US military installation in the Presidio to spy on student protestors at Berkeley and San Francisco State University, and eventually to use military force to quell protests (the latter to especially devastating effect during the People's Park Protests of 1969, when National Guard helicopters indiscriminately sprayed tear gas on the Berkeley campus). For more details, see De Groot, "Ronald Reagan and Student Unrest in California," 116–17. On Reagan's intervention in the reappointment of Herbert Marcuse and

pushing the Regents to reinstate veto power over faculty hiring, see 123. De Groot notes that Reagan generally accomplished his goals relative to the university system with bluster, as mere threats usually achieved his desires and avoided potentially embarrassing legal defeats.

71. De Groot, "Ronald Reagan and Student Unrest in California," 123.

72. Newfield, *Unmaking the Public University*, 5.

73. "Creativity Studies," Volume 3, Office of the Governor of California.

74. In Reagan's scheme, college and university students would be "given" a mixture of loans and grant monies that varied in proportion from year to year. At the beginning of their education, they would be aided primarily through loans (75 percent of their aid at that point), and fully through grants only in their final year of college. "Creativity Studies," Volume 3, Office of the Governor of California.

75. Curtis Marez, "Ronald Reagan, the College Movie: Political Demonology, Academic Freedom, and the University of California," *Critical Ethnic Studies* 2, no. 1 (Spring 2016): 152.

76. Quoted in Marez, "Ronald Reagan, the College Movie," 173.

77. Quoted in Marez, "Ronald Reagan, the College Movie," 174.

78. Quoted in Marez, "Ronald Reagan, the College Movie," 175.

79. Quoted in Marez, "Ronald Reagan, the College Movie," 175.

80. Newfield, *Unmaking the Public University*.

81. "Ronald Reagan, the College Movie," 176.

Chapter 3

1. Tim Bajarin, "Why the Maker Movement Is Important to America's Future," *TIME*, May 19, 2014, http://time.com/104210/maker-faire-maker-movement/

2. See more on this in chapter 6. As China attempts to rebrand itself from global manufacturing location to global innovation capital, for example, it frequently touts the presence of its Maker spaces, especially in cities such as Shenzhen that are key to these rebranding goals. See the 2016 WIRED media documentary, *Shenzhen: The Silicon Valley of Hardware,* that promotes it as a city of the future on the basis of its creative capacity. WIRED UK, "Shenzhen: The Silicon Valley of Hardware (Full Documentary) | Future Cities," YouTube video, 1:07:50, July 5, 2016, https://www .youtube.com/watch?v=SGJ5cZnoodY

3. The Maker Faire, inaugurated in 2006, is the Maker movement's primary mass live event. Variously referred to as "the 21st-century version of the state fair" and "the greatest show-and-tell on earth," Maker Faires form the primary in-person social network of Maker culture. Maker Media cofounder Mark Hatch notes the parallels to the state fair in that "You swap out animals for robots and technology. You still have the quilting folks and have a lot of the same things you'd see at a state fair but with a more technical bent to it." While the framing of the Faires as a species of quaint, even rustic, Americana aids the emphasis on localness and personalized

face-to-face contact that is frequently valued in, say, upscale retail operations, Maker Faires are simultaneously heralded as a global phenomenon, with events held in diverse global locations, the flagship sites being San Mateo, California (just north of Silicon Valley), and New York.

4. For an example of this narrative, see Bo Cutter, "An American Renaissance: How It Is Happening, How to Nudge It Along, Why We Should Care," *Innovations* 7, no. 3 (2012): 15–24. Cutter predicts that "the ecology of manufacturing will look very different. At the core of this ecology will be high-tech commodity manufacturers, with relatively few employees in big or small plants, depending on the market, building the core product. Surrounding this manufacturer will be a complex of independent firms that adapt the core product and offer highly specialized versions to particular submarkets; independent design, logistics, marketing and sales, and supply-chain firms. The result of this new manufacturing complex will be mass specialization at a level that has never before been possible. And while the core manufacturer of any given product complex will employ fewer men and women than analogous businesses of the past, the overall manufacturing complex will employ at least as many and probably more" (20). This narrative has been popularized by Maker Media founder Dale Dougherty and picked up by Barack Obama at the first Maker Faire to be held at the White House, in 2014. The president predicted that "Your projects are examples of a revolution that's taking place in American manufacturing, a revolution that can help us create new jobs and industries for decades to come." Quoted in Fred Turner, "Millenarian Tinkering: The Puritan Roots of the Maker Movement," *Technology and Culture* 59, no. 4 (Fall 2018): S161. See also Dale Dougherty, "The Maker Mindset," in *Design, Make, Play: Growing the Next Generation of STEM Innovators*, eds. Margaret Honey and David E. Kanter (New York: Routledge, 2013), 7–11.

5. See, for example, the Wikipedia entry on "Maker Culture," which features this quote by MIT physicist Neil Gershenfeld. "Maker culture," Wikipedia, last modified June 5, 2021, https://en.wikipedia.org/wiki/Maker_culture

6. Wikipedia entry on "Maker Culture."

7. David Gauntlett, *Making Is Connecting: The Social Power of Creativity, From Craft and Knitting to Digital Everything*, 2nd ed. (San Francisco: Polity Press, 2018), i.

8. Office of the White House Press Secretary, "Remarks by the President at the White House Maker Faire," June 18, 2014, https://obamawhitehouse.archives.gov /the-press-office/2014/06/18/remarks-president-white-house-maker-faire

9. Mark Hatch, *The Maker Movement Manifesto: Rules for Innovation in the New World of Crafters, Hackers, and Tinkerers* (New York: McGraw-Hill Education, 2013), 1–2.

10. Leah Buechley, "Introduction," in *The Art of Tinkering: Meet 150+ Makers Working at the Intersection of Art, Science & Technology*, eds. Karen Wilkinson and Mike Petrich (San Francisco: Weldon Owen, 2014), 9.

11. Jessamyn Hatcher and Thuy Linh Nguyen Tu, "'Make What You Love': Homework, the Handmade, and the Precarity of the Maker Movement." *WSQ* 45, no. 3–4 (Fall/Winter 2017): 276.

12. Hatch, *The Maker Movement Manifesto*, 1.

13. Gauntlett, *Making Is Connecting*.

14. Gauntlett, *Making Is Connecting*, 2.

15. Nicholas Ridout, *Passionate Amateurs: Theatre, Communism, and Love* (Ann Arbor: University of Michigan Press, 2015), 8.

16. Ridout, *Passionate Amateurs*, 11.

17. Neil Gershenfeld, *Fab: The Coming Revolution on Your Desktop—From Personal Computers to Personal Fabrication* (Basic Books: New York, 2005), 6.

18. Ridout, *Passionate Amateurs*, 12.

19. David Lang, *Zero to Maker: A Beginner's Guide to the Skills, Tools, and Ideas of the Maker Movement*, 2nd ed. (San Mateo, CA: Make Community LLC, 2017), 8.

20. Turner, "Millenarian Tinkering," S160.

21. Turner, "Millenarian Tinkering," S163.

22. Dougherty, "The Maker Mindset," 8.

23. Office of the White House Press Secretary, "Remarks by the President at the White House Maker Faire."

24. Ken Robinson, "Do Schools Kill Creativity?" filmed 2006, TED video, https://www.ted.com/talks/sir_ken_robinson_do_schools_kill_creativity/transcript?language=en#t-132537; Cutter, "An American Renaissance," 19.

25. Cutter, "An American Renaissance," 21.

26. Turner, "Millenarian Tinkering," S170.

27. Dougherty, "The Maker Mindset," 8.

28. Edward P. Clapp, "Presenting a Symptomatic Approach to the Maker Aesthetic," *Journal of Aesthetic Education* 51, no. 4 (Winter 2017): 78.

29. Edward P. Clapp, Jessica Ross, Jennifer O. Ryan, and Shari Tishman, *Maker-Centered Learning: Empowering Young People to Shape Their Worlds* (New York: John Wiley & Sons, 2016), 7–8.

30. Erica Rosenfeld Halverson and Kimberly M. Sheridan, "The Maker Movement in Education," *Harvard Education Review* 84, no. 4 (2014): 495–504.

31. Clapp et al., *Maker-Centered Learning*, 109.

32. Johan Huizinga, *Homo Ludens: A Study of the Play-Element in Culture* (London: Routledge, 1949), 1.

33. C. F. Von Schiller, "Letters Upon the Aesthetic Education of Man," quoted in Robert Anchor, "History and Play: Johan Huizinga and His Critics," *History and Theory* 17, no. 1 (February 1978): 63.

34. Office of the White House Press Secretary, "Remarks by the President at the White House Maker Faire."

35. Bill Brown, "Thing Theory," *Critical Inquiry* 28, no. 1 (Autumn 2001): 2.

36. Lang, *Zero to Maker*, 9.

37. Hatch, *The Maker Movement Manifesto*, 12.

38. Clapp et al., *Maker-Centered Learning*, 10.

39. Clapp et al., *Maker-Centered Learning*, 9.

40. Office of the White House Press Secretary, "Remarks by the President at the White House Maker Faire."

41. Margaret Honey and David E. Kantor, *Design, Make, Play: Growing the Next Generation of STEM Innovators* (New York: Routledge, 2013), 3.

42. Michael Schad and W. Monty Jones, "The Maker Movement and Education: A Systematic Review of the Literature." *Journal of Research on Technology in Education* 52, no. 1 (2020): 65.

43. Dougherty, "The Maker Mindset," 7. *Edge*, "Digital Reality: A Conversation with Neil Gershenfeld," January 23, 2015, edge.org/conversation/neil_gershenfeld -digital-reality. Clapp et al., *Maker-Centered Learning*, 22–23.

44. Clapp, "Presenting a Symptomatic Approach," 79.

45. Clapp, "Presenting a Symptomatic Approach," 83–93.

46. Po Bronson and Ashley Merryman, "The Creativity Crisis," *Newsweek*, July 10, 2010, http://www.newsweek.com/creativity-crisis-74665

47. Kyung Hee Kim, "The Creativity Crisis: The Decrease in Creative Thinking Scores on the Torrance Tests of Creative Thinking," *Creativity Research Journal* 23, no. 4 (2011): 285–95. The Torrence Tests, devised by psychology researcher Ellis Paul Torrence, assess divergent thinking skills, and are the gold-standard test for an individual's creative capacity. Torrence actually developed them for a landmark longitudinal study to determine whether high scores in early primary school could accurately predict high levels of creative work later in life.

48. "According to a major new IBM survey of more than 1,500 Chief Executive Officers from 60 countries and 33 industries worldwide, chief executives believe that—more than rigor, management discipline, integrity or even vision—successfully navigating an increasingly complex world will require creativity." Anonymous, "IBM 2010 Global Study: Creativity Selected as Most Crucial Factor for Future Success." https://www-03.ibm.com/press/us/en/pressrelease/31670.wss, posted May 18, 2010, accessed August 12, 2014.

49. Robinson, "Do Schools Kill Creativity?"

50. Bronson and Merryman, "The Creativity Crisis."

51. Hatcher and Tu, "'Make What You Love,'" 281.

52. Hatcher and Tu, "'Make What You Love,'" 272.

53. "Industrial Homework or Piecework Law and Legal Definition," US Legal, accessed June 12, 2020, https://definitions.uslegal.com/i/industrial-homework-or -piecework/#:~:text=Industrial%20homework%20or%20piecework%20is,who %20permits%20or%20authorizes%20such

54. Hatcher and Tu, "'Make What You Love,'" 277.

55. Hatcher and Tu, "'Make What You Love,'" 276.

56. "Industrial Homework."

57. Hatcher and Tu, "'Make What You Love,'" 279–80.

58. Hatcher and Tu, "'Make What You Love,'" 281.

59. Hatcher and Tu, "'Make What You Love,'" 281.

60. See Alex de Ruyter, Martyn Brown, and John Burgess, "Gig Work and the Fourth Industrial Revolution: Conceptual and Regulatory Challenges," *Journal of International Affairs* 72, no. 1 (2019): 37–50.

61. Lauren Berlant, *Cruel Optimism* (Durham, NC: Duke University Press, 2011), 3.

62. For an excellent analysis of Doctorow's novel, see Fred Turner, "Millenarian Tinkering."

63. Gibson has described his writing as "standing at the intersection of technology and paranoia."

64. Tina Casey, "When the Military Meets the Maker Movement," *Triple Pundit*, May 29, 2012, https://www.triplepundit.com/story/2012/when-military-meets-maker-movement/65156

65. Dougherty, "The Maker Mindset," 13.

Chapter 4

1. Catastrophone Orchestra and Arts Collective, "What Then Is Steampunk?" *Steampunk Magazine*, September 1, 2009, 4, https://issuu.com/baccioly/docs/spm1-printing

2. For a more extensive introduction to the Maker Faire Steampunk Village, see the following promotional video: Angela Sheehan, "Steampunk Village @ Maker Faire 2010," YouTube video, 1:53, June 6, 2010, https://www.youtube.com/watch?v=YPkUfABmS48

3. Steampunk & Makers Fair, accessed August 25, 2015, https://web.archive.org/web/20150813013957/http://steampunkandmakersfair.org/

4. See James H. Carrott and Brian David Johnson, *Vintage Tomorrows: A Historian and a Futurist Journey Through Steampunk into the Future of Technology* (Sebastopol, CA: Maker Media, 2013). See especially chapter 2, "Beats, Pranksters, Hippies, Steampunks!" where author Carrott reminisces about a college visit from Timothy Leary, who claims digital culture writ large as a new counterculture; Johnson claims this visit as the beginning of his own set of enthusiasms around history, technology, and counterculture that eventually lead him to steampunk.

5. Fred Turner, "Burning Man at Google: A Cultural Infrastructure for New Media Production." *New Media & Society* 11, nos. 1 & 2 (2009): 73–94.

6. Dick Hebdige, *Subculture: The Meaning of Style* (New York: Routledge, 1979), 18.

7. For the origin of the term, see Jeter's letter to the editor of *Locus* magazine (a science fiction and fantasy fan mag published in Oakland, California) in April 1987. Noting his inclusion in the "gonzo-historical" turn that science fiction and fantasy writing had recently taken, he predicts that "Victorian fantasies are going to be the

next big thing, as long as we can come up with a fitting collective term Something based on the appropriate technology of that era; like 'steampunks' perhaps." "The Birth of Steampunk," Letters of Note, March 1, 2011, https://lettersofnote .com/2011/03/01/the-birth-of-steampunk/

8. Mike Dieter Perschon, "The Steampunk Aesthetic: Technofantasies in a Neo-Victorian Retrofuture," PhD dissertation (University of Alberta, 2012), 5.

9. Perschon, "Steampunk Aesthetic," 6.

10. Perschon, "Steampunk Aesthetic," 7.

11. Perschon, "Steampunk Aesthetic," 44.

12. Perschon, "Steampunk Aesthetic," 9.

13. Rebecca Onion, "Reclaiming the Machine: An Introductory Look at Steampunk in Everyday Practice," *Neo-Victorian Studies* 1, no. 1 (2008): 138.

14. The SCA's website, for example, showcases its annual exhibition event with sun-drenched videos of participants in medieval tunics engaged in period fighting tournaments and holding period baskets, cups of mead, and swords. See "SCA Videos," Society for Creative Anachronism, accessed March 30, 2020, https://www.sca .org/videos/

15. Catastrophone Orchestra and Arts Collective, "What Then Is Steampunk?": 5.

16. Onion, "Reclaiming the Machine," 151.

17. William Gibson and Bruce Sterling, *The Difference Engine* (New York: Random House, 1990). For another example in this vein, see K. W. Jeter's *Infernal Devices* (New York: St. Martin's Press, 1987).

18. In the words of Babbage biographer Doron Swade, Ada Byron "saw something that Babbage in some sense failed to see. In Babbage's world his engines were bound by number. He saw that the machines could do algebra in the narrow sense that they could manipulate plus and minus signs. . . . What Ada Byron saw was that numbers could represent entities other than quantity. So once you had a machine for manipulating numbers, if those numbers represented other things, letters, musical notes, then the machine could manipulate symbols, of which number was one instance, according to rules. It is this fundamental transition from a machine that is a number cruncher to a machine for manipulating symbols according to rules that is the fundamental transition from calculation to computation." Quoted in Jon Fuegi and Jo Francis, "Lovelace & Babbage and the Creation of the 1843 'Notes,'" *IEEE Annals of the History of Computing* 25, no. 4 (2003): 24.

19. On the implications of Snowden's revelations of NSA data surveillance, see Glenn Greenwald, "Edward Snowden: The Whistleblower Behind the NSA Surveillance Revelations," *The Guardian*, June 11, 2013, https://www.theguardian.com/wo rld/2013/jun/09/edward-snowden-nsa-whistleblower-surveillance. On Cambridge Analytica's use of data mining to undermine democratic political processes in several countries, see the 2019 documentary *The Great Hack*, directed by Jehane Noujaim and Karim Amer (Los Gatos, CA: Netflix, 2019).

20. Perschon, "Steampunk Aesthetic," 92.

21. For a definition of what tech and business writers refer to as humanist technological criticism, see L. M. Sacasas, "Humanist Technology Criticism," Technology, Culture, and Ethics, July 9, 2015, https://thefrailestthing.com/2015/07/09/humanistic-technology-criticism/. From a protechnology, economist standpoint, see Andrew McAfee, "Who Are the Humanists, and Why Do They Dislike Technology So Much?" *Financial Times*, July 7, 2015, https://www.ft.com/content/8fbd6859-def5-35ec-bbf5-0c262469e3e9; or Adam Thierer, "Is It 'Techno-Chauvinist' and 'Anti-Humanist' to Believe in the Transformative Potential of Technology?" The Technology Liberation Front, September 18, 2018, https://techliberation.com/2018/09/18/is-it-techno-chauvinist-anti-humanist-to-believe-in-the-transformative-potential-of-technology/. Thierer is Senior Research Fellow at the Mercatus Center, a research center on technology and economics at George Mason University that quotes Friedrich Hayek—the Austrian economist who first began to articulate and advocate for neoliberal ideals—on its homepage. See Mercatus Center, https://www.mercatus.org/

22. Thomas Carlyle, "The Mechanical Age," in *A Carlyle Reader: Selections from the Writings of Thomas Carlyle*, ed. G. B. Tennyson (Cambridge: Cambridge University Press, 2001).

23. "History Has Sharp Edges," *Vintage Tomorrows*, directed by Byrd McDonald (2015).

24. "History Has Sharp Edges."

25. "History Has Sharp Edges."

26. Fredric Jameson, *Postmodernism, or, the Cultural Logic of Late Capitalism* (Durham, NC: Duke University Press, 1992), 197, quoted in Perschon, "Steampunk Aesthetic," 27.

27. Svetlana Boym, *The Future of Nostalgia* (New York: Basic Books, 2008), 9.

28. Boym, *Future of Nostalgia*, 13.

29. Istvan Csicsery-Ronay Jr., *The Seven Beauties of Science Fiction* (Middletown, CT: Wesleyan University Press, 2011), 180–89, quoted in Perschon, "Steampunk Aesthetic," 45.

30. *Vintage Tomorrows*.

31. Perschon, "The Steampunk Aesthetic," 62.

32. *Vintage Tomorrows*.

33. Boym, *Future of Nostalgia*, 10.

34. Scott Magelssen, *Simming: Participatory Performance and the Making of Meaning* (Ann Arbor: University of Michigan Press, 2014), 3.

35. Magelssen, *Simming*.

36. "We affirm that the world's magnificence has been enriched by a new beauty: the beauty of speed. A racing car whose hood is adorned with great pipes, like serpents of explosive breath—a roaring car that seems to ride on grapeshot is more beautiful than the *Victory of Samothrace*." F. T. Marinetti, "The Founding and Manifesto of Futurism," in *F. T. Marinetti: Critical Writings*, ed. Günter Berghaus, trans. Doug Thompson (New York: Farrar, Straus and Giroux, 2008), 13.

37. Katherine Beckmar in discussion with the author, October 2016.

38. Shannon O'Hare in discussion with the author, October 2016.

39. "Recycling . . . I call it down-cycling. They smash bricks, they smash everything. What we need is up-cycling, where old products are given more value, not less." "Reiner Pilz," *Salvo Monthly*, October 1994, 14, https://www.salvoweb.com/fi les/sn99sm24y94tk181119.pdf. However, the term "upcycling" itself has acquired a mass appeal that extends well beyond the constricted worlds of the art market, producing a larger cultural model of production and consumption that steampunk makers often adapt. According to the Wikipedia entry on the word, "the number of products on Etsy or Pinterest tagged with the word 'upcycled' increased from about 7,900 in January 2010 to nearly 30,000 a year later—an increase of 275%. As of April 2013, that number stood 263,685, an additional increase of 879%." "Upcycling," Wikipedia, last modified April 24, 2021, https://en.wikipedia.org/wiki/Up cycling. This narrative regarding the popularity of the term "upcycling" has been challenged in the "Talk" page of its Wikipedia entry. User Jcmcc450 notes that the increasing popularity of the term on what is primarily a retail site (i.e., Etsy) may in fact indicate a marketing trend more than an actual grassroots cultural phenomenon. I would note that as with other phenomena of the web, it's often difficult to differentiate individualized "bottom-up" activity from more institutionalized "top-down" forms, if for no other reason than the dizzying speed with which digital cultures move from one domain to the other; moreover, such movement is not usually unilinear. "Talk:Upcycling," Wikipedia, accessed November 1, 2015, https://en.wik ipedia.org/wiki/Talk:Upcycling

40. "El Pulpo Mecanico," http://elpulpomecanico-story.com/

41. *Vintage Tomorrows*.

42. Raymond Malewitz, *The Practice of Misuse: Rugged Consumerism in Contemporary American Culture* (Palo Alto, CA: Stanford University Press), 8.

43. Malewitz, *Practice of Misuse*.

44. O'Hare in discussion with the author, October 2016.

45. Margaret Werry, *The Tourist State: Performing Leisure, Liberalism, and Race in New Zealand* (Minneapolis: University of Minnesota Press, 2011), 7.

46. Jacques Rancière, "Doing or Not Doing: Politics, Aesthetics, Performance," in *Thinking—Resisting—Reading the Political: Current Perspectives on Politics and Communities in the Arts*, Vol. 2, eds. Anneka Esch van Kan, Stephan Packard, and Philipp Schulte (Zurich: Diaphanes, 2013), 101.

47. Steampunk sculptures, for example, operate as mobile, miniature immersive theatrical environments, much in the manner of theme-park rides like Pirates of the Caribbean, on a smaller, moveable scale. Some steampunk artists, like *El Pulpo*'s creator Duane Flatmo, explicitly mark their long-term fascination with theme-park environments in their work, and reproduce them in the way the sculptures are rendered as public events. Sculpture operators usually cosplay in steampunk-themed Victorian garb, and in many cases participant-spectators are encouraged to tour the interiors. These are usually elaborately and wittily detailed, often with reference

to preindustrial technology such as the camera obscura, vintage gauges and dials, antique navigation instruments, and so forth. The immersive nature of the kinetic sculptures renders them participatory theatrical environments; without their viewers, they are essentially incomplete projects. Moreover, the creators of these works often present themselves in character. Shannon O'Hare, creator of *Neverwas Haul*, introduces himself in interviews as "Major Catastrophe, Master and Commander of *The Neverwas Haul*, leader of the intrepid Traveling Academy of Unnatural Science, and owner and operator of Obtainium Works in Vallejo CA," with the requisite booming, plummy, British military dialect. While O'Hare doesn't maintain this front as strictly as, say, Sacha Baron Cohen does when interviewed, he (like many other steampunk practitioners and enthusiasts) uses steampunk as a mechanism to create an alter ego. Shannon O'Hare in discussion with the author, October 2016. For Flatmo's discussion of theme parks, see "El Pulpo Mecanico," accessed October 16, 2015, http://elpulpomecanico-story.com/

48. Gibson and Sterling, *The Difference Engine*, 1990.

49. Gibson and Sterling, *Difference Engine*.

50. Gibson and Sterling, *Difference Engine*.

51. Frederic Jameson, "Progress Versus Utopia; or, Can We Imagine the Future?" *Science Fiction Studies* 9, no. 2 (July 1982): 150–51.

52. Jameson, "Progress Versus Utopia," 153.

53. My gratitude to Kimberly Skye Richard for her insights into rehearsals for the end, in her excellent dissertation, "Crude Stages of the Capitalocene: Performance and Petro-Imperialism," PhD dissertation, University of California–Berkeley, 2019.

54. Richard, "Crude Stages."

Chapter 5

1. Jennifer Schuessler, "Frankenstein at 200," *New York Times*, October 25, 2018, https://www.nytimes.com/2018/10/25/arts/frankenstein-at-200.html?action =click&module=RelatedCoverage&pgtype=Article®ion=Footer

2. Imre Szeman, "Neoliberals Dressed in Black; or, the Traffic in Creativity," *ESC: English Studies in Canada* 36, no. 1 (March 2010): 21.

3. Harriet Hustis, "Responsible Creativity and the 'Modernity' of Mary Shelley's Prometheus," *Studies in English Literature 1500–1900* 49, no. 4 (Autumn 2009): 993–1007.

4. The last decade witnessed at least four separate critical editions of the novel (three in 2012 alone), and reissues of full-text illustrated versions like Lynd Ward's.

5. David H. Guston, Ed Finn, and Jason Scott Robert, "Editors' Preface," in Mary Shelley, *Frankenstein: Annotated for Scientists, Engineers, and Creators of All Kinds*, eds. David H. Guston, Ed Finn, and Jason Scott Robert (Cambridge, MA: MIT Press, 2017), xi.

6. Guston, Finn, and Robert, "Editors' Preface," xi–xiii.

7. Bear argues that Victor "undertakes his research in a spirit of self-aggrandizement: it's not knowledge he seeks but power and renown, and this ambition leads him to become far more a monster than the creature he creates." Elizabeth Bear, "*Frankenstein* Reframed: or, The Trouble with Prometheus," in Mary Shelley, *Frankenstein*, 231.

8. Cory Doctorow, "I've Created a Monster (and So Can You!)," in Mary Shelley, *Frankenstein*, 213.

9. See Stanford's events held over the course of the 2018–2019 academic year, "F@200 Events at Stanford," Stanford University Center for Biomedical Ethics, https://med.stanford.edu/medicineandthemuse/FrankensteinAt200/frankenstein -200-stanford-events.html; or similarly, "The Frankenstein Bicentennial Project, 1818–2018," Arizona State University, https://frankenstein.asu.edu/

10. Snow's conception of literary culture as made up of "natural luddites" was rooted in an entirely different social and historical milieu than that of the contemporary US, one characterized by a class-based, British disdain for the sciences as "grubbily" linked to labor and manufacturing and an idealization of the humanities as "gentlemanly" (both of these distinctions have very much the opposite connotations in the US). At the time of Snow's 1959 lecture, he could point to the arts' tainted associations with fascism and anti-Semitism (particularly in the work of Ezra Pound, Wyndham Lewis, and T.S. Eliot), while he could still claim for the sciences— even at the height of the nuclear age—a kind of communal public service that would create new technologies and eradicate poverty. See Stefan Collini's introduction to C. P. Snow, *The Two Cultures and the Scientific Revolution* (Cambridge: Cambridge University Press, 2013), ix–xvii.

11. Unlike in his earlier work, where he argued that religion and science were what he called "non-overlapping magisteria," Gould asserted that there were significant overlaps between the sciences and the humanities (by which he meant both the practice of visual arts, literature, and music, and their academic study). Stephen Jay Gould, *The Hedgehog, the Fox, and the Magister's Pox: Mending the Gap between Science and the Humanities* (Cambridge, MA: Harvard University Press, 2011).

12. Gould, *Hedgehog*, 17. Gould stressed that the divisions between the humanities and sciences comprised a form of institutionalized "stuckness," wherein participants of both arenas remained caught up in the legitimation battle from the early years of the scientific revolution, when scientists were in fact primarily caught up in a fight with religious institutions and their cultural and political power. This conflict, he insists, "became both silly and harmful long ago" (Gould, *Hedgehog*, 19–20).

13. Gershenfeld argued that "We've been living with this notion that making stuff is an illiberal art for commercial gain and it's not a means of expression. But, in fact, today, 3D printing, micromachining, and microcontroller programming are as expressive as painting paintings or writing sonnets but they're not means of expression from the Renaissance." *Edge*, "Digital Reality: A Conversation with Neil

Gershenfeld," January 23, 2015, edge.org/conversation/neil_gershenfeld-digital-rea
lity

14. Raymond Williams, *Keywords: A Vocabulary of Culture and Society*, rev. ed. (New York: Oxford University Press, 1983), 277.

15. In the late eighteenth century, "changes in ideas of nature encouraged the further specialization of ideas of method and demonstration towards the 'external world,' and the conditions for the emergence of science as the theoretical and methodical study of nature were then complete. Theory and method applied to other kinds of experience (one area was metaphysical and religious; another was social and political; another was feeling and the inner life, now acquiring its new specialized association with art) could then be marked off as not science but something else" (Williams, *Keywords*, 278). For the argument that modernity was founded on this very separation, see Jürgen Habermas, "Modernity: An Unfinished Project," in *Habermas and the Unfinished Project of Modernity*, eds. Maurizio Passerin d'Entrèves and Seyla Benhabib (Cambridge, MA: MIT Press, 1997), 1–38.

16. Amanda Jo Goldstein, *Sweet Science: Romantic Materialism and the New Logics of Life* (Chicago: University of Chicago Press, 2017), 2.

17. William Wordsworth, "Preface," in *Lyrical Ballads: 1798 and 1802*, ed. Fiona Stafford (London: Oxford World's Classics, 2013), 105–6.

18. Wordsworth, "Preface," 105–6.

19. Wordsworth, "Preface," 105–6.

20. James Engell, *The Creative Imagination: Enlightenment to Romanticism* (Cambridge: Harvard University Press, 1981), 15.

21. Quoted in Engell, *Creative Imagination*, ix.

22. Percy Bysshe Shelley, "A Defense of Poetry," *Poetry Foundation*, last modified October 13, 2009, https://www.poetryfoundation.org/articles/69388/a-defence-of-poetry

23. Shelley, "A Defense of Poetry."

24. Arthur Kahn, "'Every Art Possessed by Man Comes from Prometheus': The Greek Tragedians and Science and Technology," *Technology and Culture* 11, no. 2 (April 1970): 158.

25. Barry Allen, "Prometheus and the Muses: On Art and Technology," *Common Knowledge* 12, no. 3 (Fall 2006): 354.

26. Cal Performances, "Artist Conversation with Manual Cinema," 23:38, https://calperformances.org/related-events/pre-performance-conversation-for-frank enstein

27. "Poor" denotes here not financial poverty, but the aesthetics of the Poor Theater of Jerzy Grotowski, which in many ways prefigured the upcycling techniques of contemporary artisanal practices. See Jerzy Grotowski, *Towards a Poor Theater* (New York: Routledge, 2002).

28. Manual Cinema, "Behind the Scenes of Manual Cinema's *Frankenstein*," accessed December 16, 2020, http://manualcinema.com/behind-the-scenes-of-manu

al-cinemas-frankenstein/. On steampunk self-definitions, see the following quotation: "Steampunk is the non-luddite critique of technology. It rejects the ultra-hip dystopia of the cyberpunks—black rain and nihilistic posturing—while simultaneously forfeiting the 'noble savage' fantasy of the pre-technological era. It revels in the concrete reality of technology instead of the over-analytical abstractness of cybernetics. . . . steampunk machines are real, breathing, coughing, struggling and rumbling parts of the world. They are not the airy intellectual fairies of algorithmic mathematics but the hulking manifestations of muscle and mind." Catastrophone Orchestra and Arts Collective, "What Then Is Steampunk?" *Steampunk Magazine*, September 1, 2009, 4, https://issuu.com/baccioly/docs/spm1-printing

29. A number of reviews pointed to this characteristic: "The technology of this 'Frankenstein' is deliberately backward looking. Yes, there's a camera. Yes, there's electricity independent of lightning. But puppetry, magic lanterns, the painted scene unspooling slowly between two poles—a device called a crankie—all these would have been familiar to Shelley." Alexis Soloski, "It's Alive! Well, the Puppeteers Are," *New York Times*, October 25, 2018, https://www.nytimes.com/2018/10/25/th eater/frankenstein-manual-cinema.html

30. Shannon Jackson and Marianne Weems, *The Builders Association: Performance and Media in Contemporary Theater* (Cambridge, MA: MIT Press, 2015), 4.

31. Soloski, "It's Alive!"

32. Cal Performances "Artist Conversation with Manual Cinema."

33. Drew Dir, "Program Notes," Program for Manual Cinema's *Frankenstein* at Cal Performances, Berkeley, California. *Playbill* 2020, 3. Note that this argument about assemblage is one that Paul Rae has argued is central to the act of theater-making itself; he suggests that the assembled nature of the theater may well drive the popularity of *Frankenstein* adaptations for the stage, as Victor's cobbling together of the Creature mirrors the director's labor of bringing together the multitude of semantic registers that make up the world of performance. Paul Rae, "Workshop of Filthy Creation: The Theatre Assembled," *TDR: The Drama Review* 59, no. 4 (Winter 2015): 118.

34. Jeanette Winterson, *Frankissstein: A Love Story* (New York: Jonathan Cape, 2019), 238.

35. Winterson, *Frankissstein*, 131.

36. Winterson, *Frankissstein*, 134–35.

37. Winterson, *Frankissstein*, 134–35

38. Winterson, *Frankissstein*, 136.

39. Winterson, *Frankissstein*, 150.

40. Winterson, *Frankissstein*, 291, please note that this quote is unverified—I have not been able to find it to ensure that Page actually said or wrote this.

41. Winterson, *Frankissstein*, 151.

42. Winterson, *Frankissstein*, 310.

43. Winterson, *Frankissstein*, 312.

44. Winterson, *Frankissstein*, 313–14.

45. Winterson, *Frankissstein*, 285–86.

46. Winterson, *Frankissstein*, 285–86.

47. Winterson, *Frankissstein*, 322–23.

48. Winterson, *Frankissstein*, 320.

49. Winterson, *Frankissstein*, 322–23.

50. Mary Shelley, *Frankenstein: Annotated for Scientists, Engineers, and Creators of All Kinds*, eds. David H. Guston, Ed Finn, and Jason Scott Robert (Cambridge, MA: MIT Press, 2017), 38–40.

51. Mihaly Csikszentmihalyi, *Creativity: The Psychology of Discovery and Invention* (New York: Harper Collins, 2013), 2.

52. Gould, *The Hedgehog*, 16.

53. The 2011 National Theatre production is perhaps the most widely known and commented-on production of the last decade, in no small part due to the star power of its leads and the distribution network of the "National Theatre Live" program, which broadcast the show into cinemas around the world. But it is also thematically paradigmatic for many of the adaptations that follow, most notably for its insistence that the Creature is a sympathetic protagonist. Taking Bruno Latour's injunction to "love your monsters" to heart, the Dear/Boyle adaptation jettisons the familiar iterations of the groaning, raging Creature of early horror film in favor of a figure not just articulate and literate, but capable of rational thought and companionable longing. This version of the Creature returns audiences to Shelley's insistence that his monstrousness is the result of repeated exposure to the most profound hypocrisies and violence of mankind. In keeping with her novel, Dear's Creature is repeatedly beaten, shunned, and reviled, and in turn becomes a monster "by virtue of what he learns from a monstrous world." As Paul Rae has pointed out, the production aesthetics even suture the audience directly to the Creature's interiority, using, for example, the gorgeous lighting array by Bruno Poet to convey a first-person experience of the shock the Creature experiences during its birth-by-electrical current. Bruno Latour, "Love Your Monsters: Why We Must Care for Our Technologies As We Do Our Children," *The Breakthrough Institute*, February 14, 2012, https://thebreakthrough.org/journal/issue-2/love-your-monsters. Audrey A. Fisch, *Frankenstein: Icon of Modern Culture* (Hastings, UK: Helm Information, 2009), 25. Rae, "Workshop of Filthy Creation," 125.

54. Nick Dear, *Frankenstein: Based on the Novel by Mary Shelley* (New York: Faber and Faber, 2016), 56–57.

55. Dear, *Frankenstein*, 37.

56. Mark Hatch, *The Maker Movement Manifesto: Rules for Innovation in the New World of Crafters, Hackers, and Tinkerers* (New York: McGraw-Hill Education, 2013), 1–2.

57. Robert J. Sternberg and Todd I. Lubart, "The Concept of Creativity: Prospects and Paradigms," in *Handbook of Creativity*, ed. Robert J. Sternberg (New York: Cambridge University Press, 1998), 8–9.

58. On this, see again the idea that "by the end of the eighteenth-century, it was concluded that whereas many persons may have talent of one sort or another . . . original genius was truly exceptional and by definition was to be exempt from the rules, customs, and obligations that applied to the talented." Robert S. Albert and Mark A. Runco, "A History of Research on Creativity," in *The Cambridge Handbook on Creativity* (Cambridge: Cambridge University Press, 1999), 21.

59. Alan Gewirth, *Self-Fulfillment* (Princeton: Princeton University Press, 2009), 48–49.

60. Gewirth, *Self-Fulfillment*, 48–49.

61. Gewirth, *Self-Fulfillment*, 48–49.

62. Gewirth, *Self-Fulfillment*, 48–49.

63. Gewirth, *Self-Fulfillment*, 6.

64. Gewirth, *Self-Fulfillment*, 105.

65. Shelley, "A Defense of Poetry," 17.

66. For those uninitiated in the details of the Shelleys' relationship, it was one marked by extraordinary levels of emotional upheaval (to say the least), which has led to significant skepticism about Percy's claims about poets' capacity for ethical guardianship. Percy first met Mary when she was fourteen (he was five years her senior), and began a relationship with her when she was sixteen, despite being married at the time. Within the next year, she and Percy eloped, despite his wife's pregnancy; on their return to London, Mary had to deal with her own pregnancy (with a daughter who would soon die), the birth of Shelley's son to his wife, and his affair with Mary's stepsister Claire Clairmont (who would later herself become pregnant by Byron). The two would not marry until after Percy's wife drowned herself in late 1816, in the period during which Mary was still drafting *Frankenstein*.

67. Shelley, "A Defense of Poetry."

68. In his *Images of the Gods of the Ancients* (1556), the mythographer Vincenzo Cartari first compared Prometheus to artists, and by the time Francesco Morandini painted *Nature and Prometheus* for Francesco Medici's Palazzo Vecchio in 1570, Prometheus was figured as the father of all art—an allegory that Byron probably viewed in his various Italian wonderings. Olga Raggio, "The Myth of Prometheus: Its Survival and Metamorphosis up to the Eighteenth Century," *Journal of the Warburg and Courtauld Institutes* 21, no. 1/2 (January–June 1958): 45.

69. Marilees Roberts, "*Prometheus Unbound*: Reconstitutive Poetics and the Promethean Poet," *The Keats-Shelley Review* 34, no. 2 (September 2020): 178–93.

70. Shelley, *Frankenstein*, 19.

71. Dear, *Frankenstein*.

72. See Istvan Csicsery-Ronay Jr., *The Seven Beauties of Science Fiction* (Middletown, CT: Wesleyan University Press, 2011).

73. Gewirth, *Self-Fulfillment*, 3.

74. Gewirth, *Self-Fulfillment*, 3 and 48.

Chapter 6

1. Norman Macrae, "Pacific Century: 1975–2075?" *The Economist*, January 4, 1975: 15, http://normanmacrae.ning.com/forum/topics/asia-pacific-youth-collabor ation-century-macrae-economist-survey

2. See, for example, Ezra F. Vogel, "The Advent of the Pacific Century," *Harvard International Review* 6, no. 5 (March 1984): 14–16; David P. Gardner, "The Pacific Century," *Science* 237, no. 4812 (July 17, 1987): 233 (written while Gardner was president of the University of California system). For an example of "the Pacific Century" as embodying the military and diplomatic "pivot" to that region under the Obama administration, see Hillary Clinton, "America's Pacific Century," *Foreign Policy*, October 11, 2011, https://foreignpolicy.com/2011/10/11/americas-pacific -century/

3. Wendy Brown, *In the Ruins of Neoliberalism: The Rise of Antidemocratic Politics in the West* (New York: Columbia University Press, 2019), 183.

4. Clinton, "America's Pacific Century."

5. Clinton, "America's Pacific Century."

6. James McBride, Andrew Chatzky, and Anshu Siripurapu, "What's Next for the Trans-Pacific Partnership (TPP)?" Council on Foreign Relations, September 20, 2021, https://www.cfr.org/backgrounder/what-trans-pacific-partnership-tpp

7. Brown, *In the Ruins of Neoliberalism*, 183.

8. McBride, Chatzky, and Siripurapu, "What's Next for the Trans-Pacific Partnership (TPP)?"

9. See Office of the United States Trade Representative, "Fact Sheet: The Biden-Harris Administration's New Approach to the US-China Trade Relationship," October 4, 2021, https://ustr.gov/about-us/policy-offices/press-office/press-releases/20 21/october/fact-sheet-biden-harris-administrations-new-approach-us-china-trade -relationship

10. Office of the White House, "Fact Sheet: In Asia, President Biden and a Dozen Indo-Pacific Partners Launch the Indo-Pacific Economic Framework for Prosperity," May 23, 2022, https://www.whitehouse.gov/briefing-room/statemen ts-releases/2022/05/23/fact-sheet-in-asia-president-biden-and-a-dozen-indo-pacific -partners-launch-the-indo-pacific-economic-framework-for-prosperity/

11. As in other aspects of US culture, China has come to feature importantly in the US theatrical imaginary of the past decade. For just a short list, see for example Christopher Chen's plays *Caught* (2015) and *The Hundred Flowers Project* (2014), Lucy Kirkwood's *Chimerica* (2013), Frances Ya-Chu Cowhig's *The World of Extreme Happiness* (2013), and Lauren Yee's *The Great Leap* (2018).

12. Colleen Lye, *America's Asia: Racial Form and American Literature* (Princeton: Princeton University Press, 2004).

13. As Daisey describes it, *Agony* "examines globalization by exploring the exploitation of Chinese workers through the lens of [the] rise and fall and rise [of] Apple, industrial design, and the human price we are willing to pay for our technology." An

excerpt of Disney's piece was broadcast in January 2012 as part of an episode of National Public Radio's *This American Life,* and became the most downloaded podcast in its history. The show was eventually exposed by a range of China-based journalists for a number of fabrications, which Daisey initially denied. In the original script (a different version of which Daisey continued to perform on the international theater circuit), he exaggerated the threat of physical violence that Western journalists face when investigating Foxconn. He described gun-toting factory guards, augmenting the sense of disorientation created by capitalism run amok with his story of a cab-driver who nearly plunges Daisey and his taxi-mates to their deaths on a highway exit that ends abruptly, and worst of all, invented details of the experiences of actual factory workers at Foxconn. For more on the controversy, see my essay, "Neoliberal Scandals: Foxconn, Mike Daisey, and the Turn Toward Nonfiction Drama." Copyright © 2014 Johns Hopkins University Press. This article first appeared in *Theatre Journal* 66, no. 1 (March 2014): 1–18. Published with permission by Johns Hopkins University Press.

14. Laikwan Pang, *Creativity and Its Discontents: China's Creative Industries and Intellectual Property Rights Offenses* (Durham, NC: Duke University Press, 2012), 14.

15. Enrico Moretti, *The New Geography of Jobs* (Boston: Houghton Mifflin Harcourt, 2012), 5.

16. For a longer consideration of this view, see Hentyle Yapp, *Minor China: Method, Materialisms, and the Aesthetic* (Durham, NC: Duke University Press, 2021), 145–46.

17. Thomas L. Friedman, *The World Is Flat: A Brief History of the Twenty-First Century* (New York: Farrar, Straus and Giroux, 2005), 107. Emphasis in original.

18. As David Roh, Betsy Huang, and Greta Niu argue, "techno-Orientalism, like Orientalism, places great emphasis on the project of modernity—cultures privilege modernity and fear losing their perceived 'edge' over others. Stretching beyond Orientalism's premise of a hegemonic West's representational authority over the East, techno-Orientalism's scope is much more expansive and bidirectional, its discourses mutually constituted by the flow of trade and capital across the hemispheres. . . . The discourse on China's 'rise' in the U.S. context, consistent with techno-Orientalist contradictions, has focused on constructing its people as a vast, subaltern-like labor force and as a giant consumer market whose appetite for Western cultural products, if nurtured, could secure U.S. global cultural and economic dominance. This dual image of China as both developing-world producers and first-world consumers presents a representational challenge for the West: Is China a human factory? Or is it a consumerist society, like the United States, whose enormous purchasing power dictates the future of technological innovations and economies?" Roh, Huang, and Niu, *Techno-Orientalism: Imagining Asia in Speculative Fiction, History, and Media* (New Brunswick, NJ: Rutgers University Press, 2015), 3–4.

19. For a detailed account of this shift, see chapter 4 of Pang, *Creativity and Its Discontents*; Michael Keane, *Created in China: The Great New Leap Forward* (New

York: Routledge, 2007); Michael Keane, *China's New Creative Clusters: Governance, Human Capital and Investment* (New York: Routledge, 2013); Justin O'Connor and Xin Gu, *Red Creative: Culture and Modernity in China* (Bristol, UK: Intellect, 2020).

20. Mike Daisey, *The Agony and the Ecstasy of Steve Jobs*, 17. A script copy of this play had been available on Daisey's website (http://mikedaisey.blogspot.com/mon ologues.html), but in the wake of the scandals about the show it was removed. All quoted material is from the original 2011 version of the script from the website.

21. Daisey, *The Agony and the Ecstasy of Steve Jobs*, 45.

22. Lewis Hyde, *The Gift: How the Creative Spirit Transforms the World* (London: Canongate, 1979), 8.

23. See, for example, Maurizio Lazzarato, "Immaterial Labor," in *Radical Thought in Italy: A Potential Politics*, eds. Paulo Virno and Michael Hardt (Minneapolis: University of Minnesota Press, 1964), 132–47.

24. Richard Florida, *The Rise of the Creative Class: Revisited* (New York: Basic Books, 2014), 11.

25. *Edge*, "Digital Reality: A Conversation with Neil Gershenfeld," January 23, 2015, edge.org/conversation/neil_gershenfeld-digital-reality

26. Daisey, *The Agony and the Ecstasy of Steve Jobs*, 12.

27. Daisey, *The Agony and the Ecstasy*, 35–36.

28. Daisey, *The Agony and the Ecstasy*, 52.

29. Daisey, *The Agony and the Ecstasy*, 54.

30. Winnie Wong, "Shenzhen's Model Bohemia and the Creative China Dream," in *Learning from Shenzhen: China's Post-Mao Experiment from Special Zone to Model City*, eds. Mary Ann O'Donnell, Winnie Wong, and Jonathan Bach (Chicago: University of Chicago Press, 2017), 206.

31. *WIRED UK*, "Shenzhen: The Silicon Valley of Hardware (Full Documentary) | Future Cities," YouTube video, 1:07:50, July 5, 2016, https://www.youtube.com/watch?v=SGJ5cZnoodY

32. *WIRED UK*, "Shenzhen."

33. Wong, "Shenzhen's Model Bohemia," 206.

34. *WIRED UK*, "Shenzhen."

35. *WIRED UK*, "Shenzhen."

36. *WIRED UK*, "Shenzhen."

37. *WIRED UK*, "Shenzhen."

38. *WIRED UK*, "Shenzhen."

39. *WIRED UK*, "Shenzhen."

40. *WIRED UK*, "Shenzhen."

41. David Henry Hwang, "Show, Interrupted (By Life)," Curran, June 5, 2018, https://sfcurran.com/the-currant/articles/show-interrupted-by-life/

42. John Howkins, *The Creative Economy: How People Make Money from Ideas* (London: Allen Lane, 2011), vii–viii.

43. One of the musical's subplots involves Hwang's participation in the creation

of a musical that could raise China's international stature—a story that reflects his own experience of being pitched by Chinese producers on projects designed for just this: "For a number of years I was getting pitched on Chinese projects. China has, among its many soft power goals—not so much anymore—but at one time had the desire to create a musical that would end up on Broadway. Prior to the musical *Allegiance* in 2015 I was the only even nominally Chinese person ever to have written anything to end up on Broadway, so I would be pitched for a number of things. . . . But China, particularly prior to 2020, was really interested in getting their movies onto the world stage, having an international hit, having a show on Broadway, having international TV shows, as part of their projection of soft power. It's not like Asian material from other countries can't hugely impact the world market—just look at what Korea has managed to do, or Hong Kong cinema at a certain point." David Henry Hwang, personal interview, March 31, 2022.

44. For an alternative reading of *The King and I*, see Christina Klein, *Cold War Orientalism: Asia in the Middlebrow Imagination, 1945–1961* (Berkeley: University of California Press, 2003).

45. David Henry Hwang, "Soft Power" (unpublished manuscript), 40. Many thanks to Hwang for giving me access to this manuscript in the summer of 2020.

46. Although Clinton would oppose the TPP in her 2016 campaign, as secretary of state she had praised it as "the gold standard in trade agreements." For a discussion of Clinton's role in focusing Obama's foreign policy on East Asia, see Catherine Putz and Shannon Tiezzi, "Did Hillary Clinton's Pivot to Asia Work?" *FiveThirtyEight*, April 14, 2016, https://fivethirtyeight.com/features/did-hillary-clintons-pi vot-to-asia-work/; Eric Bradner, "Clinton's TPP Controversy: What You Need to Know," *CNN*, July 27, 2016, https://www.cnn.com/2016/07/27/politics/tpp-what -you-need-to-know/index.html

47. Hwang, "Soft Power," 9, 18–19, emphasis in original.

48. Hwang, "Soft Power," 11.

49. Hwang, personal interview, March 31, 2022.

50. Hwang, "Soft Power," 43.

51. Hwang, "Soft Power," 73.

52. Hwang, "Soft Power," 7–8.

53. In a personal interview, Hwang avers, "I do ultimately want to be asserting the value of democracy, and particularly by the time we get to the finale with the 'Democracy' reprise which is sung by the ensemble which is Asian American, that I want us to battle through the disillusionment and the heartbreak and come back to democracy in a sadder and wiser sense. But the power ballad version of 'Democracy' by Hillary was really conceived as a torch song, you know, that she can't leave her abusive lover, democracy, and so that's kind of the original concept. In the ballad version it's more ambivalent and tortured, by the time you get to the finale with the chorus it's more trying to reclaim democracy with a stage full of Asian American faces." Personal interview, March 31, 2022.

Epilogue

1. Wendy Brown, *In the Ruins of Neoliberalism: The Rise of Antidemocratic Politics in the West* (New York: Columbia University Press, 2019), 6–7.

2. Brown, *In the Ruins of Neoliberalism*, 2.

3. On the debate among historians as to the long-standing impact of Reconstruction, see Eric Foner, *Reconstruction: America's Unfinished Revolution* (New York: Harper Perennial Modern Classics, 2014); Saidiya Hartman, *Scenes of Subjection: Terror, Slavery, and Self-Making in Nineteenth-Century America* (New York: Oxford University Press, 1997); Joseph Reidy, *Illusions of Emancipation: The Pursuit of Freedom and Equality in the Twilight of Slavery* (Durham: University of North Carolina Press, 2019).

4. Andreas Reckwitz, *The Invention of Creativity: Modern Society and the Culture of the New*, trans. Steven Black (Cambridge: Polity Press, 2017), viii and 24.

5. Vlad Glăveanu, "Creativity as a Sociocultural Act," *Journal of Creative Behavior* 49, no. 3 (2015), 165.

6. Vlad Glăveanu, *Creativity: A Short Introduction* (Oxford: Oxford University Press, 2021), 19, 22.

7. Brown, *In the Ruins of Neoliberalism*, 27–28.

8. Shannon Jackson, *Social Works: Performing Art, Supporting Publics* (New York: Routledge, 2011), 13–17.

9. Moreover, the financial realities of socially engaged art practice—where it is able to enrich the social in the ways that Brown describes—mean that in the US it nearly always involves practice outside of the best-funded and wealthiest arts institutions (i.e., the ones with enough financial capital to pay artists in ways they can survive on), operating more consistently in community-based organizations whose missions and identities are specifically geared toward "the social" in Brown's sense.

10. Debra Webb, "Placemaking and Social Equity: Expanding the Framework of Creative Placemaking," *Artivate: A Journal of Entrepreneurship in the Arts* 3, no. 1 (Winter 2014): 38. For a consideration of equity-based creative placemaking, and the role of artists in ensuring community participation beyond Webb's very suggestive article, see Tom Borrup, "Just Planning: What Has Kept the Arts and Urban Planning Apart?" *Artivate: A Journal of Entrepreneurship in the Arts* 6, no. 2 (Summer 2017): 46–57; Jennifer Minner, "Preservation that Builds Equity, Art that Constructs Just Places," *Future Anterior* 17, no. 2 (Winter 2020): 132–46; Walter Hood and Grace Mitchell Tada, eds., *Black Landscapes Matter* (Charlottesville: University of Virginia Press, 2020).

11. Vlad P. Glăveanu and Ronald A. Beghetto, "Creative Experience: A Non-Standard Definition of Creativity," *Creativity Research Journal* 33, no. 2: 76.

12. Glăveanu and Beghetto, "Creative Experience": 76.

13. Nicholas Confessore, "Cambridge Analytica and Facebook: The Scandal and the Fallout So Far," *New York Times*, April 4, 2018, https://www.nytimes.com/2018/04/04/us/politics/cambridge-analytica-scandal-fallout.html. Carole Cadwalladr

and Emma Graham-Harrison, "Revealed: 50 Million Facebook Profiles Harvested for Cambridge Analytica in Major Data Breach," *The Guardian*, March 17, 2018, https://www.theguardian.com/news/2018/mar/17/cambridge-analytica-facebook -influence-us-election

14. John Gardner, *Self-Renewal: Innovation and the Innovative Society* (New York: HarperCollins, 1963), 32.

15. Jon Porter, "Streaming Music Report Sheds Light on Battle Between Spotify, Amazon, Apple, and Google," *The Verge*, January 20, 2022, https://www.theverge .com/2022/1/20/22892939/music-streaming-services-market-share-q2-2021-spoti fy-apple-amazon-tencent-youtube

16. Ennica Jacob, "How Much Does Spotify Pay Per Stream? What You'll Earn Per Song, and How to Get Paid More for Your Music," *Business Insider*, February 24, 2021, https://www.businessinsider.com/how-much-does-spotify-pay-per-stream

17. Alex Ross, "Reasons to Abandon Spotify that Have Nothing to do with Joe Rogan," *New Yorker*, February 2, 2022, https://www.newyorker.com/culture/cultur al-comment/imagine-a-world-without-spotify

18. "For each dollar of revenue Spotify earns, 58.5 cents goes to the owner of a song's sound recording (usually a record label), Spotify keeps 29.38 cents, 6.12 cents goes to whoever owns publishing rights (usually the songwriter) and 6 cents goes to mechanical rights (often, but not always, owned by the songwriter)." Travis M. Andrews, "For Many Musicians, Their Grudge Against Spotify Runs Deeper than Joe Rogan," *Washington Post*, February 2, 2022, https://www.washingtonpost.com /arts-entertainment/2022/02/02/young-rogan-belly-delete-spotify/

19. Damon Krukowski, "The Big Short of Streaming," *Dada Drummer Almanach*, February 1, 2022. https://dadadrummer.substack.com/p/spotify-is-misinforma tion?s=r

20. Maria Eriksson, Rasmus Fleischer, Anna Johansson, Pelle Snickars, and Patrick Vonderau, *Spotify Teardown: Inside the Black Box of Streaming Music* (Cambridge: MIT Press, 2019), 4–5.

21. Ericksson et al., *Spotify Teardown*, 4–5.

22. Shoshana Zuboff, *The Age of Surveillance Capitalism: The Fight for a Human Future at the New Frontier of Power* (London: Profile Books, 2019), 8.

23. Ericksson et al., *Spotify Teardown*, 4–5.

24. Edmund L. Andrews, "The Science Behind Cambridge Analytica: Does Psychological Profiling Work?" Stanford Graduate School of Business, April 12, 2018, https://www.gsb.stanford.edu/insights/science-behind-cambridge-analytica-does-ps ychological-profiling-work

25. For an elaboration of this argument see Zuboff, *The Age of Surveillance Capitalism*, 13.

26. On the implications of the passage of Proposition 22, which enshrined gig labor in California in defiance of labor protection laws designed to mitigate it, see Rebecca Heilweil, "California Has Rejected a Major Gig Economy Reform, Leaving

Workers Without Employee Protections," *Vox*, November 4, 2020, https://www.vox .com/recode/2020/11/4/21539335/california-proposition-22-results-gig-economy -workers. Greg Bensinger, "Other States Should Worry About What Happened in California," *New York Times*, November 6, 2020, https://www.nytimes.com/2020 /11/06/opinion/prop-22-california-labor-law.html

27. See for example the sentiment in the following: Kim Kavin, "California Voters Saved Uber and Lyft—and Writers, Artists, and Other Independent Workers," *NBC News*, November 5, 2020, https://www.nbcnews.com/think/opinion/californ ia-voters-saved-uber-lyft-gig-economy-backing-prop-22-ncna1246680

28. Brown, *In the Ruins of Neoliberalism*, 163–64.

29. Hans Sluga, "Donald Trump: Between Populist Rhetoric and Plutocratic Rule" (presentation, UC Berkeley Critical Theory Symposium, Berkeley, CA, 2017), quoted in Brown, *In the Ruins of Neoliberalism*, 224, footnote 2.

30. Brown, *In the Ruins of Neoliberalism*, 161.

31. Brown, *In the Ruins of Neoliberalism*, 168.

Bibliography

Adams, Gordon. *The Politics of Defense Contracting: The Iron Triangle.* New York: Routledge, 1981.

Albert, Robert S. "The Concept of Genius and Its Implications for the Study of Creativity and Giftedness." *American Psychologist* 24 (1969): 743–53.

Albert, Robert S. "Toward a Behavioral Definition of Genius." *American Psychologist* 30, no. 2 (1975): 140–51.

Albert, Robert S., and Mark A. Runco. "A History of Research on Creativity." In *Handbook on Creativity*, edited by Robert J. Sternberg, 16–31. New York: Cambridge University Press, 1998.

Allen, Barry. "Prometheus and the Muses: On Art and Technology." *Common Knowledge* 12, no. 3 (Fall 2006): 354–78.

Allyn, Bobby. "People Are Talking about Web3. Is It the Internet of the Future or Just a Buzzword?" NPR, November 21, 2021. https://www.npr.org/2021/11/21/1056988346/web3-internet-jargon-or-future-vision

Amazon. "Think Different Poster Mahatma Gandhi, 11 x 17 Inches." http://www.amazon.com/Mohatma-Ghandi-Think-Different-Poster/dp/B004XX5N20

Andrews, Edmund L. "The Science Behind Cambridge Analytica: Does Psychological Profiling Work?" Stanford Graduate School of Business, April 12, 2018. https://www.gsb.stanford.edu/insights/science-behind-cambridge-analytica-does-psychological-profiling-work

Andrews, Travis M. "For Many Musicians, Their Grudge Against Spotify Runs Deeper than Joe Rogan." *Washington Post*, February 2, 2022. https://www.washingtonpost.com/arts-entertainment/2022/02/02/young-rogan-belly-delete-spotify/

Apple. "Guidelines for Using Apple Trademarks and Copyrights." http://www.apple.com/legal/intellectual-property/guidelinesfor3rdparties.html

Arizona State University. "The Frankenstein Bicentennial Project, 1818–2018." https://frankenstein.asu.edu/

Auchincloss, Elizabeth L., and Eslee Samberg, eds. *Psychoanalytic Terms and Concepts*, 4th edition. New Haven: Yale University Press, 2018.

Bajarin, Tim. "Why the Maker Movement Is Important to America's Future." *TIME*. May 19, 2014. http://time.com/104210/maker-faire-maker-movement/

Becker, Madelle. "Nineteenth-Century Foundations of Creativity Research." *Creativity Research Journal* 8, no. 3 (1995): 219–29.

Benjamin, Walter. "The Work of Art in the Age of Mechanical Reproduction." In *Illuminations*, edited by Hannah Arendt. London: Fantana, 1968.

Bensinger, Greg. "Other States Should Worry About What Happened in California." *New York Times*, November 6, 2020. https://www.nytimes.com/2020/11/06/opinion/prop-22-california-labor-law.html

Berlant, Lauren. *Cruel Optimism*. Durham, NC: Duke University Press, 2011.

Bloom, Harold. *The Anxiety of Influence: A Theory of Poetry*. New York: Oxford University Press, 1973.

Borrup, Tom. "Just Planning: What Has Kept the Arts and Urban Planning Apart?" *Artivate: A Journal of Entrepreneurship in the Arts* 6, no. 2 (Summer 2017): 46–57.

Box 66. Ronald Reagan Presidential Library & Museum, Simi Valley, California.

Boym, Svetlana. *The Future of Nostalgia*. New York: Basic Books, 2008.

Bradner, Eric. "Clinton's TPP Controversy: What You Need to Know." *CNN*, July 27, 2016. https://www.cnn.com/2016/07/27/politics/tpp-what-you-need-to-know/index.html

Brad Brenner, "Creativity is Your Secret Advantage for Mental Health and Well-Being," Therapy Group of NYC, September 16, 2019, https://nyctherapy.com/therapists-nyc-blog/creativity-is-your-secret-advantage-for-mental-health-and-well-being/.

Brilliant, Mark. *The Color of America Has Changed: How Racial Diversity Shaped Civil Rights Reform in California, 1941–1978*. New York: Oxford University Press, 2010.

Bronson, Po, and Ashley Merryman, "The Creativity Crisis." *Newsweek*, July 10, 2010. http://www.newsweek.com/creativity-crisis-74665

Brouillette, Sarah. "Creative Labor." *Mediations: Journal of the Marxist Literary Group* 24, no. 2 (Spring 2009): 140–49.

Brown, Bill. "Thing Theory." *Critical Inquiry* 28, no. 1 (Autumn 2001): 1–22.

Brown, Edmund G., Bernice Layne Brown, and Ronald Reagan. *Political Spots. Pat Brown. 1966 Gubernatorial Campaign. Vote for a Real Governor, Not an Acting One*, 1966. Berkeley Art Museum and Pacific Film Archive, University of California–Berkeley.

Brown, Wendy. *In the Ruins of Neoliberalism: The Rise of Antidemocratic Politics in the West*. New York: Columbia University Press, 2019.

Brown, Wendy. "Neo-liberalism and the End of Liberal Democracy." *Theory and Event* 7, no. 1 (Winter 2003).

Buechley, Leah. "Introduction." In *The Art of Tinkering: Meet 150+ Makers Working*

at the Intersection of Art, Science & Technology, edited by Karen Wilkinson and Mike Petrich, 9. San Francisco: Weldon Owen, 2014.

Cadwalladr, Carole, and Emma Graham-Harrison. "Revealed: 50 Million Facebook Profiles Harvested for Cambridge Analytica in Major Data Breach." *The Guardian*, March 17, 2018. https://www.theguardian.com/news/2018/mar/17/cambri dge-analytica-facebook-influence-us-election

Cal Performances. "Artist Conversation with Manual Cinema." 23:38. https://calp erformances.org/related-events/pre-performance-conversation-for-frankenstein

Casey, Tina. "When the Military Meets the Maker Movement." *Triple Pundit*, May 29, 2012. https://www.triplepundit.com/story/2012/when-military-meets-mak er-movement/65156

Catastrophone Orchestra and Arts Collective. "What Then Is Steampunk?" *Steampunk Magazine*, September 1, 2009. https://issuu.com/baccioly/docs/spm1-pri nting

Clapp, Edward P. "Presenting a Symptomatic Approach to the Maker Aesthetic." *Journal of Aesthetic Education* 51, no. 4 (Winter 2017): 77–97.

Clapp, Edward P., Jessica Ross, Jennifer O. Ryan, and Shari Tishman. *Maker-Centered Learning: Empowering Young People to Shape Their Worlds*. New York: John Wiley & Sons, 2016.

Clinton, Hillary. "America's Pacific Century." *Foreign Policy*, October 11, 2011. https://foreignpolicy.com/2011/10/11/americas-pacific-century/

CONELRAD6401240. "Ronald Reagan Announces for Governor: 01/04/1966." YouTube video, 29:35. Posted June 11, 2011. https://www.youtube.com/watch?v= 0VNUOO7POXs&list=PL6MBh9P9pssjq1ZzFrcbEvfeggIiszEd0&index=8&t =773s

Confessore, Nicholas. "Cambridge Analytica and Facebook: The Scandal and the Fallout So Far." *New York Times*, April 4, 2018. https://www.nytimes.com/2018 /04/04/us/politics/cambridge-analytica-scandal-fallout.html

Csicsery-Ronay Jr., Istvan. *The Seven Beauties of Science Fiction*. Middletown, CT: Wesleyan University Press, 2011.

Csikszentmihalyi, Mihaly. *Creativity: The Psychology of Discovery and Invention*. New York: Harper Collins, 2013.

Cutter, Bo. "An American Renaissance: How It Is Happening, How to Nudge It Along, Why We Should Care." *Innovations* 7, no. 3 (2012): 15–24.

Daisey, Mike. "Monologues." http://mikedaisey.blogspot.com/monologues.html

Dallek, Matthew. *The Right Moment: Ronald Reagan's First Victory and the Decisive Turning Point in American Politics*. New York: Free Press, 2001. Kindle.

Daniels, Victor. "Handout on Carl Gustav Jung." Accessed July 2, 2021. https://web .sonoma.edu/users/d/daniels/jungsum.html

David S. Broder Papers. Manuscript Division. Library of Congress, Washington, DC.

Dear, Nick. *Frankenstein: Based on the Novel by Mary Shelley*. New York: Faber and Faber, 2016.

De Groot, Gerard J. "'A Goddamned Electable Person': The 1966 California Gubernatorial Campaign of Ronald Reagan." *History* 82, no. 267 (2002): 429–48.

De Groot, Gerard J. "Ronald Reagan and Student Unrest in California, 1966–1970." *Pacific Historical Review* 65, no. 1 (February 1996): 107–29.

DeGroot, Gerard J. *Selling Ronald Reagan: The Emergence of a President.* London: I. B. Tauris, 2015.

Deresiewicz, William. "The Death of the Artist—and the Birth of the Creative Entrepreneur." *The Atlantic,* January/February 2015. http://www.theatlantic.com /magazine/archive/2015/01/the-death-of-the-artist-and-the-birth-of-the-creati ve-entrepreneur/383497/

de Ruyter, Alex, Martyn Brown, and John Burgess. "Gig Work and the Fourth Industrial Revolution: Conceptual and Regulatory Challenges." *Journal of International Affairs* 72, no. 1 (2019): 37–50.

Dewey, John. "Creative Democracy—The Task Before Us." https://www.philosop hie.uni-muenchen.de/studium/das_fach/warum_phil_ueberhaupt/dewey_creat ive_democracy.pdf

DiEM25 Communications. "Yanis Varoufakis on Crypto, the Left, and Techno-Feudalism." DiEM25, January 27, 2022. https://diem25.org/yanis-varoufakis-cr ypto-the-left-and-techno-feudalism/

Diversus Health, "The Mental Health Benefits of Creativity," https://diversushealth .org/the-mental-health-benefits-of-creativity/

Dougherty, Dale. "The Maker Mindset." In *Design, Make, Play: Growing the Next Generation of STEM Innovators,* edited by Margaret Honey and David E. Kanter, 7–12. New York: Routledge, 2013.

Eckersall, Peter, and Helena Grehan, eds. *The Routledge Companion to Theatre and Politics.* London: Routledge, 2019.

Edge. "Digital Reality: A Conversation with Neil Gershenfeld." January 23, 2015. edge.org/conversation/neil_gershenfeld-digital-reality

"El Pulpo Mecanico." Accessed October 16, 2015. http://elpulpomecanico-story .com/

Engell, James. *The Creative Imagination: Enlightenment to Romanticism.* Cambridge: Harvard University Press, 1981.

Eriksson, Maria, Rasmus Fleischer, Anna Johansson, Pelle Snickars, and Patrick Vonderau. *Spotify Teardown: Inside the Black Box of Streaming Music.* Cambridge: MIT Press, 2019.

Fisch, Audrey A. *Frankenstein: Icon of Modern Culture.* Hastings, UK: Helm Information, 2009.

Florida, Richard. *The Rise of the Creative Class: Revisited.* New York: Basic Books, 2014.

Foner, Eric. *Reconstruction: America's Unfinished Revolution.* New York: Harper Perennial Modern Classics, 2014.

Forry, Steven Earl. *Hideous Progenies: Dramatizations of "Frankenstein" from the*

Nineteenth Century to the Present. Philadelphia: University of Pennsylvania Press, 1990.

Foucault, Michel. "Technologies of the Self." In *Technologies of the Self: A Seminar with Michel Foucault*, edited by Luther H. Martin, Huck Gutman, and Patrick H. Hutton. Amherst: University of Massachusetts Press, 1988.

Free Republic. "The Creative Society speech by Ronald Reagan (University of Southern California, April 19, 1966)." Posted August 30, 2002. https://freerepublic.com/focus/news/742041/posts

Friedman, Gerald. "The Rise of the Gig Economy." *Dollars and Sense: Real World Economics* (March/April 2014): 28–29. http://dollarsandsense.org/archives/2014/0314friedman.html

Friedman, Thomas L. *The World Is Flat: A Brief History of the Twenty-first Century.* New York: Farrar, Straus and Giroux, 2005.

Fuegi, Jon, and Jo Francis. "Lovelace & Babbage and the Creation of the 1843 'Notes.'" *IEEE Annals of the History of Computing* 25, no. 4 (2003): 16–26.

Galton, Francis. *Hereditary Genius: An Inquiry into its Laws and Consequences.* London: Macmillan and Co., 1869.

Galton, Francis. *Hereditary Genius: An Inquiry into its Laws and Consequences.* 2nd edition. New York: Macmillan and Co., 1892.

Gardner, David P. "The Pacific Century." *Science* 237, no. 4812 (July 17, 1987): 233.

Gardner, John. *Self-Renewal: Innovation and the Innovative Society.* New York: HarperCollins, 1963.

Gauntlett, David. *Making Is Connecting: The Social Power of Creativity, From Craft and Knitting to Digital Everything.* 2nd edition. San Francisco: Polity Press, 2018.

Gershenfeld, Neil. *Fab: The Coming Revolution on Your Desktop—From Personal Computers to Personal Fabrication.* Basic Books: New York, 2008.

Gewirth, Alan. *Self-Fulfillment.* Princeton: Princeton University Press, 2009.

Gibson, William, and Bruce Sterling. *The Difference Engine.* New York: Random House, 1990.

Gilbert, Elizabeth. "Your Elusive Creative Genius." Filmed 2009. TED video, 19:15. http://www.ted.com/talks/elizabeth_gilbert_on_genius?language=en

Glăveanu, Vlad. "Creativity as a Sociocultural Act." *Journal of Creative Behavior* 49, no. 3 (2015): 165–80.

Glăveanu, Vlad, ed. *Creativity: A Very Short Introduction.* Oxford: Oxford University Press, 2021.

Glăveanu, Vlad. *The Creativity Reader.* Oxford: Oxford University Press, 2019. Kindle.

Glăveanu, Vlad. "Revisiting the 'Art Bias' in Lay Conceptions of Creativity." *Creativity Research Journal* 26, no. 1 (2014): 11–20.

Glăveanu, Vlad, and Ronald A. Beghetto, "Creative Experience: A Non-Standard Definition of Creativity." *Creativity Research Journal* 33, no. 2 (2021): 75–80.

Goldman, Alexandra. "The 'Google Shuttle Effect': Gentrification and San Fran-

cisco's Dot Com Boom 2.0." Master's thesis. University of California–Berkeley, 2013.

Goldstein, Amanda Jo. *Sweet Science: Romantic Materialism and the New Logics of Life*. Chicago: University of Chicago Press, 2017.

Gould, Stephen Jay. *The Hedgehog, the Fox, and the Magister's Pox: Mending the Gap between Science and the Humanities*. Cambridge: Harvard University Press, 2011.

Greenwald, Glenn. "Edward Snowden: The Whistleblower Behind the NSA Surveillance Revelations." *The Guardian*, June 11, 2013. https://www.theguardian .com/world/2013/jun/09/edward-snowden-nsa-whistleblower-surveillance

Guilford, J. P. "Can Creativity Be Developed?" *Art Education* 11, no. 6 (June 1958): 3–7,14–18.

Guilford, J. P. "Creativity." *American Psychologist* 5, no. 9 (September 1950): 444–54.

Guilford, J. P. "Three Faces of Intellect." *American Psychologist* 14, no. 8 (1959): 469–79.

Habermas, Jürgen. "Modernity: An Unfinished Project." In *Habermas and the Unfinished Project of Modernity*, edited by Maurizio Passerin d'Entrèves and Seyla Benhabib, 1–38. Cambridge: MIT Press, 1997.

Halverson, Erica Rosenfeld, and Kimberly M. Sheridan. "The Maker Movement in Education." *Harvard Education Review* 84, no. 4 (2014): 495–504.

Haney López, Ian. *Dog Whistle Politics: How Coded Racial Appeals Have Reinvented Racism and Wrecked the Middle Class*. New York: Oxford University Press, 2014.

Hartman, Saidiya. *Scenes of Subjection: Terror, Slavery, and Self-Making in Nineteenth-Century America*. New York: Oxford University Press, 1997.

Harvey, David. *A Brief History of Neoliberalism*. New York: Oxford University Press, 2007.

Harvie, Jen. *Fair Play: Art, Performance and Neoliberalism*. New York: Palgrave Macmillan, 2013.

Hatch, Mark. *The Maker Movement Manifesto: Rules for Innovation in the New World of Crafters, Hackers, and Tinkerers*. New York: McGraw-Hill Education, 2013.

Hatcher, Jessamyn, and Thuy Linh Nguyen Tu. "'Make What You Love': Homework, the Handmade, and the Precarity of the Maker Movement." *WSQ* 45, no. 3–4 (Fall/Winter 2017): 271–86.

Hebdige, Dick. *Subculture: The Meaning of Style*. New York: Routledge, 1979.

Heclo, Hugh. "Issue Networks and the Executive Establishment." *Public Policy Theories, Models, and Concepts: An Anthology*, edited by Daniel C. McCool, 268–87. Hoboken, NJ: Prentice Hall, 1995.

Heilweil, Rebecca. "California Has Rejected a Major Gig Economy Reform, Leaving Workers without Employee Protections." *Vox*, November 4, 2020. https:// www.vox.com/recode/2020/11/4/21539335/california-proposition-22-results -gig-economy-workers

Higgins, Michelle. "Dumbo Roars." *New York Times*, September 19, 2014. http:// www.nytimes.com/2014/09/21/realestate/transforming-a-brooklyn-neighborh ood-with-new-condos.html

Hill, Gladwin. "California Politics." In *The California Revolution*, edited by Carey McWilliams, 172–84. New York: Grossman Publishers, 1968.

Holden, Kenneth. *The Making of the Great Communicator: Ronald Reagan's Transformation from Actor to Governor*. Guilford, CT: Lyons Press, 2013.

Honey, Margaret, and David E. Kantor. *Design, Make, Play: Growing the Next Generation of STEM Innovators*. New York: Routledge, 2013.

Hood, Walter, and Grace Mitchell Tada, eds. *Black Landscapes Matter*. Charlottesville: University of Virginia Press, 2020.

Hoppe, Arthur. "Ronald Reagan for Prince of Denmark." *San Francisco Chronicle*, January 7, 1966.

Howkins, John, *The Creative Economy: How People Make Money from Ideas*. London: Allen Lane, 2011.

Huizinga, Johan. *Homo Ludens: A Study of the Play-Element in Culture*. London: Routledge, 1949.

Hustis, Harriet. "Responsible Creativity and the 'Modernity' of Mary Shelley's Prometheus." *Studies in English Literature 1500–1900* 49, no. 4 (Autumn 2009): 993–1007.

Hwang, David Henry. "Show, Interrupted (By Life)." Curran, June 5, 2018. https://sfcurran.com/the-currant/articles/show-interrupted-by-life/

Hwang, David Henry. "Soft Power." Unpublished manuscript.

Hyde, Lewis. *The Gift: How the Creative Spirit Transforms the World*. London: Canongate, 1979.

IBM. "IBM 2010 Global Study: Creativity Selected as Most Crucial Factor for Future Success." May 18, 2010. https://www.ibm.com/news/ca/en/2010/05/20/v384864m81427w34.html

Jackson, Shannon. *Social Works: Performing Art, Supporting Publics*. New York: Routledge, 2011.

Jackson, Shannon, and Marianne Weems. *The Builders Association: Performance and Media in Contemporary Theater*. Cambridge: MIT Press, 2015.

Jacob, Ennica. "How Much Does Spotify Pay Per Stream? What You'll Earn Per Song, and How to Get Paid More for Your Music." *Business Insider*, February 24, 2021. https://www.businessinsider.com/how-much-does-spotify-pay-per-stream

Jameson, Fredric. *Postmodernism, or, the Cultural Logic of Late Capitalism*. Durham, NC: Duke University Press, 1992.

Jeter, K. W. *Infernal Devices*. New York: St. Martin's Press, 1987.

Jonçich, Geraldine. "A Culture-Bound Concept of Creativity: A Social Historian's Critique, Centering on a Recent American Research Report." *Educational Theory* 14, no, 3 (July 1964): 133–43.

Kahn, Arthur. "'Every Art Possessed by Man Comes from Prometheus': The Greek Tragedians and Science and Technology." *Technology and Culture* 11, no. 2 (April 1970): 133–62.

Karwowski, Maciej, and Dorota Jankowska. "Sir Francis Galton and the 'Statistics of Mental Imagery.'" In *The Creativity Reader*, edited by Vlad Glăveanu. Oxford: Oxford University Press, 2019. Kindle.

Kaufman, Micha. "The Gig Economy: The Force that Could Save the American Worker?" *WIRED*, September 17, 2013. http://www.wired.com/2013/09/the-gig-economy-the-force-that-could-save-the-american-worker/

Kavin, Kim. "California Voters Saved Uber and Lyft—and Writers, Artists, and Other Independent Workers." *NBC News*, November 5, 2020. https://www.nbcnews.com/think/opinion/california-voters-saved-uber-lyft-gig-economy-backing-prop-22-ncna1246680

Keane, Michael. *China's New Creative Clusters: Governance, Human Capital and Investment*. New York: Routledge, 2013.

Keane, Michael. *Created in China: The Great New Leap Forward*. New York: Routledge, 2007.

Kettering, C. F. "How Can We Develop Inventors?" In "A Symposium on Creative Engineering." New York: American Society of Mechanical Engineers, 1944.

Kim, Kyung Hee. "The Creativity Crisis: The Decrease in Creative Thinking Scores on the Torrance Tests of Creative Thinking." *Creativity Research Journal* 23, no. 4 (2011): 285–95.

Kingfisher, Catherine, and Jeff Maskovsky. "The Limits of Neoliberalism." *Critique of Anthropology* 28, no. 2 (2008): 115–26.

Klein, Christina. *Cold War Orientalism: Asia in the Middlebrow Imagination, 1945–1961*. Berkeley: University of California Press, 2003.

Kőváry, Zoltan. *Homo Creativus: The Psychobiographical Study of Eminent Creativity*. New York: Scholars' Press, 2017.

Krukowski, Damon. "The Big Short of Streaming." *Dada Drummer Almanach*, February 1, 2022. https://dadadrummer.substack.com/p/spotify-is-misinformation?s=r

Lang, David. *Zero to Maker: A Beginner's Guide to the Skills, Tools, and Ideas of the Maker Movement*. 2nd edition. San Mateo, CA: Make Community LLC, 2017.

Latour, Bruno. "Love Your Monsters: Why We Must Care for Our Technologies As We Do Our Children." *Breakthrough Institute*, February 14, 2012. https://thebreakthrough.org/journal/issue-2/love-your-monsters

Lazzarato, Maurizio. "Immaterial Labor." In *Radical Thought in Italy: A Potential Politics*, edited by Paulo Virno and Michael Hardt. Minneapolis: University of Minnesota Press, 1964.

Letters of Note. "The Birth of Steampunk." March 1, 2011. https://lettersofnote.com/2011/03/01/the-birth-of-steampunk/

Liu, Alan. *The Laws of Cool: Knowledge Work and the Culture of Information*. Chicago: University of Chicago Press, 2004.

Lookingglass Theatre Company. "FRANKENSTEIN: Unearthed." YouTube video, 1:41. September 28, 2018. https://www.youtube.com/watch?v=brSw8D08i6U

Lye, Colleen. *America's Asia: Racial Form and American Literature*. Princeton: Princeton University Press, 2004.

Macrae, Norman. "Pacific Century: 1975–2075?" *The Economist*, January 4, 1975.

http://normanmacrae.ning.com/forum/topics/asia-pacific-youth-collaboration-century-macrae-economist-survey

Magelssen, Scott. *Simming: Participatory Performance and the Making of Meaning.* Ann Arbor: University of Michigan Press, 2014.

Manual Cinema. "Behind the Scenes of Manual Cinema's *Frankenstein.*" Accessed December 16, 2020. http://manualcinema.com/behind-the-scenes-of-manual-cinemas-frankenstein/

Marez, Curtis. "Ronald Reagan, the College Movie: Political Demonology, Academic Freedom, and the University of California." *Critical Ethnic Studies* 2, no. 1 (Spring 2016): 148–80.

Marshall, Lee. *Bootlegging: Romanticism and Copyright in the Music Industry.* Thousand Oaks, CA: SAGE Publishing, 2005.

McAfee, Andrew. "Who Are the Humanists, and Why Do They Dislike Technology So Much?" *Financial Times.* July 7, 2015. https://www.ft.com/content/8fbd6859-def5-35ec-bbf5-0c262469e3e9

McBride, James, Andrew Chatzky, and Anshu Siripurapu. "What's Next for the Trans-Pacific Partnership (TPP)?" Council on Foreign Relations, September 20, 2021. https://www.cfr.org/backgrounder/what-trans-pacific-partnership-tpp

McDowell, Jack S. "Senators Blister UC Head." *San Francisco Examiner*, May 6, 1966. https://www-proquest-com.libproxy.berkeley.edu/hnpuswest/docview/2163958622/1FFE4F086F8E4EE5PQ/9?accountid=14496

McKenzie, Jon. *Perform or Else: From Discipline to Performance.* New York: Routledge, 2001.

McRobbie, Angela. *Be Creative: Making a Living in the New Culture Industries.* London: Polity Press, 2016.

Means, Marianne. "Reagan's Decline." *San Francisco Chronicle*, March 27, 1966.

Meer, Zubin. "Introduction: Individualism Revisited." In *Individualism: The Cultural Logic of Modernity*, edited by Zubin Meer. Lanham, MD: Lexington Books, 2011.

Mercatus Center. https://www.mercatus.org/

Minner, Jennifer. "Preservation that Builds Equity, Art that Constructs Just Places." *Future Anterior* 17, no. 2 (Winter 2020): 132–46.

Mumford, Michael. "Where Have We Been, Where Are We Going? Taking Stock in Creativity Research." *Creativity Research Journal* 15, no. 2–3 (2003): 107–20.

Newfield, Christopher. *Unmaking the Public University: The Forty-Year Assault on the Middle Class.* Cambridge: Harvard University Press, 2008.

Nielsen, Laura D. "Heterotopic Transformations: The (Il)Liberal Neoliberal." In *Neoliberalism and Global Theatres: Performance Permutations*, edited by Laura D. Nielsen and Patricia Ybarra, 1–24. London: Palgrave MacMillan, 2012.

O'Connor, Justin, and Xin Gu. *Red Creative: Culture and Modernity in China.* Bristol, UK: Intellect, 2020.

Office of the Governor of California. "Creative Studies," Volume 1. n.d.

Office of the Governor of California. "Creative Studies," Volume 3. n.d.

Office of the United States Trade Representative. "Fact Sheet: The Biden-Harris Administration's New Approach to the US-China Trade Relationship." October 4, 2021. https://ustr.gov/about-us/policy-offices/press-office/press-releases/2021 /october/fact-sheet-biden-harris-administrations-new-approach-us-china-trade -relationship

Office of the White House Press Secretary. "Remarks by the President at the White House Maker Faire." June 18, 2014. https://obamawhitehouse.archives.gov/the -press-office/2014/06/18/remarks-president-white-house-maker-faire

Onion, Rebecca. "Reclaiming the Machine: An Introductory Look at Steampunk in Everyday Practice." *Neo-Victorian Studies* 1, no. 1 (2008): 138–63.

Oxford English Dictionary. "Create," 2a. Accessed May 15, 2015. http://www.oed.com /view/Entry/4406

Oxford English Dictionary. "Create," 2c. Accessed May 15, 2015. http://www.oed.com /view/Entry/44061

Pang, Laikwan. *Creativity and Its Discontents: China's Creative Industries and Intellectual Property Rights Offenses.* Durham, NC: Duke University Press, 2012.

Perschon, Mike Dieter. "The Steampunk Aesthetic: Technofantasies in a Neo-Victorian Retrofuture." PhD dissertation. University of Alberta, 2012.

Plog, Stanley. "More Than Just an Actor: The Early Campaigns of Ronald Reagan." June 1981. MSS 83/92. Regional Oral History Office, Bancroft Library, University of California–Berkeley.

Porter, Jon. "Streaming Music Report Sheds Light on Battle Between Spotify, Amazon, Apple, and Google." *The Verge*, January 20, 2022. https://www.theverge .com/2022/1/20/22892939/music-streaming-services-market-share-q2-2021 -spotify-apple-amazon-tencent-youtube

Putz, Catherine, and Shannon Tiezzi. "Did Hillary Clinton's Pivot to Asia Work?" *FiveThirtyEight*, April 14, 2016. https://fivethirtyeight.com/features/did-hillary -clintons-pivot-to-asia-work/

Raggio, Olga. "The Myth of Prometheus: Its Survival and Metamorphosis Up to the Eighteenth Century." *Journal of the Warburg and Courtauld Institutes* 21, no. 1/2 (January–June 1958): 44–62.

Rancière, Jacques. "Doing or Not Doing: Politics, Aesthetics, Performance." In *Thinking—Resisting—Reading the Political: Current Perspectives on Politics and Communities in the Arts Vol. 2*, edited by Anneka Esch van Kan, Stephan Packard, and Philipp Schulte, 101–18. Zurich: Diaphanes, 2013.

Reagan Library. "'The Victory Squad' 1966." YouTube video, 10:56. Posted December 20, 2018, https://www.youtube.com/watch?v=FNAaB0NlJPc&list=PL6MB h9P9pssjq1ZzFrcbEvfeggIiszEd0&index=9

Reagan, Ronald. "The Creative Society" speech at University of Southern California, April 19, 1966. Box C30, Ronald Reagan Presidential Library & Museum, Simi Valley, California.

Reckwitz, Andreas. *The Invention of Creativity: Modern Society and the Culture of the New*. Translated by Steven Black. Cambridge: Polity, 2017.

Reeves, Michelle. "'Obey the Rules or Get Out': Ronald Reagan's 1966 Gubernatorial Campaign and the 'Trouble in Berkeley.'" *Southern California Quarterly* 92, no. 3 (Fall 2010): 275–305.

Reidy, Joseph. *Illusions of Emancipation: The Pursuit of Freedom and Equality in the Twilight of Slavery*. Durham: University of North Carolina Press, 2019.

Richard, Kimberly Skye. "Crude Stages of the Capitalocene: Performance and Petro-Imperialism." PhD dissertation. University of California–Berkeley, 2019.

Ridout, Nicholas. *Passionate Amateurs: Theatre, Communism, and Love*. Ann Arbor: University of Michigan Press, 2015.

Roberts, Marilees. "*Prometheus Unbound*: Reconstitutive Poetics and the Promethean Poet." *The Keats-Shelley Review* 34, no. 2 (September 2020): 178–93.

Robinson, Ken. "Do Schools Kill Creativity?" Filmed 2006. TED video, 19:12. https://www.ted.com/talks/sir_ken_robinson_do_schools_kill_creativity/transcript?language=en#t-132537

Roh, David S., Betsy Huang, and Greta A. Niu. *Techno-Orientalism: Imagining Asia in Speculative Fiction, History, and Media*. New Brunswick, NJ: Rutgers University Press, 2015.

Ronald Reagan Presidential Library & Museum. "January 5, 1967: Inaugural Address (Public Ceremony)." Accessed June 21, 2022. https://www.reaganlibrary.gov/archives/speech/january-5-1967-inaugural-address-public-ceremony

Ross, Alex. "Reasons to Abandon Spotify that Have Nothing to Do with Joe Rogan." *New Yorker*, February 2, 2022. https://www.newyorker.com/culture/cultural-comment/imagine-a-world-without-spotify

Ross, Andrew. *Nice Work if You Can Get It: Life and Labor in Precarious Times*. New York: New York University Press, 2009.

Rowe, Tiffany. "Why More Business Schools Are Teaching Creativity." Startup Digest, April 13, 2017. https://web.archive.org/web/20201127031937/http://blog.startupdigest.com/2017/04/13/business-schools-teaching-creativity/

Runco, Mark A. *Creativity: Theories and Themes: Research, Development, and Practice*. Cambridge, MA: Academic Press, 2006.

Runco, Mark A., and Garrett J. Jaeger. "The Standard Definition of Creativity." *Creativity Research Journal* 24, no. 1 (2012): 92–96.

Sacasas, L. M. "Humanist Technology Criticism." Technology, Culture, and Ethics. July 9, 2015. https://thefrailestthing.com/2015/07/09/humanistic-technology-criticism/

Schad, Michael, and W. Monty Jones. "The Maker Movement and Education: A Systematic Review of the Literature." *Journal of Research on Technology in Education* 52, no. 1 (2020): 65–78.

Schiller, C. F. Von. "Letters Upon the Aesthetic Education of Man." Quoted in Robert Anchor. "History and Play: Johan Huizinga and His Critics." *History and Theory* 17, no. 1 (February 1978): 62–93.

Sheehan, Angela. "Steampunk Village @ Maker Faire 2010," YouTube video, 1:53. June 6, 2010. https://www.youtube.com/watch?v=YPkUfABmS48

Shelley, Mary. *Frankenstein: Annotated for Scientists, Engineers, and Creators of All Kinds*. Edited by David H. Guston, Ed Finn, and Jason Scott Robert. Cambridge: MIT Press, 2017.

Shelley, Percy Bysshe. "A Defense of Poetry." Poetry Foundation. Last modified October 13, 2009. https://www.poetryfoundation.org/articles/69388/a-defence-of-poetry

Sluga, Hans. "Donald Trump: Between Populist Rhetoric and Plutocratic Rule." Presentation at the UC Berkeley Critical Theory Symposium, Berkeley, CA, 2017. Quoted in Brown, *In the Ruins of Neoliberalism*, 224, footnote 2.

Snow, C. P. *The Two Cultures and the Scientific Revolution*. Cambridge: Cambridge University Press, 2013.

Solnit, Rebecca. "Diary." *London Review of Books* 35, no. 3 (February 7, 2013): 34–35.

Solnit, Rebecca. "The Boom Interview: Rebecca Solnit." *Boom* 4, no. 2 (Summer 2014), http://www.boomcalifornia.com/2014/06/the-boom-interview-rebecca-solnit/

Soloski, Alexis. "It's Alive! Well, the Puppeteers Are." *New York Times*, October 25, 2018. https://www.nytimes.com/2018/10/25/theater/frankenstein-manual-cinema.html

Spencer, Stuart. "Developing a Campaign Management Organization." In "Issues and Innovations in the 1966 Republican Gubernatorial Campaign." 1980. Regional Oral History Office, Bancroft Library, University of California–Berkeley.

Stanford University Center for Biomedical Ethics. "F@200 Events at Stanford." https://med.stanford.edu/medicineandthemuse/FrankensteinAt200/frankenstein-200-stanford-events.html

Steampunk & Makers Fair. Accessed August 25, 2015. https://web.archive.org/web/20150813013957/http://steampunkandmakersfair.org/

Steen, Shannon. "Dogwhistle Performance: Concealing White Supremacy in Right-Wing Populism," in *The Routledge Companion to Theatre and Politics*, edited by Peter Eckersall and Helena Grehan. New York: Routledge, 2019.

Steen, Shannon. "Neoliberal Scandals: Foxconn, Mike Daisey, and the Turn Toward Nonfiction Drama." *Theatre Journal* 66, no. 1 (Spring 2014): 1–18.

Sternberg, Robert J., and Todd I. Lubart. "The Concept of Creativity: Prospects and Paradigms." In *Handbook of Creativity*, edited by Robert J. Sternberg. New York: Cambridge University Press, 1998.

Stewart, Ruth Ann. "The Arts and Artist in Urban Revitalization." In *Understanding the Arts and Creative Sector in the United States*, edited by Joni Maya Cherbo, Ruth Ann Stewart, and Margaret Jane Wyszomirski, 105–29. New Brunswick, NJ: Rutgers University Press, 2008.

Szeman, Imre. "Neoliberals Dressed in Black; or, the Traffic in Creativity." *ESC: English Studies in Canada* 36, no. 1 (March 2010): 15–36.

Terman, Lewis. *Genetic Studies of Genius*. Stanford: Stanford University Press, 1925.

Terman, Lewis. *The Measurement of Intelligence*. New York: Houghton, Mifflin and Co., 1916.

Turner, Fred. "Burning Man at Google: A Cultural Infrastructure for New Media Production." *New Media & Society* 11, no. 1 & 2 (2009): 73–94.

Turner, Fred. *From Counterculture to Cyberculture: Stewart Brand, The Whole Earth Network, and the Rise of Digital Utopianism*. Chicago: University of Chicago Press, 2008.

Turner, Fred. "Millenarian Tinkering: The Puritan Roots of the Maker Movement." *Technology and Culture* 59, no. 4 (Fall 2018): S160–S182.

US Legal. "Industrial Homework or Piecework Law and Legal Definition." Accessed June 12, 2020. https://definitions.uslegal.com/i/industrial-homework-or-piecework/#:~:text=Industrial%20homework%20or%20piecework%20is,who%20permits%20or%20authorizes%20such

Vicq, Thibault. "Création Mondiale de Frankenstein, de Mark Grey, à la Monnaie: Les Nuances de la Douleur." *Opera Online*, March 10, 2019. https://www.opera-online.com/fr/columns/thibaultv/creation-mondiale-de-frankenstein-de-mark-grey-a-la-monnaie-les-nuances-de-la-douleur

Vogel, Ezra F. "The Advent of the Pacific Century." *Harvard International Review* 6, no. 5 (March 1984): 14–16.

Webb, Debra. "Placemaking and Social Equity: Expanding the Framework of Creative Placemaking." *Artivate: A Journal of Entrepreneurship in the Arts* 3, no. 1 (Winter 2014): 35–48.

Werry, Margaret. *The Tourist State: Performing Leisure, Liberalism, and Race in New Zealand*. Minneapolis: University of Minnesota Press, 2011.

Wikipedia. "Maker culture." Last modified June 5, 2021. https://en.wikipedia.org/wiki/Maker_culture

Williams, Raymond. *Keywords: A Vocabulary of Culture and Society*. Revised edition. New York: Oxford University Press, 1983.

Wilson, Richard. "Reagan on the Razor's Edge." *Los Angeles Times*, June 21, 1966.

Winterson, Jeanette. *Frankissstein: A Love Story*. New York: Jonathan Cape, 2019.

WIRED UK. "Shenzhen: The Silicon Valley of Hardware (Full Documentary) | Future Cities." YouTube video, 1:07:50. July 5, 2016. https://www.youtube.com/watch?v=SGJ5cZnoodY

Wong, Winnie. "Shenzhen's Model Bohemia and the Creative China Dream." In *Learning from Shenzhen: China's Post-Mao Experiment from Special Zone to Model City*, edited by Mary Ann O'Donnell, Winnie Wong, and Jonathan Bach, 193–211. Chicago: University of Chicago Press, 2017.

Wordsworth, William. "Preface." In *Lyrical Ballads: 1798 and 1802*, edited by Fiona Stafford. London: Oxford World's Classics, 2013.

Young, Harvey. "3 Reasons a Theater Degree Is Important, Even in Today's Econ-

omy." *Backstage*, April 3, 2013. http://www.backstage.com/advice-for-actors/bac kstage-experts/3-reasons-theater-degree-important/

Yue, Audrey. "Creative Queer Singapore: The Illiberal Pragmatics of Cultural Pro- duction." *Gay and Lesbian Psychology Review* 3, no. 3 (2007): 149–60.

Zuboff, Shoshana. *The Age of Surveillance Capitalism: The Fight for a Human Future at the New Frontier of Power.* London: Profile Books, 2019.

Index